D1529262

In Sight of America

AMERICAN CROSSROADS

Edited by Earl Lewis, George Lipsitz, Peggy Pascoe, George Sánchez, and Dana Takagi

In Sight of America

Photography and the Development of U. S. Immigration Policy

Anna Pegler-Gordon

UNIVERSITY OF CALIFORNIA PRESS
Berkeley · Los Angeles · London

5/11/10
WW
#60 -

University of California Press, one of the most dis-
tinguished university presses in the United States,
enriches lives around the world by advancing scholar-
ship in the humanities, social sciences, and natural
sciences. Its activities are supported by the UC Press
Foundation and by philanthropic contributions from
individuals and institutions. For more information,
visit www.ucpress.edu.

University of California Press
Berkeley and Los Angeles, California

University of California Press, Ltd.
London, England

© 2009 by The Regents of the University of California

Library of Congress Cataloging-in-Publication Data

Pegler-Gordon, Anna, 1968–.
 In sight of America : photography and the
development of U.S. immigration policy / Anna
Pegler-Gordon.
 p. cm. — (American crossroads ; 28)
 Includes bibliographical references and index.
 ISBN 978-0-520-25297-4 (cloth : alk. paper)
 ISBN 978-0-520-25298-1 (pbk. : alk. paper)
 1. United States—Emigration and immigration—
Government policy—History—19th century.
 2. United States—Emigration and immigration—
Government policy—History—20th century.
 3. Portrait photography—Political aspects—United
States—History. 4. Identification photographs—
United States—History. 5. Immigrants—United
States—Identification—History. 6. Immigrants—
Health and hygiene—United States—History.
 7. Ethnicity—Political aspects—United States—
History. 8. Ellis Island Immigration Station (N.Y.
and N.J.)—History. 9. Angel Island Immigration
Station (Calif.)—History. 10. Mexican-American
Border Region—Emigation and immigration—
History. I. Title.

 JV6483.P44 2009
 325.73—dc22 2008049350

Manufactured in the United States of America

18 17 16 15 14 13 12 11 10 09
10 9 8 7 6 5 4 3 2 1

This book is printed on Cascades Enviro 100, a 100%
post consumer waste, recycled, de-inked fiber. FSC
recycled certified and processed chlorine free. It is acid
free, Ecologo certified, and manufactured by BioGas
energy.

For Neil Gordon and Maggie Pegler
In memory of David Pegler

Contents

Figures

In each case where the photographer's name or studio is known, it is listed. When an archive has given a title to an untitled image, this title is given in parentheses.

Tables

Acknowledgments

My first thanks must go to the Immigration and Naturalization Service, without whom I would not be here. Literally: I would not be in the United States. More importantly, without their inquiries about whether I had committed a crime of moral turpitude, been a member of the Communist Party, or intended to become a prostitute, I would never have thought to study immigration policy. Without their instructions to turn my head to reveal my ear when being photographed for my green card, I would never have wondered about immigration photography. I didn't come to the United States to study. I came because I married a U.S. citizen. However, this journey has brought me more than I ever imagined when I immigrated.

This book began as a question about the way I was photographed during my immigration experience, and it continued life as a research paper and a dissertation. Throughout my studies, in England and the United States, I have been fortunate to have teachers who didn't give me answers but taught me how to question. Above all, my dissertation committee members at the University of Michigan, George Sánchez, Richard Cándida Smith, and Rebecca Zurier, have gone beyond their duties to support me as a student and a colleague. They have inspired me with their learning, their intellectual generosity, and their friendship. I could not have hoped for better mentors. Although Mary Panzer joined my committee at a later date, she has been an exemplary reader as well as a friend. I also want to recognize the special contribution of Robert G. Lee to this study. I formed the basis of this project in my first graduate seminar at

Brown University, and although my focus was on Ellis Island photography, it was Bob who suggested that the story might start instead at Angel Island. I am grateful to each teacher who has guided my studies but especially to Tony Branch, Neil Clark, Tim Cunningham, and Carrie Lynch at Billericay School; Jean Gooder and Susan Manning at Newnham College, Cambridge University; Nancy Armstrong, Mari Jo Buhle, Mary Ann Doane, Shepherd Krech III, Patrick Malone, and Susan Smulyan at Brown University; and June Howard, Joanne Leonard, Maria Montoya, David Scobey, Carroll Smith-Rosenberg, Ann Stoler, and Steve Sumida at the University of Michigan, Ann Arbor. Like all great teachers, they have given me more than they know or than I can repay.

Throughout my career, I have been lucky to have friends become colleagues and colleagues become friends. The steadfast friendship of Susette Min, Nhi Lieu, Brian Locke, and Theresa Macedo Pool buoyed me through graduate school. At both Brown University and the University of Michigan, I became part of a community of engaged scholars, including especially Chloe Burke, Paul Ching, Catherine Daligga, Colin Johnson, Clara Kawanishi, Shawn Kimmel, Robin Li, Carla McKenzie, John Nichols, Mark Rogers, Nick Syrett, Jen Tilton, Wilson Valentin-Escobar, and Stacy Washington. I also want to recognize my longtime friends Deb Gordon-Gurfinkel, Elli Gurfinkel, Alice Hewitt, Claudia Malloy, Bridget Mazzey, Stephanie Meadows, Sarah Prettejohns, Usha Subbuswamy, and Hannah Worrall. Susan Manes, Carlene Stephens, Selma Thomas, and Julia Grant have been true mentors, generous and honest. At Michigan State University, I have enjoyed teaching with and learning from Allison Berg, Andaluna Borcila, Gene Burns, Joe Cousins, Maggie Chen Hernandez, Meaghan Kozar, Louise Jezierski, Andrea Louie, and Kate O'Sullivan See. I have found a very welcome home at the James Madison College of Michigan State University and have been able to help create a second home at the Asian Pacific American Studies Program. My thanks to all the faculty and staff at both locations and to Dean Sherman Garnett for supporting my traveling between them.

This book would still be a question if it weren't for the shared insights and encouragement of my writing group partners who have read all or parts of this book, often more than once. My deep gratitude to these great friends and readers: Kimberley Alidio, Kirsten Fermaglich, John McKiernan-Gonzalez, Richard Kim, Nsenga Lee, Nhi Lieu, Mindy Morgan, Stephen Rohs, and Cynthia Wu. Tom Nehil, Carly Wunderlich, and Allison Meyer provided essential research assistance. Evelyn Hu-Dehart and Judy Yung kindly answered my questions and made very helpful ob-

servations about this work. The manuscript also benefited immensely from the support of the American Crossroads series editors, the comments of two anonymous University of California Press readers, and George Lipsitz's insightful reading. I also deeply appreciate the thoughtful support and guidance of my editor, Niels Hooper, and the careful attention of Rachel Lockman, Kate Warne, Elisabeth Magnus, and Nick Arrivo.

This project has taken me to California, Texas, New York, Pennsylvania, and Washington, D.C. In each place, I have benefited from the knowledge and openness of many archivists and librarians. In particular, I would like to thank Neil Thomsen, Michael Frush, and William Greene of the National Archives in San Bruno, California; Suzanne Harris and Claire Kluskens of the National Archives, Washington, D.C.; Marian Smith and Zack Wilske at the U.S. Citizenship and Immigration Services History Office; Barry Moreno and Jeffrey Dosik at the Ellis Island Immigration Museum; Wei Chi Poon at the University of California, Berkeley; David Kessler at the Bancroft Library; Christian Kelleher at the University of Texas at Austin; Claudia Rivers at the University of Texas at El Paso; Hui Hua Chua at Michigan State University; and the librarians of the American Museum of Natural History, the Balch Institute for Ethnic Studies (now part of the Pennsylvania Historical Society), the California Historical Society, the New York Public Library, and the Library of Congress Prints and Photographs Division.

Throughout this study, I have had the good fortune of support from the University of Michigan, Michigan State University, and the Immigration and Ethnic History Society. At the University of Michigan, I was supported by fellowships from the Rackham Graduate School, the Center for the Education of Women, the Institute for the Humanities, and the Office of Academic Multicultural Initiatives. At Michigan State University, I have received support from the Intramural Research Grants Program and the James Madison College Faculty Development and Founders' Funds. I also received welcome recognition and research funds from the Immigration and Ethnic History Society George E. Pozzetta Dissertation Award.

In many of these settings, from my enrollment in a women's college at Cambridge University to various fellowships, I have benefited from both informal and established affirmative action programs. As a white woman and nontraditional student, I recognize the importance of these programs to my educational and professional development, to my presence in the academy, and to the intellectual contributions this support has allowed me to make. Like the Immigration and Naturalization Ser-

vice, which allowed me to enter the United States, I would not be here if it were not for these affirmative action programs.

Even with such support, I could never have made this journey without my family: Toby, Ellen and David, Claire, Matilda and Scout, Lorna and Simon, Alvin and Felice, Mark and Pat, Joel and Bonnie, Ginger and Jim, Lyn and Rog, Don and Claire, and their families. They have given me everything I needed, most importantly a place not to think about my work! My daughters, Maya and Naomi, have lived with this project all their lives. They have made every day of writing (and not writing) more joyful than I thought possible. My greatest thanks must go to Neil, who has supported my work in every way and is simply the most wonderful person I could hope to spend my life with. When I handwrote my undergraduate thesis, he edited and typed it for me, and he has been making my life easier and better ever since. I've learned a lot since then, including how to type, but I'm not sure that I've learned enough ways to thank him for everything. Finally, I want to thank my parents. They are the most kind and wise people I have known, and I will always be grateful that they were my first teachers. My mum, Maggie, has been my best friend for as long as I can remember. Her life has shaped the course of my own, from her always avid reading to her decision to get an undergraduate degree with four young children at home. My dad, David, died shortly before I completed the dissertation on which this book is based. He never read many books, but his way of looking at and living in the world taught me more than I will ever learn from books, no matter how many I read.

An earlier version of portions of chapters 1 and 2 appeared as "Chinese Exclusion, Photography, and the Development of U.S. Immigration Policy," *American Quarterly* 58 (March 2006): 51–77. This article was reprinted in *The Best American History Essays 2008*, edited by David Roediger et al. (New York: Organization of American Historians and Palgrave MacMillan, 2008).

Introduction

In 1930, the commissioner general of immigration began the process of standardizing immigration photographs. The U.S. Immigration Bureau required photos in twenty-one different types of cases, not counting visas, and in most cases they had different requirements for each set.[1] This patchwork system of identity documentation had developed since 1875 as a central part of U.S. immigration policy, and its unevenness was not incidental. It reflected different policies enacted to regulate the different racial groups seeking entry to the United States. As new laws limiting immigration were introduced in the late nineteenth and early twentieth centuries, they commonly involved new requirements for observing, documenting, and photographing immigrants. Under these laws, immigrants were placed in sight of immigration officials who inspected their bodies and their documents to determine whether they could enter the United States. At the same time, as immigrants were detained for inspection, they were in sight of America. "Now I am trapped in this prison place," one Chinese detainee carved in the walls of the Angel Island immigration station. "I look out and see Oakland so close, yet I cannot go there."[2] Since its beginnings, the history of U.S. immigration policy has been the history of making immigrants visible.

Historians have long focused on the turn of the last century as a key period in the expansion and restriction of immigration. Between 1880 and 1910, average annual immigration almost doubled from approximately 450,000 to approximately 880,000. In each of the years 1905,

1906, 1907, and 1910, more than one million immigrants entered the United States. Immigration stayed high through 1914, then dropped because of the outbreak of war in Europe, the implementation of strict U.S. immigration quotas in the 1920s, and the Great Depression. From 1915 through 1930, immigration averaged only about 357,000 each year. And it continued to decline after 1930 (table 1).[3]

The period between 1875 and 1930 also saw the introduction, expansion, and consolidation of immigration restrictions in the United States as immigration control shifted from a state to a federal responsibility. Prior to 1875, immigration policy was controlled by the states, which chose either to encourage, to discourage, or to do little about immigration within their borders. As the U.S. government assumed responsibility for the regulation of immigration, it developed new statutes and regulations, as well as new institutions to administer these laws. As many historians have noted, from the very beginning U.S. immigration policy was applied unfairly to different racial groups, reflecting and reinforcing dominant American understandings of these groups. Federal laws consistently distinguished between exclusion and general immigration restrictions. Exclusion laws covered only Asians and assumed no right of entry. From the beginnings of Chinese exclusion in 1875 until its repeal in 1943, these laws and regulations were consistently expanded to exclude more immigrant groups, extending to Japanese nationals starting in 1907 and almost all Asians by 1917. In contrast, general immigration laws governed all immigrants and assumed the right to immigrate, barring disqualifying factors such as physical illness or disability. Over the course of more than forty years, from 1875 until 1917, general immigration laws were repeatedly expanded through more and more disbarments. The introduction and consolidation of national quotas in the 1920s added numeric restrictions to the selective controls on European immigrants and extended exclusion to all Asians except colonized American subjects.[4]

The first federal immigration restriction, the 1875 Page Act, barred the entry of prostitutes, coolies, and criminals. Although this act has been long overlooked as a minor, weakly enforced statute affecting only Chinese women, historians of immigration policy are increasingly recognizing its significance. For example, George Anthony Peffer has shown how the law contains the origins of Chinese exclusion, and Eithne Luibhéid has identified it as central to the development of broad immigration restrictions based on gender and sexuality. The act also introduced the practice of treating Asian immigrants more harshly than other immigrants in

both policy and practice. It prohibited immigration by criminals and prostitutes in general but specifically cited immigration by Oriental subjects imported involuntarily (coolies) or for "lewd and immoral purposes." Asian immigrants were singled out for additional restrictions and subject to greater suspicion.[5]

In 1882, two new laws excluded most Chinese immigrants and placed additional restrictions on all immigrants. However, they offered very different visions of restriction. The Chinese Exclusion Act considered all Chinese undesirable as a matter of course; it banned Chinese from becoming U.S. citizens and barred all new immigration by both skilled and unskilled laborers for ten years, a prohibition that was subsequently extended to include professionals. The exclusion of the Chinese was supported by widespread American beliefs about Chinese racial inassimilability and inferiority, as well as concerns that the Chinese threatened the American standard of living by working for lower wages than free white men.[6] In contrast, the 1882 Immigration Act provided for a fifty-cent levy on new immigrants and added three new excludable groups to those already banned: lunatics, idiots, and those unable to care for themselves without becoming public charges. From these beginnings in 1875 and 1882, Asians and non-Asians were treated separately in immigration law and, consequently, immigration history. Early historians of immigration and its restriction typically ignored Asian immigration, describing it as separate from the main narrative of American immigration. Most famously, John Higham noted in his 1950s history of American nativism that opposition to Asian immigration was "historically tangential." However, historians have increasingly viewed restrictions governing Europeans and Asians as twin tracks in immigration policy, separate and unequal. More recently, some historians have challenged this twin track thesis to demonstrate that Chinese exclusion was not parallel but central to the development of U.S. immigration policy. Among others, Lucy Salyer has shown how Chinese challenges to exclusion shaped the judicial review of immigration law, and Erika Lee has explored how the administration of exclusion was pivotal in the development of the United States as a gatekeeping nation.[7]

During the 1890s, Congress implemented stronger general immigration policies and renewed Chinese exclusion laws. The Immigration Act of 1891 banned immigrants suffering from loathsome or contagious diseases, paupers and people liable to become a public charge (a broader class than outlined in 1882), "assisted immigrants" whose passage was paid for them, polygamists, and those convicted of crimes or mis-

TABLE 1. IMMIGRATION TO THE UNITED STATES, 1871–30

Decade or Year	Total Immigrants	Northern and Western European Immigrants (% of total immigrants)	Southern and East European Immigrants (% of total immigrants)	Asian Immigrants (% of total immigrants)	Mexican Immigrants (% of total immigrants)	Other immigrants (% of total immigrants)
1871–80	2,812,191	2,070,373 (73.6%)	201,889 (7.2%)	123,823 (4.4%)	5,162 (0.2%)	410,943 (14.6%)
1881–90	5,246,613	3,778,633 (72.0%)	958,413 (18.3%)	68,380 (1.3%)	1,913 —	439,274 (8.4%)
1891–1900	3,687,564	1,643,492 (44.6%)	1,915,486 (51.9%)	71,236 (1.9%)	971 —	56,379 (1.6%)
1901–10	8,795,386	1,910,035 (21.7%)	6,225,981 (70.8%)	243,567 (2.8%)	49,642 (0.6%)	366,161 (4.1%)
1911–20	5,735,811	997,438 (17.4%)	3,379,126 (58.9%)	192,559 (3.4%)	219,004 (3.8%)	947,684 (16.5%)
1921–30	4,107,209	1,284,023 (31.3%)	1,193,830 (29.1%)	97,400 (2.4%)	459,287 (11.2%)	1,072,669 (26.1%)

Year	Total					
1921	805,228	138,551 (17.2%)	513,813 (63.8%)	25,034 (3.1%)	13,774 (1.7%)	97,072 (12.3%)
1922	309,556	79,437 (25.7%)	136,948 (44.2%)	14,263 (4.6%)	7,449 (2.4%)	59,357 (19.2%)
1923	522,919	156,429 (29.9%)	151,491 (29.0%)	13,705 (2.6%)	13,181 (2.5%)	137,526 (26.3%)
1924	706,896	203,346 (28.8%)	160,993 (22.8%)	22,065 (3.1%)	17,559 (2.5%)	231,156 (32.7%)
1925	294,314	125,248 (42.6%)	23,118 (7.9%)	3,578 (1.2%)	2,106 (0.7%)	109,406 (37.1%)
1926	304,488	126,437 (41.5%)	29,125 (9.6%)	3,413 (1.1%)	3,222 (1.0%)	102,197 (33.6%)
1927	335,175	126,721 (37.8%)	41,647 (12.4%)	3,669 (1.1%)	4,019 (1.2%)	95,417 (28.5%)
1928	307,255	116,267 (37.8%)	42,246 (13.7%)	3,380 (1.1%)	4,058 (1.3%)	86,346 (28.1%)
1929	279,678	114,469 (40.9%)	44,129 (15.8%)	3,758 (1.3%)	4,306 (1.5%)	77,168 (27.6%)
1930	241,700	97,118 (40.2%)	50,320 (20.8%)	4,535 (1.9%)	5,225 (2.2%)	77,024 (31.9%)

SOURCE: U.S. Bureau of Immigration, *Annual Report of the Commissioner General of Immigration, 1930* (Washington, DC: Government Printing Office, 1930). "Other immigrants" includes immigrants from Africa, Australia, Canada, the Caribbean, and Central and South America. Between 1871 and 1903, the figures are for immigrants arriving. Between 1904 and 1906, the figures are for aliens admitted. Between 1907 and 1930, the figures are for immigrant aliens admitted.

demeanors involving moral turpitude. Under this law, the federal government assumed full responsibility for immigration control, establishing an Immigration Bureau, appointing a superintendent of immigration, commissioning the Ellis Island federal immigration station, and removing state and local authorities as the primary immigration authorities. These developments have been recognized as important because they provided the first effective enforcement mechanism to implement general immigration restrictions. For the first time, the law required that every alien be inspected and specified that all immigrants would be screened through medical inspection. Shortly after completing work on the general immigration bill and facing reelection, members of Congress turned their attention to exclusion, renewing and expanding restrictions on Chinese immigrants in the Geary Act of 1892 and its subsequent amendment. Although general histories often describe the Geary Act as the renewal of Chinese exclusion, others have shown how it made major changes to exclusion law, requiring registration of immigrants for the first time. Both laws passed in the 1890s shared an emphasis on enforcement, although, again, Chinese exclusion was far more harshly enforced.[8]

As is widely acknowledged, the next major law was the 1917 Immigration Act, which made substantial changes that affected European, Asian, and Mexican immigrants. After years of efforts by restrictionists, the law implemented a native-language literacy test, banned immigration from an "Asiatic barred zone," essentially extending exclusion to' all Asia (except for the U.S.-controlled Philippines), and brought Mexican immigrants under general immigration law for the first time, making them subject to the same head taxes and inspection practices as other immigrants.[9]

Most histories of immigration conclude that the passage of racialized national quotas in 1921 and 1924 represented the triumph of American nativism. Under these laws, fewer and fewer immigrants were allowed to enter the United States. From 1921 to 1930, total immigration was reduced from more than 800,000 to less than 242,000. Immigration from southern and eastern Europe was cut even more dramatically: from more than 500,000 in 1921 to approximately 50,000 in 1930.[10] The 1924 National Origins Act also consolidated Asian exclusion by banning the immigration of aliens ineligible for citizenship, which, by 1924, included only Asians. Although the law did not address immigration from the Western Hemisphere, 1924 also marked the establishment of the U.S. Border Patrol to prevent illegal entries on the United States' northern and southern borders.[11]

As this outline suggests, a new generation of scholars have expanded our understandings to recognize the historical importance of race, gender, sexuality, and class to the shaping of immigration regulation.[12] However, key aspects of immigration regulation have remained relatively invisible in these new histories. Although not previously acknowledged, visually based regulation played a central role in the development and implementation of these laws. Historians have largely ignored the visual history of immigration policy both because of their inattention to visual historical records and because of the foundational place of European immigration within immigration studies. European immigrants were not central to the history of photographic immigration documentation and were largely untouched by official photographic practices until they were restricted as part of the racially based National Origins Act of 1924. Since European immigrants were not central to the development of photographic immigration documentation, the history of immigration photography was not considered central to immigration history. Greater attention has been paid to the medical inspection of European and other immigrants; however, these studies rarely focus on the central role of the visual within inspection practices.[13]

This study asks: How does the history of immigration policy change when we look through the prism of visual culture? First, a central component of immigration policy comes into focus. *In Sight of America* argues that photography shaped the development of immigration policy in the United States. As Peter Quartermaine has written about colonial image making, "Photography is no mere handmaid of empire, but a shaping dimension of it."[14] From the beginning of U.S. immigration law, Chinese, Mexican, and European immigrants were not only subject to different immigration restrictions but also covered by different policies and practices of visual regulation. As the federal government introduced a series of racialized immigration restrictions, visual systems of observation and documentation became essential to their implementation and expansion. As each immigrant group was made subject to these racially based exclusions and general immigration restrictions, it was incorporated into the system of visual regulation that underpinned these controls. At the same time, these processes of observation, documentation, and representation helped reinforce popular and official understandings of different immigrant groups, as well as their differential treatment under immigration law.

As outlined in more detail in the description of chapters below, this regulation developed through two interconnected mechanisms of immi-

gration policy: photographic identity documentation and visual medical inspection. As the Chinese were subject to exclusion, the limited number of Chinese who were allowed to enter or remain in the country became the first immigrants subject to identity documentation. With the passage of the Geary Act (1892) and the McCreary Amendment (1893), almost all Chinese immigrants were required to register and provide photographic identity documentation to establish their right to reside in the United States. As immigrants were selectively restricted on the basis of their medical health starting in 1891, this screening was conducted through visually based medical inspections. In contrast to the Chinese, however, Europeans were not required to present documentation to immigration officials or carry documentation once they had successfully entered: a sign of their greater acceptance within the American polity. By 1909, all Chinese, including U.S. citizens of Chinese descent, were required to carry photographic identity documentation. When Mexicans were included under general immigration law in 1917, they were subject to both medical inspection and photographic identity documentation. However, despite the increasing restrictions on their migration, long-standing reliance on their labor in the U.S. Southwest offered intermittent opportunities for them to evade visual immigration regulation. In 1924, in the same law that implemented racial quotas and comprehensive Asian exclusion, all immigrants were required to provide photographic visas upon their arrival in the United States. Throughout this period, in statutes, regulations, and institutionalized practices, the Immigration Bureau used photographic identity documentation and visual medical inspection to restrict undesirable immigration and regulate immigrants already in the United States.

The development of immigration policy as a racialized system of visual regulation was both particular to the United States and part of broader international changes in immigration policy, identity documentation, and bureaucratization.[15] Although Europeans were not initially subject to photographic documentation upon their arrival in the United States, many of them—notably Jews arriving from eastern Europe—had been required to carry such documentation with them in their home countries, primarily to ensure that they could not depart the country without serving in the armed forces. In 1893, the same year that the United States implemented a system of photographic registration for Chinese immigrants, France passed a law requiring that all immigrant workers register with the government. As John Torpey notes in his history of the passport, the French government also determined that all resident foreigners,

not only workers, should be registered according to the Bertillon system of anthropometric measurement, a system that was originally developed in France to identify criminals and that was used in the United States during the 1900s to register Chinese. In 1894, Germany required all foreigners entering Germany to possess a passport, and by 1908 foreign workers had to carry an identity document. By 1912, when all U.S. residents of Chinese descent were required to carry photographic identity cards, French authorities had developed the *carnet de nomade,* an identity card containing both photographs and fingerprints, that immigrants without a permanent French residence were required to keep with them at all times. Although these registration laws shared similarities with American law, European requirements typically covered all foreigners, whereas American registration focused only on the Chinese. During the First World War, the United States and many European nations implemented broad photographic passport restrictions to ensure that citizens could not leave to avoid military service and that foreigners suspected of posing a threat to the nation could neither leave nor enter. However, the United States amended these for many groups after the war ended, whereas they remained in force in Europe.[16]

Looking at the development of immigration policy through the prism of visual culture, this study confirms and expands on recent histories that recognize the centrality of Chinese experiences. Such histories have most commonly compared Chinese to European immigration, partly reinscribing the idea of European immigration as normative while ignoring non-European immigration. Building on Sucheng Chan's call for more comparative studies of Chinese and European immigration experiences, Erika Lee has called for more studies that compare Asian and Latino experiences within immigration law.[17] This study explores the experiences of Chinese, Mexican, and European immigrants. It traces the circuit of photographic identity documentation, not between Ellis Island and Angel Island, the central entry point for Asian immigrants, but from Angel Island through El Paso to Ellis Island. Not only was Chinese exclusion central to the development of general immigration policy, it was the foundation of visual immigration policy. The Immigration Bureau used the early photographic identification of the Chinese as a model for their expansion of photographic documentation to other immigrant groups and, by the 1920s, all immigrants. At the same time, however, the Chinese experience remained distinct: they were more strictly regulated than any other group and resisted their photographic regulation both forcefully and effectively. The experiences of the Chi-

nese under exclusion show that Chinese exclusion was central to the development of general immigration policy and that visuality was a key component of immigration restriction.

Building on renewed attention to the centrality of race within immigration policy, this study addresses the ways that the United States' differential policies concerning immigration and photographic documentation were part of state-based practices of racial formation. Coco Fusco has argued, "Rather than *recording* the existence of race, photography *produced* race as a visualizable fact."[18] This study focuses on the ways that immigration photography produced race not only by representing it visually but also by regulating which immigrant groups would require representation. In immigration photography, racial hierarchies and the differential privilege of vision operated together to ensure that some immigrants (in particular, the Chinese) were marked and others (especially Europeans) remained unmarked. Chinese immigrants were photographed because they were viewed as different, but they were also viewed as different because they were photographed.[19]

While historians of immigration have overlooked the central place of the visual within the development of immigration policy, photographic historians have largely overlooked photographic representations of immigrants that were not taken by renowned photographers, as well as photographs used for purposes of identification. Like immigration scholars, historians of photography and visual culture have attended carefully to the late nineteenth and early twentieth centuries. These were times of innovation and expansion in American visual culture, including technological developments in photography and halftone printing: photographic prints became easier and cheaper to reproduce, and new printing processes allowed photographic images to be printed alongside text, leading to a substantial expansion in illustrated popular and government publications. These advancements enabled the mass production and circulation of images of immigrants, images that helped shape Americans' understanding and experience of immigration. Immigrants were not the only topic of interest to government officials, photographers, and reporters: America's colonial subjects, industrial workers, and the urban poor were visually inspected and represented in photographic form. However, while the visual experiences and representation of these groups have been studied extensively, immigrants have received comparatively little critical attention. Despite numerous illustrated and pictorial histories of immigration, or perhaps because of them, few serious histories of immigration have paid attention to photographic representations of immi-

grants, and few histories of photography have paid attention to immigrants. In particular, immigration identity documentation has barely been referenced. Instead, most histories of immigration photography focus on scenes and spectacles involving immigrants—photographs of Chinatown, New York's Lower East Side, and the Mexican Revolution—rather than the photographs presented by immigrants to inspectors at the Angel Island, Ellis Island, and El Paso immigration stations.[20]

In addition to engaging in the history of immigration, this study asks: How does the history of photography change when we consider immigrants and immigration identity documentation? In particular, how does immigration identity documentation challenge or complicate the dominant narrative about state photography, images taken by or for governmental and other institutional purposes? Histories of photography have typically divided portrait photography into two opposing traditions: the honorific self-presentation of bourgeois subjects and the repressive representation of prisoners, patients, and the poor. Inspired by Michel Foucault's work on the disciplinary institutions of modernity, critics such as John Tagg and David Green have contrasted the "cultivated asymmetries," soft lighting, and partial shading of the honorific studio portrait against the conventions of repressive state photography that emphasize frontality, clear lighting, and sharp detail.[21] The new visual conventions of scientific, ethnographic, and criminal photography were clearly a significant departure from the earlier honorific approach to portraiture. Nonetheless, as the images in this study show, the rupture or reversal between these two traditions and their visual conventions is not nearly as complete as these historians suggest. Instead, the honorific and repressive aspects of portraiture, as well as the varied genres of photography, have always been mixed. Chinese immigrants, for example, viewed the practices of registration and documentation requirements as repressive but probably associated the frontal perspective with honorific representation, as was common in Chinese portraiture. At the same time, European immigrants were often represented through what I will call an "honorific ethnographic" approach that both drew on and complicated the conventions of honorific personal and repressive state portraiture.[22]

In a related argument, the history of immigration identity documentation shows that photographic subjects had more control over their self-representation, the production and the circulation of photographs, than has been previously understood. Unlike earlier studies of state documentary photography, which emphasize the all-encompassing power of photography over its subjects, this study of official immigration pho-

tography emphasizes both the contestation involved in photographic representation and the fact that photography's disciplinary power is unstable and insecure.

Finally, the empirical authority of photography was never secured in the realm of immigration photography, particularly in photographic documentation. In fact, photography (and the new visual regimes with which it is associated) may be a particularly insecure means to attempt to control the representation, identity, and movement of people. Immigration restrictionists and officials believed that photographic documentation promised the optical objectivity of an image drawn directly from reality. However, as immigrants used photographs for their own purposes, they challenged this understanding of photography and revealed the insecurity of photographic authority.

In Sight of America argues that photography played an important role in the delineation of the nation as a technology to control access to national membership and as a means of representing the members of the nation. Photographic historian Laura Wexler has called for "scholars of American nationalism to attempt to clarify a photographic history of the national gaze, just as feminist scholars have long worked to elucidate a history of the male gaze."[23] This study responds by considering both the history of immigration photography and the official observational practices in which this photography was embedded. In focusing on photographic documentation, it locates the precise point at which photography and national identity converge in the form of the photographic immigration identity document.

However, immigration photography, like immigration policy, was not simply imposed upon immigrants by the federal government. This study pays close attention to the ways that immigration policies were implemented on the ground and the ways that immigrants resisted the Immigration Bureau's regulatory system of photographic documentation. Instead of viewing political history from the top down, *In Sight of America* explores immigration policy making as a dialectical process involving both immigrants and officials. At the same time, whereas some historians of photography focus their attention on images and photographers, this study views photography as a practice involving a range of actors. Immigration photography was a dialectical process of image making that involved restrictionists and reformers, immigration officials, and—most importantly—immigrants themselves.[24]

Chapter 1, "First Impressions: Chinese Exclusion and the Introduction of Immigration Documentation, 1875–1909," focuses on the Im-

migration Bureau's adoption of extensive photographic documentation in its attempts to regulate Chinese immigration. Starting in 1875 and expanding throughout the exclusion era, photographs became a central component in the administration of Chinese migration. The stringent visual regulation of the Chinese reflected popular and governmental concerns that most Chinese immigrants entered the United States illegally, aided by the fact that—according to legislators—all Chinese looked alike and were completely inscrutable. These attitudes existed prior to exclusion, but the exclusion laws became a locus for concerns about key visual issues, including Chinese immigrants' supposed illegibility, inassimilability, and inherent criminality.[25]

As Chinese immigrants became the first group to be excluded from the United States solely on the basis of race and class, they also became the first group to be photographed by the Immigration Bureau. In 1875, photographic identity documentation of Chinese women was introduced with the very first federal immigration restriction, the Page Act. As exclusion laws were expanded in 1882, 1892, and 1893, the range of photographic identity documents issued to Chinese exempted from exclusion was also expanded. In fact, Chinese photographic certificates appear to be the first government-issued photographic identification in the United States. Chinese elites fought the implementation of documentation through formal protests and legal challenges, arguing that photographic documentation practices unfairly and illegally singled the Chinese out for visual suspicion. Although their appeals reached the U.S. Supreme Court, these efforts were ultimately unsuccessful. Required to provide photographic identity portraits on their documentation, most immigrants supplied simple portraits. However, others offered elaborate individual and family studio portraits that they used for varied purposes: as symbols of respectability, class position, and citizenship; as evidence of family resemblance and relationships; and as identification. These images challenged the Immigration Bureau's regulation, suggesting that even within the strictures of state-based racial photography Chinese immigrants retained some control of their self-representation.[26]

As chapter 2 shows, however, Chinese immigrants also resisted exclusion by manipulating photographs and photographic documentation. Many scholars have focused on the history of "paper sons," Chinese immigrants who fabricated familial identities to enter the United States in spite of (and in opposition to) exclusion restrictions. However, they have not have explored the central role of photographic documentation in creating paper relationships.[27] In the words of this chapter's title, many pa-

per sons were "Photographic Paper Sons." Illegal entrants used their own photographic archives to adopt paper identities and create false identity documents, they substituted photographs on identity certificates, and they exchanged certificates among different individuals. In using photographs to resist exclusion, these Chinese immigrants not only challenged discriminatory immigration policies but also undermined the photograph's emerging authority as evidence. These immigrants' everyday acts of evasion were generally more effective at resisting exclusion than the formal protests of elite diplomats and merchants or the efforts of many applicants to present themselves favorably in their immigration portraits.

Although photographic documentation was central to the enforcement of Chinese exclusion, officials and restrictionists were concerned that these policies were not fully effective in controlling the entry of excluded immigrants. Visual immigration policies underpinned immigration control, and, where they failed, immigration restriction itself failed. Concerned about the effectiveness of Chinese exclusion, immigration officials recognized the widespread problem of fraudulent photographic documentation and worked hard to control this problem. As officials expanded the use of photographic documentation, they also worked to take more control over the production and circulation of identity photographs. In addition to receiving images supplied by immigrants, small immigration stations obtained the services of professional photographers, and larger stations purchased photographic equipment so that they could take their own images of arriving immigrants. The Immigration Bureau's extension of control also addressed the uniformity of the photographic archive. Throughout this period, as the use of photographs expanded, the bureau provided increasingly detailed guidelines for identity photographs to make them more standardized. The simultaneous expansion of documentation and contraction of acceptable images were uneven and often contested by immigrants who continued to use varied photographs even after the bureau had implemented newly restrictive rules. However, as more uniform photographs were used to document more immigrants, the earlier varied purposes of photography, including self-representation, were increasingly replaced by one primary purpose: accurate individual identification.

The next chapters consider how European immigrants were seen through Ellis Island, in terms of being guided through the process of visual medical inspection and being represented through photographic images taken at the immigration station. Although the Immigration Bureau regulated European immigrants less closely than the Chinese, immigra-

tion officials were actively involved in shaping American understandings of European newcomers and in influencing immigration policy.

The development of immigration photography depended not only on new laws and regulations but also on new institutions for its rapid expansion. More than any other immigration station, Ellis Island created a space for the observation of immigrants. Chapter 3 explores the role of Ellis Island as an "observation station" where immigrants were viewed through two interlinked scopic regimes: the medical inspection process of Public Health Service officials and the tourist practices of visitors who came to view the twin spectacles of Old World immigrants and modern mass immigration.[28] After the Ellis Island immigration station opened in 1892, visitors traveled to the island to view the newly arrived immigrants because they saw them simultaneously as ethnographic "others" and as assimilable potential Americans. According to popular accounts, it was important to view the immigrants when they first arrived because once they had left the island they would become assimilated into the general population and would lose many of their most picturesque qualities. At the island and in contrast to the Old World appearance of the immigrants, visitors were also intrigued to observe the modern procedures of inspection and restriction that the station was built to implement. The medical inspection, which attempted to weed out individual immigrants with diseases or other disbarments, relied heavily on visual techniques.

Like immigration officials who were wary of the reliability of Chinese photographic documentation, restrictionists questioned the thoroughness of visual medical inspection. Throughout this period, they increasingly challenged visual medical inspection as cursory and superficial, demanding more stringent procedures to reduce immigration. The literacy test, passed in 1917 after years of restrictionist efforts, reflected a shift away from visual inspection. According to its supporters, the requirement that immigrants read a short passage in their native language represented a deeper understanding of immigrants' capabilities and potential contributions to the United States. Historians have been right in suggesting that literacy tests were partly a mask for restrictionist efforts to reduce the overall amount of immigration. However, this argument does not fully recognize that anti-immigrant activists were seriously concerned with the ways that immigrants were inspected and the inadequacies of visual inspection.[29]

In this context, chapter 4, "Ellis Island as a Photo Studio," explores how the immigration station functioned not only as a site for observing

immigrants but also as a place for photographing them. In many ways, Ellis Island helped create the genre of immigrant photography.[30] Commercial photographers, art photographers, progressive reformers, reporters, government officials, and tourists all photographed immigrants at Ellis Island. They reproduced these images in varied settings, including newspapers, restrictionist journals, reform magazines, and government reports. In some cases, the same image was published in several contexts for varied purposes. Despite the extensive photographic representation of immigrants at Ellis Island, Europeans remained largely unmarked by governmental photographic practices. Throughout the peak immigration years, the official photographic documentation of European immigrants was limited to the photographing of deportees immediately prior to their departure to prevent their reentry.[31] This chapter focuses on immigration official Augustus Sherman and documentary photographer Lewis Hine to reveal how their photographs, which have often been viewed as sympathetic toward European immigrants, were also used to support immigration restrictions. Along with other photographers, Sherman and Hine used an honorific ethnographic approach to represent immigrants, an approach that challenges the traditional distinction between the honorific and repressive uses of portraiture. These photographic works, along with observational practices on the island, offer insights into the competing uses of photography and the complex discourses surrounding European immigration at the turn of the last century.

Chapters 5 and 6 address the uneven and often unsuccessful implementation of photographic documentation policies on the United States' Mexican border in the early twentieth century. During this time, border crossing changed from a largely unmonitored practice to a process that was increasingly regulated by the Immigration Bureau, the Public Health Service, and (after its establishment in 1924) the Border Patrol. Historians have described how early border enforcement was designed primarily to control illegal Chinese and European immigration and how, as general immigration laws were extended to include Mexican migration in 1917, the bureau used inspection practices developed at Ellis Island to regulate border crossers.[32] However, they have not attended to the uses of photographic documentation on the Mexican-U.S. border, which drew on techniques already developed at Angel Island to regulate Chinese exclusion.

Chapter 5, "The Imaginary Line: Passing and Passports on the Mexican-U.S. Border, 1906–17," focuses on three key areas of increased photographic regulation and representation: illegal Chinese and European im-

migration, the Mexican Revolution, and the First World War. Concerned about the potential threat to national security from the loosely regulated border, the U.S. government introduced passport controls and border identification almost simultaneously in 1917 to better regulate border crossing. As historians such as George Sánchez and Erika Lee have written, immigration officials were concerned about questions of racial liminality on the Mexican-U.S. border because Chinese and other immigrants were believed to pass as Mexicans in order to enter the United States illegally.[33] This chapter explores the visual instability suggested by such concerns about racial liminality, connecting it with the expansion of visual regulation on the border more generally.

Starting in 1917 and expanding in 1918, a passport-permit system was introduced on the border and throughout the United States. Although it was not aimed at Mexican immigrants, this wartime national security measure required a visaed passport of all aliens applying for admission to the United States.[34] During the First World War, passports were also required of U.S. citizens crossing the border. Under a 1918 executive order, a passport was defined as "any document in the nature of a passport issued by the United States or by a foreign government which shows the identity of the individual for whose use it was issued and bears his signed and certified photograph."[35] For the first time, all arrivals in the United States were subject to the photographic identity requirements that had originally been developed under Chinese exclusion. Although the government's regulation of passports and passing was not aimed at Mexican immigration, these new laws helped change the border from an "imaginary line" to a "dividing line," permanently changing Mexican border crossing in the region.

Chapter 6, "The Dividing Line: Documentation on the Mexican-U.S. Border, 1917–34," focuses on the uneven development of border documentation starting in 1917. In addition to passports, immigration officials introduced a broad range of photographic border-crossing documents in this year, including compulsory identification cards for agricultural laborers, optional Mexican citizen and U.S. citizen identity cards for frequent border crossers, sometimes known as "local passports," and American tourist cards for short stays in Mexico. When photographic identification cards were introduced on the Mexican-U.S. border in 1917, there were far fewer debates about their acceptability than when they had first been introduced to regulate the Chinese migrants. However, the limited discussion about Mexican photographic documentation echoed earlier debates and questioned whether restrictions developed for Chi-

nese exclusion could be extended to other immigrants.[36] As general im-
migration laws were expanded to include Mexican immigrants, the Im-
migration Bureau made various exemptions to ensure the continued sup-
ply of Mexican laborers to U.S. agricultural and industrial employers.
These exemptions were made more palatable to restrictionists by the in-
troduction of photographic identity documentation to regulate the ex-
empted laborers. However, in contrast to the strict visual regulation of
the Chinese on which these practices were based, the Immigration Bu-
reau showed little interest in regulating Mexicans once they had entered
the United States.

Responding to employer concerns about the availability of inexpen-
sive Mexican labor, the Immigration Bureau developed a dual system that
implemented an increasingly strict system of visual regulation at border
stations but allowed Mexican immigrants to remain relatively invisible
once they had entered the United States. This dual policy worked in fa-
vor of employers when they needed labor but also when they didn't. Dur-
ing the Great Depression, state and local authorities coordinated with
the Immigration Bureau to repatriate Mexicans and Mexican Americans.
Although repatriation was technically voluntary, many immigrants felt
coerced to leave the United States as they were pushed off welfare rolls
and unable to find work. These campaigns were aided by the fact that
many Mexican immigrants had been tacitly allowed to remain in the
United States despite their lack of legal status or documentation. As repa-
triation campaigns became more coercive, they were coupled with "scare-
heading" raids that focused on immigrants without legal documentation.
Between 1930 and 1933, approximately four hundred thousand Mexi-
can immigrants and Mexican Americans were repatriated to Mexico.[37]

In Sight of America follows many histories of immigration policy in
taking the 1924 National Origins Act as a narrative end point. Although
the act is now remembered as the beginning of racially restrictive quo-
tas that restricted "new" immigration from southern and eastern Europe
in favor of "old" northwestern European immigration, at the time it was
also known as "the Visa Act" for its requirement that all immigrants have
photographic visas to enter the United States.[38] Mexican immigrants were
not placed under quotas in the 1924 National Origins Act, but as non-
quota immigrants they were required to submit photographs to meet the
new law's visa requirements. The simultaneous introduction of racial-
ized immigration restrictions and photographic documentation reveals
the interconnectedness of these policies for all immigrants.[39]

When viewed through the lens of visual culture, the significance of the

National Origins Act becomes not only the exclusion of large numbers of Europeans and the consolidation of exclusions against Asians but also the incorporation of European and Mexican immigrants into a racialized system of documentation that had been long established for the Chinese. In addition, the passage of quotas marked the end of visual medical inspection as the primary means of determining which European immigrants were allowed entry to the United States. Immigrants allowed to enter under quotas were still inspected, but these inspections now happened in much smaller numbers, at the ports where immigrants boarded ship and on board ship prior to disembarking in the United States. Medical inspection had been part of an attempt to control the entry of "new" racially suspect immigrant groups through visual inspection. Restrictionists had assumed that these groups would be disproportionately diseased and liable to become public charges; therefore, medical inspection would keep them out of America. However, this did not prove true, at least not in the numbers that anti-immigrant forces had hoped. Rather than rethink their assumptions about southern and eastern European immigrants, restrictionists determined that the problem was with the inadequacy of the medical inspection, particularly the superficial nature of its reliance on visual diagnosis.

In this light, the act appears less conclusive than it is described in traditional immigration histories. In visual terms, the 1924 act represents not only the triumph of nativist lawmaking, as most immigration histories conclude, but also the end of attempting to regulate European immigrants primarily through systems of visual medical inspection. (Outside the quota system, Mexican and Chinese immigrants were already incorporated into dual systems of documentation and visual medical inspection.) It could be argued that the passage of quotas depended upon the development of new observational systems, which provided new forms of knowledge to justify the exclusion of large numbers of Europeans. However, quotas were also made possible by the failure of attempts to regulate immigrants through visual inspection. They were introduced not only because new methods of medical inspection had supposedly revealed the dangers of immigration but also because they had revealed the inadequacy and unreliability of such inspection in restricting large numbers of these immigrants. Although visually based medical inspections continue to the present, the 1920s represented a shift from visual observation to photographic documentation as the key procedure in the immigration inspection process. As addressed in the conclusion, documentation remained a concern after the passage of the 1924

National Origins and Visa Act. Despite the introduction of photographic visas to ensure that arriving quota immigrants were who they claimed to be, the law was not viewed as conclusive by restrictionists or immigration officials. In 1928, the Immigration Bureau developed a new policy of issuing photographic immigrant identity cards to all new arrivals. The following year, Congress required photographs on naturalization certificates.[40]

In the 1920s, as immigration identity documentation and national quotas were implemented, all immigrants to the United States were visually inspected and photographically documented. However, inequalities in the law and in the enforcement of the law persisted. Despite a few highly publicized raids of immigrant dance halls during the 1930s, European immigrants were largely unregulated by immigration authorities once they arrived in the United States.

Chinese immigrants continued to be closely monitored within the United States, with increasing scrutiny after the 1949 establishment of the communist People's Republic of China and the 1950s development of the immigration confession program to identify illegal Chinese immigrants.[41] Mexicans also faced closer regulation than Europeans, especially during the repatriation campaigns of the Great Depression and the Operation Wetback campaign of the 1950s.[42] Although the Immigration Bureau introduced increasingly strict controls on the Mexican-U.S. border throughout the early twentieth century, the strong demand for inexpensive labor ensured that Mexican immigrants did not need documentation to enter or work in the United States. However, during periods of heightened nativism, lack of legal documentation made immigrants particularly vulnerable to scapegoating.

In 1930, when the commissioner general of immigration decided to standardize the photographs used in immigration cases, his timing reflected the fact that all arriving immigrants were newly issued photographic identity documentation. During the fifty-five years since they were introduced, the inspection and documentation systems that underpinned U.S. immigration policy had shifted from a system of separate policies for different racial groups to an overarching system in which all immigrants were both visually inspected and issued photographic documentation. As general immigration restrictions on individual immigrants gave way to numerical racial controls for almost all immigrants, the photographic documentation required to police such restrictions replaced visual inspection as the central mechanism of visual immigration policy.

First introduced to regulate Chinese immigrants under exclusion, then

extended to Mexican and European immigrants, photographic identity documentation remains a central component of immigration policy today. At the same time, the racially differentiated practices of photographic documentation established with the very first federal immigration restrictions have echoes in new practices of visual regulation, identification, and inspection being developed in contemporary immigration policy. As in the past, immigrants today remain in sight of America.

First Impressions

Chinese Exclusion and the Introduction of Immigration Documentation, 1875–1909

In her fictionalized history of the Chinese in America, Maxine Hong Kingston writes how the Chinese immigrants who worked to build the transcontinental railroad were not included in the photograph commemorating its completion in 1869. "While the demons posed for photographs, the China Men dispersed," Kingston writes, "It was dangerous to stay. The Driving Out had begun."[1] As Kingston suggests, many Chinese immigrants who had found work on the railroads now found themselves unemployed. Although they had never been fully welcome, they had been encouraged to migrate by promises of work in America as well as by social upheaval in China. More than ten thousand strong, Chinese laborers formed as much as 90 percent of the Central Pacific Railroad workforce.[2] However, not one appeared in the photograph documenting the meeting of the rails at Promontory Point, Utah (figure 1). This photograph is a graphic metaphor for the ways that the Chinese were excluded from the United States and the ways that their long-standing presence in this country has been erased.

However, the Driving Out was not only a process of erasure. As most Chinese were excluded from the United States, forbidden to enter the country, those who were allowed to arrive or to stay in spite of exclusion were subject to extensive documentation. Rather than being erased, they were the first immigrants exposed to new techniques of representation and regulation. Chinese immigrants were more severely restricted and more closely observed than any other immigrant group. They were

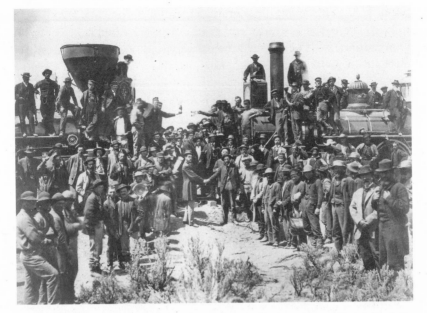

Figure 1. Andrew J. Russell, "Meeting of the Rails, Promontory Point, Utah," 1869. Image no. AJRI 227, Union Pacific Railroad Museum.

inspected, documented, and photographed by the Immigration Bureau, and the records of this process form a vast archive of Chinese in America. However, the Chinese fought against their exclusion and their regulation by the United States.

Historians of immigration regularly note that Chinese exclusion marked a new development in immigration policy as the first law to discriminate against a group of immigrants on the basis of race and class. In recent years, scholars have also drawn attention to the ways that Chinese immigration restrictions were central to the development of general immigration policy. Roger Daniels summed up the centrality of exclusion, describing it as the "hinge on which the legal history of immigration turned."[3] Lucy Salyer has shown how Chinese challenges to exclusion shaped the judicial review of immigration law. And Erika Lee has explored how the administration of exclusion was pivotal in the development of the United States as a "gatekeeping nation."[4]

However, the Chinese exclusion laws mark another critical development: the introduction of immigration identity documentation and the formal emergence of visual regulation within immigration policy. The introduction of Chinese photographic documentation marked the first

use of U.S. government photographic identity documents. From 1875 through the 1920s, as the federal government increased restrictions on immigration, it also expanded the use of visual regulation as a central mechanism within immigration administration. Starting with Chinese women, then all Chinese immigrants, and finally U.S. citizens of Chinese descent, photographic immigration identification was extended to regulate the Chinese community, and only the Chinese community, long before it was applied to other immigrant groups. In particular, the Immigration Bureau used the early photographic identification of the Chinese as a model for their expansion of photographic documentation to Mexican border crossers in the 1910s and European immigrants in the 1920s.

The first restriction on Chinese immigration came in the first federal immigration restriction, the Page Act of 1875.[5] Under this law, which prohibited the immigration of prostitutes, Chinese women were subject to particular suspicion. Unlike other women immigrants, they were required to obtain photographic identity documentation that attested to their identity and their moral character. This law was followed by the Chinese Exclusion Act of 1882, which ended almost all Chinese migration to the United States. Only a few groups of Chinese were exempt from the law: they included diplomats, merchants and their families, college students, and travelers. American citizens of Chinese descent and laborers who were already in the United States were also allowed to stay.[6] Chinese women were allowed to enter the United States only if they were themselves native-born U.S. citizens or if they were married to diplomats, merchants, or U.S. citizens.[7] The 1882 law also barred Chinese aliens from naturalized citizenship. In the following years, the exclusion acts were renewed and revised, implementing a series of increasingly stringent identification requirements for those Chinese who were exempt from exclusion.

As the exclusion acts were expanded, more and more Chinese were required to document not only their right to enter but also their right to remain in America. In 1892, all laborers were required to register their presence and obtain registration documentation.[8] In 1893, photographs were included on these documents.[9] By 1909, almost all people of Chinese descent in the United States, including U.S. citizens, were required to possess photographic documentation.[10] These photographic identity documents were checked upon entry into the United States and could be demanded at any time by immigration or other U.S. officials conducting raids or investigations. The only group not required to obtain U.S. iden-

tity documentation were Chinese diplomats, although they needed Chinese passports stating that they were part of the Chinese legation. These exclusion laws remained in force until 1943.[11]

Chinese immigrants were also subject to general immigration laws that included medical inspection by the U.S. Public Health Service (PHS).[12] In contrast to European immigrants, who were given a relatively superficial inspection, Chinese entrants were subject to an invasive inspection that required them to strip and submit to a series of tests. As Nayan Shah has argued, the medical inspection was a layered process, starting with the observation of the naked body, then extending to specific organs such as the eyes, and finally probing "beneath the skin through the microscopic inspection of internal fluids or waste products to detect traces of internal parasites." "Each new layer of visual scrutiny," Shah writes, "revealed hidden threats, which, the PHS confidently asserted, only their specialized expertise could decipher."[13] Although officials claimed that they could easily read signs of disease on European bodies, they believed that Chinese and other Asian immigrants did not exhibit such signs.[14] Chinese immigrants were considered particularly susceptible to internal parasites, which invaded the body without any obvious external manifestations, and which served as a biological metaphor for immigration officials' concerns about Chinese inscrutability and invasion.

The stringent visual regulation of the Chinese reflected widespread American beliefs about Chinese racial inassimilability, inferiority, and inherent criminality.[15] These beliefs included concerns that most Chinese immigrants entered the United States illegally, using fraudulent immigration certificates. In implementing expanded photographic identity documentation, legislators and immigration officials drew on existing police practices for documenting criminals. They argued that photographs were necessary on Chinese documents because all Chinese looked alike and all shared criminal inclinations. The apparent objectivity and detailed likeness of the photographic image were intended to link each individual to his or her identity documentation, making it impossible for the Chinese to sell, exchange, or create fraudulent documents.

Chinese resistance to exclusion laws was substantial and multifaceted. From consular responses and community legal efforts to the everyday practices of Chinese laborers, the administration of exclusion was repeatedly challenged. In particular, Chinese found the photographic requirements offensive both because of their connotation of criminality and because they recognized that photographic identity documentation could be used to harass all Chinese in the United States. Immigration inspectors

could demand documentation of all Chinese residents, including those who were exempt from documentation requirements, under the argument that they were enforcing exclusion.

Early histories maintained that the Chinese did not actively oppose American discriminatory practices because they were passive, unorganized, isolated in their communities, and afraid that resistance would lead to the discovery of illegal Chinese immigrants.[16] In countering these claims, recent histories have traced substantial activity by Chinese officials in opposing the exclusion laws.[17] Diplomats frequently protested the passage and administration of these laws.[18] Once the laws were passed, Chinese community and regional organizations mounted persistent court challenges to them.[19] In the first ten years after the passage of exclusion, for example, Chinese plaintiffs filed seven thousand cases and won the majority.[20] Most of these cases were challenges to the daily administration of exclusion, but some legal precedents were appealed all the way to the U.S. Supreme Court. These challenges secured important rights for the Chinese in America, including the right of American-born Chinese to U.S. citizenship.[21]

However, the Chinese were not successful in countering the introduction and expansion of photographic identity documentation. In addition to the public politics of protests, legal challenges, and boycotts, documented Chinese followed another path of resistance: they took control over their own photographic images, presenting identity portraits of themselves that challenged common understandings about Chinese immigrants. Different groups of Chinese, including diplomats, U.S. citizens, and women, presented themselves in different ways to immigration officials. Although these practices of self-presentation were important to the entry process, they involved accepting immigration officials' conventional understanding of respectability and ultimately depended on this acceptance. Throughout this period, as the Immigration Bureau expanded its use of photography, officials attempted to take control over immigrants' representation of themselves in their identity documentation by taking official photographs of entrants and by standardizing the range of acceptable images.

Alongside these legal strategies of resistance, some Chinese evaded exclusion successfully through a different path: the open secret of illegal immigration. They entered and lived in the United States illegally in large numbers, undermining the government's attempts to exclude all Chinese laborers. These informal acts of evasion were intimately connected to more formal aspects of opposition and were ultimately more effective. In

one letter, for example, a man involved in an illegal immigration scheme provided instructions to bribe immigration officials and requested more information about protests against exclusion.[22] Instead of seeing the presence of illegal immigrants as a reason for not resisting, as earlier historians have done, this presence itself can be seen as a sign of resistance, a sign that the Chinese refused to accept the terms of their exclusion from the United States.[23] Although the Chinese in America could not stop the implementation of photographic documentation through legal means, their extralegal uses of photographic documentation ultimately undermined the purposes of documentation and challenged the photograph's emerging authority as evidence.

The illegal entry of large numbers of Chinese caused great concern among those who hoped exclusion would end Chinese immigration. As early as 1892, government officials estimated that 95 percent of all Chinese entrants were illegal. It is impossible to know the exact numbers of Chinese who entered the United States illegally during the period of exclusion. But it is generally accepted that the numbers were substantial, with estimates ranging from a conservative 25 percent of the Chinese American population to as much as 90 percent. Most historians accept that government estimates were exaggerated, noting that many inspectors and Americans seemed to assume that all applicants were fraudulent. However, this assumption was not based merely on the racism of those who believed that Chinese were inherently duplicitous and criminal. It also reflected the effectiveness with which excluded Chinese laborers used fabricated photographs, documents, and relationships to evade the racist exclusion laws and make their way in the United States.[24] Many restrictionists believed that large-scale illegal Chinese immigration had gutted the law and that false documentation played a central role in illegal immigration. Contemporary commentator Charles Frederick Holder blamed the federation of Chinese regional organizations known as the Chinese Six Companies for "virtually defeat[ing] the intention of the law by issuing forged certificates in China, by which hordes of laborers gained entrance into the country."[25]

Although Chinese were viewed as duplicitous by Americans because of their use of false identity documentation, many Chinese viewed Americans in the same way because of the U.S. government's false promises on migration. A Chinese businessman in New York mentioned that prior to traveling to the United States he had "heard about the American foreign devils, that they were false" because they broke their treaty obligations with the Chinese "by shutting the Chinese out of their country." His views

on immigration are described in the 1906 introduction to his life story
as "generally held by his countrymen throughout America."[26]

"FACTS NECESSARY FOR IDENTIFICATION": THE INTRODUCTION OF PHOTOGRAPHIC DOCUMENTATION, 1875–92

From the beginning, photographs were used to enforce exclusion. They
were not required by statute until 1893 but were used on various docu-
ments at different times, both because of rules requiring photographs and
because local officials sometimes demanded them in excess of the regu-
latory requirements. Between 1875 and 1894, customs officers were in
charge of administering exclusion. Like the immigration officials who sub-
sequently assumed this role, customs officers strictly interpreted and en-
forced the laws. They called for stronger regulations and implemented
practices that were not sanctioned by statute or immigration regulations,
such as the use of photographs on identity certificates. Their early calls
for additional restrictions often focused on documentation and the role
of photography as a reliable representation of identity.

As early as the first federal immigration act, the 1875 Page Law pro-
hibiting the immigration of prostitutes, Chinese women had been obliged
to supply photographs with their applications for admission because of
concerns that they were being imported for immoral purposes. Although
the Page Act has been long overlooked as a minor, weakly enforced stat-
ute, historians of immigration policy are increasingly recognizing its sig-
nificance. Among others, George Anthony Peffer has shown how the law
contains the origins of Chinese exclusion, and Eithne Luibhéid has iden-
tified it as central to the development of broad immigration restrictions
based on gender and sexuality.[27]

In the history of visual immigration policy, the Page Act plays a sim-
ilarly significant role, as the law introduced the twinned principles of in-
spection and documentation. In terms of inspection, explored more fully
in chapter 3 about medical inspection at Ellis Island, the law introduced
weak policies for general immigration and strong policies for Chinese
exclusion, *allowing* customs officials to inspect vessels upon their arrival
in the United States but *requiring* the U.S. consul to inspect and certify
Asian subjects prior to their departure.

The Page Act also marked the introduction of vastly different docu-
mentation requirements for Chinese and non-Chinese arrivals. If a cus-
toms official inspected a suspicious ship, he issued a certificate for the

ship as a whole, designating any obnoxious individuals forbidden under immigration law. Chinese women, however, were each issued an individual certificate without which they could not enter the United States. Under the act's authority, every Chinese woman applying for entry to the United States was not only inspected by the U.S. consul in her port of origin but also issued a photographic identity certificate provisionally attesting to her moral character. Upon arrival, each woman was questioned again and compared with her photograph to ensure that she was the same individual who had previously been approved.[28] If the photograph on the certificate matched the applicant before the Immigration Bureau and the woman successfully presented herself as morally upright, she was allowed to enter the United States.

Photographs were not mentioned in the statute itself, but in their eagerness to implement the statute strictly the officials who administered exclusion included them as a critical part of the identification process. Almost twenty years before the statutory enactment of photographic identity documentation and forty years before passports contained photographs, these certificates were the first U.S.-issued photographic identity documents. This use of photographic identification shows that Chinese women were particularly closely regulated and suggests that their experience of exclusion may have been central to the development of broader Chinese exclusion laws, just as Chinese exclusion shaped the development of general immigration policy.[29] Other Asian women, suspected of being imported for immoral purposes, were also subject to photographic documentation requirements. Until 1907, the Immigration Bureau photographed Japanese immigrants under regulations designed to address concerns regarding the practice of picture brides. As arriving brides were married to their husbands under U.S. law, they were also photographed as a couple by the Immigration Bureau in an official wedding photograph that, like more traditional wedding photographs, served as evidence of the relationship. The Immigration Bureau hoped that the practice "would have an influence in breaking up the practice of bartering in wives or importing under the pretence of 'wife' and then compel[ling] her to follow a life of shame." This photographic practice was discontinued in 1907, at the same time as the exclusion of Japanese laborers under the "Gentleman's Agreement," because of Japanese diplomatic complaints. Thirteen years later, with the continuing expansion of exclusions against all Asians, Japanese picture brides were banned.[30]

As Eithne Luibhéid has shown, the Page Act not only enacted the differential practice of restricting Asian immigrants more than non-Asians

but also created an imbalance between restrictions on men and women immigrants. Although the ban on prostitutes was designed primarily to control Chinese prostitution, it applied to all women and had a significant impact on the ability of single women to enter the United States. European and Mexican women were not automatically suspected of being prostitutes, as Chinese women were, but immigration officials assumed they were vulnerable to prostitution. The 1875 ban on prostitutes established family migration as the only legitimate form of migration for women, although men still traveled to the United States without their families.[31]

Inspection and identity documentation were also key components of the 1882 Chinese Exclusion Act, which provided detailed information about the methods of "properly identifying Chinese laborers" and obtaining "proper evidence of their right to go from and come to the United States." An entire section of the law was devoted to step-by-step instructions that guided customs officials through the stages of inspection and certification.[32]

The law contained two documentation provisions designed to properly identify the few Chinese who were legally allowed to reside in the United States. Sections 4 and 5 provided for resident Chinese laborers to register their presence and obtain a laborer's return certificate upon leaving the United States. Under section 6, all other exempt Chinese, including merchants and their families, obtained certificates from the Chinese government stating their right to enter the United States. These exempt-class certificates were commonly known as section 6 or Canton certificates. In both cases, although photographs were not required, the documents required officials to list identifying physical features such height, weight, and physical peculiarities. The 1882 certification provisions focused on registering and documenting Chinese upon their arrival in or departure from the United States.

The exclusion laws were revised three times during this early period, in 1884, 1888, and 1892. The earliest revisions focused on limiting fraudulent certificates by controlling the agencies that issued certificates rather than the individuals who used them. However, the implementation of registration documentation in 1892 marked a shift from the regulation of issuing agencies to the control of Chinese individuals who were thought to be using fake certificates.

After only two years, the 1882 exclusion law was amended with substantial documentation revisions establishing that all Chinese arrivals required a certificate to enter the United States. The 1884 amendment

defined the laborer's identity certificate as "the only evidence permissible to establish his right of re-entry." The amendment also required that all merchants and other exempt Chinese obtain certificates prior to their departure for the United States. Removing from Chinese governmental agencies the right to issue their own passports, the new law required that these certificates be checked and visaed (authorized) by U.S. authorities prior to travel. In addition to documentation provisions, the law expanded Chinese exclusion by extending it to all people of Chinese descent, whether they were subjects of China or another power. This clarification, in response to a court case brought by a Chinese resident of Hong Kong, made it clear that Chinese exclusion was a racial rather than a national policy.[33]

Although photographs were not required by statute, they were sometimes placed on return certificates as an additional means of identification.[34] In 1885, the San Francisco customs collector in charge of Chinese exclusion called for a new rule requiring photographs on return certificates. The collector, William Sears, noted that Judge Hoffman, a federal judge who dealt extensively with the Chinese, required Chinese plaintiffs to submit photographs of themselves when they appeared in court. In addition, Judge Hoffman had repeatedly recommended photographs on return certificates. Although the exclusion law did not refer to photographs, Sears cited the law when he argued that it did require information about the applicant's "name, age, occupation, last place of residence, physical marks or peculiarities and all facts necessary for the identification of each of such chinese laborers." The photograph, wrote Sears, "would be a very important '*fact necessary*' for their identification, and to prevent the transfer of certificates, and the traffic in them at Hong Kong, and other ports."[35] Although it appears that Sears was looking for a loophole in the law that would allow his office to require photographs from Chinese immigrants, it is significant that he refers to the photograph as a "fact." At this point, early in the development of visual identity documentation, immigration officials seemed confident in the empirical power of photography and its ability to control the trade in identity documentation. However, after photographs had been introduced on Chinese documentation and found less than effective in reducing the circulation of fraudulent certificates, immigration officials adopted a more cautious and complex understanding of photography.

Certificates were required by law; however, they provided no guarantee that the holder would be allowed admission. Section 6 certificates were supposed to act as prima facie proof of the right to enter the United States,

but American officials consistently ignored this and interrogated exempt
Chinese. In 1888, all laborers' return certificates were invalidated by the
Scott Act, which forbade the return of Chinese laborers who traveled out-
side the United States.[36] Laborers had previously been allowed to depart
and return to the United States, obtaining return certificates to facilitate
this process. However, the Scott Act voided between twenty thousand and
thirty thousand certificates issued to laborers who had not yet departed
and to those who had left the country on the assumption that their cer-
tificates guaranteed them the right to return.[37] The courts ruled that cer-
tificates were only evidence of identity and offered no such guarantee.[38]

Although laborers were no longer allowed entry or reentry, merchants
and other exempt Chinese still needed to obtain certificates attesting to
their right to enter or reenter the United States.[39] Federal regulations did
not require photographs, but customs officers in San Francisco neverthe-
less obtained photographs from merchants to place in their files. In 1891,
Inspector Ruddell testified before Congress that photographs were com-
monly used on merchants' return certificates and that Chinese returnees
without photographs were subject to especially thorough investigations.[40]

The early expansion of identity documentation was rapid and largely
uncontested outside the Chinese community. Customs officials strictly
enforced the law, often exceeding its requirements in their attempts to
limit the entry of the Chinese. However, as nativists worked to expand
exclusion, implementing an internal passport system containing photo-
graphic identity documentation, the use of photography to regulate Chi-
nese immigrants became a subject of debate.

"THE BADGE OF DISGRACE": DEBATING THE GEARY ACT
AND MCCREARY AMENDMENT, 1892–93

In 1892, ten years after its passage, the Chinese Exclusion Act came up
for reauthorization. The new Chinese exclusion law, known as the Geary
Act, was far harsher than the original law.[41] In addition to continuing
exclusion, the Geary Act required that all Chinese laborers, including
long-standing residents, register for certificates of residence proving their
right to remain in the United States. Although they were not required to
register, Chinese merchants, students, and travelers who were exempt
from exclusion could also apply for such a certificate to prove their le-
gal presence in the country. The act substantially fulfilled earlier attempts
to impose an internal passport system on all Chinese, a system that had
come close to success before President Arthur vetoed it in 1882.

Significantly, the Geary Act's new documentation requirements represented a shift from the regulation of travel to the regulation of the Chinese themselves, from border to interior enforcement of Chinese exclusion. In a related move, the act also signaled a shift in the presumption of guilt. Unless they could produce a certificate or other evidence of their right to remain in the United States when they entered, left, or were arrested, all Chinese were presumed to be illegal. Although only laborers were *required* to register, the presumption of illegal residence meant that, as a practical matter, all Chinese in the United States had to register or possess other evidence of their legal residence. For the first time within U.S. immigration law, illegal residence itself was made a federal crime.[42] The penalties for illegal residence included one year's hard labor followed by deportation, although the hard labor provisions were later ruled unconstitutional. In her sympathetic history of the Chinese in America, published in 1909, Mary Coolidge wrote that, under the law, "all Chinese are treated as suspects, if not as criminals."[43]

The Chinese Six Companies strongly opposed the Geary Act's establishment of a registration and internal passport system. They urged Chinese not to register and vowed to support anyone who was arrested for failing to do so. The Chinese community strongly supported this strategy. About two months before the act went into effect, the Six Companies had raised $60,000 to cover their litigation costs.[44] One month before the registration deadline only 439 Chinese San Franciscans had applied for certificates, out of an estimated twenty-six thousand Chinese laborers required to register in the city.[45] Nationwide, only about thirteen thousand people registered, leaving an estimated eighty-five thousand liable for deportation.[46]

Under the Geary Act, registration certificates were not required to contain a photograph. The original bill had included a photograph requirement, but after substantial congressional debate the provision was dropped. Nevertheless, the introduction of documentation quickly developed into a regulatory system of photographic identification. Although photographs were not required by statute, the Treasury Department promulgated rules that required them, and the application form for a section 6 certificate gave detailed instructions regarding these photographs. Historian Lucy Salyer notes that in an attempt to encourage registration in the face of widespread resistance the Treasury Department dropped its rule requiring a photograph. As she writes, the Chinese found the photographic requirement "one of the more offensive features of the law."[47] However, although the Six Companies fought the case all the way to the

U.S. Supreme Court, in 1893 the act's registration and certification re-
quirements were ruled constitutional.[48]

In the same year, the Geary Act was amended to extend the period of
Chinese registration for an additional six months, as the majority of Chi-
nese had not registered in order to protest the law. This extension was
known as the McCreary Amendment, and although it has received little
attention from historians it marked a significant expansion of existing
law by requiring photographs on registration certificates. Throughout the
passage of the exclusion acts, the use of photography had been debated.
However, it was not until the passage of the McCreary Amendment in
1893 that photographic documentation became a consistent feature of
immigration regulation. The McCreary Amendment contained the first
statutory requirement of photographic identification on immigration doc-
umentation, a requirement that remains part of immigration law today.[49]

Early debates about the use of photography on Chinese certificates re-
vealed a range of assumptions about both the nature of the Chinese and
the nature of photography. In congressional and diplomatic circles, the
debate quickly solidified around two primary positions: the necessity of
requiring photographs versus the emotional and financial cost such a re-
quirement would impose upon the Chinese. Exclusionists and photog-
raphy proponents argued that photographs were legally allowed and
justified by widespread document fraud. Supporters of Chinese immi-
gration and opponents of photographic documentation claimed that the
practice was a humiliating form of unequal treatment that violated the
U.S. Constitution and U.S. treaty obligations with China.

The arguments for photographic documentation are especially fully
expressed in an extended speech inserted into the *Congressional Record*
by the primary sponsor of the 1892 and 1893 legislation, Representative
Thomas Geary (CA). In support of the statutory photograph requirement,
Geary argued that "all Chinamen look alike, all dress alike, all have the
same kind of eyes, all are beardless, all wear their hair in the same man-
ner."[50] Written descriptions alone were insufficient, he maintained, and
therefore photographs were required to provide a more detailed form of
description.

Geary claimed that the "fact" that all Chinese looked alike was re-
lated to the fact that they associated among themselves and did not as-
similate. According to Geary, the new arrival immediately connected with
his fellow nationals and "the next day no white man could identify him
from other Chinamen who had been here sometime."[51] In his argument,
Chinese men not only looked alike at any given time—regardless of class,

status, or occupation—but also looked alike across time. As a result, it became impossible to distinguish the longtime legitimate resident from the recent illegal immigrant. Without some kind of certification, it was impossible to distinguish the merchant from the laborer, or the recently arrived laborer (banned by exclusion) from the legal laborer (admitted prior to exclusion). This argument implicitly contrasted legitimate, assimilable European immigration with the assumed illegal immigration and inassimilability of the Chinese.

The corollary of the argument that all Chinese looked alike was that they all acted alike. Unlike white American workers, Geary argued, Chinese laborers were controlled by their despotic government and the Chinese Six Companies. In fact, even their resistance to Chinese exclusion and their refusal to register for certificates of residence under the Geary Act were orchestrated by the Six Companies, "the masters of these slaves."[52] Like many anti-Chinese whites, Geary saw sinister motives in the companies' legitimate political activity and believed that Chinese resistance to exclusion was top-down, administered by Chinese merchants.

Further, Geary believed that the sameness of the Chinese extended to their habit of sticking together and protecting the illegal immigrants among them rather than behaving honorably and independently like other (presumably European) immigrants. "If Chinese residents in the United States had done their duty as other aliens do," Geary stated, "if they had not become shielders and protectors of these criminals: if they had not stood ready at all times to lend their testimony to establish a lie, we would never have asked for the passage of the law of 1892."[53]

This idea of an impenetrable community in which Chinese had allegiance only to other Chinese drew from and reinforced stereotypical ideas about Chinese inscrutability. Documentation proponents suggested that Chinese were particularly effective at evading exclusion laws because they would never betray one another or allow Westerners to see who they really were. The unstated conclusion of Geary's logic was that, as a result of their shared behavior, all Chinese were tainted by the presence of illegal immigrants among them and all were potential frauds. This, in the end, was the justification for the requirement that the Chinese carry documentation.

As Geary's comments suggest, concerns about immigration fraud were thoroughly steeped in Orientalist fears about masses of passively obedient, inscrutable Chinese workers controlled by unscrupulously intelligent leaders. These ideas of Chinese immigration fraud were central to arguments in favor of registration. But proponents argued that registration

was not enough to stop fraud without photography. "The registration of a Chinaman without a photograph is not worth the paper it is written on," Representative Eugene Loud (CA) maintained while introducing the 1893 amendment to the Geary Act. "Unless you have a photograph, every registration certificate of men between the ages of 20 and 40 will command in the markets of China or in Victoria from \$200 to \$400 or \$500."[54] The hyperbole of Loud's argument, that "every" certificate was susceptible to being sold, revealed a deeper belief that every Chinese immigrant was suspect.

Exclusionists often suggested that the entire Chinese community was engaged in criminal activities, even that criminality and immorality were part of the Chinese racial character. According to Representative Henry Blair (NH), the Chinese had created "a Sodom in San Francisco and a Gomorrah in New York."[55] The popular conception of Chinese criminality was multifaceted and has been well documented by scholars. It included gambling, prostitution, opium smuggling, and gang warfare.[56] But one of the most common and least studied aspects of Chinese criminality was the assumption that all Chinese were illegal immigrants using fake immigration documents and that their presence in America was itself criminal.[57] This idea, enshrined in the Geary Act, represented the most fundamental concerns about Chinese criminality. The very presence of the Chinese in America was assumed to be not only economically, morally, and racially dangerous but also criminal.

Popular associations of cunning and criminality with the Chinese were not new. John Kuo Wei Tchen traces these ideas as far back as the 1770s.[58] Even prior to the enactment of medical inspection, ideas about Chinese craftiness and criminality appeared to warrant opening the Chinese body to close visual inspection. In 1877, a cover illustration for *Harper's Weekly* showed a dense crowd of Chinese arrivals in the San Francisco customhouse with more Chinese entering the building in the background. Standing toward the right of the image is a Chinese immigrant with one white inspector on either side. With his upper body viewed from behind and his queue snaking down his spine, the Chinese man is partially disrobed. One of the inspectors holds up what looks like an item of clothing such as a silk scarf. The accompanying article explains that John Chinaman "is an expert at eluding the vigilance of the revenue officers." Customs has developed strategies "to get even with" the Chinese, who are compelled to open their luggage "before the inquisitive eyes of the inspectors." In some cases, "these crafty fellows" are required to disrobe in case they have concealed silks, ivory, or opium on their person.[59] After

exclusion was enacted, Chinese bodies continued to be subject to special scrutiny.

Widespread understandings of Asians as cunning and criminal were not limited to the Chinese. In later cases regarding Japanese immigrants, immigration officials argued that photographs were required to establish family relationships because "the cunning of the ordinary Oriental" undermined the government's ability to prosecute illegal immigrants.[60] As exclusion policies were expanded from the Chinese to the Japanese in 1907 and almost all Asians in 1917, exclusion enforcement became a locus for concerns about Asian inscrutability and illegality. More than for any other immigrant groups, legislators and immigration officials attempted to address these concerns by turning to photographic identity documentation.

"THE LAW ITSELF MAKES ALL GUILTY": LEGAL AND POLITICAL OPPOSITION TO PHOTOGRAPHIC DOCUMENTATION

Supporters of Chinese immigration generally opposed registration and photographic documentation, arguing that these practices violated U.S. treaty obligations and discriminated against the Chinese. In contrast to the exclusionists, who assumed that all Chinese were tainted by criminality, documentation opponents were concerned that photographic documentation marked innocent Chinese residents as criminals. Representative James McCreary (KY) had proposed the 1893 amendment that bore his name only as a compromise six-month extension to the implementation of registration. McCreary had supported the Geary Act but was not in favor of adding the statutory photograph requirement. "There is no good reason now for our Government," he argued, "to still further violate the treaty between the United States and China by requiring [the Chinese] to be tagged, marked, or photographed." The disjuncture between McCreary's support for registration and his opposition to photographic documentation as being "tagged" or "marked" illustrates the particular concerns that were associated with the photographic component of identity documentation at this time.[61]

Opponents of photographic registration often compared it to the ticket-of-leave system, under which Britain issued permits to convicted criminals allowing them to work outside prison while completing their sentences.[62] The Chinese Equal Rights League, formed in New York in response to the Geary Act, protested "that for the purpose of prohibit-

ing Chinese immigration more than one hundred thousand honest and respectable Chinese residents should be made to wear the badge of disgrace as ticket-of-leave men in your penitentiaries." Whereas other elite Chinese groups often phrased their opposition to the Geary Act in class terms, arguing that registration would humiliate Chinese professionals, the Chinese Equal Rights League based their argument on length of residence in the United States. Addressing an imagined audience of white restrictionists, the league argued that it was acceptable to exclude Chinese, stating "we do not want any more Chinese here than you do." However, they claimed it was unfair to submit existing residents to additional and unnecessary public scrutiny.[63]

If the 1893 bill was adopted, Representative Charles Hooker (MS) argued, every Chinese man "will be compelled to go about with his photograph in his pocket, with a sort of ticket-of-leave about him, like that which the British government requires from convicts in its penal colonies in Australia."[64] In addition to emphasizing Chinese innocence of any crime, the equation of identity documents with tickets-of-leave implicitly drew attention to America's supposed innocence of European authoritarianism and harsh colonialism.

Identity photographs were strongly associated with criminality because, prior to Chinese registration, suspected and convicted criminals formed the primary group of people being photographed by the state for identification purposes. Chinese complaints about being branded as criminals were reinforced by the fact that the only other group consistently photographed by the Immigration Bureau at this time were immigrants being deported because they had violated immigration or other U.S. laws. Although the idea of using photography to detect criminals had been proposed since its invention in the 1840s, it was not commonly used for this purpose until the 1860s.[65] The San Francisco Police Department was a pioneer in the field of photography and criminal identification. Between 1854 and 1859, the department contracted with a commercial photographer to make daguerreotypes of all people arrested in the city.[66] In 1861, the department opened its own photographic studio.[67] As criminal suspects were brought into the police station, they would be led to this room to be photographed. The photographer took two shots: full frontal and side profile. These photographs were placed in large "mug book" albums or displayed in wall-mounted galleries known as rogues' galleries. In mug books, police officers would add information about names, aliases, and crimes next to the identity photographs. The images were indexed to a different notebook that contained more detailed information about the

individual and the outcome of each case. These books and galleries were archives used for recording and identification purposes. In rogues' galleries, crime victims could peruse the wall-mounted photographs to look for possible suspects, and police officers could check the faces of people in their custody to see whether they had previously committed crimes under different names.[68] The racial dimensions of photographic regulation are highlighted by the fact that, from the 1860s through the 1940s, the San Francisco Police Department kept its books of Chinese criminals separate from other criminals. This division was clearly racial rather than national, as it kept Chinese suspects separate from others regardless of their country of birth or place of residence.[69] San Francisco's pioneering role in identity photography may have been connected to concerns about Chinese criminality in the city.

Opponents of Chinese registration frequently compared registration photographs to rogues' galleries because these archives were the only American counterpart to the systematic documentation of Chinese residents. In fact, the 1893 McCreary Amendment marked the first time that U.S. law required civilians to be photographed for government documentation purposes. Contributing to the Chinese sense of being unfairly criminalized, the Immigration Bureau used many of the same techniques and even the same equipment that the police used to document suspects, such as the Bertillon method for photographing and measuring criminals.

One of the most disjunctive aspects of the debate about photographic documentation was the fact that, although both sides consistently referred to the entire Chinese race, only laborers were required to hold residence certificates. Other Chinese were required to provide extensive documentation when they traveled between China and the United States or made a claim to citizenship, but they were not required to possess documentation of their status at all times. Despite the racial rhetoric, the practice of certification was largely the practice of labor regulation, a practice that (partly because of existing treaty obligations) respected many Chinese class distinctions even as it rhetorically claimed that all Chinese were racially suspect and were all the same.

Chinese protests continued long after the Geary Act and McCreary Amendment had passed. Erika Lee has argued that, as exclusion became established law, Chinese elites changed their goals from overturning exclusion to meliorating its harsh enforcement, particularly against elites.[70] In 1905, Chinese merchants in China and throughout the diaspora started to boycott American goods in protest at U.S. exclusion policies. Histo-

rians have disagreed about the effectiveness of the Chinese boycott. Delber McKee notes that it was traditionally seen as a failure. However, reinterpretations by historians such as McKee and Erika Lee have offered a more positive view: although the boycott failed to achieve its purpose of ending exclusion, it had some success in curtailing the harsh enforcement of exclusion and galvanizing the transnational Chinese community in America and abroad.[71]

The shift from general opposition to more particularized concerns about enforcement was also true for the photographic identity policies that were central to the entrenchment of exclusion. In 1902, Chinese consul Wu Ting Fang complained that a respectable student who wanted to study in the United States "must submit to be photographed as if he were a criminal and candidate for the rogues' gallery."[72] In 1908, Chinese newspaper editor and community leader Ng Poon Chew argued that while laborers might be excluded, exempt classes "must no longer be detained, photographed and examined as if they were suspected of crime."[73]

Although Chinese elites attempted to distinguish between themselves and working Chinese, white exclusionists did not recognize this distinction. They suspected almost all Chinese of having committed the crime of illegal entry. It was this pervasive suspicion that undergirded the construction of a photographic identification policy designed to distinguish between legal and illegal entrants. Chinese elites clearly recognized that the system of registration and documentation did not separate legal immigrants from illegal entrants but made every Chinese person suspect.

The registration requirement of the Geary Act and photography requirement of the McCreary Amendment did more than create the appearance of Chinese criminality. These laws literally criminalized Chinese residents by requiring them to obtain documentation and then establishing the presumption of guilt for all Chinese without it. According to Representative Robert Hitt (IL), "The law itself makes all guilty."[74] Although the registration and photography requirements were compared to the rogues' gallery, in many ways they were more denigrating and controlling. Criminal suspects were photographed for the rogues' gallery only after they had been accused of wrongdoing; Chinese were photographed upon their entry into the United States. The rogues' gallery was located at the police station; archives of Chinese photographs not only were held in a central location but also marked each individual who was required to possess an identity certificate. The rogues' gallery was used to identify individuals accused of wrongdoing; any Chinese person could be stopped in the street and asked to produce his or her identity certificate

to prove legal status in the United States. In short, the registration system was the concrete implementation of exclusionists' beliefs that all Chinese were suspect at all times.

The Chinese Six Companies recognized this situation in their criticism of registration policy. They argued that the Geary law would subject "every Chinese merchant in the United States to blackmail of the worst type." For example, "A Chinese merchant who has resided in San Francisco for many years and who may desire to go to New York on business can be stopped at every little hamlet, village, and town on the line of the railroad and arrested on the charge of being a laborer who has refused to register."[75] As the Six Companies clearly understood, the registration law resulted from dominant racist assumptions that all Chinese were laborers, criminals, and illegal immigrants. It also helped to foster these assumptions and provide opportunities for the harassment of Chinese residents.

The Geary Act's presumption that all Chinese were in the country illegally unless they could prove otherwise affected all Chinese in America. Starting shortly after the implementation of registration, immigration officials expanded interior enforcement efforts, including individual investigations and broad raids on Chinese communities. By 1915, the Immigration Bureau issued regulations that allowed Chinese inspectors to examine "all Chinese persons in the country not personally known to them to be legally entitled to be and remain in the country."[76]

Section 6 certificates were only one of an array of documents required under Chinese exclusion, many of which included photographs. Although return certificates were not provided to laborers after the Scott Act banned returning laborers in 1888, these certificates continued to be used by Chinese merchants and native-born Americans of Chinese descent who left the United States wishing to return. Chinese hoping to travel through the United States en route to another destination were issued transit certificates.[77] Diplomats, although not required to carry U.S. documentation, had to present Chinese passports stating their position as part of the Chinese legation. Other documents were also used in support of Chinese claims to reside in the United States: birth certificates and marriage certificates, for example, typically contained photographs. When Chinese witnesses testified in affidavits or Chinese plaintiffs filed court cases, they were also required to include identification photographs.[78] In almost all cases, photographs were required only of the Chinese. By the 1890s, photographic documentation was a central component in the administration of exclusion.

A FAVORABLE APPEARANCE:
STRATEGIES OF SELF-REPRESENTATION

After the certification provisions of the Geary Act were upheld by the U.S. Supreme Court in 1893, there was a rush on photography galleries as immigrants were required to register and have their photographs taken.[79] Although Chinese fought against requirements to be photographed, once these requirements were enacted they chose the ways in which they represented themselves in their identity photographs. These choices were constrained by Immigration Bureau policies, photographic technologies, and portraiture conventions, but they were more free than previous accounts of photography have suggested. The expansion of photographic documentation offered a forum for Chinese immigrants to control their own representation of themselves, challenge common stereotypes, and assert their place in the United States.

Photographic historians such as John Tagg and David Green have described honorific portraits taken for the purpose of self-representation as distinctly different from portraits taken by the state for the repressive and often racialized purposes of criminal identification and scientific observation. The difference between honorific and repressive photography, these historians argue, is visible in the form of the photograph. According to Green's description of the repetitive pattern of scientific photographs, the subject "is positioned full face and in profile to the camera, the body isolated within a shallow space and sharply defined against a plain background, the lighting is uniform and clear."[80] Tagg notes that in contrast to the "cultivated asymmetries," soft lighting, and partial shading of the honorific studio portrait, scientific visual conventions were also used in criminal photography.[81] Whereas studio portraits contained props, identity photographs eliminated all outside detail. Scientific conventions were clearly a significant departure from the earlier honorific approach to portraiture. Nonetheless, the rupture between these two traditions and their visual conventions is not nearly as complete as these critics suggest. In fact, immigration identity documentation offers an example of repressive, racialized, state-based photographic identification that challenges this photographic history.

Although classic accounts of repressive photography describe a complete lack of power on the part of criminals and scientific subjects, Chinese immigrants played a role in shaping their representations of themselves. In addition to the framing, posing, and presentation of the subjects, some immigrants were involved the development of the nega-

tive and the printing of the image. For at least fifteen years after the passage of the Geary Act, Chinese immigrants retained significant control over the ways in which they were represented in their identification photographs. They retained this control because their photos were typically taken by studio photographers under their direction and then submitted to the Immigration Bureau.

In San Francisco, as on the Mexican-U.S. border after the introduction of photographic identity documentation in 1917, studio photographers worked with a wide range of clients. Although theorists have traditionally understood honorific and repressive photographic practices as fundamentally opposed, studio photographers were employed by Chinese residents to create conventional honorific images for their identity certificates and for their personal use. At the same time, they were hired by the Immigration Bureau to photograph Chinese immigrants upon arrival and prior to deportation, using photographic conventions generally reserved for criminal suspects. As explored later, studio photographer Fong Get was employed by the Chinese consul general, taking official portraits that were inscribed with friendly messages to the San Francisco commissioner of immigration (see figure 8, p. 53), and by ordinary immigrants who used their identity photographs to gain legal and illegal admission to the United States. Similarly, Shew's Pioneer Gallery was both commissioned by members of the Chinese elite to take their photographs (see figures 9 and 14, pp. 54 and 61) and contracted by the Immigration Bureau to photograph Chinese detainees.[82]

There were a number of successful Chinese photography galleries in San Francisco's Chinatown. Ka Chau was the first known Chinese photographer in San Francisco, opening his "Daguerrean Establishment" in 1854.[83] From the 1860s to the 1920s, there were more than twenty-five professional Chinese photographers and galleries in San Francisco as well as others in different cities.[84] Prior to exclusion, some white photographers advertised for Chinese clients in Chinese-language newspapers, and the Chinese photographer Lai Yong advertised in English-language city directories.[85]

In addition to Chinese galleries, Chinese immigrants had their photographs taken by European and Japanese photographers active in San Francisco.[86] Some of these studios, for example Shew's Pioneer Gallery, invested in ornate Chinese props and elaborate backdrops of Orientalized garden scenes, suggesting that they had a significant Chinese clientele (figures 9 and 14, pp. 54 and 61).[87] Photo studios were common not only in American Chinatowns but also in China. First introduced to China

by the British during the Opium War between 1840 and 1842, photography quickly became popular. From the 1840s to the 1890s, photography studios opened in Hong Kong, Shanghai, Tianjin, and Peking.[88] Although there was strong local demand for photographic portraits, this demand may also have been supported by Chinese emigrants, who frequently sat for their portraits before traveling to the United States.

It is not only the institutional role of photography studios that challenges the traditionally sharp delineation between honorific and repressive photography. The visual conventions of immigration photographs also suggest that these boundaries were blurred. Early rules about identity photographs required only that the images not be retouched or mounted. Early application forms specified further that "the photographs shall be sun pictures, such as are usually known as card photographs of sufficient size and distinctness to plainly and accurately represent the entire face of the applicant, the head not to be less than $1 \frac{1}{2}$ inches from the base of the hair to the base of the chin."[89] Following these requirements, the vast majority of identity photographs were simple, frontal portraits that focused on the subject's facial features, following many of the conventions suggested by David Green (figures 2–6).

However, there was still wide variation in the types of photographs submitted to and accepted by the Immigration Bureau. Photographs presented to the Immigration Bureau came in all sizes and shapes: most were rectangular vertical portraits, but some had trimmed corners and others were shaped as arches or ovals. They were placed in various positions on the document: in the upper or lower corners, crammed sideways along the edge, or displayed in the exact center of the paper. Although certificates typically required photographs, most did not identify a photograph location until after 1903.[90] The photographs represented a range of portraiture conventions from elaborate studio portraits to simple head shots. They incorporated aspects of Chinese and Western conventions, and they presented their subjects standing, seated, facing the camera, or looking to the side. Some photographs also show changes in the immigrant's appearance and self-presentation over time. In the Immigration Bureau archives, there are a few images of immigrants who first appear wearing Chinese clothes and are subsequently depicted in American outfits. While most Chinese men and almost all women dressed in Chinese clothes, some Chinese men presented themselves with all the markers of Western masculine respectability: suits and ties, short hair, and even facial hair.

The variation that exists in Chinese identity photographs can be

Figure 2. Return certificate of merchant's child, Lau Lum Ying, 1886. File August 22, 1888/557, San Francisco District Office, Immigration Arrival Case Files, 1884–1944, Records of the Immigration and Naturalization Service (Record Group 85), National Archives and Records Administration, Pacific Region (San Francisco).

STATE OF CALIFORNIA,
CITY AND COUNTY OF SAN FRANCISCO, ss.

Return Certificate of Native Born Child —

Whereas my son Young Chee, who was born in the United States, as more particularly appears from his Certificate of Birth, a certified copy of which is hereto attached, and who is now about one year and eight months old, and whose photograph is also hereto attached, is about to depart for China on a temporary visit, with his mother Ah June, and intending to return to the United States. Now therefore, for the better identification of the said Young Chee, and in order to facilitate his landing on his said return, the undersigned hereby makes affidavit that the aforesaid Young Chee is a native born citizen of the United States, and is therefore entitled to land on his return to the United States at any time.

Young Sue

Subscribed and sworn to before me this
3d day of December 96
_____ Notary Public.
In and for the City and County of San Francisco.
State of California.

Figure 3. Return certificate of native-born child, Young Chee, 1896. In re: Young Chee, File 9599/64, San Francisco District Office, Immigration Arrival Case Files, 1884–1944, Records of the Immigration and Naturalization Service (Record Group 85), National Archives and Records Administration, Pacific Region (San Francisco).

IN RE WONG CHUN,

NATIVE BORN CITIZEN OF THE UNITED STATES.

STATE OF CALIFORNIA,

CITY AND COUNTY OF SAN FRANCISCO. } ss.

We, the undersigned, being first duly sworn upon oath, each for himself, and not one for the other, do depose and say:-

That we are acquainted with Wong Chun, whose photograph is hereto attached, and that we have known him since the time of his birth. That the said Wong Chun is a Native Born Citizen of the United States, and that we make this certificate in order to identify him as such.

That the said Wong Chun is the son of Wong Soo Oy and Dong Shee, and was born in the City and County of San Francisco, State of California, at #924 Dupont Street. That he is now about 28 years of age.

And we do further state that the said Wong Chun has always resided in the United States, but that he is now about to pay a temporary visit to China, intending soon to return to the United States the land of his nativity.

Signature. Address.

黃秀兆 Wong Su Sue 1113½ Dupont Street

胡机永 Woo Kee Wing 725 Commercial Street

Subscribed and sworn to before me, this 17th day of September, A. D. 1902.

Thomas S. Burnes

NOTARY PUBLIC.
In and for the City and County of San Francisco, State of California

Figure 4. Affidavit in support of native-born U.S. citizen, Wong Chun, 1902. In re: Wong Chun, File 10058/366, San Francisco District Office, Immigration Arrival Case Files, 1884–1944, Records of the Immigration and Naturalization Service (Record Group 85), National Archives and Records Administration, Pacific Region (San Francisco).

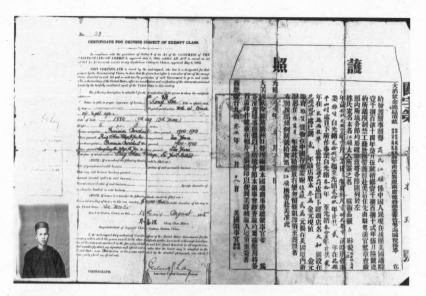

Figure 5. Certificate for Chinese subject of exempt class (section 6 certificate), Kong Kee, 1905. In re: Kong Kee, File 14610–176, Entry 132, Records of the U.S. Immigration and Naturalization Service (Record Group 85), National Archives and Records Administration, Washington, D.C.

interpreted in many ways: as evidence that the conventions of identity portraiture were contested, as a sign of resistance to dominant representations of the Chinese, and as a graphic representation of the different ways these immigrants negotiated their place in America. Although Chinese immigrants retained control over their identity photographs, this control was always relational. As public displays of status and identity, their portraits were always a part of the social contexts in which they were produced and circulated.

In Chinese immigration cases, the identity photograph was not only a form of identification but also a means of supporting an application through self-presentation. In presenting themselves to immigration officials, Chinese immigrants defied American stereotypes by making themselves appear respectable. This is not to suggest that Chinese were not respectable, but respectability is always a process of appearances. Chinese honorific identity portraits were both a conscious counter-representation to popular stereotypes and a succinct visual argument in support of their application to enter the United States. By presenting themselves as conventionally respectable, Chinese immigrants opposed exclusion through seeking acceptance.

Figure 6. Transit certificate, Chong Kok, 1906. In re: Chong Kok, File 14604-4, Entry 132, Records of the U.S. Immigration and Naturalization Service (Record Group 85), National Archives and Records Administration, Washington, D.C.

Of course, Chinese immigrants didn't emphasize their respectability purely to impress the immigration officials. Like most portrait subjects, they also used these photographs for personal purposes. As art historian Richard Vinograd has written, Chinese portraiture traditions "stressed the role of the individual as a link in a family lineage or as a member of a class or professional community." [91] These roles were both similar to and independent from traditional Western portraiture, which also constructed for its subjects a sense of familial and societal position. Although Chinese and Western traditions were different, they were not entirely distinct. In the late nineteenth and early twentieth centuries, Chinese traditions of portrait painting were being reconfigured by social upheaval in China as well as the influence of Western painting and photography.[92] Like the social and familial positions of overseas Chinese, portraiture traditions were in flux.

The evolving traditions of Chinese likenesses were sometimes consistent with and at other times in conflict with the purposes and practices of photography in America. The traditional Chinese role of portraits in

displaying family lineage and profession, for example, was consistent with the categories established to regulate exclusion. Chinese immigrants were allowed entry to the United States if they were related to an exempt individual or belonged to an exempt profession. At the same time, however, illegal immigrants subverted the purposes of photographic portraiture by using it to falsify family relations and professional identities.

The formal conventions of Chinese portraiture also interacted in complex ways with American conventions. Commemorative portraits (painted by local artisans to honor their clients' deceased relatives) had specific ritual purposes, which shared little with studio photographs except a focus on close likeness. However, commemorative portraits were influenced by the introduction of photography in China, and photographs increasingly were used as memorials.[93] In formal terms, Chinese commemorative portraits looked more like American identity photographs than American studio portraits. Memorial portraits were, according to Vinograd, "rigidly frontal" and devoid of context.[94] This custom may suggest why many otherwise conventional American studio portraits represent their Chinese subjects facing the camera directly rather than looking to the side, as was more common with American subjects. The side angle was not unfamiliar in honorific Chinese traditions, but it was almost obligatory in American studio portraits. Familiar with both Chinese and American conventions, Chinese photographers and their subjects often combined different aspects of these traditions in their portraits. John Thomson, the most renowned Western photographer in China, noted that many of his Chinese subjects requested full-length frontal portraits in the manner of memorial portraits. However, many Chinese subjects in nineteenth-century photographs also adopted an angled pose.[95] Of course, these photos were not only presented to immigration officials but also shared among family members in China and the United States. In this process, they both drew on and contributed to the circulation of changing pictorial conventions between China and the United States.

Although most photographic portraits were very similar, strategies of self-presentation sometimes worked differently for different groups of Chinese. These differences reflected people's varied relations to both Chinese and American portraiture traditions, as well as their status within U.S. exclusion policies. Almost all Chinese American portraits display some intermingling of Chinese and American portraiture traditions, but they do so in diverse ways. These approaches often split along the fault lines of immigration status created by exclusion: diplomats, merchants, native-born citizens, laborers, men and women, children traveling alone,

and families traveling together often presented themselves in ways that reflected their group status. However, within the constraints of Immigration Bureau policies and portraiture conventions, individuals also chose to present themselves in their own ways. U.S. citizens Young Chee and Wong Chun wore traditional Chinese clothes for their portraits (figures 3 and 4), while Chong Kok presented himself in a highly Western fashion, although his certificate lists him as a Chinese laborer permitted transit to return to China (figure 6). Whether diplomats or laborers, legal or illegal, Chinese subjects actively presented themselves before the camera in the ways they wanted to be seen. Chinese photographers sought to assist them in these representations, collaborating with their subjects to present different images to different audiences.

Diplomats were least directly affected by the exclusion laws and were not required by U.S. law to be photographed. As Jan Stuart and Evelyn Rawski note in their study of memorial portraiture, Chinese government officials who interacted with foreigners were particularly quick to adopt photography.[96] They commonly used their official portraits to promote their role as a link between China and the United States, presenting these formal photographs to high-level U.S. immigration officials with inscriptions that claimed shared respect and friendship.[97] They appeared in these images in Chinese dress, often in elaborate ceremonial clothing emphasizing their high class position and their role as representatives of the Chinese government. However, they also adopted Western portrait poses, angling their bodies and faces to look slightly to the side of the camera. Sometimes they used the Western portrait format showing only the head and shoulders. Consul General Hsu Ping Chen, for example, favored more casual Western traditions in both formal individual and informal family portraits, including his choice of an unusual pose in a family portrait, sitting at an angle with his legs crossed (figures 7 and 8). At other times, diplomats presented themselves in full-length frontal portraits drawing more closely on Chinese portraiture traditions. This is true in the image of an unidentified gentleman wearing the square rank badge of a Qing official, which shares many visual conventions with memorial portraits (figures 9 and 10). Diplomats presented themselves as simultaneously Chinese and modern, in contrast to cartoons that stereotyped Chinese generally and diplomats specifically as physical manifestations of a decadent, outdated civilization that had descended into barbarism. The diplomats' embodiment of themselves as modern Chinese reflected their position as emissaries: diplomacy was a modern profession in China, with the first legation established in the United States in 1878.

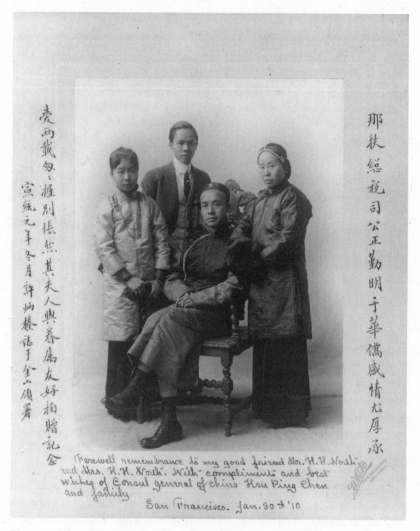

Figure 7. White Photo Studio, New York, "Farewell Remembrance to My Good Friend Mr. H. H. North and Mrs. H. H. North" (portrait of Consul General Hsu Ping Chen), 1910. 1980.098:73—PIC, Photographs of the Hart Hyatt North Papers, Bancroft Library, University of California, Berkeley.

In contrast to Chinese diplomats, some native-born U.S. citizens emphasized their Americanness by favoring more Western conventions. In one case, a man of Chinese descent, Lee Gum Yoke, was required to prove his U.S. birth in order to claim his U.S. citizenship and his right to reenter the United States. The mayor of Park City, Utah, testified to Lee's U.S.

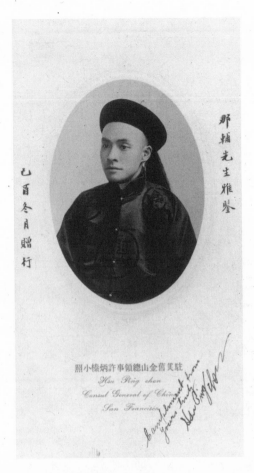

Figure 8. Fong Get Photo Studio, San Francisco, "Hsu Ping chon," no date. 1980.098:71—PIC, Photographs of the Hart Hyatt North Papers, Bancroft Library, University of California, Berkeley.

birth and identified his photograph. The Chinese inspector noted the reputable nature of Lee's white witnesses and concluded that "his appearance is decidedly in favor of his claims."[98] The photograph Lee submitted also supported this appearance and his claims of respectability and U.S. citizenship (figure 11). In this photograph, Lee wears Western clothing: a stylish well-fitting suit jacket, starched shirt, and elegant tie. The jacket is unbuttoned to reveal a watch chain hanging from his waistcoat. Lee's clothes, the length of the portrait (reaching almost to his waist, instead of just his head and shoulders), and the gentle fading at the lower edge of the photograph reveal this to be more than an identity photograph: it is a studio portrait.

Although Lee presents himself within the tradition of bourgeois American portraiture, he looks directly at the camera in a pose more often

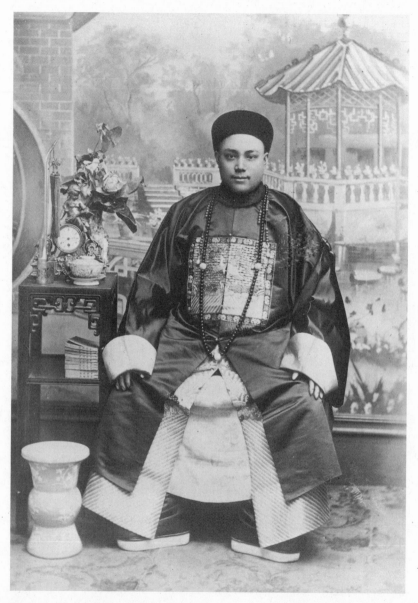

Figure 9. Shew's Pioneer Gallery, San Francisco, Untitled ("Chinese Gentleman in the 'Nineties"), ca. 1890. 1905.5278.79—PIC, Bancroft Library, University of California, Berkeley.

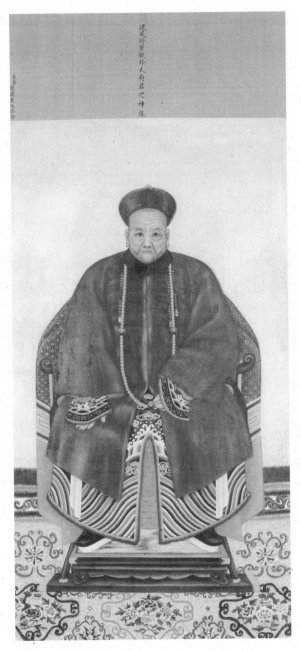

Figure 10. Unknown painter, "Portrait of Father
Ruifeng," Qing dynasty, ca. 1890. No. S1991.136,
Arthur M. Sackler Gallery, Smithsonian Institution,
Washington, D.C.

```
 1   United States of America,  )
 2   State of Utah,             ) SS.
 3   County of Summit.          )
 4         James Don                    , being first duly sworn,
 5   on oath deposes and says: That he is a citizen of the United
 6   States, over the age of twenty one years; that he is a resident
 7   of Park City, Utah, and has resided in said City ever since the
 8   year  1882    ; that he knows Lee Gum Yoke, whose picture
 9   is hereto attached and made a part hereof, ever since his birth;
10   that said Lee Gum Yoke was born in Park City, Utah, sometime
11   during the year 1884 and has resided in Park City during all
12   of the time since his birth except about the last four years.
13                       James Don
14         Subscribed and sworn to before me this 28th day of
15   March, A.D. 1904.
16
17                                   Notary Public for Summit County,
18                                         Utah.
```

Picture Identified
G. M. Nilson, Mayor of Park City

Exhibit a

HENDERSON, PIERCE, CRITCHLOW & BARRETT
ATTORNEYS-AT-LAW
SALT LAKE CITY

Figure 11. Affidavit of James Don in support of native-born U.S. citizen Lee Gum Yoke, 1904. In re: Lee Gum Yoke, File 10061/28, Immigration Arrival Case Files, 1884–1944, Records of the Immigration and Naturalization Service (Record Group 85), National Archives and Records Administration, Pacific Region (San Francisco).

associated with identity photographs. As already noted, frontality was common in Chinese portraiture. However, Lee's face reveals another possible reason for this pose. While he is wearing American clothes, Lee's hair is cut in the Chinese style. It is shaved in the front and longer in the back, probably braided in a queue. By looking directly at the camera, Lee hides the evidence of this Chinese cultural practice and presents himself as a shorthaired American man dressed in Western clothes. It may be that the suit that appears to fit him so well was loaned to him by the photo studio for the occasion. Such practices were fairly common, as people borrowed clothes to dress up for their portraits.[99] Or it could be that the photograph represents the dual aspects of Lee's life as a Chinese man in America. Regardless, Lee presented himself to the immigration authorities as a respectable, appropriately American citizen.

Like Chinese men, the vast majority of women presented simple identity certificates to immigration officials. However, whereas men's varied exemption status sometimes influenced their presentation of themselves in their applications and their photographs, women were consistently concerned with presenting themselves as respectable, traditional, and chaste. Inspectors, like Americans generally, had varying ideas about Chinese men depending on their political views and their understanding of class differences within the Chinese community. However, whether women were seeking entry as wives of merchants, wives of native-born citizens, or citizens themselves, inspectors typically assumed that all Chinese women were prostitutes. Few women escaped this widespread prejudice, and all had to prove that they were not being imported for immoral purposes. According to the official report on her case, Wong Joy Ow avoided such suspicion because she "has a very respectable appearance, and seems to be a woman of refinement." Further, "Her manner of testifying, and the character of her testimony favorably impressed the officers, and they are of the opinion that she is not a prostitute."[100]

Given the importance of appearing respectable, it is not surprising that Chinese women filled their identity photographs with evidence of their class status and home life. Although the majority of photographs of women, like Wong Joy Ow's, were simple identity photographs, Chinese women also submitted elaborate studio photographs of themselves to the Immigration Bureau. Outside the immigration records, photographs of Chinese women almost always portrayed them surrounded by Chinese props in elegant settings. These conventions of ostentation were partly because the few Chinese women who were able to enter the United States were often wealthy.

In the matter of Young Fou, for example, a merchant and his wife sought to gain entry to the United States for their son. The photograph of Young Fou shows the upper body of a small boy seated in a large ornate Chinese chair. The boy looks straight ahead. The affidavit of his father contains a simple identity photograph of a man facing the camera in plain black Chinese clothes and a black hat. Only his face and shoulders are shown. However, the photograph of his wife, Low Shee, is a full-length studio portrait of a woman seated in a chair similar to her son's but surrounded by familiar symbols of Chinese culture and tradition (figure 12).[101] The photograph is placed sideways on the affidavit and still barely fits in the space available. It could have been cut down to a smaller size, as the son's portrait apparently has, but instead it is used in its entirety to include the wealth of detail in the apparently Chinese context.

This photograph is not uncommon. It looks very like many other photographs of Chinese women taken in America in the 1890s and 1900s (see, for example, figures 13 and 14). It also looks similar, in staging if not posing, to photographs of Chinese gentlemen taken around the same time (see figure 9). It may well have been the one photograph that the family had available: some immigrants commented on the expense of photographs and how their only photographs were for the immigration authorities.[102] However, its use as an identity photograph is still significant. The surplus of props, for example, is especially noticeable when the image becomes an identity photograph, since such images are usually devoid of extraneous detail. The Chinese props and background place Low Shee, like the other female subjects, in an unmistakably Chinese context. Their respectability is represented as an adherence to Chinese traditions through the Chinese-style setting.

This visual adherence to traditional respectability, however, is not complete. Low Shee's feet—just visible and placed firmly together on a footstool—appear to be unbound. The footstool is a traditional feature of Chinese portraits, but women's feet were rarely represented in decorous portraiture, since they were considered erotic. "For reasons that are still unexplained," art historians Stuart and Rawski have noted, "the introduction of the camera ushered in the innovation of . . . Chinese women displaying their feet in photographs."[103] Immigration officials often looked favorably on applicants with bound feet, recognizing the practice as a marker of high class position within Chinese society that they associated with respectability. However, officials also noticed markers of Western respectability. Although Low Shee's feet are not bound, her left

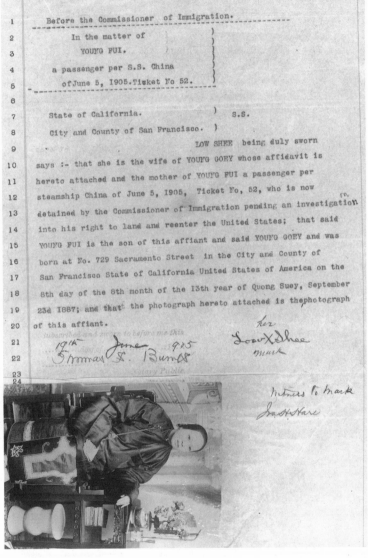

1 Before the Commissioner of Immigration.

2 In the matter of)
3 YOUNG FUI,)
4 a passenger per S.S. China)
5 of June 5, 1905. Ticket No 52.)

7 State of California.) S.S.
8 City and County of San Francisco.)
9 LOW SHEE being duly sworn
10 says :- that she is the wife of YOUNG GOEY whose affidavit is
11 hereto attached and the mother of YOUNG FUI a passenger per
12 steamship China of June 5, 1905, Ticket No, 52, who is now
13 detained by the Commissioner of Immigration pending an investigation
14 into his right to land and reenter the United States; that said
15 YOUNG FUI is the son of this affiant and said YOUNG GOEY and was
16 born at No. 729 Sacramento Street in the City and County of
17 San Francisco State of California United States of America on the
18 8th day of the 8th month of the 13th year of Quong Suey, September
19 23d 1887; and that the photograph hereto attached is the photograph
20 of this affiant.

Figure 12. Affidavit of Low Shee in support of merchant's son, Young Fui, 1905. In re: Young Fui (also spelled Young Fou), June 19, 1905, File 10059/52, Immigration Arrival Case Files, 1884–1944, Records of the Immigration and Naturalization Service (Record Group 85), National Archives and Records Administration, Pacific Region (San Francisco).

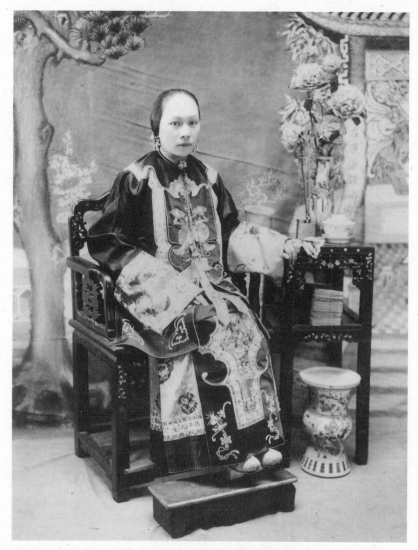

Figure 13. W. F. Song, San Francisco, Untitled ("Formal Portrait of Chinese Woman"), ante 1930. FN-19253, SF—Social Groups, Chinese (ante 1930), California Historical Society, San Francisco.

hand is carefully positioned on the edge of the table to display what appears to be a wedding ring. In traditional commemorative portraiture, women's hands were often more carefully hidden in the sleeves of their garments than men's. However, although wedding rings were not customary in China, women in this photographic portrait and others may

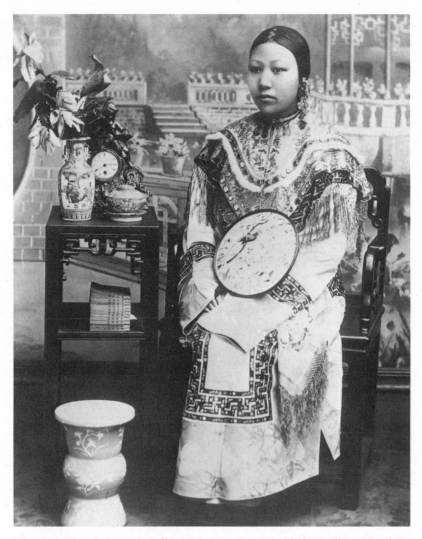

Figure 14. Shew's Pioneer Gallery, San Francisco, Untitled ("A Chinese Lady in the 'Nineties"), ca. 1890. 1905.5278.75—PIC, Bancroft Library, University of California, Berkeley.

have presented their ringed fingers to register their married status and respectability to a Western viewer (see figure 13). Unlike uniform identity portraits, these photographs encased their female subjects within apparently Chinese settings. These visual strategies made few claims on America but still presented women as accepting some of the immigration officials' American expectations of respectability.

Although Chinese immigrants resisted both exclusion and American stereotyping by representing themselves in photographic portraits, this resistance was never fully effective. While they were successful in using photographs to persuade immigration officials of their rights to enter the United States, they could not control the ways that these officials viewed them. In the end, immigration inspectors and Americans looked at the Chinese in America and saw what they wanted to see.

Strategies of self-presentation, of course, were not limited to photography. "When the steamer arrives and also when you are examined in Angel Island," one paper son was instructed, "wear your foreign clothes or new Chinese clothes in order to present a good appearance."[104] This appearance was not only for the immigration inspectors but also for the photographs that were taken at Angel Island. After the statutory implementation of photographic documentation in 1893, the Immigration Bureau expanded its control over the production of images and attempted to standardize the range of acceptable images. This expansion of control included efforts to limit Chinese opportunities for self-presentation, to control the circulation of photographs in the Chinese community, and to require all individuals of Chinese descent to carry uniform certificates of identity.

In addition to the studio photographs that they placed on their certificates, Chinese were photographed by the Immigration Bureau. They were photographed as they entered the United States and, if they were arrested or deported, immediately after their arrest or prior to their deportation. Larger stations such as Honolulu had their own photographic equipment and typically used an immigration officer to take such photographs. Since its volume was so great, the San Francisco station employed its own photographer. At stations with less Chinese immigration, such as Philadelphia and Malone, New York, on the border with Canada, these photographs were typically taken by local studio photographers.[105] The Immigration Bureau photographs look more like standard identity photographs than the portraits supplied by the Chinese, although they are far from standardized. Applicants were often photographed against a plain background holding a chalkboard on which the details of their case were written (figure 15). These photographs were typically trimmed of details, such as the chair in which they were sitting or their hands holding the board, leaving only the board and their face stapled to their file (figure 16). In the early years at Angel Island, arrivals were photographed in front and side profiles against the background of the white clapboard

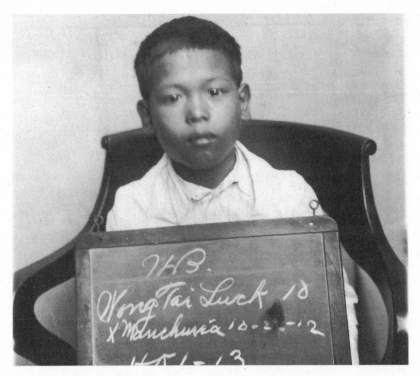

Figure 15. Unknown photographer, "Wong Tai Luck," 1912. In re: Wong Tai Luck, File C-2770, Old Chinese Immigration Case Files, 1903–1915, Honolulu District Office, Records of the Immigration and Naturalization Service (Record Group 85), National Archives and Records Administration, Pacific Region (San Francisco).

buildings. Instead of a completely plain background, these photographs showed the shadow lines of the boards and often a door. In many cases, the faces of the subjects were not clearly illuminated, and these images are often less effective as identity photographs than the studio portraits placed on certificates.[106]

As part of the process of establishing more uniform documentation and photography practices, the Immigration Bureau issued a single certificate of Chinese identity in 1909. These certificates expanded documentation requirements until they covered almost all people of Chinese descent in the United States, including U.S. citizens. By 1914, most photographs on certificates of identity had a uniform appearance. In photographs on certificates taken in San Francisco, all the men face the camera directly and are hatless. Their faces are similar sizes, and the

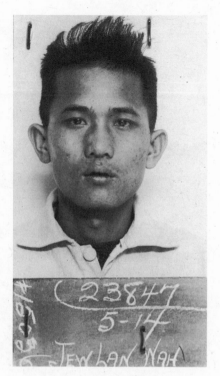

Figure 16. Unknown photographer, "Jew Lan Wah," 1924. In re: Jew Lan Wah, File 23487/5–14, Immigration Arrival Case Files, 1884–1944, San Francisco District Office, Records of the Immigration and Naturalization Service (Record Group 85), National Archives and Records Administration, Pacific Region (San Francisco).

photographs themselves are cut to a uniform size. These San Francisco images have consistent backgrounds, exposures, and photograph quality, suggesting that they were taken by an official photographer (figure 17). However, certificates issued to Chinese in other ports, such as Seattle, were less uniformly presented and have aged differently, suggesting that these images may have been taken not by an official photographer but by local studio photographers operating under authority from the Immigration Bureau.[107]

Although the Immigration Bureau started to improve documentary consistency in 1909, it was not until 1926 that immigration regulations specified a uniform photograph size or pose, largely codifying what had by then become standard practice: the full frontal view without hat. Despite this codification of both the practice and conventions of identity portraiture, Chinese immigrants continued to offer photographs of themselves and their families that looked quite unlike conventional identity photographs. They took the Immigration Bureau's photographic requirement and used it to provide a wide range of their own images that were included in their case files to support their claims. The Immigration

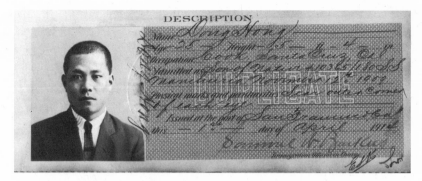

Figure 17. Certificate of identity, Dong Hong, 1914. In re: Dong Hong, File 14559, Duplicate Certificates of Identity, 1908–1943, Records of the Immigration and Naturalization Service (Record Group 85), National Archives and Records Administration, Pacific Region (San Francisco).

Bureau's codification of identity photograph conventions limited the opportunities for Chinese immigrants' representations of themselves in their immigration portraits. However, it did not end their ability to use photographs to enter the country during the exclusion era.

As this chapter suggests, the introduction of documentation was intimately connected to the racism faced by the Chinese in America. According to anti-Chinese activists, Chinese residents had criminal tendencies and no respect for American laws, particularly immigration laws. Their natural inclination to evade exclusion laws was aided by the fact that they all looked alike. For exclusionists, these shared criminal tendencies and physical traits provided the rationale for documentation. They believed that photographic documentation was necessary to distinguish individuals among the mass of Chinese and to ensure that they did not break the law. As restrictionists worked to expand the scope of Chinese exclusion, they relied on photographic documentation to enhance the government's efforts at enforcement.

The Chinese community strenuously fought the introduction and expansion of exclusion using diplomacy, political protests, and legal challenges to the laws. These challenges were successful in reducing the scope of exclusion and providing some protections for Chinese living in America. But they were not enough to stop the introduction of registration and photographic identity documentation.

In their identity photographs, Chinese immigrants often presented themselves in ways that defied conventional American beliefs about them

and consequently made them more acceptable to immigration officials. Although many Chinese identity photographs deployed honorific portraiture conventions for repressive purposes, these images did not fundamentally challenge the common beliefs about photography that had encouraged the introduction of identity documentation: the understanding of photographs as reliable, detailed likenesses of the immigrants depicted in them.

Although legal strategies were important in opposing exclusion, they were consistently less effective at undermining the laws than extralegal efforts. During the exclusion era, substantial numbers of Chinese immigrants entered the United States illegally, and their presence alone undermined the purpose of exclusion. The success of these illegal efforts depended significantly on the weakness of U.S. registration policies and the vulnerability of photographic documentation. The partial registration system did not just create difficulties for legitimate Chinese residents without certificates; it offered opportunities for some illegal Chinese immigrants to pass as legal residents. These illegal entrants not only challenged discriminatory immigration policies but also undermined the emerging authority of photography.

Photographic Paper Sons

Resisting Immigration Identity Documentation,
1893–1943

In the aftermath of San Francisco's 1906 earthquake, fires approached the Immigration Records Building. Hart Hyatt North, the commissioner of immigration for San Francisco, wrote to his boss, Commissioner General Frank Sargent: "On Friday the fire got so hot around here that I thought it would be best to remove our most valuable records into a place of safety, consequently they were taken downstairs and down the street into the district that had already been burned over, where they were piled high and a guard was mounted over them until danger was past. Your picture occupied a prominent place in this movement, and you were mounted on top of the heap of records, where your magnificent face lent dignity to the scene. The heat cracked the glass covering your picture, but otherwise you are unhurt."[1] From his perch in San Francisco, Sargent could do little about the fire that destroyed the Immigration Records Building and most of the Chinese records it contained. From his office in Washington, he could do little more to limit the wave of questionable Chinese applications and admissions that followed the fire.

Fraudulent claims and documents had been filed with the bureau since the beginnings of Chinese exclusion in 1875. However, after the Records Building was burned, these practices appear to have increased dramatically.[2] Before the fire, it had often been necessary to make a return trip to China in order to create opportunities to evade the exclusion laws. Overseas Chinese who returned to China permanently might sell or give their certificate to someone who was not able to enter the United States

legally. If they were U.S. citizens or merchants and planned to return to the United States, they could claim that they had fathered a son to create a record for future use by a young man intending to emigrate. Some Chinese sold or loaned their certificates after successfully entering the United States, but they faced difficulties if they were discovered without documentation.[3] Others obtained consular certificates in China and Hong Kong in order to sell them or sold them once they decided not to travel to the United States.[4] After the 1906 fire destroyed most Chinese records, however, Chinese without certificates could claim that they were native-born U.S. citizens or that they had fathered sons in China with rights to derivative citizenship.

To detect such evasions, the Immigration Bureau developed an increasingly elaborate system of checking an applicant's life history against the stories of his alleged relatives. Applicants and their sponsors were generally asked questions about the last time they had seen their relatives, the location of buildings in their village, and even the number of steps leading to their house. If their histories were internally consistent and matched one another, then the applicants were usually allowed entry. If not, they were considered frauds. If they decided not to appeal or if their appeals were unsuccessful, they were deported. Historian Roger Daniels estimates that approximately 18 percent of Chinese applicants were denied entry.[5] However, the interrogations were so detailed that sometimes even real family members failed or had to be coached to answer the questions correctly.[6] One of the inspectors noted that when he asked his sons questions similar to those asked during the interrogation, their answers were not consistent and "they would have failed."[7] The extensive notes that young men used to rehearse their adopted identities became known as coaching papers. The young men who used these coaching notes to obtain their certificates of residence (or papers) became known as paper sons.

Histories of Chinese immigration and exclusion have typically described the practice of obtaining certificates of residence for paper sons through coaching papers.[8] However, photographs were just as significant as papers to the successful entry of many sons. By 1893, photographs were required of almost every Chinese person who applied for entry to the United States. These photographs and their accompanying documentation had become central to the enforcement of Chinese exclusion. At the same time, photographs became central to the evasion of these laws. As the Immigration Bureau increasingly relied on photos to help determine an applicant's identity and right of admission, the Chinese in-

creasingly used such photos in support of fraudulent cases. As Judge Hanford noted in his ruling that two Chinese men had brought a woman into the country for immoral purposes: "They were successful in imposing upon the immigration officers by means of false representations, and skilful use of photographs identifying the girl as a daughter of the accomplice, and a native of this country."[9]

Chinese immigrants developed numerous ways to evade exclusion using photography, and immigration officials developed many forms of investigation in response. Some Chinese followed established paths of evasion developed by immigrants before them, such as the paper son system. Others became part of complex schemes to enter large numbers of immigrants, schemes that typically involved corrupt immigration officials. Chinese immigrants also forged certificates, although this practice appears to have been less common, as the forged certificates were fully effective only if they matched existing immigration records.[10] Finally, some Chinese improvised ways to take advantage of a fortuitous situation, such as access to certificates with faded or indistinct photographs or with images of people who happened to look like them.

In addition to falsifying documentation, some Chinese immigrants crossed the Mexican and Canadian borders or were smuggled into the country aboard ships calling at ports such as Galveston and New Orleans. These efforts, described in chapter 5, allowed immigrants to escape the detection of immigration officials and avoid obtaining certificates.[11] However, if they were discovered without a certificate once in the country, they had to prove that they were native-born citizens to explain their exemption from exclusion and registration requirements, as well as the lack of records regarding their entry into the United States.[12] Although there were ways to enter the United States illegally without standing before the camera, the central role of photographic documentation in the administration of exclusion meant that many Chinese relied on photography as part of their strategy to elude exclusion.

Ironically, as Lucy Salyer has suggested, the introduction of documentation probably made it easier for Chinese to enter the United States illegally.[13] Although exclusionists and immigration officials believed that documents would authenticate real identity claims, Chinese used documents to fabricate new identities and relationships, and although photographs were introduced to control the flow of fraudulent documents, fraudulent photographs themselves became part of this market. The widespread use of fake documents and photographs enabled substantial numbers of Chinese to resist exclusion and evade the law. The Immigration

Bureau recognized this in 1901 when it recommended the "use of photographs for identification purposes in all cases" but admitted this would only partially overcome the problems of documentation.[14] As Mae Ngai has written, "The logic of enforcing exclusion compelled immigration officials to impose an upward spiral of evidentiary requirements upon Chinese immigrants; but, at the same time, the authorities mistrusted the entire register of documentary evidence that they had created."[15] As photographic documentation was made a central mechanism of enforcement, the curtailment of fraudulent documents and photographs became central to exclusion's primary aim of curtailing Chinese immigration.

This chapter traces the course of Chinese engagement with the Immigration Bureau, starting with the multiple ways that Chinese immigrants manipulated photographic documentation in order to enter the United States despite being excluded. Unlike strategies of self-presentation, these practices deliberately undermined the Immigration Bureau's administration of exclusion and the premises of reliable photographic documentation. This discussion is then expanded to the creation and questioning of Chinese families, addressing both the formal aspects of photographic presentation and the role of photography in the practice of establishing paper families. Whereas other immigrants were observed only at the immigration station, the official regulation of the Chinese through photographic documentation extended to their everyday life. Documents and photographs were used extensively as the Immigration Bureau conducted investigations and raids in Chinatowns across the country.

A "RATHER GOOD RESEMBLANCE": ENFORCING AND
RESISTING EXCLUSION THROUGH PHOTOGRAPHY

As already noted, proponents of photographic documentation argued that photographs were necessary to distinguish individuals out of the masses of Chinese, who all supposedly looked so similar that "the description of one Chinaman would answer substantially for his whole race."[16] According to this argument, although the similar appearance of all Chinese facilitated the circulation and selling of certificates, photographs would reveal the slight differences between Chinese that couldn't be given in written descriptions and would therefore make it impossible for Chinese to exchange certificates. From the moment of their invention, photographs had been praised for representing minute details that were often overlooked by the naked eye. This thoroughgoing accuracy was attributed to the indexical quality of photography: since photographs were the

result of the direct impression of light upon the light-sensitive photographic paper, they represented everything, including apparently insignificant details.

At the same time and for the same reasons, photographs were assumed to be objective. They necessarily represented whatever was placed before them. One of the most basic assumptions about photography and one of the reasons for its use on identity documentation was that it reliably represented reality, that it objectively transcribed the scene before the camera into a two-dimensional image. The photographic image was introduced to act as the link between the information contained in the document and the individual who stood before the immigration inspector, to ensure the correlation between the document and the immigrant. According to this logic, photography's indexicality secured a complete and objective accuracy that could never be achieved by other forms of representation such as drawings and written descriptions.

However, this understanding of photography viewed the image in isolation from the pressures of its purposes. It imagined the photographic production process as a closed system of disinterested mechanical reproduction and considered the image without reference to its context. In fact, in contrast to the ideal of the objective image promoted by supporters of photographic identification, photographic prints could be manipulated through various means.

Paper sons and other excluded Chinese broke the apparently secure link between the document and the immigrant, the image and the referent, in two key ways: they exploited vulnerabilities in the image, and they changed the referent, the thing represented in the image. Chinese immigrants manipulated the photographic image by intentionally altering the image (e.g., retouching it), exploiting existing imperfections in the image (such as blurriness), and substituting one image for another on photographic identity documentation. Without making any changes to the image, they also changed the referent by exchanging documents among immigrants. In these cases, immigration officials carefully reviewed the identity document to search for signs of retouching, substitution, or a mismatch between the image and the individual who claimed to be represented in it.

Perhaps most significantly, paper families also carefully manipulated the referent, creating entirely new identities for paper sons and other relatives. In these cases immigrants exploited the weakness of the link between the caption and the image. On immigration documents, the caption and the image together formed the identity photograph: the visual

representation and the written identification of a given individual. An identity photograph was reliable only if both the image and the caption were reliable. However, false captions could be adopted without affecting the photograph's indexicality and without leaving a trace on the image itself. The counterfeiting of captions, names, and identities was a common practice among paper sons. Chinese immigrants would place their photograph on papers that had been prepared for an imaginary individual, falsifying the relationship between the caption and the image without altering the photograph. Since there was no manipulation of the image and since the identity photographs correctly represented the individual applicant, the link between the image and the referent was relatively secure. In these cases, immigration inspectors focused not on the identity document but on the individual. In detailed and extended investigations, officials used photographs from the bureau's archives and other sources to test the claimed family relationships.

Finally, in addition to creating false identities to obtain government-issued documents, Chinese immigrants created their own fake documents. Raids of Chinese businesses unearthed counterfeit seals with the names of various U.S. commissioners used to forge a range of identity certificates. In one case, the New York police raided a laundry near the Bowery searching for opium. Instead, they discovered two counterfeit seals from former U.S. commissioners Woodward and Johnson under the laundry owner's berth. The owner, Dong Min Jung, claimed that the seals belonged to the previous owner and that although he did not know their purpose he was saving them in case the rightful owner returned. Unlikely as this story might sound, Jung himself had no papers showing his right to reside in the United States, so he was arrested and taken into custody.[17] Most of the seals that inspectors located were not especially accurate copies. Therefore, they would forward a description of the discrepancies between the genuine and fake seals to all immigration districts, allowing bureau officials to evaluate the certificates purported to be issued by the commissioner in question.[18] Like other ways of faking documents, these practices allowed many immigrants to enter but also brought all Chinese documents under suspicion of being forged.

In looking for a photographer who worked closely with the Chinese community to help subvert Chinese exclusion and some of the common assumptions about photography, we need look no further than Fong Get. Fong maintained a gallery at 914 Stockton Street in San Francisco from before 1910 to about 1920, taking photographs of both elite Chinese and ordinary immigrants. He was commissioned by the Chinese consul

general, Hsu Ping Chen, for a number of official portraits, which his studio mounted in elaborately decorated frames. These traditionally styled photographs were sent with compliments to U.S. officials such Hart Hyatt North, the San Francisco commissioner of immigration between 1898 and 1910 (figure 8).[19] At the same time, Fong also took workmanlike identity photographs of immigrants. Some of these immigrants, however, were involved in an elaborate illegal immigration operation. As part of this scheme, Fong took and printed small, unmounted images of Chinese men with queues dressed in traditional clothes and caps. Although Fong professed no knowledge of their illegal actions, he testified as part of an immigration investigation that all of the men had come to his studio dressed in American clothes and had proceeded to don Chinese clothes and wigs before sitting for their portraits. These prints, taken in 1916, were then aged and substituted on certificates from the 1890s with the help of immigration officials.[20] As the extensive Densmore investigation discovered one year later, "For some time, certain inspectors, clerks, interpreters, watchmen, and even some of those employed at the station in the capacity of laborers, were engaged in criminal attempts to secure the landing of inadmissible Chinese." Twenty-five bureau employees, including seven of the eleven immigration inspectors, were subsequently dismissed for facilitating their entry through "substitution of photographs, alterations of testimony, . . . and other shrewd devices."[21]

Fong Get's photographs on doctored certificates gave the impression that the Chinese applicants had previously lived in the United States and were entitled to reenter. In Roland Barthes's realist analysis of photography, the photograph always represents "that *the thing has been there.*"[22] However, these Chinese laborers exploited the fact that the thing that appears before the camera is not necessarily what it appears to be. Carefully placed by corrupt immigration officials on 1890s immigration certificates, the faked photographs appeared to represent that the immigrants had been there, before the camera, in the United States at that time. However, in the subsequent investigation into official corruption, it became apparent that—through the photograph—the past and the apparent presence of the immigrant had been manipulated.

Intentional alterations to images included not only deliberate aging but also retouching and blurring. Some immigrants altered photographs to make the images fit the family and the history they had created. In one unusual case, a Detroit photographer helped a paper father doctor a family photograph by placing an image of his paper son over his biological daughter. The photograph was submitted as evidence of a familial rela-

tionship, but certain features such as the son's Chinese clothing had not been changed to match the family's American clothes because of the extra expense. In this case, the crude retouching and discrepancies in the image revealed the photograph as a fraud and caused the paper son's application to be denied.[23]

Photo substitution was also a critical means by which Chinese were able to evade their exclusion, presenting a significant problem for immigration officials. Starting in the 1880s, administrators introduced a series of rules designed to limit photo substitutions, which included official stamps that covered part of the photograph and the document. However, these measures, which were incorporated into immigration identity documentation as it was expanded to other groups, appear to have had only moderate success. Paper sons continued to place new photographs on old documents, visually falsifying the family relationships and legal residence that they claimed in their testimony before the immigration inspectors.[24]

Despite the popular argument among supporters of photographic documentation that photographs were needed to distinguish among Chinese because they all looked the same, photograph substitutions were routinely discovered by reference to the detailed descriptions and distinguishing marks listed on the certificates. In the absence of clear evidence of substitution, obvious differences between the image and the description of distinguishing marks helped inspectors to identify these cases.

In cases of suspected substitution, inspectors also applied to the national office to obtain a duplicate of the certificate to compare the two photographs. If the photographs did not match, it was clear there had been a substitution. The photographs of two different men on identity certificates issued to Chin Tom (figure 18) suggest how different immigrants used the same documentation of their right to reside in the United States and how the Immigration Bureau regulated such practices. As noted on the certificates, both men were deported for their deception.[25] Starting with the Geary Act, the Immigration Bureau required three photographs to maintain its comprehensive archive of Chinese immigrants. One photograph was placed on the certificate, one on the original application generally kept at the local immigration station, and one on the duplicate record located at the central office. At first, the bureau required only three photographs, but it later specified that these images should be identical prints produced in triplicate from the same negative, in order to aid immigration investigations.[26]

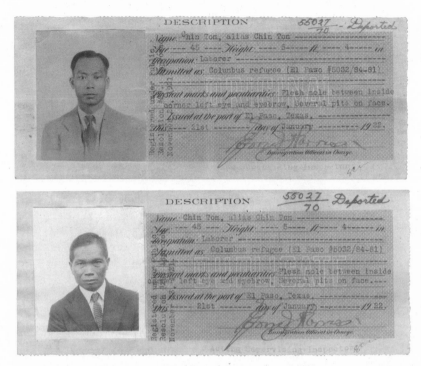

Figure 18. Two certificates of identity issued to Chin Tom, 1922. In re: Chin
Tom, File 55027, Duplicate Certificates of Identity, 1908–1943, Records of the
Immigration and Naturalization Service (Record Group 85), National Archives
and Records Administration, Pacific Region (San Francisco).

In addition to intentional manipulation and photo substitution, Chi-
nese applicants exploited the imperfect indexicality of many early im-
ages that had been incidentally blurred and made indistinct with age. As
much as possible, excluded Chinese used documents that contained im-
ages of individuals who looked similar to them. These photographs had
usually been taken when the original individual was much younger and
were sometimes presented to immigration authorities after the photo-
graph had aged or been damaged, making it difficult to compare the im-
age to the individual holding the document. Mr. Lai, for example, de-
scribed his father's entry as a young man using a certificate originally
issued to a child who had died while in China.[28] In addition to these im-
provised examples, there were larger-scale systems by which excluded
Chinese shared and sold identity documents. In Walla Walla, Washing-
ton, an inspector located 110 pawned identity certificates. Since the cer-
tificates had no monetary value and were intended only as evidence of

identity, the inspector determined that these were resold if their original holders defaulted on their loans.[28]

Immigration officials' concerns about the Chinese exchanging identity documents were more broadly shared. These concerns focused on both the unreliability of the Chinese and the unreliability of photography. Charles R. Shepherd, for example, filled his novel *The Ways of Ah Sin* with racist stereotypes about the Chinese. The narrative starts with the importation of a girl for immoral purposes. Unaware of her fate, the girl is able to enter the United States illegally because she looks so like the importer's daughter that she can use the daughter's passport. Although this novel focuses on the supposed similarity between Chinese people rather than the flaws in photography, it addresses popular concerns about the Chinese ability to evade exclusion.[29]

The indistinctness of photographs at this time was also a subject of concern for various enforcement officials, including the courts. In *Reisterer v. Lee Sum,* for example, a Chinese laborer was assumed to have a fraudulent certificate with a photograph that did not resemble him. However, the court determined that the photograph was indistinct and therefore that the lack of resemblance did not seriously impeach the authenticity of the certificate.[30] In other cases, regional offices requested a good copy of the certificate from the national office if the photograph was difficult to read because it was aged or damaged.[31] Such verifications and coordination between the regional offices and national office were quite common. Inspectors also used the photograph's mass reproducibility to determine whether a cracked and faded image was really that of the person holding the document. When possible, they would locate the photography gallery where the first photograph was taken and have a new print made from the original negative. They were helped in these investigations by the fact that galleries kept detailed record books and often held their negatives for long periods while they remained in business. These new prints would then be compared to a photograph of the applicant to check for a match.[32]

In investigating identity documents that they believed had originally been held by other individuals, immigration officials typically claimed that the difference between the individual and the photograph was obvious. In separate cases, Angel Island commissioner Samuel Backus emphasized the fact that these differences were "plain" to see. "A comparison of the applicant with these photographs," he concluded in one report, "shows plainly that they are not the same person."[33] In another report, he wrote, "It is plain that the photograph is not of himself."[34] In ques-

tioning the reliability of the document, immigration inspectors reasserted the authority of their own eyes.

Inspectors also relied on the camera to make their case. From their inception, photographs had been praised for their ability to capture minute, almost incidental details that might normally be overlooked. To allow for more detailed comparison and for the detection of these hidden differences, the Immigration Bureau sometimes enlarged photographs dramatically. Images measuring only a couple of inches were blown up to show life-size faces on photographs larger than the files that held them. As the photos were enlarged, so were the differences. According to one inspector, "The enlarged photographs show at a glance the great difference in the shape of the ears, the eyes, and the general contour of the face."[35]

As a result of these practices, immigration inspectors never assumed that the photograph represented the applicant before them. The widely reported problem of fraudulent documentation, which had been one of the main reasons for the introduction of photographs, continued. Only now it included concerns about photographs as well as documents. In contrast to the assumptions of members of Congress who supported photographic identification, immigration officials gradually realized that photography was not entirely reliable.[36] Although inspectors initially praised photographs for providing detailed representations of masses of supposedly similar faces, Chinese oppositional practices raised significant questions about the reliability of the photographic image as documentary evidence.[37] Immigration inspectors' suspicions about the prevalence of fraudulent photographs and their assumptions about Chinese duplicity reinforced one another: the images were considered unreliable evidence because the Chinese were considered unreliable witnesses, and vice versa.

Further, inspectors seemed to believe that Chinese photographs and Chinese witnesses shared a particularly treacherous artifice: on the surface both appeared honest, but this apparent honesty concealed a deeper duplicity. To the casual observer, the Chinese identity photograph might appear reliable, but the inspector's experienced eye could detect it as a fraud. To the careless listener, Chinese testimony might appear to support the applicant's claims of legal residence, but the inspector could hear subtle inconsistencies and reject the application. Even when it was clear that applicants were lying, one inspector commented, "They wouldn't give up." Expanding on these comments, he added, "You know how Chinese are, they're very stone-faced."[38]

Chinese immigrants' successful use of photographs to evade exclusion and immigration inspectors' Chinese stereotypes worked together to

destabilize the credibility of photographic identification. Given immigration officials' general distrust of Chinese immigrants, the existence of some fraudulent applications undermined the trustworthiness of all. However, this uncertainty did not affect every photograph. The authority of the image depended on the conditions of its production. Therefore, indexical authority continued to be conferred upon apparently disinterested images of art or social documentation taken by white photographers distanced from their subjects, such as photographs of immigrants taken at Ellis Island. At the same time, photographs paid for and taken under the direction of immigrants as part of their immigration cases were considered less reliable. This was particularly true for Chinese because of the way in which they were racialized: Chinese immigrants and Chinese photographs alike were considered untrustworthy. As Derrick Price has noted, "When it became plain that the technologies of photography were not automatic transcribers of the world, other questions about the nature of authenticity began to be raised and other guarantors of photography's fidelity were advanced. Among these was the notion that we need to trust, not the mechanical properties of the camera, but the personal integrity of the photographer."[39]

In making their searches of photographs, officials acted like detectives searching photographs for clues to the real identity of the Chinese applicant. As the San Francisco commissioner of immigration noted, an officer working with Chinese immigration records occupied "a somewhat similar position to that of the Officer in Charge of the Identification Bureau in the Police Service."[40]

Although the photograph played a critical role in identifying fraudulent applicants, it was not always the final arbiter in immigration decisions. Occasionally, applicants were admitted despite their dissimilarity to the photographs on their certificates because their testimony appeared to be consistent.[41] More often, applicants were rejected despite their similarity to the photographs on record. Genuine applicants were told that they didn't look like the people in their photographs. Mr. Tsang, a native-born citizen, relayed his experience of almost being rejected upon his return to the United States because immigration officials said he didn't look like his baby picture. He was allowed to enter only after a doctor confirmed that his appearance had been altered by a cut under his left eyebrow.[42] In another case, Ah Jew Mooey supported his application as a native son with numerous photographs, including a group photograph of him at a U.S. school. Although the Immigration Bureau acknowledged his "rather good resemblance" to these photographs, Mooey was rejected

because his mother was suspected of being a professional witness, he couldn't speak English, and he was unable to recall certain events that had happened when he was supposed to have lived in the United States.[43]

The Immigration Bureau also ruled against Yee Kim Sue because he appeared younger than the person named on his identity certificate. Although the photograph on record "resembles him considerably," the inspector stated, this was not because they were the same person but because "the person interested in the case of this applicant would pick out a boy to resemble as nearly as possible the person who departed in 1902."[44] This logic was difficult to escape. While looking different from your identity photograph was typically sufficient reason for deportation, looking like your photograph was not always good enough for admission. In the first case, immigration inspectors relied on the photograph as effective evidence. In the second, they distrusted the photograph because they distrusted the Chinese. These rulings moved in contradictory directions but usually favored denial and deportation. Such outcomes were consistent with government rules requiring that if inspectors had any doubt about the case they should rule "in favor of the exclusion of the alien."[45]

Whether an applicant was admitted or rejected depended not only upon the written and visual evidence but also on the inspectors themselves. Although most cases of mismatched identities were ruled against the Chinese, one factor could work in their favor in these cases: the corruption of some immigration officers. In one case, a Chinese applicant was almost denied entry because his "ear was creased and the ear in the picture was not." According to the Bertillon system, which combined photographic documentation with detailed measurements, the shape of the ear was unique and acted as a unique biometric identifier to distinguish between different individuals. Like Mr. Tsang mentioned above, the man was eventually allowed to enter using the excuse that his ear had been hurt. However, he was not the person represented in the photograph and had bribed the officials to let him in.[46] As another Chinese immigrant commented about the immigration inspection, "If you answered wrong, it took a lot of money to correct it."[47]

In immigration investigations, neither the photograph nor the testimony alone was sufficient to secure the applicant's successful entry. When the oral, written, and visual evidence was internally consistent and corroborated by outside witnesses, then the application was generally successful. However, the status of each form of evidence was also critical. Just as inspectors questioned the reliability of the photograph, they were

concerned about the reliability of the witnesses who appeared before them.[48] Both Chinese and whites were sometimes suspected of being paid or professional witnesses, although this suspicion fell more often on the Chinese. When Tang Tun asked an immigration inspector whether he wanted Chinese or white witnesses who could account for his birth in the United States, the inspector replied, "I would prefer white people."[49] Whether Chinese or white, witnesses were considered more reliable if they were seen as more respectable. As the immigration inspectors saw it, the appearance of respectability on the surface revealed a deeper truth about the genuineness of the Chinese testimony.

THE BERTILLON SYSTEM OF VISUAL DOCUMENTS AND MEASUREMENTS

To facilitate these comparisons between images and individuals, the Immigration Bureau briefly adopted the Bertillon system of criminal identification between 1903 and 1907.[50] Like the other aspects of the bureau's early photographic policy, this system of photographing and documenting new arrivals was used exclusively for Chinese immigrants. The Bertillon method, also known as signaletics, was originally developed by French detective Alphonse Bertillon in the 1880s and adopted by U.S. police departments in the 1890s. The system of uniform front and profile photographs combined with detailed bodily measurements was used to identify recidivist criminals who attempted to evade detection through the use of aliases. Designed to improve on the basic identity photographs of police mug books and rogues' galleries, the system reflected Bertillon's own uncertainty about the strengths of photography alone as a tool of identification.[51]

Photography studios submitted bids to local offices of the Immigration Bureau, providing prices for photographs taken in the method "required by the Bertillon system of measurements."[52] However, it is not clear how closely Bertillon's methods were followed. Immigration officials adopted the signaletic practice of paying close attention to the shape of the ear, since it—like a fingerprint—was considered unique to each individual and supposedly changed little over time. On the basis of information provided by a photographer, Acting Commissioner General F. H. Larned argued that the ear was relied upon because it was "a feature which the lapse of 13 or even 30 or 60 years, would not change."[53]

By 1907, however, the Immigration Bureau had stopped using the signaletic system. Historian Erika Lee explains that the discontinuation was

part of the bureau's decision to enforce Chinese exclusion less harshly in response to the 1905 Chinese boycott of American goods.[54] A contemporary observer and Chinese American activist, newspaper editor Ng Poon Chew, suggests that the central Washington office of the Immigration Bureau did not provide local offices with enough personnel for the complex measuring process.[55] In addition to these reasons, it is also possible that the Bertillon system was not particularly useful to the Immigration Bureau. First, the system was primarily designed to identify recidivists. And although the bureau made efforts to identify Chinese who were suspected of reentering the United States after being deported, this was not an enforcement priority. Second, the Bertillon system was designed to archive individuals at the most basic level, through their physical features alone. It was created to eliminate the necessity of knowing anything other than their bodily measurements. However, the Immigration Bureau investigated Chinese arrivals through an elaborate process that demanded intricate details about people's lives and relationships. The bureau then archived these complex genealogies of Chinese lives, families, and communities. The Bertillon system, although it fit with the bureau's efforts to remake itself as a professional progressive institution, was not especially relevant to the agency's methods. Signaletics was designed to help identify individuals solely through their physical features. In the Immigration Bureau's excessive record of Chinese entrants, Bertillon's detailed physical measurements were largely unnecessary.

Although the Immigration Bureau's experiment with signaletics was short-lived, aspects of the system were expanded to identify other immigrant groups and continued to be used by the Bureau of Citizenship and Immigration Services (BCIS) until 2004. For example, though law enforcement agencies have long used fingerprints rather than ear shape as a means of identification, the BCIS continued to use both methods to identify immigrants. Prior to the 2004 implementation of the 2003 Border Security Act, permanent alien residents were required to have their photos taken with their head angled to the side and one ear clearly visible. These images were then placed alongside their fingerprints with other identifying information on their green cards.[56]

Bertillon's uncertainty about the photograph as a complete method of identification led him not to reject it entirely but to bolster it with other forms of identification. This was the same approach taken by the Immigration Bureau as its officials realized that photographs were not always fully reliable. In some cases where there was uncertainty about the images, photographers would be introduced as expert witnesses. However,

the Immigration Bureau and the immigrants both used photographers to
make conflicting evaluations of photographs. Consequently, these expert
photographers merely proved that multiple interpretations were possi-
ble from a single, supposedly objective, image.[57]

A FAMILY RESEMBLANCE: CREATING AND CHALLENGING FAMILIES THROUGH THE PHOTOGRAPHIC ARCHIVE

Many Chinese based their claims to U.S. residence on their father's status
as a laborer exempt from exclusion, a merchant, or a native-born citi-
zen. Therefore, many investigations explored family relationships in de-
tail. Chinese entering the United States occasionally offered family pho-
tographs as evidence of their relationships, but more often their family
portrait was constituted out of individual identity photographs on file
with the Immigration Bureau. The lack of group portraits reflected the
fact that Chinese families were kept apart by exclusion. Under the law,
laborers could not bring their wives to the United States: Chinese wives
were allowed to enter only if they were married to merchants or U.S.
citizens. As a result, most Chinese men remained bachelors or married
women who remained in China.

Some Chinese couples attempted to marry by proxy, using photogra-
phy, through the practice of "picture brides." A woman's family would
typically provide a man with her photograph, and if he agreed they could
be married without his presence. Although this practice was accepted in
China, such marriages were not recognized by the Immigration Bureau.
In some cases, picture brides were remarried to their husbands in an Amer-
ican ceremony on the ship's deck or the dock. In others, especially where
the brides were suspected of being imported for prostitution, they were
deported.[58]

Photo-historian Laura Wexler has described the family album as one
location in which Chinese families could be together, with photographs
of distant family members reunited on the page.[59] She traces the ways
that the album constructed the family and the ways that the nation con-
structed the album. In addition to the family album identified by Wexler,
the photographic archive of the Immigration Bureau was another loca-
tion where family members existed alongside one another, at least in the
camera's eye. However, these images did not represent an imagined fam-
ily reunion. They were part of a complex family tree that applicants had
to trace in detail before they would be allowed to rejoin their relatives.

Both biological and paper families used photographs to create family

trees and represent themselves as a family. In some cases, where family photographs were used on identification papers, the importance of representing familial togetherness and likeness conflicted with the imperatives of individual identification. Immigration officials viewed these photographs through their concerns about the widespread creation of paper relationships, often questioning Chinese efforts to represent themselves as families.

During the immigration investigation, applicants would be asked to identify first their own photograph and then the photographs of their family and friends. If they could not identify all of these images, their application for admission was generally rejected. These photographs were taken from other immigration files as well as affidavits supplied by witnesses testifying that the applicant was exempt from the exclusion laws. After 1912, every applicant had to provide a photograph of his father if his father lived in the United States and had not already provided a photograph with his affidavit.[60] If the witnesses were Chinese, as was usually the case, they had to supply photographs with their affidavits. The bureau's enforcement of this requirement could be harsh. When a Chinese witness failed to provide a photograph, the applicant's landing papers were held by the Immigration Bureau until a photograph was filed.[61]

White witnesses filing affidavits in support of Chinese applicants, however, were not required to provide photographs. The Immigration Bureau did not explain this distinction, but its investigative practices suggest the reasons. The Immigration Bureau used photographs of Chinese witnesses as part of its extensive investigative archive. Photographs of whites were not required for this archive because their photographs were rarely used in investigations. In addition, as Chinese organizations had argued, requirements to submit photographs were denigrating. Although this requirement was acceptable for Chinese, it was not deemed appropriate for whites. Finally, since whites were considered more reliable and less likely to act as professional witnesses, the Immigration Bureau believed there was no need to authenticate their testimony with a photograph.[62]

In addition to the studio portraits that applicants selected for their certificates, an official Immigration Bureau photographer took photographs of all applicants arriving at or being deported from Angel Island and Honolulu. Other smaller stations did not have their own photographers or equipment but relied on local studio photographers.[63]

The Immigration Bureau's increasingly detailed case files and their accompanying photographs formed a vast archive of Chinese living in

America. Each applicant typically had to provide images in triplicate,
with one photograph placed on the identity certificate, one remaining
at the immigration station, and one being sent to the national offices of
the Immigration Bureau in Washington, D.C. This system created a truly
national archive in which different immigration stations actively coor-
dinated to share their images with one another. This archive was cross-
referenced to allow the bureau to check the stories of Chinese against
one another whenever they chose to enter, leave, or return to the United
States or when they were arrested without a certificate. The photographs
of applicants attempting to enter, for example, might be checked against
the photographs of deported applicants if they were deemed somewhat
suspicious. However, this archive was not limited to the files of the Im-
migration Bureau. As photographs began to be placed in passports and
court records of cases involving immigrants, these were also made avail-
able to the Immigration Bureau.[64]

In response to this regulation, some Chinese also created their own
provisional family archives. These archives typically contained only a few
well-chosen photographs, but they were very effective at enabling Chi-
nese to evade the exclusion laws. The photograph's mass reproducibil-
ity helped Chinese immigrants to evade the law: they could keep identi-
cal copies of an image, so that paper sons could recognize the photos on
file with the Immigration Bureau and paper fathers could recognize their
sons. The coaching letters that paper fathers supplied frequently included
portraits that enabled the young men to learn the identities of their pa-
per family members and witnesses.[65] The fathers warned their wards to
destroy not only their coaching papers once they had memorized them
but also the photographs that accompanied these papers.[66]

At the same time, because photographs were used to establish fictional
relationships between family members and because detainees were
searched for coaching papers and photographs, it was not possible for
paper sons to bring evidence of their real families when they traveled to
the United States. "You didn't dare" bring pictures, commented one man
detained at Angel Island in 1913. "Not even letters."[67]

Paper relatives were also familiar with the Immigration Bureau's pho-
tographic archives. They often knew whose photographs would be
shown to the paper sons during the immigration interrogation because
they were aware whose photographs were on file with the Immigration
Bureau; they knew that all Chinese were required to submit their pho-
tographs to the bureau, that families selected those who testified for new
immigration cases, and that witnesses were required to provide a pho-

tograph with their affidavit. "Bing Suey's photograph is in the Detention House," wrote one paper uncle in a secret coaching note. "If they again ask you if you know Bing Suey's photograph, say that you know him and talked to him when he was in China."[68] In other cases, paper relatives decided who would be called as witnesses and sent photographs to enable the paper son to identify his alleged acquaintances. "For the present Lee Gim Jem is not to be used for your witness," wrote a paper father. "The inspectors do not have his photograph to give you to identify. If Lee Gim Jem is to be used for your witness later, you will then be notified."[69]

During the interrogation, not only was an applicant asked detailed questions about his village, home, and family, but he was also commonly asked about any photographs that he used to authenticate these relationships. He was asked when and where the photographs were taken, whether he had seen photographs of family members before or had sent photographs to the United States, and whether there were photographs of relatives in his home in China.[70] These questions were an attempt to confirm whether the applicant was really related to the father, brother, or uncle as he claimed or whether this relationship had been established only through photographs. They also reflected the officials' awareness of the ways that some Chinese used photographs to create paper families. The photographs themselves, which had been introduced to help officials in their investigation, became one of the subjects of investigation.

Immigration officials were sometimes quite elaborate in their attempts to test the authenticity of these family relationships, locating photographs that they were confident the applicant hadn't seen. An immigrant inspector in Honolulu, for example, located numerous photos of seven siblings and forwarded them to San Francisco to test whether the applicant Wong Quon Young could identify them. Wong claimed birth in Hawaii as part of this family, but the inspectors suspected that he had never left China before and that he would be unable to identify the children who had not visited China.[71] Wong was able to identify a few, but not all, of the photographs of his family and was denied admission.[72] In a different case, immigration officials in San Francisco were suspicious of an applicant who claimed U.S. citizenship through birth in Hawaii. They requested that a Honolulu-based immigration inspector take photos of the places where the applicant was supposed to have lived. When the applicant could not identify these places, or aspects of Hawaiian life, immigration officials rejected his application and returned him to China.[73]

Inspectors also paid close attention to the context in which images or

individuals were recognized. They commented in their reports on whether supposed family members recognized one another too quickly or too slowly, too confidently or too hesitantly. In one case, a witness recognized a photograph of his friend's son "at once" although he had not seen the boy for eleven years. The inspector immediately dismissed his testimony.[74] At the same time, the boy's father was faulted for mistaking him for another son. In this case, the child was denied admission and deported. In most cases, however, there was little that the inspectors could do to prove or control the Chinese use of coaching photos to learn the identities of their paper relatives.

Although the indexical correspondence between the photograph and its subject meant that paper family members could recognize their supposed relatives, retouching disrupted this correspondence. In the case of portraits, retouching was most often used to eliminate physical imperfections in the subject's face. As a result, the use of retouched photographs sometimes led to applicants being denied admission. In 1924, Quong Sam Fat attempted to enter the United States, claiming that he was the son of a native-born citizen. When questioned by the Board of Special Inquiry, he identified a photograph of his brother and described a scar on his mouth, visible in the photograph, as a distinguishing mark. When the brother was presented before him, however, he had a large, more noticeable scar on his forehead. This mark had been retouched out of the photograph. Although Quong Sam Fat told the same story as his brother regarding the scar and claimed that he had forgotten about it, this misidentification was one of the reasons he was deported. It is possible that Quong Sam Fat had simply forgotten about his brother's scar, but also possible (as the inspectors assumed) that he had memorized his story from coaching notes and his paper brother's face from a photograph.[75] In another case, a son was denied admission after his father failed to describe a mole that had been retouched out of his photograph.[76]

Immigration inspectors didn't use photographs only to test whether given genealogies were genuine. They also looked at the photographs to check for a family resemblance. As already noted, Chinese exclusion divided real families across continents. The policy maintained limited opportunities for some Chinese (mostly men) to travel to the United States but prohibited others (including almost all women) from joining them. At the same time, Chinese methods of evading exclusion undermined the idea of the unified, biological family. The practice of creating paper sons and wives developed new networks of labor and exchange that parodied traditional families. Where biological fathers were expected to support

their sons in exchange for filial respect and support in their old age, paper fathers sponsored sons in a cash exchange. Where traditional wives were expected to provide companionship and sexual relations for their husbands, paper wives were imported to work as prostitutes offering sexual pleasure to numerous partners.

In their search for a family resemblance, immigration officers attempted to reassert the integrity of the family by claiming that family relationships were represented in the faces of family members. In cases where family members sought entry at the same time, inspectors commonly made judgments about the similarity of the applicants' features. Their determinations were not the only evidence on which inspectors based their decisions, but they were part of the evidence. Inspectors often ended their reports claiming that the applicants' photographs clearly supported their conclusions regarding resemblance and implicitly inviting more senior officials to review the images and make their own comparisons of family members. According to one official, these judgments were important because rejected Chinese could base their appeals "on the fact that there is a close resemblance."[77] When one applicant was rejected because of his dissimilarity to this father, for example, the appeal was upheld on the basis that he looked like his mother instead. In their emphasis on resemblance, inspectors suggested that the hidden truth of family identity (concealed in one's blood) was represented on the surface (in one's features). In addition to their investigations of family relationships, they asserted their ability to *see* these connections in applicants' photographs. At the same time, some rejected applicants based their appeals on the unreliability of the bureau's methods of establishing family resemblance. In a number of cases, this strategy was successful.[78]

This understanding of shared family characteristics was similar to the inspectors' belief in common and clearly visible racial characteristics. Most families who appeared before the Immigration Bureau were exclusively Chinese. However, questions of family resemblance were sometimes compounded with questions of racial identity, as two applicants discovered in 1925. The applicants claimed to be the sons of a man whose father was Chinese and whose mother was white. As in many other cases, the immigration inspector concluded that there was no family resemblance and that "the photographs will bear me out in this opinion." However, the inspector also added that, unlike their father, "neither of the applicants show any indication of having any white blood in their veins." As with family identity, the inspector maintained that racial identity was always visible: "It is inconceivable that there is no indication of

a white strain in their makeup." If race is not visible in someone's fea-
tures, the inspector concluded, it does not exist in their blood. This rul-
ing, which affirmed the truth of visual appearances, was confirmed by
the other inspectors on the special board of inquiry and approved by their
superiors.

The inspectors' assumptions about family resemblance and racial iden-
tity were somewhat akin to physiognomy's claim that the deeply hidden
truths about races, families, and individuals were visible in the shape of
people's skulls. Physiognomic ideas informed the widespread belief that
cultural characteristics associated with particular races were revealed in
racially typical features: the supposed inscrutability of the Chinese, for
example, could be read in their narrow eyes. Although they shared these
stereotypic characterizations, immigration inspectors were not overtly
concerned with them. Their readings of Chinese faces were intended to
match one surface image to another, checking for a resemblance between
family members or individuals and their photographs, rather than re-
vealing deep racial truths. Allan Sekula has contrasted the police work
of Alphonse Bertillon developing an archive of criminal individuals and
the eugenic work of Francis Galton attempting to distill racial essence
through his photographic archives of composite portraits. The work of
immigration inspectors was closer to that of the Bertillon police detec-
tive who archived masses of individuals. However, the officials inspect-
ing European immigrants placed more emphasis on racial typing, in the
manner of Francis Galton, to distinguish between the different European
racial groups in the inspection process.[79]

Although family photographs were not common, the few families that
had not been divided by exclusion also emphasized the visual trans-
parency of their kinship in the family photographs that they presented
to the Immigration Bureau. Of course, it is not possible to tell through
the photographs whether these relationships were real, paper, or a mix-
ture of both. But the family photographs were offered as evidence that
these were genuine families. The images were designed to make this claim
through two main strategies: the representation of resemblance and the
fact of the family's presence together in the photograph.

In most of the images, family resemblance is emphasized by each mem-
ber of the group facing in the same direction. This posing allows the
viewer, initially the immigration inspector, to better compare the features
of different individuals. This strategy is seen clearly in a 1906 photograph
of the Lee family "taken in Oakland just prior to their departure for
China" (figure 19). The photograph was submitted with each family

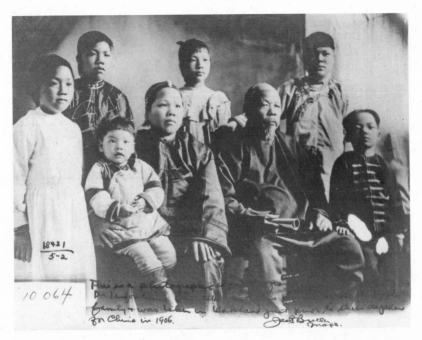

Figure 19. Unknown photographer, "This photograph is a photographic copy of a group photo exhibited by Dr. Lafontaine who states that this picture represents the applicant's family and was taken in Oakland just prior to their departure for China in 1906," 1906. In re: Lee Sin Yuck, File 18431/5–2, Immigration Arrival Case Files, 1884–1944, San Francisco District Office, Records of the Immigration and Naturalization Service (Record Group 85), National Archives and Records Administration, Pacific Region (San Francisco).

member's application to return to the United States as a native-born citizen in 1919.[80] In this somewhat unusual image, most of the family look out of the photograph's frame to the right. Only two boys look directly at the camera, their faces echoing one another. The reasons for this unusual posing are not clear, but it is possible that the image was intended to aid immigration inspectors in accordance with the Bertillon system of identifying individuals by the unique shape of their ears.

More typically, family members look straight ahead, facing the camera and consequently the viewer. When Leong Shee applied to join her merchant husband in the United States, she submitted a group photograph of herself and her children (figure 20).[81] As each of them looks directly out of the photograph, the strong light cast from the left highlights their shared features: the line of the nose and curve of the cheekbone under the eye especially. With its plain background and focus on

faces, this photograph is far starker than earlier family photographs used in immigration cases. Taken in 1927, it represents both the increasing standardization of immigration photographs and the persistence of nonstandard images within the immigration archives. Identity photographs are characterized by the elimination of all detail extraneous to the primary purpose of identification. The plain background in this image suggests an identity photograph. However, the presence of five people together in the same frame echoes a family portrait. The grouping of all family members together not only aids their identification as a family with shared features but makes an implicit argument that they belong together. In fact, since the family filed a single application for a visa with the American Consulate, their cases would have been decided together. In contrast, Leong Shee's servant Lui Ngan Fa had a separate application in which she appeared in her photo—clearly an identity photo—alone.[82]

Like the appearance of a family resemblance, the presentation of togetherness was used to support the claim that all the members represented in a photograph were part of one family. Because most Chinese families were separated by exclusion, the very fact of a family being in one place at the same time was favorable to their claims. This was particularly true when individuals were applying for admission as native-born citizens and their photographs were taken in the United States. Robert Lym, a Chinese interpreter and official photographer at Angel Island, submitted two family photographs in support of his brother's claim to American nativity. The first undated studio portrait presented his immediate family in front of a backdrop of Chinese pagodas, with the father and mother in traditional Chinese dress and the sons in Western suits. Through its staging and posing, this image recalls the Lee family photograph and represents the Lym family as primarily Chinese. The second photograph from 1914 was taken by Robert Lym himself and has the appearance of a family snapshot except that each person has a number inked onto his or her chest (figure 21). These numbers correspond to an index of each family member on the reverse. In this image, taken outside in front of a Western house, almost all the subjects wear Western dress. In its location, its style, and the fact that it was taken by one of the family members, it presents a strong statement about the Americanness of Lym's Chinese American family. And Lym, aligning himself with the U.S. immigration authorities for whom he worked, noted that he submitted this photograph not only to prove the American birth of his brother but also "to obviate any claim by outsiders to

AMERICAN CONSULATE GENERAL

Canton, China. December 20, 1927.

Precis in re LEONG SHEE (accompanied by her minor children)
Non-immigrant Section 6 Student, Visa No. 40-

Certificate issued by the Non-immigrant Declaration Form 257,
executed at American Consulate General,
at Canton on December 20, 1927

Visa by the undersigned granted on December 20, 1927.

Bearer's birthplace: Loh Tin Village, Nam Hoi District, Kwangtung.
Date of birth: February 26, 1891.
Nationality Chinese

Family (ages by Chinese reckoning): Husband, Fong Yun (52). Minor children,
Fong Ming Keun (m)(14), Fong Ming Ho (m),(13), Fong Ming Haw (m),
(10), and Fong Chuey Lau (f) (6), all accompanying her.

Review of bearer's education: Merchant status.
Her husband is a lawfully domiciled Chinese treaty merchant,
in business at the F. See On Company, 510 North Los Angeles St.,
Los Angeles, California.

Plans for education in the United States. None.

Provision for financial support: Her husband, Fong Yun, will support her.

Reference in the United States: Fong Yun. F. See On Co., 510 N. Los
Angeles St., Los Angeles, California.

Consular investigation and remarks: Applicant presented affidavit showing
that merchant status of husband had been
conceded. Affidavit had attached photo-
graph of herself and children. Husband
also accompanied her. The couple was mar-
ried 19 years ago, village ceremony. Leong
Ming Hing, father of applicant, and who i[s]
a flour merchant in Fatshan, was present
at the marriage, and knows each child is
the issue of this marriage. The second
witness was Tse King, aged 37, of Tai Lek
Village. He is now a farmer but was form-
erly in the bamboo business until last
year. He is a nephew of Fong Yun and was
present at the marriage and knows that
each child was the issue of the marriage.

A true copy of
the signed orig-
inal.
/C.
Date of departure: January 3, 1927.
By Steamship: SS President McKinley,
Port of arrival: San Francisco, Calif.

J. C. HUSTON
American Consul in Charge

Consul General

Figure 20. American Consulate General (Canton) Certificate, Leong
Shee and minor children, 1927. In re: Fong Yun (also spelled Kwong
Yung), December 20, 1927, File 23852/2–15, Immigration Arrival Case
Files, 1884–1944, Records of the Immigration and Naturalization Ser-
vice (Record Group 85), National Archives and Records Administration,
Pacific Region (San Francisco).

membership in our family."[83] The photograph was intended both to illustrate who was included in his family and to delineate the boundaries of exclusion. Ironically, the presence of this photograph in the Return Certificate Case Files means that Robert Lym's brother, who was claiming U.S. nativity to facilitate his reentry into America after visiting China, probably never returned to his country of birth.

The dual aims of representing both individual identity and family togetherness were sometimes in tension with one another in these family identification portraits. This is particularly clear in figure 20, the photograph of Leong Shee and her children, where each person in the image stares directly ahead, allowing the viewer to compare their features but creating the effect of separateness. They appear alongside one another in the photograph, but they do not appear together as family. Togetherness is suggested by the way that family members look at, touch, or hold one another. In the Lee family portrait (figure 19), the mother's arm enfolds the child and her fingers press into his clothes as she balances him on her knee, yet both parties look ahead and away from one another. In most family portraits, a mother's arm around her child hints at a protective closeness; in this image the act seems in tension with the way that she is presenting her child for review by the immigration authorities. In the Lym family photograph (figure 21), the woman looking at her child is the only person not looking at the camera. The angle of her gaze subtly removes her from the photograph's purpose of identification and makes her alone seem to belong in a more traditional family portrait. In almost all the images of families, criss-crossed arms and hands disrupt the simple linear planes of the identity photograph and offer intimate details that have been erased from the photograph of Leong Shee and her children.

In more traditional Chinese family portraits, the representation of togetherness is emphasized over identification or family resemblance, although here too these purposes are still interwoven. In their differences and similarities, two studio portraits of respectable Chinese families offer interesting points of comparison with the group identification portraits used in immigration case files. Both Jessie Gee Fou and Lori Sing presented photographs of themselves and their families to the Angel Island immigration commissioner Hart Hyatt North (figures 22 and 23).[84] As gifts to an official, these images still circulated within the archives of the Immigration Bureau. However, they occupied a different position from images in the case files. Like the group identification portraits, they were

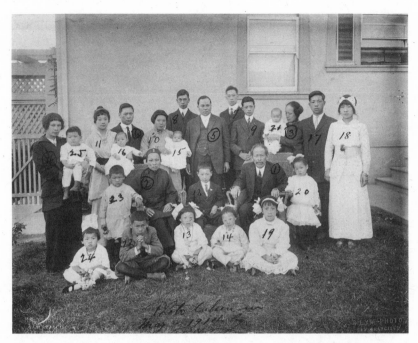

Figure 21. Robert Lym, "The Lym Family," 1914. File 12017/5542, Return
Certificate Case Files, 1912–1944, Records of the Immigration and Naturaliza-
tion Service (Record Group 85), National Archives and Records Administra-
tion, Pacific Region (San Francisco).

both artifacts of self-presentation and agents of identification. But al-
though they shared their presentation of familial respectability, the more
traditional portraits were remembrances and aids to personal recogni-
tion rather than official identification.

There is a subtle symmetry at work in the photographs from Hart Hyatt
North's collection, which present a similarly self-contained image of fam-
ily. In figure 22, a Chinese man and woman stand on either side of a child
in a family group that draws exclusively on Western portraiture con-
ventions. Both parents place their arms around the child, but the mother's
arm encloses the child while the father is slightly removed, his hand placed
out of sight behind both the child and mother. The mother wears a Chris-
tian wedding ring, and the subjects stand not before a pavilion but in
front of a library backdrop, dressed in Western clothes, presenting them-
selves as an American family. However, their acculturation may be more
strongly suggested by the apparently casual way in which they are posed.

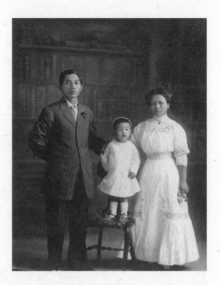

Figure 22. Buchman Photo Studio,
Tucson, Arizona Territory, "Jessie
Gee Fou and Family," no date.
BANC PIC 1979.032—AX, Photo-
graphs of the Hart Hyatt North
Papers, Bancroft Library, University
of California, Berkeley.

The child between them echoes the poses of both father and mother, with
his left hand behind his back (like the father on his left) and his right
hand held just in front (like the mother on his right). In the whiteness of
his dress, the way his arm fits neatly into the shape of the mother's waist,
and his physical placement, the child is presented as closer to his mother.

In contrast, figure 23 presents children as the embodiment of their fa-
ther. Lori Sing holds his two youngest sons close to him while his oldest
son stands alongside him, separate but echoing him in his dress, posing,
facial expression, and features. More than other traditional family por-
traits, this image emphasizes family resemblance and brings to mind the
photograph of Leong Shee with her children (figure 20). However, here
the plain linear formality of the father and his first son is punctuated by
the informality of the elaborately dressed younger boys, with their sleeves
too long or too short and their feet either hidden or standing a little un-
steadily on the worn carpet.

More obviously posed and carefully constructed, the families in the
photographs presented to Hart Hyatt North are only apparently closer
to one another. Their togetherness is created for the camera, just like the
images of togetherness in all family portraits. Whether paper or real or
a mixture of both, Chinese families used photographs to construct im-
ages of themselves. All photographs in the immigration archives were con-
structed in this way, regardless of their apparent authenticity. Since most
claims for legal residence were traced through family lineage, Chinese
immigrants used photographs not only to represent their families but also

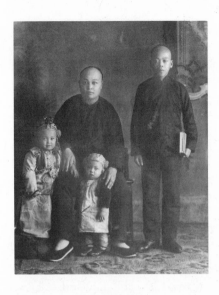

Figure 23. Shanghai Bazaar, San Francisco, "Lori Sing and Sons," no date. 1980.098:78—PIC, Photographs of the Hart Hyatt North Papers, Bancroft Library, University of California, Berkeley.

to create paper families and authenticate fabricated relationships. These practices cast doubt on both the integrity of the family and the reliability of photography.

INTERIOR ENFORCEMENT: INVESTIGATING IMMIGRANTS IN CHINATOWN

Throughout the country, immigration inspectors left their stations and ventured into Chinatowns to investigate people's immigration status and documents. In doing so, they both supported border enforcement and initiated interior enforcement. Sometimes the inspectors continued investigations that started at immigration stations, using photographs to identify individuals and to find out about their work and family status. At other times, in general censuses and raids on the Chinese population, they started new investigations as part of interior enforcement. They used photographs in the same ways these were used at immigration stations: as tools to aid the investigation and as subjects of the investigation. Inspectors checked identification documents, sometimes using the photographs on these documents to determine whether the papers belonged to the people holding them and at other times questioning the reliability of these photographs. As they did in their station-based investigations, the inspectors both used photographs and questioned the status of photography.

In supporting existing cases, immigration inspectors visited the ad-

dresses given by merchants to confirm that these places were active commercial establishments and that the merchant was a member in the firm as he claimed. They also visited other workplaces, using photographs to locate people and learn more about their family and citizenship status. Whites who worked in Chinatown as merchants, watchmen, or policemen were asked to identify individuals from photographs and to provide as much information as they could about the person represented.[85] In the course of questioning, inspectors would also check the credentials of Chinese residents with whom they came into contact. Conducting a typical investigation, Inspector Charles Franklin toured San Francisco with an interpreter, a stenographer, and a photograph of Lee Jock Min in an attempt to determine whether Lee was a native-born citizen and the father of a man applying for admission at Angel Island. Franklin's party worked their way from hotel to hotel, interviewing Lee's former employers and fellow employees, showing them his photo, asking about his work, and checking whether he had ever talked about his son. In most cases they were able to secure sworn statements from the people they interviewed that revealed Lee as a good worker who spoke a little about his boy. These statements were incorporated into the record of his son's application.[86] Inspector John Robinson conducted similar investigations early in his career, locating and deporting Chinese women who worked as prostitutes. Robinson's photographs of Chinese immigrants, taken from police mug shots, immigration identity documents, and studio portraits, list aliases and identifying information on the reverse. One even notes that the subject "hangs out at the Matsuoka Hotel."[87]

Officials were also involved in "systematic census-taking among the Chinese" and raids on Chinatowns throughout the country.[88] Raids were part of an interior enforcement policy that affected almost all Chinese regardless of their status, a policy that was contested, with varying success, throughout the exclusion period. Raids and inspections of Chinese premises were conducted in large cities and small towns from Boston to Madera, California. However, they started only after the exclusion acts began requiring certificates for Chinese laborers and after those certificates required photographs. The first large-scale raid occurred in Denver in 1897, when armed marshals, police, and detectives surrounded the Chinese quarter and removed almost every Chinese person on the suspicion that some did not have certificates.[89] Other raids were conducted in Portland throughout 1898, in New York throughout 1902, in Boston in 1902 and 1903, and in various U.S.-Mexican border towns until at least 1905.[90] There was also a census of Chinese living in Boston in 1905. In one court case,

Chin Hen Lock admitted that "just prior to the taking of the Chinese census in Boston, in 1905, he a got a certain Chinaman there to 'fix it' [his discharge certificate], and had his photograph attached."[91]

Although such raids required approval from the commissioner general, approval did not require much evidence. Representing the general suspicion of Chinese communities, Erika Lee cites a case in which an inspector at New Orleans received permission to conduct a raid on the assumption that it was "not unreasonable to suppose that some Chinamen may have affected an unlawful entrance . . . and are now hiding here."[92] In most reported cases of raids, residents were rounded up with little chance to prove their identities and immigration status. The law did not require that Chinese carry their certificates on them at all times, and the rules allowed them reasonable time to produce their documentation. Regardless, it was standard practice that everyone who could not immediately produce their identity papers was arrested. At times, even when they did produce their papers, these were dismissed as "fraudulent or suspicious or on the grounds that the photographs on them were indistinct or faded."[93] Raids were commonly reported in the local press, often portraying the Chinese sympathetically because of the poor treatment they received at the hands of immigration officials.[94] According to Immigration Bureau rules, Chinese arrested on suspicion of being in the country illegally were photographed "immediately."[95] In the more notorious raids, they were handcuffed and marched out of Chinatown, treated roughly, and held in crowded rooms overnight without food or water. In the end, most of those arrested produced their certificates, and few were actually charged with any crime.

In addition to raids, officials routinely inspected the immigration status of any Chinese person picked up for any offense. These policies continued through at least the 1920s. In 1924, a Los Angeles inspector arrested a Chinese woman on an immorality charge. Finding her "so-called birth certificate with faded photograph" suspicious, he contacted the San Francisco office of the Immigration Bureau. This office compared her arrest photograph with the photographs in their files and located her record even though she was using an alias.[96] Renowned Chinatown photographer Arnold Genthe assumed that his Chinese subjects' resistance to being photographed was the result of superstitious tradition. However, it is more likely that they were concerned Genthe was an immigration inspector and that his photographs might be used against them in an immigration investigation.[97]

Immigration raids, censuses, and investigations enacted the criminal-

ization of the Chinese and realized the fears of documentation opponents. In opposing the development of an internal passport system, the Chinese had argued that it unfairly discriminated against Chinese and cast them in the same light as criminals. The model for the photographic archive of Chinese immigrants was the rogues' gallery, and Chinese immigrants were sometimes photographed according to the Bertillon system of documenting criminals. Only in the British penal colonies, documentation opponents noted, were ticket-of-leave men required to carry documentation of their status as criminals. Chinese were treated as criminals for not having documentation, a crime that was supposed to reveal the deeper crime of being in the United States illegally. Despite the popular American association of the Chinese with criminal activities such as gambling, prostitution, and opium use, these raids usually revealed little evidence of illegal Chinese entry into the country.

It is impossible to establish the exact number or frequency of raids and "censuses."[98] However, it is clear that they were experienced as a constant possibility. One Chinese man stated that immigration inspectors "would come to the restaurants at any time and arrest you."[99] A retired inspector himself acknowledged that "if you were Chinese, you could be arrested, just off the streets, and you were made to prove your right to be here."[100] In these raids, the regulation of immigrants was extended beyond the U.S. borders into everyday life. Other immigrants faced photographic documentation and inspection at border stations, but at this time only the Chinese faced it in their homes and communities. The patchwork internal passport system developed by the Geary Act was essential to interior enforcement.

Raids relied on the fact that Chinese looked different from Europeans, amassing all Chinese under the suspicion of illegality. At the same time, raids were not possible without a system of certification and photographic documentation that differentiated between individuals and connected individual holders to their certificates. All Chinese were suspect, but they were not always equally suspect. Different groups of Chinese faced different official requirements and informal practices to prove their right of U.S. residence in different contexts and at different times. Nevertheless, immigration raids and document inspections operated on the assumption that all Chinese were outsiders, equally involved in breaking the law. As the Texas inspector-in-charge claimed, justifying widespread house inspections, "All Chinese persons in El Paso are engaged directly or indirectly in the smuggling of coolies . . . even those claiming to belong to the exempt classes."[101]

Raids swept all Chinese together regardless of class, and during "sys-

tematic censuses" inspectors demanded documents of all Chinese, including those who were exempt from such requirements: merchants, students, travelers, and diplomats. These investigations realized the concerns of elite Chinese that class distinctions between different residents would not be respected. A Chinese consular official, for example, was stopped by an immigration inspector in Winslow, Arizona in 1903. Although he produced his official card, the inspector persisted "in his demand for the laborer's certificate, which he said was the only evidence he would accept."[102] He may have simply been intent on harassing the official. However, the inspector's insistence on the laborer's certificate could suggest that he believed that all Chinese were laborers. He may also have been demanding a photograph, since laborers' certificates contained photos but diplomatic papers did not.

In their correspondence with the State Department, Chinese consular officials complained about the lack of respect paid to "respectable" Chinese, and white supporters of Chinese immigration often echoed this complaint.[103] A Chinese diplomat wrote in the *Spokane Press* that Cantonese coolies were "the most despised people in the empire. We do not care whether you exclude them or let them in." However, he continued, "we do object to the inhuman treatment to which our merchants, professional men and travelers are subjected."[104]

Immigration inspectors generally saw little difference between Chinese laborers and "respectable" members of the exempt classes, treating them all with the same lack of respect. In their anti-Chinese racism, they not only saw all Chinese as essentially similar but also believed them all to be in secret collaboration with one another. Somewhat perversely, the exclusion laws facilitated this behavior by inspectors in the field because it so clearly distinguished between laborers and others. The laws did not require certificates or photographs from nonlaboring Chinese in the early 1900s because they recognized these requirements as degrading. As a result, the law created opportunities for inspectors to harass exempt Chinese without certificates in the same way that they harassed undocumented Chinese laborers. The Bureau of Immigration officials claimed that exempt Chinese would not face harassment if they did not possess a certificate because the certificate proved only right of admission, not their right to remain in the United States.[105] Even when nonlaboring Chinese chose to get documentation of their exempt status, these documents were not considered prima facie evidence because their status depended on the actual work they conducted. If merchants, for example, were involved in any kind of manual labor, they forfeited their

exemption. In arguing that exempt Chinese would not be harassed if
they did not have a certificate, the bureau was in fact suggesting that
possessing a certificate did not prevent harassment.

Although immigration inspectors were typically suspicious of all Chi-
nese, Immigration Bureau policy makers professed to respect class dif-
ferences. In 1905, in the face of well-publicized opposition to Chinese
raids and an incipient Chinese boycott of American goods, President Roo-
sevelt called for more careful enforcement of the exclusion laws.[106] The
Immigration Bureau issued a circular instructing officers that "Chinese
persons whose appearance or situation clearly indicates that they do not
belong to the class of laborers must be treated with the same considera-
tion extended to members of any other nationality, and they are not un-
der any circumstances to be subjected to unnecessary surveillance."[107]
Although laborers were no better protected from harassment under the
new rules, nonlaborers were to receive better treatment on the basis of
their appearance.

This policy, issued in and known as Circular 81, instructed inspectors
to stop looking at and treating all Chinese people the same. It required
them to recognize the class distinctions within the Chinese community.
According to the policy, these class distinctions were visible in people's
appearance and situation. However, Circular 81's policy of deferential
enforcement for elite Chinese was never enacted. The circular warned
inspectors that anyone violating the Immigration Bureau's policy of re-
spectful enforcement would be barred from the service. Instead of insti-
tuting a period of courteous control, immigration inspectors saw Circu-
lar 81 as a ban on any interior enforcement in the period after 1905.[108]
Their response suggests that exclusion laws were rarely administered with
respect during raids, that officials could not distinguish between differ-
ent classes of Chinese, and that inspectors believed it simply was not pos-
sible to enforce exclusion laws carefully and fairly in the field.

The Immigration Bureau was also concerned with making its own dis-
tinctions among Chinese. When the commissioner general of immigration
recommended the rescinding of Circular 81 and a return to the policy of
interior enforcement in 1909, he explicitly stated that this would focus
on "the most flagrant cases—of the greenest, most recently imported Chi-
namen." [109] In doing so, he recognized that longtime residents, even if il-
legal, had strong support within and beyond the Chinese community.[110]
Contrary to popular arguments that Chinese could not assimilate in Amer-
ica, he also recognized the acculturation of longer-term residents.

However, the motivation for this recognition was not the rights of long-

term residents but the fact that, if arrested, such residents could make strong claims in the courts that they were native-born U.S. citizens. If Chinese residents spoke English well and were familiar with American current events, they could falsify a birth certificate or produce witnesses who claimed that they had been born in the United States. If the judge was persuaded by the evidence, he would issue a "certificate of discharge" that acted as proof of their U.S. citizenship. Like other certificates, these discharge certificates typically contained photographs and were circulated among Chinese who either replaced the photographs or hoped that they looked similar to the original holder.[111]

Immigration officials believed, probably with some cause, that Chinese who seemed like convincing U.S. citizens deliberately attempted to get themselves arrested to prove their apparent citizenship status in court. This practice was a source of some concern to the Immigration Bureau. "The purpose of the policy against making these arrests," the acting commissioner general explained in 1912, "is to avoid turning Chinamen into 'American citizens' when the Bureau is satisfied they are not really entitled to that status."[112] In conflict with the courts, bureau officials determined that they were better able to decide on the immigration status of Chinese. This policy meant that these Chinese would remain in an indeterminate illegal status, without a certificate of discharge or other proof that they were native-born U.S. citizens, rather than getting the possible opportunity to become legalized.[113]

Some Chinese fought the official harassment of raids and censuses with preemptive measures, attempting to make their position more secure by obtaining control over the documents and photographs required to prove their lawful presence in the United States. Through their lawyers and business partners, they made claims upon the Bureau of Immigration and questioned the bureau's policies. In one case, a merchant requested that his certificate of identity be returned to him, since it was being held by the Immigration Bureau at his port of entry in Malone, New York.[114] In another, a merchant accounted for his lack of identification by testifying that his certificate had been taken from him in a raid on a restaurant and never returned.[115] After photographs were required on registration certificates, a Massachusetts-based Chinese laborer who was issued a certificate without a photograph asked for his to be reissued with a photograph. When the Immigration Bureau ruled that he did not need a photograph, his lawyers wrote back that he wanted to obtain one regardless

to save him "much expense and trouble in proving his identity."[116] Countering the earlier arguments for photographic documentation made by bureau officials, the commissioner general responded that an accurate personal description was sufficient to identify and protect the certificate holder. Although these claims were often rejected, they reveal the Chinese refusal to accept the Immigration Bureau's terms of their entry into and residence in the United States.

As legal historians Charles McClain and Lucy Salyer have documented, Chinese residents also fought the exclusion laws in the courts. Salyer has argued that judges, although sometimes sympathetic to the cause of exclusion, were bound by established legal principles to overturn many of the Immigration Bureau's rulings on Chinese applicants.[117] The Immigration Bureau responded to this situation by working to remove its rulings from judicial oversight. After Chinese rights to judicial appeal were limited, it became easier for the bureau to exclude and deport Chinese immigrants.

Although few cases concerning photographs were brought before the courts, the judges in these cases refused to accept immigration officials' readings of photographs or even to accept the images themselves as reliable evidence. In 1897, a Chinese laundryman in Buffalo was arrested on suspicion that the photograph on his certificate did not represent him. The man had several scars that were not represented in the photograph. However, in the case that followed, a photographer testified that the scars were not visible because the image was so indistinct. This explanation, which emphasized the unreliability of photography, was accepted by the court.[118]

In the case of Wong Ock Hong, the Immigration Bureau claimed that Wong was not the person named in his certificate. They provided evidence that a different Chinese man had used a certificate with the same number and argued that Wong did not look like the person represented in his photograph. However, a second witness with Immigration Bureau experience offered the opinion that Wong was the person shown on his certificate, suggesting that images weren't always as easy to read as some immigration officers suggested. The district court judge ruled in favor of Wong, arguing that Wong's testimony and his possession of the certificate made the better case. In doing so, he set aside the contradictory evidence about the photograph, choosing to rely on the nonvisual evidence instead.[119] This case is particularly interesting, as it occurs in 1910, once the photograph had become more accepted as a form of evidence and photographic quality had improved.

These men were not the only ones to attempt to secure control over

their documents and photographs. By 1911, Immigration Bureau policy required that identity certificates be cancelled by the bureau upon the holder's death so that they could not be fraudulently circulated. However, family members asked to keep the official photographs as mementos of their loved ones. In Hastings, Minnesota, the white widow of a Chinese laundryman requested that her husband's identity photograph be removed and returned to her "as it was the only one she had of her husband, and she and the children are very desirous of keeping it."[120] A Chinese son in Boston made the same request and had his father's photograph returned to him.[121] In regaining possession of the photograph and the image of their father, family members reclaimed its meaning. They changed the purpose of the photograph from the identification of an unknown Chinese laborer to the intimate recognition of a familiar face. However, the photograph always contained both possibilities. Its meaning always depended on its context and its viewer.

Ellis Island as an Observation Station

Spectacle and Inspection, 1892–1924

This "entrance to the United States" was only an imaginary
line across the waters, marked by the eyes of immigration
inspectors stationed in the bastions of the old forts, but there
had to be a line somewhere, and that was where it had been
established.

> Henry Curran (Ellis Island commissioner, 1923–26),
> *From Pillar to Post*

Between 1875 and 1891, new laws established the practice of differen-
tial treatment for different immigrant groups under U.S. immigration pol-
icy. Whereas Chinese immigrants were observed, photographed, and doc-
umented, European immigrants were simply observed. If they passed the
inspection process at Ellis Island or another immigration station, Euro-
pean immigrants entered the United States almost unmarked. Although
each Chinese immigrant was regulated through individual case files con-
taining photographs and detailed descriptions, the barest data were
recorded about European immigrants. European bodies were closely ob-
served at Ellis Island, but for many years they remained officially un-
marked in America.

The differential treatment of Chinese and European immigrants both
reflected and recreated the Immigration Bureau's understanding of these
groups' racial status. Chinese exclusion policies revealed popular and gov-
ernmental concerns about the danger of almost all Chinese immigration
and the unscrupulous inscrutability of the few Chinese who were per-
mitted to enter the United States. Therefore, exclusion policies prevented
the entry of almost all Chinese, and photographic documentation poli-
cies introduced to enforce exclusion were implemented strictly.

In contrast, Europeans were not subject to numerical limitations on their immigration to the United States until the 1920s. During this period, general immigration policies operated on a principle of selective restriction. European immigrants were prohibited entry only if they were disqualified by particular restrictions. These restrictions were expanded throughout the late nineteenth and early twentieth centuries, and many of them remain part of immigration law today. They included bars on criminals and prostitutes (starting in 1875); lunatics, idiots, and immigrants who could not support themselves without becoming a public charge (1882); and contract laborers (1885). In 1891, these categories were substantially expanded with a new law prohibiting the entry of immigrants who were suffering from loathsome or contagious diseases, had been convicted of crimes or misdemeanors involving moral turpitude, were deemed liable to become a public charge (a more restrictive standard than that introduced in 1882), had received help in paying for their passage, or were polygamists or paupers. Although these prohibitions represented a significant shift from the period before 1875, when there had been no federal restrictions on immigration, they never resulted in substantial numbers of immigrants being rejected at Ellis Island or other ports of entry. Between 1891 and 1928, the percentage of rejected immigrants was never higher than 3 percent of all arrivals.[1] In the peak immigration years between 1900 and 1914, approximately 1 percent of immigrants arriving at Ellis Island were debarred each year.[2]

The Immigration Act of 1891 was significant not only because it broadly expanded general immigration restrictions but also because it created a federal bureaucracy to enforce these restrictions. Prior to 1891, federal immigration restrictions were enforced by state officials in uneven and sometimes ineffective ways. However, the Immigration Act brought general immigration law into line with Chinese exclusion policies that had, from the beginning, been implemented by federal officials. The law established the Bureau and Superintendent of Immigration, required that every arriving immigrant be inspected, and specified the means of inspection. It also provided for the building of Ellis Island and other immigration stations to implement the law. The immigration inspection, particularly the medical inspection, which formed the core of immigration policy after Ellis Island opened in January 1892, was a primarily visual procedure.

However, even as visual inspection was being established as the central means of restricting European immigrants, nativists were criticizing it as inadequate and calling for more far-reaching restrictions. In 1917,

they succeeded in passing a literacy test as part of broad restrictions affecting European, Mexican, and Asian immigrants. The literacy test required all immigrants over the age of sixteen who were physically capable of reading to be able to read a short text in their native language. However, it had limited impact on European immigration, as increasing literacy rates ensured that most immigrants passed the test.[3]

The introduction of quotas in 1921 and 1924 marked a shift from selective restriction and medical observation to numerical racial restrictions. These restrictions reduced the overall number of European immigrants and limited each nationality to an annual quota based largely on their perceived racial desirability. Northwestern Europeans received quotas that were far higher than the number of immigrants from these countries, whereas southern and eastern European immigration was sharply restricted. With the implementation of European quotas and the subsequent reduction in immigration, U.S. medical inspections were often conducted on board arriving ships. These changes ended Ellis Island's purpose as a medical inspection station.

Although the 1924 National Origins Act delineated a shift away from visual medical inspection, the law introduced photographic identity documentation for European immigrants by requiring that all visas include photographs that proved the holder's right of entry. As European immigrants were incorporated into the United States' racialized system of immigration restrictions, they also entered into the system of photographic documentation and regulation that underpinned these restrictions. In contrast to Chinese exclusion documentation, these photographs were shown only upon the immigrant's entry and were not retained by the Immigration Bureau. In 1928, immigration officials realized the limits of requiring photographs only upon arrival and started to issue immigrant identity cards to all new immigrants, with copies retained by both the immigrant and the Immigration Bureau.

Although they were not required to obtain or carry documentation until the 1920s, Europeans were closely observed on Ellis Island. The immigration station was designed as a forum for viewing immigrants, and the viewing process took two primary forms: spectacle and inspection. At Ellis Island, members of the public enjoyed the spectacle of picturesque Old World peasants, while medical immigration officials inspected immigrant bodies for signs of disease, poor physique, and immorality. Immigration Bureau officials also conducted nonvisual inspections, interviewing immigrants to ensure that they met legal requirements for entry such as literacy and lack of a prior criminal record. However, the prac-

tices of spectacle and inspection were primary, both reflecting and rein-
forcing the racialized understanding of European immigrants.

European immigrants were seen through Ellis Island in various ways.
As they made their way through the immigration process, they were
viewed by tourists visiting the station. They were examined by physicians
in visually based medical inspections. They were photographed by nu-
merous amateur, commercial, and documentary photographers. And they
were viewed through the prism of popular attitudes about immigrants,
attitudes that the Ellis Island administration played a role in shaping. El-
lis Island was never simply a site for inspecting and recording the immi-
grants who passed through its doors or were returned to Europe. It was
also a place for staging changing ideas about immigration. The photo-
graphs taken and the records kept at the station were commonly used
by senior immigration officials to create an image of ever larger numbers
of dangerous, diseased, impoverished, and racially suspect immigrants
arriving from eastern and southern Europe.

The laws passed to regulate European immigration rarely directly ad-
dressed concerns about visuality, as did Chinese exclusion laws and rules
regarding photographic documentation. However, they framed the ways
that the Immigration Bureau observed European immigrants by estab-
lishing Ellis Island as an immigration station where immigrants were
viewed and represented by tourists, medical inspectors, and photogra-
phers alike. From 1892 to 1924, practices of tourism, medical inspec-
tion, and photography provided the lens through which European im-
migrants were viewed at and beyond Ellis Island. The immigration
station was also an observation station.

IMMIGRATION TOURISM AND THE SPECTACLE
OF ELLIS ISLAND

The 1891 Immigration Act not only represented a turning point in the
federal control of immigration but also marked a shift in the observa-
tion and representation of immigrants. In addition to the establishment
of a federal Bureau of Immigration, the law required the superintendent
of immigration to produce an annual report on the bureau's work. The
new law also narrowed the channel through which a newly identified
"flood of immigrants" flowed. Before 1891, immigrants had entered the
United States through various state-run ports. After the new law was in-
troduced, immigrants had to enter through a few federal stations, of
which Ellis Island was by far the largest. In 1893, 119 of the Immigra-

tion Bureau's 180 employees were stationed at Ellis Island.[4] Throughout the time that the immigration station was open, approximately 70 percent of all immigrants entered through Ellis Island.[5]

The island's contained space, particularly the Great Hall at the center of the immigration station, created visible crowds out of the arriving immigrants. Descriptions and photographs of crowds of immigrants at Ellis Island were common. Images of steerage provided the first contained frame through which to view masses of immigrants. These photographs, which showed crowds of immigrants crammed into the photograph as they either boarded or disembarked their ship, often contained captions that presented immigrants as a threat. One halftone in *Harper's Weekly* identified "Cheap Foreign Labor as it crowds Vessels bound for the United States."[6] Edwin Levick's image of steerage (figure 24) appeared in the tabloid New York *World* in 1912, cropped to eliminate any space, such as the sea or the ship, that wasn't filled with immigrants. "On Guard," ran the caption, "Here they come!"[7] Photographs of the Great Hall packed with immigrants who had been detained for further inspection provided the viewer with a similar sense of rapidly expanding immigration (figure 25).

Throughout its history, Ellis Island was used as a marker of scale against which to measure immigration. The station was frequently described as being too small to handle the excessively large number of arriving immigrants. Annual immigration reports often made implicit associations between the immediate problems of administering immigrants on the island and the subsequent difficulties of assimilating so many new immigrants into America. Immigration officials argued that the island (and, by extension, America) could not cope. These reports concluded both that the immigration station would have to be expanded and that immigration would have to be cut back.

The first Ellis Island building, which opened on January 2, 1892, soon faced difficulties with congestion. According to the 1896 annual report, this congestion was caused both by increasing numbers of immigrants and by higher rates of detention due to the "more rigid" inspection of immigrants.[8] However, after a fire destroyed the first wooden building in 1897, a monumental new brick structure was commissioned, and construction was completed in 1900. The new station was substantially larger and was frequently augmented with new buildings. Throughout almost its entire occupation of Ellis Island until the introduction of immigration quotas in the 1920s, the Immigration Bureau and its supporters continually described the station as inadequately small. The Immigration Bu-

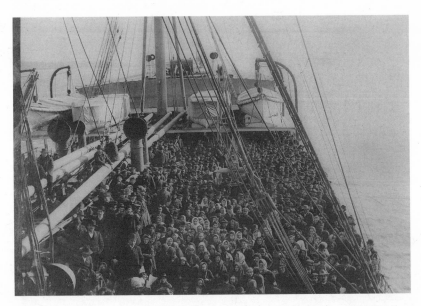

Figure 24. Edwin Levick, "Immigrants on an Atlantic Liner," 1912. LC-USZ62–11202, Library of Congress, Washington, D.C., Prints and Photographs Division.

reau called for additional buildings in 1902, only two years after the new building was completed, and the Marine Hospital Service requested additional space before the new hospital was even finished.[9] "All authorities agree," Frederick Haskin claimed in 1913, "Ellis Island is often overcrowded and needs enlargement."[10]

Like the Angel Island immigration station, which opened in San Francisco in 1910, the New York station was both part of and set apart from the city. However, unlike the wooden structures hidden in a cove on Angel Island, the impressive Ellis Island station was clearly visible from New York. Angel Island, sometimes called the Ellis Island of the West, also served a very different purpose: its primary role was the detention and exclusion of immigrants.[11] Initially, Chinese seeking entry to the United States were detained on Angel Island for as long as two months while their cases were reviewed. After they complained and conditions improved, most Chinese applicants were detained on the island for an average of two to three weeks.[12] In contrast, Ellis Island was designed primarily for the inspection of immigrants. Over the years of its operation, most immigrants were admitted immediately after they passed inspection. A small number were detained on the island for a few days while undergoing further inspection, waiting to recover from a minor illness

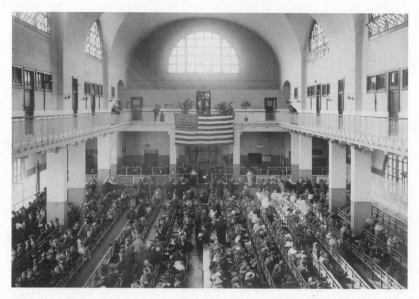

Figure 25. Unknown photographer, "Inspection Floor as Rearranged with Benches," ca. 1907–12. MFY 95–39, William Williams Photograph Collection, Miriam and Ira D. Wallach Division of Art, Prints and Photographs, New York Public Library.

or for relatives to meet them. Some stayed longer, but usually only because they were being treated for more serious illnesses.[13]

More than any other immigration station, Ellis Island created a space for the observation of immigrants. At the station, aliens were separated from and subordinated under the visual inspection of their superiors in various ways. As the *New York Times* noted in its description of the first immigration station, the main hall was bordered by a gallery that allowed for "an inspection of the immigrants by the immigration authorities or others interested . . . without the necessity of actual contact with them."[14] An official noted that "visitors to Ellis Island and other immigration stations often expressed apprehension regarding the results of a mutiny or riot" as well as the danger of contagious diseases.[15] The gallery allowed visitors to enjoy the spectacle of mass immigration without encountering any immigrants.

The second station also had a gallery overlooking the registry hall (figure 25). Although Ellis Island was designed for the official observation and examination of immigrants, the gallery served limited official purposes. Various guides make no mention of inspectors using the gallery as part of the inspection process. In addition, there are very few references

to officials being present in the gallery. One exception was Victor Safford, an Immigration Service surgeon, who wrote that he happened to witness a fight between the immigrants from this vantage point.[16] Immigration inspectors worked mostly on the main floor, looking at immigrants more closely. In fact, the balcony seems to have been designed primarily to facilitate the popular practice of visitors viewing the immigrants. It was built, not to allow the inspection of individual immigrants, but to enable visitors to observe the inspection of masses of immigrants. In the second immigration station, the visitors' entrance led up to the gallery, where explanatory statements about the inspection process were posted.[17] Visitors clearly understood that this observation area was "the visitor's gallery."[18]

As magazines and guidebooks noted, Ellis Island was "one of the 'sights' of New York."[19] People interested in visiting Ellis Island had to obtain permission from the immigration commissioner or get a pass from one of the organizations associated with the island.[20] The New York Bible Society, for example, distributed passes and informational leaflets to ministers and other interested parties.[21] Photographer Lewis Hine brought students from his class at the Ethical Culture School. College professors brought groups of students.[22] And physicians visited the island to view the medical inspection process and gain "familiarity with certain diseases, which may be seen at Ellis Island in larger numbers, perhaps, than anywhere else."[23] It was a sufficiently popular excursion that by 1912 the commissioner often limited the number of people on Saturdays.[24]

Visitors were able to visit most of the areas frequented by immigrants in the main station, including the dining rooms, dormitories, railroad rooms, and meeting places. At most of these points there were statements of information for visitors, and the visitor's guide advised that "interesting scenes may often be witnessed as a result of the meeting of people who have been separated for some time."[25] The theater of Ellis Island was also cited in an immigrant aid organization's description of the inspection hall, "where many human scenes are daily enacted."[26] Although visitors were not allowed access to all areas (they were, for example, limited to the entrance of the dormitories), the Immigration Bureau expressed no concerns about visitors invading the immigrants' privacy. Bureau officials were concerned only about visitors disrupting their work.[27] In contrast to Ellis Island, the few visitors to Angel Island usually came to testify in support of applicants for admission and were not allowed to mingle freely with the detainees. Angel Island visitors were issued passes only for Tuesdays and Fridays, workdays when they were less likely to visit for the entertainment of viewing the immigrants.[28]

Philip Cowen, an inspector with strong immigrant sympathies, suggested that visitors used Ellis Island like a zoo, coming "to see the animals."[29] Another immigration official likened the experience to the fascination of watching a "circus procession plus the hustle and bustle lacking in the more deliberate circus parade."[30] However, a more accurate comparison may be the various world's fairs hosted in the United States, particularly the Columbian Exposition of 1893 and the St. Louis World's Fair of 1904, where American fairgoers enjoyed living ethnographic displays of primitive people, particularly from Asia and Africa but also from selected countries in Europe.[31]

At Ellis Island, visitors engaged in a form of slumming, the practice of middle-class whites touring urban working-class districts inhabited by African Americans, Chinese, and European immigrants. More real than the visual and textual exposés of slums written by Jacob Riis and others, Ellis Island offered visitors a taste of the immigrant slums without any of its potential dangers.[32] Like the world's fairs, visitors were safely removed from the objects of their observation.

Primed by stories about the explosion of immigration, people came to Ellis Island expecting to be awed by enormous numbers of immigrants. In 1903, Commissioner Williams apologized to the commissioner general about the small number of immigrants who arrived on a day when a group had come to witness the inspection of immigrants. In response to an apparent complaint by the group's leader, he wrote, "I am sorry there were not more" immigrants but stated that "I extended to him every courtesy within my power."[33] Three years later, author H. G. Wells described his trip to the island. He was not disappointed. "I visited Ellis Island yesterday," he wrote. "It chanced to be a good day for my purpose. For the first time in its history this filter of immigrant humanity has this week proved inadequate to the demand upon it. It was choked."[34] Although immigration authorities and many Americans expressed concerns about the large number of immigrants arriving in the United States, it was clear that when people visited Ellis Island they expected the spectacle of mass immigration. Ellis Island was designed to offer them that scene, so long as enough immigrants arrived.

MEDICAL INSPECTION: THE OFFICIAL VISION
OF ELLIS ISLAND

Although visitors saw the island as an observation station, immigration authorities more commonly described it as an industrial plant. Only a

year after the station opened, the commissioner referred to it as "the large
plant at Ellis Island."[35] Officials spoke in terms that suggested mass pro-
duction, emphasizing the peak periods during which as many as five thou-
sand people a day were processed through the depot. They also imple-
mented scientific management methods, hoping to improve the inspectors'
speed, efficiency, and accuracy during the inspection process. Not only
did Ellis Island administer the new federal restrictions designed to en-
sure that immigrants functioned productively in modern industrial Amer-
ica, but the immigration station itself also functioned industrially. It
processed immigrants in line inspections that echoed the industrial pro-
duction line, passing workers of acceptable quality and rejecting those
that did not meet newly imposed standards.

Historian of science Amy Fairchild has argued that the immigrant med-
ical inspection was designed not as much to exclude immigrants who
could not function in America's industries as "to communicate indus-
trial values and norms in a public setting."[36] Although historians have
commented on Ellis Island's status as an exemplar of scientific manage-
ment and progressive efficiency and expertise, few have connected these
concerns with the central role of observation and new visual technolo-
gies in progressive culture.[37]

The inspection process changed over time as new laws were introduced,
new inspection methods were developed, and new commissioners imple-
mented various reforms on the island. However, the central elements of
the process remained the same from the opening of the first immigration
station in 1892 to the passage of restrictive immigration quotas in the
1920s.[38] Ellis Island then became used primarily as a detention and depor-
tation center until it was closed in 1954.[39] The 1891 Immigration Act not
only established the federal supervision of immigration under the newly
created Bureau of Immigration. It also required that medical examina-
tions of immigrants be conducted by the U.S. Marine Hospital Service,
renamed the U.S. Public Health Service in 1912 (and hereafter referred to
as the PHS). PHS physicians worked alongside Immigration Bureau em-
ployees, with physicians reporting the results of the medical inspection to
the Immigration Bureau officers who determined which immigrants would
be allowed entry and which would not.

In the typical inspection procedure at Ellis Island, New York state offi-
cials first boarded the arriving ships to check whether they needed to be
quarantined.[40] Once the ship was declared safe from epidemic diseases,
PHS physicians would arrive to inspect U.S. citizens and aliens in the first-
and second-class cabins. During the early period of federal inspection

until 1900, the bureau generally assumed that immigrants could not afford such travel and treated cabin passengers as visitors or tourists.[41] In the bureau's annual reports, as in the inspection process, steerage immigrants and alien passengers were listed separately, and little information was recorded about cabin passengers. Although they avoided the long delays and indignities of the island, many of these passengers complained about being questioned at all. The on-board inspection was primarily designed to preserve class divisions and protect citizens and wealthy newcomers from "the embarrassments" of contact with ordinary immigrants. However, it was also essential to the effective operation of Ellis Island: if the inspectors were not always clearly seen to be above those whom they inspected, the authority of the inspection might have been undermined. After 1901, as the cost of traveling in these classes decreased, annual immigration reports expressed increasing concerns about the difficulties of on-board examinations and the problem of objectionable individuals traveling in second class to avoid detection in the more rigorous island examination.[42]

Immigrants traveling in third class or steerage were transferred by barge to Ellis Island, where Immigration Bureau officers attached tags to them with numbers corresponding to the ship's manifest, a record of the arriving immigrants made by the shipping company. "Everybody was tagged," Irish immigrant Manny Steen remembered about landing at Ellis Island in 1925. "They didn't ask you whether you spoke English or not, everybody was tagged. They took your papers and they tagged you. That was the first thing."[43] These tags, visible in most photographs of immigrants on Ellis Island, linked the individual immigrant to an archive of information compiled about every immigrant processed at Ellis Island. These data were then used to provide statistics for the Immigration Bureau's annual reports and often to argue for further restrictions in immigration policy.[44]

After being tagged, immigrants joined "the Line." Originally a single line of immigrants, a second line was added in 1903, then a third, and finally a fourth in 1914.[45] The number of PHS surgeons also quadrupled during this period, from six physicians in 1892 to twenty-five by 1914.[46] During the prewar period, the line inspection was designed to handle about four thousand immigrants per day.[47]

From beginning to end, the line inspection was a visual inspection. It was described in many contemporary accounts in strongly visual terms, emphasizing the sharpness of the inspectors' eyes and the way that the strength of their gaze gave them mastery over the immigrants. In the

1910s, when the medical inspection faced increasing criticism for failing to detect certain diseases and to exclude sufficient numbers of immigrants, these criticisms focused around the superficiality of visual inspection. As the Ellis Island assistant surgeon Alfred Reed noted, "The routine inspection on the line is that part which the visitor sees, and is the most important feature of the medical sieve spread to sift out the mentally and physically defective."[48] Visitors to Ellis Island could see the inspection process so clearly because the line inspection itself was a process of viewing.

The inspector watched the immigrants from a distance as they walked upstairs to the registry hall, checking their energy and overall appearance. The inspector then observed more closely as the immigrants approached and made a forty-five-degree turn immediately in front of him, allowing him to see not only their faces but also their profiles and backs. As Reed described the procedure, the medical officer

> sees each person directly from the front as he approaches, and his glance travels rapidly from feet to head. In this rapid glance he notes the gait, attitude, presence of flat feet, lameness, stiffness at ankle, knee, or hip, malformations of the body, observes the neck for goiter, muscular development, scars, enlarged glands, texture of skin, and finally as the immigrant comes up face to face, the examiner notes abnormalities of the features, eruptions, scars, paralysis, expression, etc. As the immigrant turns, in following the line, the examiner has a side view, noting the ears, scalp, side of neck, examining the hands for deformity and paralysis, and if anything about the individual seems suspicious, he is asked several questions. . . . As the immigrant passes on, the examiner has a rear view which may reveal spinal deformity or lameness.[49]

Although Reed's summary captures the fact that the officer had to inspect the immigrant's entire body in a "rapid glance," his description of an individual officer inspecting an individual immigrant masks the fact that one medical officer inspected many immigrants, often making his entire survey of an approaching immigrant in the space of twelve feet.[50]

In the "Book of Instructions for the Medical Inspection of Immigrants," many of the guidelines concern lighting and the inspector's ability to see the immigrants clearly as they pass before him. Reading almost like a photographic manual, the instructions state that the examination "should be made by daylight and never, except in an emergency, attempted in poorly lighted rooms or by artificial light." Further, "there should be abundant light coming from behind the examiner." However, immigrants should not have direct sunlight in their eyes and should not be allowed to pass from shadow into light (or vice versa), as this may

cause them to squint or look down, lessening the inspector's ability to read their faces.[51]

The inspectors were searching for signs of loathsome or contagious diseases or deformities, as well as any evidence that the immigrant might be unable to work and "liable to become a public charge." The "public charge" category was used extensively and increasingly by medical inspectors, and it covered a wide range of conditions, including poor physique, "lameness, deformity, defective eyesight," and other ailments.[52] As historian Anne-Emmanuelle Birn notes, however, the diseases that were pursued through the line inspection were those disorders of the skin (favus) and eyes (trachoma) that could be seen on fully clothed individuals. Other more dangerous diseases, such as pneumonia and tuberculosis, were diagnosed less often at Ellis Island because they were more easily hidden from the inspector's eye.[53]

The final stage of the line exam was the test for trachoma, a contagious eye disease that caused blindness and therefore affected immigrants' ability to earn a living. In this exam, which all immigrants underwent after 1905, the body was penetrated rather than observed. After the immigrants had passed by the first inspector, a second physician everted the immigrant's eyelid with his fingers or a buttonhook to check for signs of infection. "By a quick movement and the force of his own compelling gaze," wrote one journalist, the inspector "catches the eyes of his subjects and holds them. You will see the immigrant stop short, lift his head up with a quick jerk and open his eyes very wide. The inspector reaches with a swift movement, catches the eyelash with his thumb and finger, turns it back, and peers under it."[54]

Written and oral histories suggest that most immigrants considered the trachoma test the worst part of the inspection process. The anxiety about the exam, and associated loss of control, is shown in two children's comments about the fear of losing their eyes. Dora Rich, who came to the United States from Austria in 1909 when she was thirteen, remembers that "when we came to Ellis Island, they begin pulling on my eye, you know, the doctors that was examining it I thought they'd take my eye out." A younger girl of five, Elda Willits, arrived from Italy in 1916. A knowledgeable gentleman with an eye patch who had traveled between Italy and America several times befriended her family during the voyage. Before they arrived, Elda remembers, "he took me on a walk one day and he said 'You know what? When you get over to Ellis Island they're going to be examining your eyes with a hook,' and he says 'Don't let them do it because you know what? They did it to me and one eye fell

in my pocket.'"[55] Willits screamed so hard when her turn came that the PHS physicians allowed her to pass without the trachoma test. Although Willits later acknowledged that the man had been playing a joke on her, the girls' fears may not have been entirely unfounded. In 1913, a Dutch immigrant Franciscus van Loon wrote a plaintive letter to the surgeon general of the PHS requesting treatment or compensation for the damage he claimed had been done to his eyes during the examination, damage that prevented him from pursuing his trade as an art painter.[56]

The mechanized violence of turning the eyelid inside out recognized some of the inadequacies of the superficial visual inspection: the inspectors' attempts to read the interior through the exterior were not fully sufficient. The primacy of vision was not questioned, but it had to be assisted by the primitive technology of the buttonhook. In the trachoma test, the interior had to be physically exposed; it was not enough to look into the immigrant's eye to determine health, the inspector had to look inside the eye. Inspectors were particularly concerned about trachoma, since it was not only contagious but difficult to diagnose and typically hidden.[57] Although it lasted only a few seconds, the eye exam was the most direct physical expression of the inspector's power over the immigrant. In this final medical test, immigrants were observed through the invasion of their eyes, their own means of observation.

Although the medical inspection was a primarily visual inspection conducted by the PHS, at the conclusion of the medical test immigrants were also questioned by Immigration Bureau officers about whether they met other legal criteria for entry to the United States. These officers attempted to determine whether each immigrant was a contract laborer, was liable to become a public charge, or had received help in paying for passage to the United States. Checking answers against information listed in the ship's manifest, inspectors were also charged with preventing the entry of criminals, prostitutes, polygamists, paupers, unaccompanied children under age sixteen, and, after 1917, immigrants over the age of sixteen who could not read a short text in their native language.[58] "At Ellis Island," in the words of a Hungarian laborer, "they put my life in a book and asked me a lot of funny questions. Did I believe in law? Was I in favor of government?"[59] In contrast to the medical inspection, this legal inspection was based on oral rather than visual inspection.

If PHS inspectors suspected from their brief observations that an immigrant had a disease or deformity, they marked his or her clothes with chalk letters that identified the probable defect. As one of the many *Popular Science Monthly* articles about Ellis Island noted: "The gait and gen-

eral appearance suggest health or disease to the practised eye, and aliens who do not appear normal are turned aside, with those who are palpably defective, and more thoroughly examined later."[60] Public health officials believed that many internal illnesses marked themselves on the outward appearance of the body: "Deep lines about the mouth seemed to go with a hernia, . . . a certain pallor called for examination of the heart, and the glint of the eyes suggested tuberculosis."[61] Another officer stated that "almost no grave organic disease can have a hold on an individual without stamping some evidence of its presence upon the appearance of the patient."[62] Marked immigrants, who averaged about 20 percent of the total number of immigrants between 1892 and 1905, were detained on the island for closer inspection, questioning, or treatment.[63]

When immigrants were removed for more detailed medical tests, they were isolated in small groups in rooms surrounding the great hall, out of sight of visitors.[64] It was only at this stage that medical officers used modern diagnostic techniques. In examination rooms surrounding the great hall, physicians used microscopes, stethoscopes, and thermometers to check for visible and other signs of various diseases. They administered psychological exams to determine whether immigrants were mentally fit to enter the United States. After 1910, PHS officials used x-rays to look beyond the external manifestations of disease into the immigrant's body. And as immigration decreased during the First World War, they were able to engage in more intensive physical examinations.[65] However, out of the one-fifth of immigrants who were marked, no more than 3 percent were eventually deported during the time that the immigration station functioned as a medical inspection site.[66]

Although third-class and steerage immigrants could not avoid the line inspection, if they had health problems they would try to avoid the inspector's gaze. Medical inspectors were always alert for any deceptions. As they saw it, the "nonchalant individual with an overcoat over his arm is probably concealing an artificial arm . . . a case of favus may be so skillfully prepared for inspection that close scrutiny is required to detect the evidences of recent cleansing," and so on.[67] Immigrants themselves told of people marked by the inspectors who either rubbed the chalk marks off their coats or turned them inside out to avoid detention. It isn't clear whether these events were common, occasional, or apocryphal, but the idea of escaping the inspector's gaze and subverting his control, even for a second, was clearly appealing to the people processed through Ellis Island.[68] Photographs of the inspection process at Ellis Island also show that it was not only tourists and inspectors who viewed the arriving im-

migrants. Although their view was not as clear as that of the visitors standing in the balcony or the inspectors positioned at the top of the stairs, immigrants themselves craned their necks to check for other arriving immigrants, presumably friends and family members. The processes of viewing were hierarchical, but immigrants were also involved in looking.[69]

When immigrants were marked for further inspection, they resisted by protesting and questioning the inspectors. However, the physicians usually refused to answer their questions. Emphasizing the imperatives of scientific management, one contemporary author described this refusal as "most conducive to a successful and speedy working of the system."[70] He compared the inspection process to a "complicated machinery [that] to work well, really must work fairly 'silently.'"[71] Ellis Island assistant surgeon Alfred Reed praised the fact that "in all the manifold and endless details that make up the immigration plant, there is system, silent, watchful, swift, efficient."[72] Both authors equated the inspection with the industrial production process and silence with the streamlined motion of machinery. However, Reed also equated silence with watchfulness, stressing the primacy placed on visuality in the Ellis Island inspection process.

Even as immigration officials touted the speed and efficiency of the inspection process and the extent to which they were in control, their concerns about immigrant deceptions revealed some of their uncertainties and reflected outside concerns that the inspection process was cursory.[73] As historian Elizabeth Yew has noted, the PHS faced increasing criticisms about the adequacy of the visual medical inspection, both because relatively few immigrants were rejected and because of the medical profession's success in establishing itself as a prestigious, modern field. The line inspector watching thousands of immigrants walk past him, Yew notes, "did not satisfy the public's image of the physician."[74] Criticisms of the inspection focused on its speed and superficial nature. These criticisms were elaborated in visual descriptions of the medical inspector's quick glance that could not penetrate beneath external appearances.[75]

PHS officials generally accepted the assessment that the inspection relied upon a quick glance. However, they maintained that it was still effective and claimed that they "suspected at a glance a handicap which might later require a week to prove."[76] Another physician acknowledged the criticism of the inspection as too quick and too superficially visual, turning it into a photographic metaphor. "In these days of laboratory experimentation and the use of refined methods of diagnosis," he wrote in 1911, "the value of simple inspection of the patient has gradually been

lost sight of, and the art of snapshot diagnosis has been left almost en-
tirely in the hands of the charlatan."[77] Although European immigrants
were not officially photographed by the Immigration Bureau, they under-
went a process of diagnosis in which each immigrant was viewed in a
quick inspection that shared many features with the snapshot photograph.

Although they defended the effectiveness of the line examination, PHS
officials introduced more intensive examinations after 1915 when im-
migration through Ellis Island was reduced by war and, later, immigra-
tion restrictions. In 1921, Commissioner of Immigration Frederick Wal-
lis claimed that the medical examinations were superficial "farces," much
to the annoyance of the PHS. However, in a report following the pas-
sage of the 1924 National Origins Act, W. C. Billings, the chief medical
officer at Ellis Island, suggested that every PHS official appreciated the
weakness of the routine inspection. "Imagine fifteen medical officers, well
trained though they were, endeavoring to isolate from an avalanche of
five thousand persons a day," Billings wrote, "all of the persons suffer-
ing from one or another of the physical or mental conditions specified
in the Immigration Law, and this by the simple process of having these
aliens file past them all day long at a distance of about one rod apart!"[78]
Despite the weakness of the inspection process, he concluded that it was
the best possible system given the small size of the island, the limited PHS
staff, and the large number of immigrants.

In the medical inspection process, PHS physicians were looking not
only for evidence of disease but also for evidence of racial identity. In
language that echoes descriptions of the inspectors' ability to detect dis-
ease quickly, a public health official wrote that "experience enables the
inspecting officer to tell at a glance the race of an alien."[79] Inspectors be-
lieved that their ability to read and understand the immigrant's racial
identity was critical to successful inspections. The "Regulations for the
Medical Inspection of Aliens" further specified that "knowledge of racial
characteristics in physique, costume, and behavior are important to this
inspection procedure."[80] According to public health and immigration
officials, Ellis Island was the best school in the world for learning racial
identification. The 1905 *Annual Report of the Surgeon General* noted
that "the medical officers possess a familiarity with the different racial
types and demeanor which could be acquired nowhere else in the world
so thoroughly as at Ellis Island and they have a full sense of the great
responsibility which devolves upon them in this important part of their
work."[81]

Inspectors believed that their specialized understanding of racial iden-

tity helped them to inspect immigrants in two primary ways. First, it enabled them to understand when a case of apparently abnormal behavior should be overlooked because it represented normal behavior by a given racial group. This culturally relativist racialism was particularly common in searching for signs of mental illness.[82] Second, inspectors believed racial knowledge helped them to identify problems that were commonly associated with or considered inherent in a given racial group. Contagious diseases such as trachoma, for example, were believed to be common in certain populations, including Syrians, Greeks, and Finns. Other more general problems such as poor physique were associated with Jews.[83] Immigrants who were members of suspect racial groups faced particular suspicion and special scrutiny during the inspection, increasing their chances of being detained or deported. This racial profiling operated in opposition to inspectors' culturally relativist racialism. Like the understanding of some groups as having different standards of normal behavior, it categorized certain groups of people within racial categories that were considered significantly different from Americans. However, the resulting categorization made them more likely to be debarred. Although this way of reading race focused on immigrant bodies rather than minds, it considered the racial identity of suspect immigrant groups not only through racial heredity or genetics but also through their culture. In late nineteenth- and early twentieth-century understandings of race, mental, physical, and cultural characteristics were all associated with race and inextricably linked.[84]

🐝 🐝 🐝

Most European immigrants successfully represented themselves to inspectors as acceptably healthy and able to support themselves. Immigrant advocates, such as the Hebrew Immigrant Aid Society, had originally opposed medical inspections but came to accept them as they realized that they could negotiate effectively within the law to ensure that most immigrants were allowed entry. Since few immigrants were turned back under medical inspection, immigrants negotiated the system of visual inspection and, as detailed in the following chapter, the photographers who occasionally wanted their likenesses. For European immigrants, unlike the Chinese in America, there was little was at stake in being inspected or photographed. Therefore, they were generally able to work within visually based immigration policies, and they made few efforts to subvert the system.

Restrictionists, however, were strongly critical of medical inspection,

arguing that the reliance on visual diagnostics resulted in a process that was both superficial and inadequate. This charge was especially common among eugenic restrictionists who believed that southern and eastern Europeans were disproportionately subject to disease and problems such as poor physique. Since medical inspections did not lead to more than a few percent of immigrants being debarred each year, such restrictionists believed that the inspections must have overlooked many immigrants with physical problems and contagious diseases. In place of selective medical restrictions, nativists argued for literacy tests and then comprehensive numerical controls on immigration in the form of national quotas. Literacy tests were introduced in 1917 after more than a decade of efforts by restrictionists. Quotas, introduced in 1921 and expanded in 1924, substantially reduced immigration and rebalanced the type of immigration from less racially desirable southern and eastern Europeans to nativists' preferred northwestern Europeans. However, these laws were not significant merely for their shift from selective to broadly restrictive immigration policies. They also marked the end of visual medical inspection as the primary mechanism of general immigration enforcement and the end of large-scale visual inspection at Ellis Island.[85]

Ellis Island as a Photo Studio

The Honorific Ethnographic Image, 1904–26

Anne Haverick Cross sailed on the *Caledonia* from Scotland to the United States in 1902. As she debarked at Ellis Island, she recalled, "It was such a big fuss because some reporters came in and they fingerprinted us and we had to take blood tests . . . and if we were not in good health we were not admitted. . . . There were a lot of reporters. And we said, 'Why are these reporters here?' And they said, 'Well, these people just came from Scotland. There's a lot of us from a newspaper.' . . . And they took pictures of us, you know."[1] Although Cross conflated immigration inspectors, photographers, and reporters, photographic documentation was never part of the official inspection process for European immigrants. In contrast to Chinese experiences, such documentation was limited to recording the identities of deportees, immigrants who had violated immigration or other laws. However, many immigrants who were photographed at Ellis Island, particularly those without Cross's advantage of knowing English, may have thought that the visual medical inspection extended from the physical to the photographic. As Cross's arrival suggests, immigrants at Ellis Island were not only viewed by visitors and inspected by officials; they were also photographed extensively.

Professional photographers provided images of immigrant types and immigration scenes for various publishers, including Brown Brothers, Keystone View Company, and Underwood and Underwood. After the first commercial use of halftones in 1880, which enabled images to be printed inexpensively alongside text, such images were increasingly pub-

lished in newspapers and magazines, as well as on stereograph cards.[2] Right around the time that Anne Haverick Cross arrived at Ellis Island, the immigration station was featured in a marketing brochure, *Quarantine Sketches*, published by the Maltine Company. Tourists used Kodak cameras, first distributed in 1888, to record their observations of immigrants in casual snapshots. Commercial photographers were employed by the Immigration Bureau or the Public Health Service (PHS) to provide photographs for official purposes. Immigration officials themselves, such as the first commissioner of Ellis Island, Colonel Weber, and a longtime employee Augustus Sherman, also took numerous photographs of immigrants in a semiofficial capacity. Ellis Island functioned not only as an observation station but also as a photo studio.[3]

Unlike the photographs of Chinese immigrants that were required by and used to enforce exclusion, images of European immigrants were somewhat separate from official visual policies concerning the inspection of immigrants. However, they were not as independent from these policies as historians of photography have suggested.[4] In popular publications and government reports, including the Immigration Bureau's annual reports, photographs were used to illustrate immigrants' racial identities and to argue for increased immigration restriction. Often without the approval of the photographers, these photographs circulated through various types of publications: a Lewis Hine photograph was used to illustrate a magazine article in favor of eugenics, Augustus Sherman's images were provided by Commissioner William Williams to the *New York Times* to promote Williams's work at Ellis Island, and the PHS solicited Underwood and Underwood for photographs of the service's medical inspection.[5] Like the medical inspection and the popular spectacle of immigration, these images both were shaped by and helped shape ideas about immigrants and immigration policy.

THE HONORIFIC ETHNOGRAPHIC IMAGE

Images of immigrants represent more than the individuals who stood before the camera: they reflect the ways that the photographers behind the camera viewed immigrants. In contrast to Chinese immigrants, who worked hard to maintain control of their photographic identity documentation, European immigrants had limited control over the ways that they were photographed at Ellis Island and the ways that their images were subsequently circulated. European immigrants may have accepted

this limited control because there was less at stake for them in being pho-
tographed: their portraits did not help determine whether they would be
admitted to the United States. Nonetheless, as with the medical inspec-
tion process, immigrants at Ellis Island exercised some agency as they
were photographed.

Photographer Julian Dimock noted that he used different interpreters
to ask different groups of immigrants to pose for him: some were more
effective at soliciting pretty girls, others at talking to aristocratic-look-
ing men or rank-and-file immigrants. His concern about how best to re-
quest a photograph suggests that some immigrants refused him. Others,
notably an Iowa farmer returning from Europe with his bride, simply
humored him. As Dimock attempted to pose his subject using sign lan-
guage, the Iowan pretended not to understand English. Only when Di-
mock had exhausted his signing abilities did the man ask, in English,
whether he was posed correctly. Dimock describes this incident as an
amusing mistake but fails to acknowledge the farmer's deliberate, though
good-humored, disruption of his photographic session.[6]

Immigrants may also have accepted their limited control over the pho-
tographic process because of the way in which they were represented.
Most photographs of European immigrants were at least moderately and
often strongly positive. In contrast to illustrations and cartoons, which
presented picturesque genre scenes and immigrants with accentuated
racial features, photographs of immigrants at Ellis Island were generally
respectful portraits.[7] These portraits often invoked bourgeois family or
artistic portraiture in their posing. However, almost all immigrant por-
traits also engaged in some form of racial typing, whether through their
attention to ethnographic cultural details, their focus on racial aspects
of physical features, or their captioning as racial types.

Created by many different photographers with different ideological
and institutional objectives, images of immigrants at Ellis Island drew
on diverse visual idioms. Sharing aspects of both the spectacle and in-
spection of immigrants, these idioms included pictorialism and straight
photography, expressive and documentary styles. Straight documentary
photographs were published in reform magazines but quoted artistic el-
ements from Renaissance portraiture. Photographic illustrations of dif-
ferent racial groups sometimes rejected the hard-edged style associated
with scientific images in favor of soft focus that created the effect of a
fine portrait. Photographers often used varied approaches within a sin-
gle frame, even as they developed their own distinct style.

The most common approach was an "honorific ethnographic" perspective that reflected the liminal position of the new immigrant through both scientific detachment and elements of studio portraiture. Histories of photography commonly place photographic styles along a continuum, with artistic, "honorific" photography at one end and "repressive" objective, disciplinary, scientific images at the other. However, just as Chinese immigrants challenged these distinctions in their honorific identity photographs, European immigrants were represented in countless photographs that blurred the boundaries between honorific and repressive representations.

Balanced on the unstable axis between honorific and repressive photography, the "honorific ethnographic" was a flexible and varied style that incorporated aspects of bourgeois studio portraiture, anthropometrics, cultural ethnography, and artistic pictorialism. While the use of the honorific ethnographic to represent immigrants, particularly European immigrants, may be seen as the photographer's decision, it also reflects the mixed status of photography and the liminal position of European immigrants. European immigrants were most commonly represented through this "honorific ethnographic" approach.

This style, as we will see in images by Augustus Sherman, Lewis Hine, and other photographers, simultaneously recognized European immigrants and distanced them. It focused on difference but, by representing racial difference through cultural elements apparently exterior to the subject's essential identity, allowed for incorporation. The honorific ethnographic was particularly appropriate to the liminal position of European immigrants, especially the southern and eastern European immigrants who formed the majority of immigrants during Sherman's tenure at Ellis Island. These European immigrants were considered more acceptable than Chinese and other Asian immigrants but more suspect than earlier immigrant groups from northern and western Europe. They were considered white, but their whiteness was compromised by the fact that they came from Mediterranean and Alpine races rather than northwestern Teutonic or Nordic stock.[8] They were assumed to be assimilable but were criticized for maintaining their traditional folkways in America or for returning to their home countries without making commitments and contributions to America. Like all immigrants, they had a liminal legal status as well: at Ellis Island, they were no longer Europeans and not yet Americans. Their legal status as either Europeans or potential Americans depended on the decisions of medical inspectors and immigration officials.

AUGUSTUS SHERMAN: IMMIGRATION OFFICIAL, UNOFFICIAL PHOTOGRAPHER

The photographer who worked most consistently at Ellis Island and most closely within the Immigration Bureau was Augustus Sherman. His images illustrate the complex, interlocking idioms of photographic representation that operated at Ellis Island. They offer insights into the ways that Ellis Island officials viewed immigrants: through multiple and often contradictory honorific and ethnographic visual discourses.

Sherman started working in the Registry Division, which dealt with immigrant documentation, when Ellis Island opened in 1892. When he died in 1925, he was chief clerk of Ellis Island, in charge of the Immigration Bureau's extensive correspondence.[9] Sherman's employment at Ellis Island covered the entire period of substantial immigration activity at the station, ending shortly after the passage of the National Origins Act in 1924, which sharply reduced the amount of immigration. The Augustus Sherman Collection at the Ellis Island Library numbers about 150 photographs, mostly individual and group portraits of immigrants. Only about ten photographs are not portraits: these contain scenes of Ellis Island, including the immigration station, an immigrant concert, and group portraits of missionaries, employees, and visitors to the island. From the markings on Sherman's prints, it appears that he was photographing immigrants from about 1904 to 1924, although many photographs are not marked and may have been taken earlier.[10]

Although he was employed at Ellis Island, Sherman never counted photography among his official duties. Nonetheless, various commissioners of immigration at Ellis Island appear to have been interested in photography and supportive of his work. Commissioner William Williams, who served two terms from 1902 to 1905 and 1909 to 1913, hired commercial photographers such as Edwin Levick to document and publicize improvements in the physical plant at Ellis Island. Since Williams was concerned with improving the external appearance of the island, as well as the station's operations, he found photographs particularly useful for his promotional purposes. Williams provided Sherman's photographs to various publications, where they were used to illustrate articles about the commissioner, Ellis Island, and immigration in general. He also kept many of Sherman's photographs in his private papers and pasted the images and the articles they illustrated into his scrapbooks.[11] Robert Watchorn, commissioner of Ellis Island from 1905 to 1909, seems to have been equally interested in photography. Like Williams, he wrote articles that

were illustrated with halftones, and he used Sherman's photographs in official reports. Watchorn also compiled his own collection of immigrant photos taken on Ellis Island by Julian Dimock.[12]

Like other photographers at Ellis Island, Augustus Sherman took photographs of immigrants during the inspection process and while they were being held in detention. Since Sherman's duties did not involve monitoring immigrants, it seems likely that he took time from his regular tasks to observe arriving immigrants or that he asked other officials to inform him of the presence of interesting groups and individuals.[13] At this point, Sherman used his authority as an immigration official to remove immigrants from the inspection process to a room or an outside area where he took their portrait. Most of Sherman's photographs were taken in an interior room with a simple background, which appears to have functioned as his impromptu studio. Probably available to him only because he was an immigration official, the location may have been selected simply to remove his subjects from the distracting crowds that Hine later describes. However, its quiet separation appears to have given Sherman the opportunity to take more time and more control over the photographic process.

Almost all Sherman's photographs are portraits. Although they are held together as a collection by their shared look, they also illustrate the range of styles that fall under portraiture. The images include individual, group, and family portraits as well as portraits of "freaks" and seminaked muscular men.[14] The photographs can be broadly grouped into three types: upper-body portraits of seated immigrants, often women; full-length portraits, predominantly of men; and family and ethnic group portraits, almost the only photographs in which men and women appear together. Most of the subjects are presented in frontal poses, with a minimum of distracting background. Roughly half of the prints are marked with handwritten notes across the image describing the racial identity of the subject. However, almost all of the photographs allude to this identity. Immigrants are typically shown wearing distinctively traditional national costumes. These clothes, along with the physiognomies which they frame, are emphasized by Sherman as markers of racial identity.

Sherman viewed the immigrants in a similar way to the PHS physicians working the line inspection: he made a snapshot judgment based on external appearance. However, while the physicians removed immigrants from the line inspection because they deviated from a healthy norm, Sherman removed them because they appeared different. This difference is especially emphasized in Sherman's photographs, since he not

only documented immigrants who looked different from the image of Americans but also selected immigrants who looked distinctively different from the other immigrants arriving at Ellis Island.

From the evidence of his images, it appears that Sherman's eye was attracted by racial types that did not generally pass through the immigration station. For example, although Italians were the largest group of immigrants, making up more than one-fifth of total immigration during Sherman's photographic career, he appears to have taken only five photographs of Italians. However, he took fifteen photos of Dutch immigrants, who immigrated in much smaller numbers, forming only about 1 percent of immigration between 1899 and 1924.[15] Sherman also took sixteen photographs of Russians, who were associated with the new eastern European immigration, but these images include a range of races and types: Russian Germans, Russian Jews, Cossack soldiers, radicals and freaks. Sherman paid particular attention to the small number of Asian, African, and Caribbean immigrants at Ellis Island, taking seventeen photographs of non-European immigrants.

As Sherman took his photographs, he temporarily removed the immigrant's body from the inspection process. However, although most immigrants returned to this process, their image remained in Sherman's possession at Ellis Island and entered a different circulation system of mass-produced images. As he wrote across one of his photographs, which was presumably loaned out: "Return this group of Wallachians (Austria) to A. F. Sherman—Ellis Island, N.Y."[16] Sherman's images were reproduced as halftones and reworked into illustrations for a wide range of books and periodicals, including the *New York Times, National Geographic, Popular Science Monthly,* and *City Life and Municipal Facts.* They were also used occasionally in the annual reports of the commissioner general of immigration, and displayed around the visitor's balcony at Ellis Island. Letters written to Commissioner Williams suggest that he gave Sherman's portraits as mementos to guests who visited Ellis Island.[17] Sherman's images did not just reflect the Immigration Bureau's understanding of immigrants. They were used by immigration officials, popular magazines, and other publications to shape understandings and influence opinions about immigrants. A collage including many of Sherman's portraits illustrating "Types in the New Immigration," for example, sat opposite the title page of Peter Roberts's *The New Immigration,* a 1912 volume that enumerated the perils of southeastern European immigration (figure 26).[18]

Despite the broad use of Sherman's photographs, publications did not

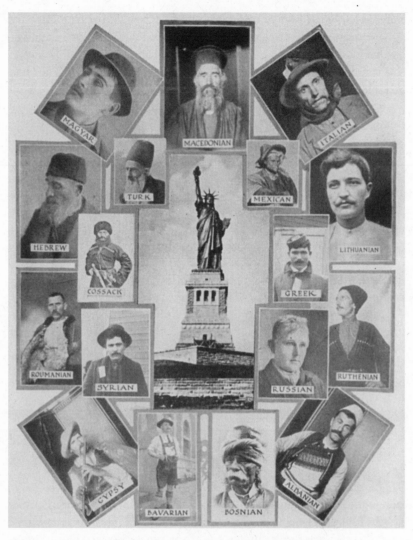

Figure 26. "Types in the New Immigration," collage including Augustus
Sherman's and other, unidentified photographic portraits. In Peter Roberts,
The New Immigration (New York: Macmillan, 1912), opp. title page.

attribute them to him but instead presented them as an official photographic record of immigrants and ethnic types.[19] Little is known about
Sherman's life outside his work for the Immigration Bureau, and the only
photographs in his collection were taken at Ellis Island. The *New York
Times,* in his obituary, described Sherman as a "veteran official of the Immigration Bureau on Ellis Island" and listed "Commissioner Henry H.

Curran, with Deputy Commissioners Uhl and Landis, and a majority of the 500 employees of the bureau" as present at his funeral. Sherman was a bachelor, and his obituary, unlike the adjacent ones, does not mention any family or aspect of his life outside the island.[20] Sherman was defined exclusively in relation to the Immigration Bureau, just as his photographs were viewed as the official vision of the Immigration Bureau. At the moment that Sherman took a photograph, his personal interest, his personal authority, and the authority of the Immigration Bureau combined to form the contour of the lens through which he viewed his subject. This vision was complex and even contradictory.

Sherman's photography reflected and recreated the liminal, unstable racial identity of European immigrants. Sherman attempted to limit this instability in his photographs by visually taking the immigrant out of Ellis Island and by heavily controlling the posing of his subjects. His efforts to stabilize the image of the immigrant can be seen as part of the immigration station's progressive project: controlling the potentially disruptive aspects of mass immigration, selecting suitable industrial workers, and regulating national identity.[21] However, in some images, Sherman's efforts at photographic control appear to have been disrupted by the nature of the photographic process, by the particularity of the individuals he hoped to present as racial types, and by the efforts of the immigrants themselves.

Most photographers, such as Lewis Hine, were concerned to show the immigrant in context at Ellis Island. However, Sherman's photographs deemphasize the context of the institution. In some images, a cloth backdrop or screen is placed behind the subject (figure 27).[22] In others, the background is visible but not explicable (see, for example, figures 29 and 30, pp. 135 and 137). At the moment in which the immigrant's status is most vulnerable, most dislocated—between Old Country and New World, legally in a no-man's-land—the elimination of the photographic context of Ellis Island doubles that dislocation.

Sherman's masking of Ellis Island serves various purposes. It creates a studio effect, to evoke the honorific bourgeois photograph, and it removes the immigrant from his or her surroundings, to focus on ethnographic detail. In figure 27, for example, a Rumanian woman adopts a pose suitable for a studio photograph: her back is held upright, but her head is slightly tilted, with her headscarf tumbling casually along one shoulder, and her two hands are placed unevenly: one in her lap and the other on the arm of her chair. From this perspective, the gentle asymmetry of her pose, the quality of her clothes and jewelry, and the apparent openness of her face

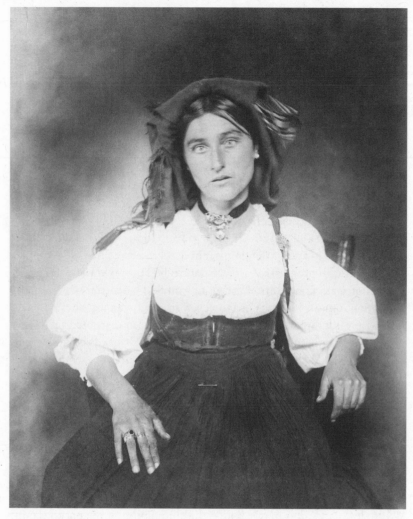

Figure 27. Augustus Sherman, Untitled (Rumanian Woman), ca. 1904–24.
Photo no. A-14, Augustus Sherman Photographic Collection, Statue of Liberty
National Monument, U.S. National Park Service, New York, N.Y.

present an image of sensitive respectability. However, these aspects of the
photograph can also be read through the prism of ethnography.[23]

When Sherman's photograph is compared with Julian Dimock's por-
trait "A Roumanian from Bukharest" (figure 28), Sherman's ethnographic
approach becomes more clear.[24] Dimock was one of the only other pho-
tographers working on Ellis Island who eliminated the presence of the

Figure 28. Julian Dimock, "A Roumanian from Bukharest," ca. 1908.
World To-Day, April 1908, 339.

station from his work, framing the immigrant's face far more tightly than Sherman. Dimock claimed that, in selecting his subjects, he only chose "typical people without regard to character, but always . . . avoided the best-looking ones lest the result compare too favorably with the work at a Fifth Avenue studio."[25] However, Dimock's image has many aspects of the Fifth Avenue studio photograph: the subject's face is artistically posed looking away from the viewer, limiting any reference to her racial identity through the face; her clothes are stylishly elegant and reflect the caption's statement that she is a modern, urban woman from Bucharest. Like his institutional patron, Commissioner Robert Watchorn, Dimock was favorable toward the immigrant, noting that he gave up trying to find "the poorest specimens" since "there were no bad types, or so few as to be negligible."[26]

Dimock's photograph is strongly honorific. Sherman's approach seems more ambivalent, as was that of his most active supporter, Commissioner William Williams. Williams was well known both for working to improve conditions for immigrants at Ellis Island and for supporting increased restrictions on immigrants.[27] When viewed again, the Rumanian woman in Sherman's photograph is presented with her head tilted and her hands uneven, but her face and body are opened directly to the viewer. This posing allows the viewer to read not only the racial identity of her face but also the ethnographic details of her folk clothing. The shape of her blouse and bodice and the placement of her headscarf and ornate jewelry are emphasized through her pose in this photograph. In other images, Sherman clearly angles his subjects or places them in profile to accentuate their features. In many of his photographs, he highlights the ethnographic effect of their attire (figure 29). Whereas Dimock's approach to immigrants is honorific, Sherman's is both honorific and ethnographic.

Occasionally, the Ellis Island buildings play a significant role in locating the immigrant, but in these cases the presence of Ellis Island is used to suggest another place. In figure 30, for example, a Chinese woman stands on a lawn in front of a canopy with fluted ornamentation reminiscent of an imagined Orient.[28] But the canopy is corrugated iron and leads to the main entrance hall of Ellis Island. Although most photographs view the main building's facade from directly in front, Sherman has the woman stand at an angle to the building. With the canopy behind her and the decorative elements outlined, the immigration station is framed to look more like a vaguely Asian temple than a Beaux Arts U.S. government building. The presence of the Chinese woman is at the center of this dislocating effect: her racial identity informs our reading of the buildings.[29] Sherman

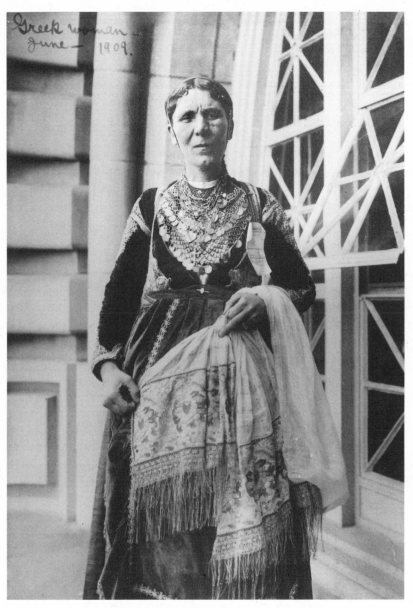

Figure 29. Augustus Sherman, "Greek Woman," 1909. Photo no. 1A-22, Augustus Sherman Photographic Collection, Statue of Liberty National Monument, U.S. National Park Service, New York, N.Y.

exploits the apparent fixity of this identity, represented in both her facial features and her dress, to elicit an image of Ellis Island as elsewhere. In contrast, Sherman's photograph of Commissioner Robert Watchorn is angled to include all of Ellis Island from the boardwalk to the roof of the building. The commissioner is represented confidently in context.[30]

Sherman creates a similar effect in figure 31: a full-body portrait of another non-European, a man identified as Algerian.[31] Here, however, Sherman almost eliminates the immigration buildings by placing the subject directly in front of a hedge and using a very low camera angle. Only one of the uppermost towers of the main immigration building is visible, and it rises like a minaret above the foreground. The resulting image is respectful of the man standing erect with his head held high and angled in the manner of a studio photograph. In fact, this pose is one that Sherman uses in photographs that celebrate the masculinity of Bavarians, Russian Cossacks, and Danes. However, the photograph engages in a sleight of site that substitutes the presence of Ellis Island for the illusion of Algeria. In some ways these images operate like the ethnographic exhibits at the 1893 Chicago World's Fair and other expositions: the pleasure of viewing derives from the experience not only of witnessing the Other but of witnessing the Other in America. The artifice of the experience, or the awareness that the photograph is actually located on Ellis Island, is part of the pleasurable effect for the viewer. In both cases, only the ethnographic subjects are real: the homeland in which they appear to be located is a clever artifice. At the same time, these images appear also to suggest that the figures they represent are unassimilable. Sherman seems to suggest that just as the Filipinos at the 1904 St. Louis Fair required an entire artificial village to house them and separate them from America, the Chinese and Algerian immigrants in these photographs require another country to frame them.[32]

Sherman removes immigrants not only from their presence at Ellis Island but also from the presence of other immigrants. Most photographers who worked at Ellis Island commonly show immigrants of different races in the same image, picturing them together on ships and at the station. This was typical of the way immigrants traveled and arrived. Sherman, however, consistently segregates his subjects by racial group and gender, using the photograph's frame as a boundary between each group. Figure 32 shows J. H. Adams's photo of eight varied "Types of Aliens Awaiting Admission at Ellis Island Station." It appears uncredited in the 1903 annual immigration report and in a *National Geographic* article summarizing immigration trends in 1904.[33] Men and women of

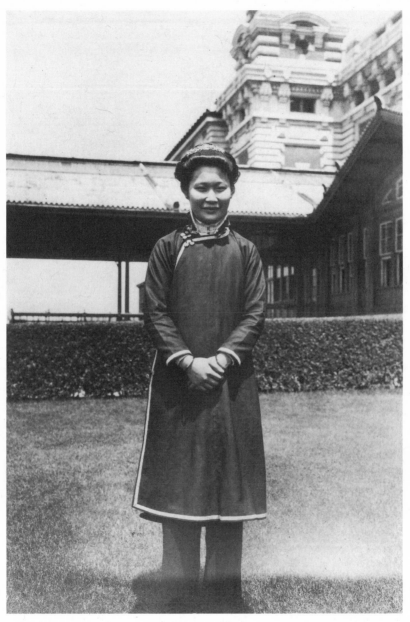

Figure 30. Augustus Sherman, Untitled (Chinese Woman), ca. 1904–24.
Photo no. 1A-47, Augustus Sherman Photographic Collection, Statue of
Liberty National Monument, U.S. National Park Service, New York, N.Y.

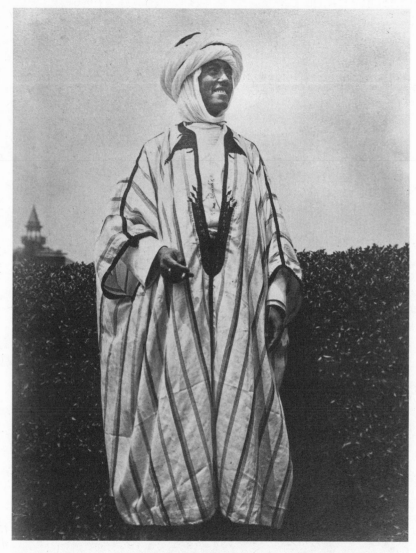

Figure 31. Augustus Sherman, Untitled (Algerian Man), ca. 1904–24. Photo no. 4A-8, Augustus Sherman Photographic Collection, Statue of Liberty National Monument, U.S. National Park Service, New York, N.Y.

different ethnicities are lined up within the borders of one photograph, facing the same way both to suggest the effect of waiting in a line and to aid comparison. In a related photograph in the 1903 annual report, a similar group faces the camera directly. This group is all women, and some of the women are the same as those in the later photograph, sug-

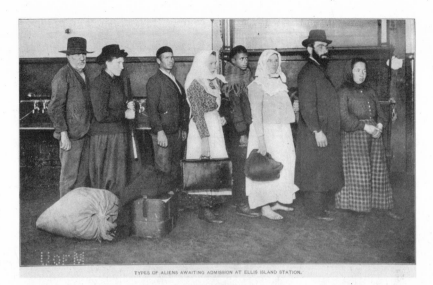

Figure 32. J. H. Adams, "Types of Aliens Awaiting Admission at Ellis Island Station," ca. 1903. U.S. Bureau of Immigration, *Annual Report of the Commissioner-General of Immigration* (Washington: Government Printing Office, 1903).

gesting that the immigrant types are not lined up waiting for admission but have been posed for the photograph. In *National Geographic* these two images appear together, like the two angles of a mug shot: front and side.[34] Although they are presented as "types," the haphazard arrangement of the subjects underscores the contrasting order of many of Sherman's photographs.

Most of Sherman's photographs adopt an honorific ethnographic approach. However, Sherman also took photographs of immigrants in a more scientific ethnographic—or anthropometric—mode, in which racial identity figured centrally. The woman in figure 33 is typical of Sherman's strongly ordered anthropometric portraits. She is seated with a straight back, her hands placed carefully in her lap. The woman's face is turned fully to the camera, her lips closed in a straight line. There is a profound stillness in this photograph, as well as in similar images such as a photograph of two Dutch women that appeared in the Immigration Bureau's 1907 annual report.[35] In such official images, Sherman has controlled the process of photography to suppress its uncertainties.

This stillness is disrupted in another image of the Dutch women that was not used officially (figure 34).[36] This photograph shows the two women in poses almost identical to the official image. However, here, the

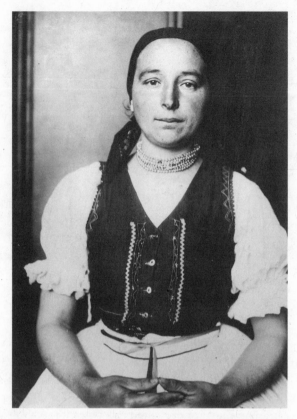

Figure 33. Augustus Sherman, "Magyar," ca. 1904–
24. Photo no. 1A-26, Augustus Sherman Photographic
Collection, Statue of Liberty National Monument, U.S.
National Park Service, New York, N.Y.

presence of the blurred baby and the ring on the mother's hand suggest
that this woman is both a wife and a mother: she has an existence beyond
the limits of her racial typing in the photograph. The blurring of the child
also draws attention to the process of taking the photograph and ques-
tions the photographer's control, as the child moves through the expo-
sure time. The stillness in Sherman's racial portraits is closely associated
with the frontality of his portraits and the uniformity of the poses in his
groups. The frontal pose with the subject's eyes focused on the observer—
the photographer or subsequent viewer—implies a closed system of ref-
erence in which the subject's purpose is to be observed, to be an object of
observation. In contrast, a blur or the subject's glance attracted by some-
thing other than the photographer suggests an existence outside the photo-

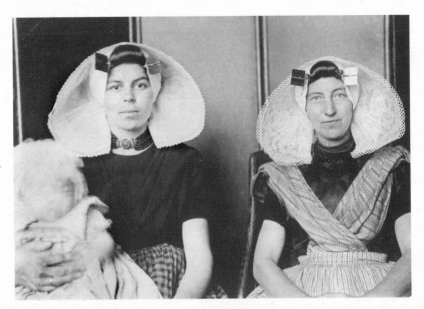

Figure 34. Augustus Sherman, Untitled (Two Dutch Women with Child),
ca. 1907. Photo no. 1B-7, Augustus Sherman Photographic Collection, Statue
of Liberty National Monument, U.S. National Park Service, New York, N.Y.

graph, either temporally (while the photograph is taken) or spatially (out-
side the frame).

But what are we supposed to observe in the photographs of these
women? If they are seen as objects, what did Sherman intend them to
represent? The viewer is told in the annual report's captions that define
the women: they represent "Magyar" or "Dutch Women." The photo-
graphs are intended to show racial types of immigrants. The women's
clothes reinforce the captions, emphasizing their nationality and estab-
lishing uniformity. The full frontal pose and simple background function
in these photographs as they do in the repressive photographs of crimi-
nals that began to be compiled in the late nineteenth century and in those
that were required of all deportees. They enable the viewer to see the de-
tails in the subject's face, to establish the subject's identity. However, Sher-
man is not attempting to establish the identity of an individual in these
images; he is concerned with defining racial identity. The images of Mag-
yar and Dutch women appeared in the 1907 annual immigration report
with six other plates all identified by racial type. Sherman's consistent
posing across different photographs was a key feature of anthropomet-
ric photography, since it allowed comparisons between races as well as

within one race.[37] Sherman's photographs were a useful addition to the charts and graphs of the annual reports, which had been classifying immigrants by racial type since 1899.

In Sherman's photograph of a group of Slovak girls (figure 35), the existence of other, less ordered elements in the background complicates the impulse to view the women as objects while it reinforces their status as such.[38] Labeled with tags as part of the inspection process, they form a bold contrast with the boys slouched in the doorway behind them, who, intrigued by the cameraman, choose to be photographed, or with the woman looking out of the frame to the left, who appears to be participating in the Slovak girls' supervision. The photograph of Slovak girls positions their faces in two horizontal lines, enabling the viewer to better read the similarities and differences between their features. The horizontal lines of their eyes and lips almost encourage this reading across the page. The fact that the girls wearing white headscarves are placed in front of the dark background of the door, while the only girl with a dark scarf stands in front of the lighter brick wall, allows the viewer to see their facial features more clearly by outlining the shape of their faces. Sherman has selected and ordered eight Slovak girls to demonstrate the single "Slovak" of the caption. The caption instructs the reader to view the girls as representatives of the "Slovak" race.

This imposition of the unified idea of one race on a group of individuals with distinct features is suggestive of Francis Galton's composite photographs of criminals and racial types. In Galton's system, negatives were exposed directly over one another in an attempt to represent the essence of, for example, Jewish facial features. According to Galton, individual details would become blurred, while the features that appeared the same in each overlapping negative—the essence of a given race or criminal physiognomy—would remain clear in the final print.[39] Sherman's photograph of Slovak girls offers a more basic form of the same principle: the group portrait is employed as a visual definition of the Slovak racial type. Sherman attempts to access the general (race) through the particular (individuals). However, his method does not blur individual detail and consequently represents the single racial type less effectively than Galton's symbolic portraits. Sherman's photograph of Slovak girls as "Slovak" is disrupted by the fact that the undoctored photograph represents details. These details allow the spectator to read not only the similarity but also the differences between the individuals. In Sherman's photographs the details are the elements that he has tried to suppress by posing, captions, and uniform costuming. However, whereas in Galton's photographs

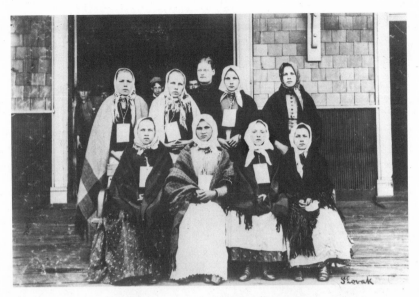

Figure 35. Augustus Sherman, "Slovak," ca. 1904–24. Photo no. 5–8,
Augustus Sherman Photographic Collection, Statue of Liberty National
Monument, U.S. National Park Service, New York, N.Y.

the detail has been eliminated by multiple exposures, in Sherman's por-
traits of racial types the particular always threatens to disturb the general.

The disruptive activity of the particular seems especially apparent in
one of Sherman's finest photographs: a portrait of a gypsy family (figure
36).[40] This image is one of the few group photographs in which not all
the individuals are facing the camera. Here the three children are in profile
with one looking back up at his mother, while the father tilts his head
slightly toward his wife, who smiles out at the camera. The mother stands,
her hands cupped to the side holding her daughter on her hip; the little
girl's bare feet are angled, and her hands mirror in miniature the mother's
clasp immediately below. The right hands of the father and his sons are
each placed on their right leg, forming a triangle that matches their po-
sition to the left of and lower than the mother. The mother is standing
with her daughter, while the father and sons are seated, following the
conventions of the bourgeois family photograph. The two frontal por-
trayals and three profiles might suggest a composite reading of gypsy fea-
tures, but the apparently disordered elements of the photograph resist
this reading. The woman is the focus of this disorder: her hair, the coins
of her necklace, and the folds of her skirt fall in asymmetrical patterns.

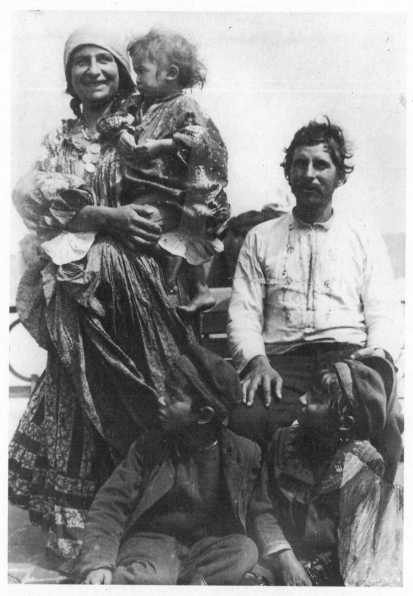

Figure 36. Augustus Sherman, Untitled (Gypsy Family), ca. 1905. Photo no. 2A-10, Augustus Sherman Photographic Collection, Statue of Liberty National Monument, U.S. National Park Service, New York, N.Y.

The hair of the daughter and husband is also ruffled, outlined against the white of the sky.

This lack of order is in strong contrast to most of Sherman's photographs but follows a pattern in his pictures of gypsies. As in Sherman's other photographs, the subjects have been carefully located; the disorder is deliberate. In posing the gypsy family to look less posed, Sherman presents what he perceives as the spontaneity and naturalness of gypsy character. According to the *Dictionary of Races and Peoples,* published as part of the U.S. Immigration Commission's massive report in 1911, "Everywhere the Gypsy resents the restraint of a higher social organization."[41] Although this image, along with other Sherman images, was later used as an illustration of "Old World Types That Arrive in the New World," this family was in fact denied permission to land and deported in July 1909. Newspaper accounts noted that they had sufficient funds to enter the United States and did not describe any physical or legal bars to their admission; however, "Commissioner Williams said that he looked upon the gypsies as an undesirable class, as his predecessors had, and he was making no precedent by excluding them." Part of a larger group from Argentina, the gypsies made the news not only because they were "picturesque" but also because they openly resisted being deported. Released from the detention pen, they first refused to move and then, when immigration officials seized them, fought back. Contemporary coverage was strongly in favor of deportation and suggested that their violent resistance was justification for deportation, even though no other justification was given. Sherman's photographs were taken earlier during their detention, and the gypsies appear to be willing subjects, smiling and engaged in their own representation. Although the family had no control over how their story was represented or their portrait circulated, we can read both image and story as the engagement and resistance of Ellis Island arrivals who refused to be restrained by Sherman or their deportation.[42]

In contrast to the gypsy family portrait, Sherman's photographs of families are usually constructed in a simple, highly ordered manner. His image of a Russian German family is very simply structured, with ten family members lined up in order of ascending height (figure 37).[43] Sherman used this formula, which was also popular in personal family portraits of the time, in almost all his large family portraits. Here it is coupled with the categorization typed on the photo: "Jakob Mithelstadt and family, Russian Germans, ex SS *Pretoria,* May 9, 1905. Admitted to go to Kuln, ND." The family is completely opened up and ordered for observation.

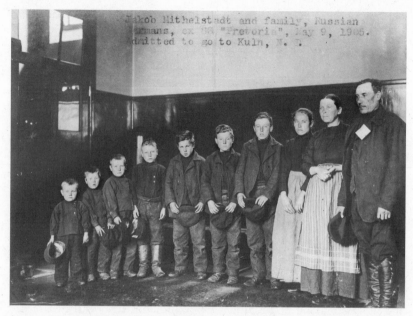

Figure 37. Augustus Sherman, "Jakob Mithelstadt and Family," 1905.
Photo no. 2B-7, Augustus Sherman Photographic Collection, Statue of Liberty
National Monument, U.S. National Park Service, New York, N.Y.

The detailed location of the family members matches the specificity of the
typed caption, which locates Kuln in North Dakota. The ordering of the
family members, like the fact that they are planning to settle in a rural
area, suggests that the Mithelstadt family is both suitable and assimila-
ble. This photograph offers a different message from that of the gypsies
awaiting deportation: the Mithelstadts, with an open door in the back-
ground, are clearly identified as a family with an American future.

Although Sherman located older immigrants in the Old Country, his
photos of children are more varied, suggesting the possibility of assimi-
lation or, in the case of his photo of children in a roof garden, seeming
to stress the necessity of Americanization (figure 38). The appearance of
this photograph, an unusual one for Sherman, in the 1904 annual report
suggests that it is one of his earliest. It is also reproduced in numerous
additional publications and in Commissioner Williams's scrapbook out-
lining improvements made at Ellis Island.[44] In the photograph, a large
group of immigrant children are at play. The number of children, the care-
ful placing of the toys, and the stiff way in which they hold American
flags while adults look on from the back of the scene make obvious the

Figure 38. Augustus Sherman, Untitled (Children's Playground), ca. 1904. Photo no. 5–7, Augustus Sherman Photographic Collection, Statue of Liberty National Monument, U.S. National Park Service, New York, N.Y.

degree to which the photograph is staged. This artificiality is reinforced in the annual report by a crude attempt to paint legs, shoes, and a shadow (at a different angle from the other shadows) for the boys on the right. While the placement of the children and consequent depth of perspective are unusual for Sherman, the photo shares the stasis of all his photographs. The flags provide almost the only movement, with the wheels of the "Uncle Sam" trolley and the rockers of the rocking horse clearly arrested. This photograph professes to depict Ellis Island as an Americanization kindergarten. As Commissioner Howe wrote, "Ellis Island is not only the 'gateway of the nation' but it is the nation's great kindergarten of Americanization."[45]

However, the children will not necessarily return to the inspection process when the photo session is over; they are, in fact, in legal detention on Ellis Island. The apparent flag-waving patriotism and implied pleasantness of the 1904 annual report's caption, "Children's Roof Garden," belie the fact that these children may never enter America and that they are actually at play in a rooftop exercise yard. At this moment, the children are denied America but represented as American. Sherman's deliberate erasure of the context of detention represents the institution of

Ellis Island as a beneficent medium for Americanization through the photograph as a neutral representation of reality. However, both Ellis Island and the photographic medium wield enormous power to present themselves as the opposite of what they are: the institution is operating not as a medium for Americanization but as a means of exclusion, and the photograph gives credence to this reversal through its supposed power to present the unmediated truth.

The U.S. Immigration Commission and the Immigration Bureau at this time were involved in creating nostalgia for imagined past forms of immigration. The commission had been formed by congressional act in 1907 to study the issue of immigration. Composed mostly of restrictionist senators and representatives, the commission concluded its work in 1911 with a comprehensive forty-one-volume study that detailed the state of immigration and called for more restrictive immigration controls.[46] The commission drew, in its own words, a "convenient" distinction between "old" and "new" immigration. It defined this difference in terms of location and assimilability: the old immigrants were "settlers" involved in "agricultural pursuits," who assimilated quickly so that "the racial identity of their children was almost entirely lost and forgotten." By contrast, the new immigrants were "far less intelligent" laborers who worked in industry, "congregated together" in urban areas, and were "racially . . . essentially unlike" the old immigrants. In his 1906 annual report, the commissioner general stated explicitly, "The physical and mental quality of the immigrants we are now receiving is much below those who have been coming in former years."[47] This distinction between "old" and "new" immigration was key to the passage of quotas in the 1920s, which explicitly rebalanced U.S. immigration in favor of "old" northwestern countries and races such as the Germans and the English.

These attitudes demonstrated an anxiety not only about the immigrant's place in the United States but also about United States itself. The nostalgia about past immigration was partly nostalgia for the pastoral, while the suspicion of new immigration was partly suspicion of urbanization and industrialization, with which immigration had become closely associated. The national nostalgia for past immigration served at least two political purposes: restrictionists argued that new immigrants would never fully assimilate and therefore should be excluded, while many progressives maintained that assimilation was difficult but required an aggressive program of Americanization. While the political purposes contradicted one another, the ideal end result remained the same: a relatively homogeneous American population.

In fixing the ethnographic image of the immigrant in the Old Country rather than the present reality of Ellis Island, Sherman invokes an ethnographic nostalgia. Sherman's presentation of immigrants in folk dress invokes the Old Country as both a place and a time before the immigrant enters America and becomes assimilated. The photos, in their ordered ethnography and separate portrayal of each race, suggest nostalgia for an imaginary time and place where the races are discrete and distinguishable. This place is often invoked in popular magazine articles about European races, which provided racial maps of Europe with different shadings representing the different races.[48]

Sherman's portraits valorize immigrants not by deemphasizing their racial identity, as Dimock's published photographs do, but by focusing on it. The honorific and ethnographic constitute one another as Sherman lauds the immigrant through his or her racial identity. However, Sherman is valorizing not only this identity but the fact that this identity is explicitly clear in these photographs. Sherman constructs the immigrants as having a distinct identity, defined by their national origin and racial history, prior to their arrival at Ellis Island. He presents this stable past identity as he writes Ellis Island out of the photograph.

Sherman's choice of immigrants in folk dress also reveals his nostalgia for an imaginary Europe untouched by industrialization and urbanization, elements of social change that led many immigrants to migrate to the United States. As a journalist for the *Spectator* wrote of Ellis Island, "The costumes are astonishing—far more curious than the casual tourist would ever see in Europe for many of these people come from remote villages whereof the tourist agencies wot not."[49] For this visitor, the immigrants at Ellis Island are particularly authentic because they are untouched by modernity, including the modern practice of tourism. However, by the 1920s, an immigration official lamented that "distinctive local costumes are in much less general use in Europe than twenty-five years ago and one certainly feels like regretting it when he sees a square-headed, tow-haired, pale-faced Finnish girl who has discarded her white embroidered kerchief head covering for a milliner's creation of light straw with red flowers and pale blue trimmings."[50]

Sherman's honorific ethnographic nostalgia functions, in an attenuated way, like Renato Rosaldo's imperialist nostalgia. Rosaldo analyzes the ironies involved when colonial administrators lament the loss of traditional lifeways that they are themselves responsible for destroying. In his photographs, Sherman valorizes the separate racial identities of groups that will lose their distinctive racial and cultural identity in Amer-

ica. As an Immigration Bureau functionary, however, Sherman was involved in facilitating this assimilation by introducing immigrants to the United States and institutions of Americanization, including Ellis Island. Like the "agents of colonialism [who] long for the very forms of life they intentionally altered or destroyed," Sherman in his photographs preserves an image of people whose lives he played a part in changing.[51]

Photographs are particularly powerful conveyors of nostalgia, since they capture a moment out of the continuum of time, separating the subject as it existed at that moment from the moments that precede and follow the photograph. Sherman's photographs repeatedly construct this moment of arrival in the United States, immediately prior to assimilation. The original moment was always chosen with the intention of referring to the image at a later date. This referral had multiple potential functions: one, in the case of police and immigration photographic documentation, was disciplinary identification. Another function, used more often in the case of European immigrants, was nostalgia: as soon as the photograph was taken, it became a record of "the way we were." The present became the past.

Lewis Hine's photographs, like Sherman's, entered into and engaged with debates about immigration in a variety of ways. As Paul Kellogg wrote of Hine's photographs, they "help give substance and reality to our presentations of fact."[52] Hine himself claimed that "the photograph has an added realism of its own."[53] But although Hine adopted an explicitly progressive approach to immigration, his photographs were used to illustrate other arguments besides progressive ones. In his own work, Hine framed his photographs with extensive captions to create word studies in which the image and the written word together presented his views on immigrants and immigration policy.

LEWIS HINE: AMBIVALENT PROGRESSIVE

Lewis Hine was one of the many photographers who traveled to Ellis Island to depict the immigrants there. As an instructor at the Ethical Culture School in New York City, he first traveled to the island in 1905 with his supervisor, Frank Manny. He returned a number of times in the period from 1905 until at least 1906. The images that he took at that time are considered his first serious photographs. As Alan Trachtenberg has written, Hine "went to Ellis Island as a school photographer; he left it as a master."[54] Hine received his first photographic commissions in 1907, documenting poor people's lives and working conditions for the National

Child Labor Committee (NCLC) campaign to end child labor and for the massive social study the Pittsburgh Survey. After he left the Ethical Culture School in 1908 and became a full-time professional photographer, Hine documented a wide range of social conditions for different progressive organizations and publications. In the early part of his career, until 1918, he worked primarily with the NCLC and the social scientific reform journal *Charities and the Commons,* later renamed the *Survey.* Hine's Ellis Island photographs appeared in *Charities and the Commons* and the *Survey,* as did his photographs of immigrant workers and types that he took for the Pittsburgh Survey. Hine returned to Ellis Island in 1926, taking another set of images of immigrants. He may also have visited at other times, especially in the early period, but these trips are less well documented.[55] Later, after he lost editorial control of his images, Hine's photographs were used to illustrate far more negative discussions of immigrants. A cropped version of Hine's famous "Climbing into America," for example, is attributed to the stock photo house Ewing Galloway in a 1931 article, entitled "Birth Control and the Racial Future," for a magazine on eugenics.[56]

Hine's own recollections offer a vivid picture of his work at Ellis Island. "Now," he wrote, "suppose we are elbowing our way thro the mob at Ellis trying to stop the surge of bewildered beings oozing through the corridors, up the stairs and all over the place, eager to get it all over and be on their way. Here is a small group that seems to have possibilities so we stop 'em and explain in pantomime that it would be lovely if they would only stick around just a moment. The rest of the human tide swirls around, often not too considerate of either the camera or us." As Hine and his assistant focused the camera and prepared the flash lamp, mixing magnesium and an accelerator in a pan, "the group had often strayed around a little and you had to give a quick focal adjustment, while someone held the lamp." Finally, by the time that Hine was completely ready, he wrote that "most of the group were either silly or stony or weeping with hysteria because the bystanders had been busy pelting them with advice and comments, and the climax came when you raised the flash pan aloft over them and they waited, rigidly, for the blast. It took all the resources of a hypnotist, a supersalesman and a ball pitcher to prepare them to play the game and to outguess them so most were not either wincing or shutting eyes when the time came to shoot."[57]

Hine's comments evoke his brief, complicated relationship with the immigrants that he pulled out of the crowds to become his photographic subjects. Hine's first visits took place during the peak years of immigra-

tion, and his description of the immigrants as an oozing mob and a surging tide echoes some restrictionist accounts of Ellis Island. At the same time, he recognizes the immigrants' humanity and sympathizes with their desire to get through the inspection process and "be on their way." It was probably not clear to the immigrants, especially since Hine was unable to make himself understood, that the photographer was not an official and that this brief moment of documentation was not part of the inspection process. Hine's subjects may also have thought, as they received advice from watching immigrants, that their momentary detention represented a problem with their entry into America, that they were being marked by the photograph in the same way that other immigrants were marked with chalk letters identifying their defects.

Hine does not claim the authority of the inspector, but he does position himself in partial control over his subjects. According to Hine, the immigrants' resistance to being photographed, their moving around and becoming "silly or stony or weeping with hysteria," is not deliberate but bewildered. As they wait, they become anxious and upset, not because of their own concerns but because others are bothering them. They themselves seem emptied of all intention. At the same time, Hine is filled with purpose, required to use all his resources to retain control of the difficult situation. Whether this passage accurately reflects Hine's experiences on Ellis Island, his reflections years later, or the image he wanted to create of himself as a pioneering documentary photographer, Hine clearly controls the terms of the written encounter. However, the frenetic activity and emotion he describes in this passage are barely visible in the thoughtful, even calm images that he produced during his first trips to Ellis Island.

At least since Judith Gutman's 1967 rediscovery of his work in *Lewis Hine and the American Social Conscience,* Hine has been canonized as the quintessential social documentary photographer. Although his interpreters emphasize different aspects of his work, most share strong similarities in their analysis.[58] Hine is described as the consummate photographer of his time.[59] He is contrasted favorably with both the unbridled aestheticism of the Photo-Secessionists and the exploitative exposés of reform photographers such as Jacob Riis.[60] Most significantly, he is repeatedly described as a compassionate photographer, presenting his subjects with dignity, humanity, and individuality. According to Judith Gutman, Hine infused his photographs with compassion. In support of her argument that he always viewed and represented his subjects as individuals, Gutman notes that Hine "named, placed, and aged" each child in

his child labor photographs.[61] Alan Trachtenberg writes that Hine viewed his subjects "with love and respect," allowing them "room for *their* self-expression."[62] Sharing this understanding, Daile Kaplan argues that "Hine's work empowered his subjects," incorporating "their point of view, their 'voice' in his captions."[63]

These commentators claim that Hine's photographs and his attitudes toward immigrants were overwhelmingly positive.[64] They cite Hine's recollection that Frank Manny hoped to instill in his students "the same regard for Castle Garden and Ellis Island that they had . . . for Plymouth Rock."[65] However, Hine never claimed this hope for himself. They note that when Hine first traveled to Ellis Island to photograph the arriving immigrants in 1905 his colleagues were concerned about the increasingly restrictionist anti-immigrant environment in the United States.[66] However, Hine never commented on immigration restriction. They reference Hine's positive comments about immigrant contributions to America but ignore his more equivocal statements.[67]

In fact, Hine's photographs of immigrants were never completely positive. Instead, they reflect his complex ambivalence toward immigrants, an ambivalence he shared with many of his progressive colleagues. Unlike restrictionists, who saw immigration as an economic and racial danger, most progressives believed that immigration presented both opportunities and difficulties. As an editorial in the liberal Republican *Outlook* magazine noted: "He is a poor American who does not feel the thrill of Ellis Island, yet he is also a foolish American who can visit Ellis Island without questioning . . . the future."[68]

To summarize broadly, restrictionists feared that immigrants would lower the American standard of living by accepting lower wages than white Americans.[69] Many restrictionists believed that the white race was divided ethnographically into Teutonic or Nordic, Mediterranean, and Alpine types or races, which overlapped broadly with popular divisions between northwestern, southern, and eastern Europeans. Restrictionists were concerned not only about immigrants from Asia and Latin America but also about those from southern and eastern Europe, who were considered racially liminal because of their apparent difference from northwestern Europeans as well as their native country's racial and geographic proximity to Africa and Asia. Restrictionists generally believed that non-Teutonic immigrants could never assimilate into American culture; these immigrants would therefore threaten the Teutonic race physically, through miscegenation, and culturally, by maintaining native folkways that were

at odds with American culture. In the turn-of-the-century concept of race, of course, physical, mental, and cultural attributes were inextricably linked.[70]

Progressives were just as aware of the racial identity of immigrants, but they believed that almost all immigrants were capable of assimilation and of contributing to social progress in America. However, these immigrants required assistance by American reformers to do so. As a result, progressives engaged in a series of legislative and community-based reforms designed to replace immigrant customs with more modern and supposedly healthful American practices. These Americanization programs were aimed at all aspects of immigrant life, including work, education, leisure, and home life, but they were rarely as successful as reformers hoped.[71] In short, restrictionists focused on immigration reform because they believed assimilation was impossible and undesirable; progressives concentrated on reforming immigrants because they believed that assimilation was both necessary and achievable.

This progressive ambivalence cut along many different axes, like progressivism itself.[72] Jane Addams, who founded and directed Hull House within Chicago's immigrant community, favored banning diseased and poor immigrants but did not support restricting the entrance of insane or feeble-minded immigrants, since it broke up families.[73] Ellis Island Commissioner Henry Curran, who served from 1923 to 1926, was known for his efforts to humanize the immigration station at a time when its primary responsibility was shifting from immigration inspection to detention. He lamented that "mothers were torn from their children, fathers from their wives" under the new 1924 law because they belonged to different nations with different quotas. But although Curran was progressive and proimmigrant, he supported immigration quotas. "The newcomers bring diverse and valuable contributions to our national character," he wrote, "but there can be too much of a good thing all at once."[74]

Although Hine never wrote extensively about immigrants or commented directly on immigration policy, his photographs and writings reflect this progressive ambivalence. Despite the claims of previous critics, this ambivalence is apparent in most of Hine's writings, images, and photo-studies, including his Guggenheim proposal, his Russell Sage portfolio, and his private notes. Hine's progressive perspective is particularly clear in his 1940 proposal to the Guggenheim Foundation for a photographic portfolio showing the ways that "our adopted citizens" have responded and contributed to "our American democracy." Although the project was never undertaken, Hine hoped that this objective visual

record would help ordinary Americans see the contributions of representative immigrants. Hine wrote:

> Using my collection of immigrant studies made at Ellis Island and elsewhere from 1905 to 1930 as a working base, I would follow a number of these persons and families, and others that came at the same time, to their present homes. During those years I photographed many Poles, Italians, Jews, Russians, Germans and the whole range of races represented. . . . With the cooperation of agencies working with the foreign-language groups, including the newspapers, I shall find many individuals that adequately represent their racial stocks. Then I propose to record as many phases as possible of their home life, their work life, community and recreational contacts and participation in fraternal, cooperative and trade union organizations.[75]

Hine's proposal revealed a number of progressive impulses. First, Hine hoped to educate ordinary people through the objective record of the photographic portfolio. He planned to use photographs to make hidden or unclear social situations visible and intelligible to the average American. In the progressive equation that "to see was to know, and to know was to act," Hine imagined that this representation of immigrants would lead to an understanding of them and of what to do about them.[76] To achieve this, however, he had to follow the immigrants to their homes, echoing the way that progressive reformers entered homes to educate immigrant women about American domestic practices. Unlike these visitors, Hine would not attempt to change immigrant ways. Instead he simply planned to display immigrants in such a way as to educate his intended audience of native-born Americans.

In his proposal, Hine was not interested in the individuality of immigrants except as far as individuals could serve to "adequately represent their racial stocks." With the exception of literary critic Sara Blair, discussions of Hine's work have largely ignored this concern with racial identity.[77] Although he is commonly described as focusing on his subject's individuality, Hine was also always aware of his subject's race. Just as his photographs of children generally identify the child's name and age, his photographs of immigrants at Ellis Island typically omit names but state the person's race. Hine framed his immigrant subjects as racial types in two ways: in the posing of their bodies to emphasize their racially distinct features and in the way they were framed by the caption. For Hine, the individual was never only an individual but also a representative of his or her race. In the body of his work as a whole, Hine appears to be concerned that his photographs accurately represent the range of races

immigrating to the United States, a concern that clearly was not shared by Augustus Sherman.

Finally, like many of his progressive associates, Hine was not fully accepting of immigrants unless they were accepting of America. He emphasized the contributions of "our adopted citizens" but was more ambivalent about immigrants who had not fully assimilated. "Much emphasis is being put upon the dangers inherent in our alien groups, our unassimilated or even partly Americanized citizens—criticism based on insufficient knowledge," Hine wrote in his Guggenheim proposal. "A corrective for this would be better facilities for seeing, and so understanding, what the facts are, both in possible dangers and real assets."[78] Like the *Outlook* editorial writer at Ellis Island, Hine believed that immigrants were potentially beneficial to the United States and potentially dangerous. This is the core of progressive ambivalence toward immigrants, an ambivalence reflected not only in Hine's writings but also in his photographs.

Hine's most extended meditation on immigration was the portfolio of thirty-two "photo-studies" he produced with funding from the Russell Sage Foundation. Though it was intended as a retrospective of his work, Hine was able to complete only two units (on immigration and child labor) before his death in 1940. He also produced three unfinished units entitled "Men at Work," "Women at Work," and "Miscellaneous Themes." In the portfolio, Hine reprints his photographs with extensive new inscriptions, which together form the "photo-studies." Although Hine's other writings are frequently cited in histories about him, these inscriptions are rarely referenced.[79]

Many of the images that Hine selected for this portfolio are honorific portraits of individuals portrayed with the dignity and compassion that photographic historians identify as a hallmark of his work. Hine's draft introduction to the project also stressed immigrants' contributions to America, despite the social problems they faced, and many of his captions support this perspective. Hine consistently recorded the subject's racial type but often placed this racial designation in historical context by describing the patterns of persecution that fostered immigration. In one study, for example, Hine wrote: "This young Slovak woman is one of the vast number of her people who started to come as early as the 18th century. Hungarian persecution started an extensive wave of migration by Slovaks to this country."[80] Whereas Sherman reduced his subjects to the single-word caption "Slovak," Hine placed his photographs in historical context (suggesting that Slovakian immigration was not exclusively new) and emphasized the future in many of his studies (not-

ing immigrants' perseverance, self-reliance, and strong desire to live in America).

Despite these generally positive representations of immigrants, the portfolio is characterized by an undercurrent of ambivalence that pervades both the captions and the images. The identification tags worn by immigrants as part of the immigration process, for example, have often been seen as dehumanizing aspects of their treatment. In his caption to "Slavic Mother and Child at Ellis Island," however, Hine wrote that "the identification tag on her chest is the first touch of American civilization."[81] Hine's ambivalence is not limited to this later work on the Russell Sage portfolio. In another portrait of a woman wearing a railroad tag on her chest, Hine's identifying note to himself reads simply, "Ellis Is.—1926 R.R. tag."[82] In his personal caption, Hine repeated the dehumanizing aspect of the tag by identifying the photograph as an image of a tag rather than of the individual it represented.

In the portfolio, Hine's photo-studies represented not only immigrants but also the process of immigration and Ellis Island itself. As a progressive institution, the immigration station on the island was associated with both administrative process and progress. The time that immigrants spent on the island represented for many Americans a moment between the outmoded European past and a modern American future. Like Augustus Sherman, Hine's camera captured immigrants in this moment. In his captions for the Russell Sage portfolio, he emphasized the past as a source of deep-rooted ethnic traditions, including both picturesque folkways and religious persecution. At the same time, Hine envisioned Ellis Island as the exemplar and the initial agent of assimilation into America's progressive civilization. The captions to Hine's photographs in the progressive journal the *Survey,* although not necessarily provided by him, reinscribed this opposition between the immigrant's past and America's future. In one article summarizing the findings of the U.S. Immigration Commission, Hine's photographs were captioned "Old Worlds in New" and "The Beginning of Things."[83]

This narrative of progress was extended to Ellis Island itself as Hine documented in his photo-studies the improvements he witnessed at the station. In his attention to Ellis Island, Hine draws from the Immigration Bureau's own rhetoric about the island. The portfolio opens with a series of photographs and extensive captions setting the scene at Ellis Island. This section includes photographs from Hine's trips to the island in both 1905 and 1926, and his captions consistently contrast the crowded conditions during the peak years of immigration with the later, more efficient

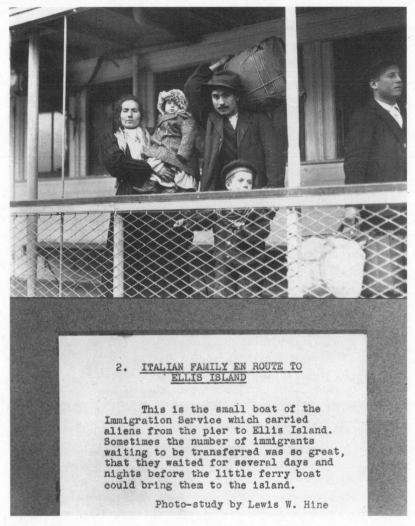

Figure 39. Lewis W. Hine, "Italian Family en Route to Ellis Island," ca. 1905. Unit 1 (Immigrants), no. 2, Lewis W. Hine Photograph Collection, Miriam and Ira D. Wallach Division of Art, Prints and Photographs, New York Public Library, New York, N.Y.

management of the island. Hine's well-known photo of an Italian family on the Ellis Island ferry boat (figure 39) is redefined to describe how "sometimes the number of immigrants waiting to be transferred was so great, that they waited for several days and nights before the little ferry boat could bring them to the island."[84] "Climbing into America" (figure 40) is

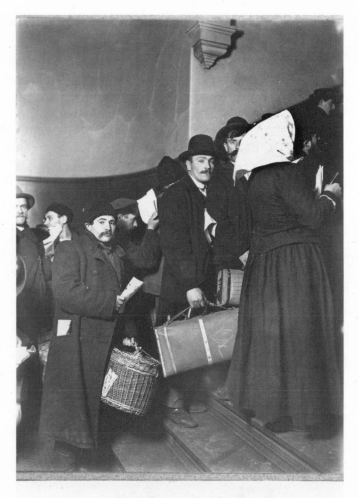

3. CLIMBING INTO AMERICA -
 ELLIS ISLAND - 1905

 Here is a Slavic group waiting to
get through entrance gate. Many lines
like these were prevalent in the early
days. There was no room to keep person-
al belongings, so the immigrants had to
carry their baggage with them all the
time.

 Photo-study by Lewis W. Hine

Figure 40. Lewis W. Hine, "Climbing into America—Ellis Island—
1905," ca. 1905. Unit 1 (Immigrants), no. 3, Lewis W. Hine
Photograph Collection, Miriam and Ira D. Wallach Division of
Art, Prints and Photographs, New York Public Library, New
York, N.Y.

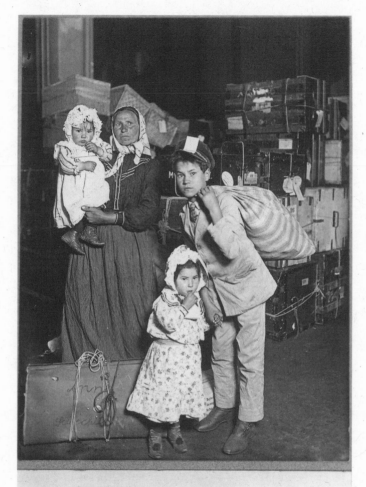

4. ITALIAN IMMIGRANTS AT ELLIS
 ISLAND - 1905

 Lost baggage is the cause of
 their worried expressions. At the
 height of immigration the entire
 first floor of the administration
 building was used to store baggage.

 Photo-study by Lewis W. Hine

Figure 41. Lewis W. Hine, "Italian Immigrants at Ellis Island—
1905," ca. 1905. Unit 1 (Immigrants), no. 4, Lewis W. Hine photo-
graph Collection, Miriam and Ira D. Wallach Division of Art,
Prints and Photographs, New York Public Library, New York, N.Y.

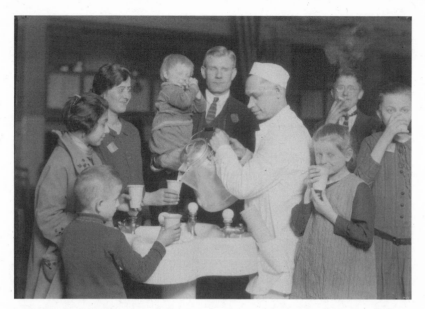

Figure 42. Lewis W. Hine, "Morning Lunch at Ellis Is. A Big Improvement over Former Years," ca. 1926. Photo no. 77.0177.0028, Photography Collection, George Eastman House, Rochester, N.Y.

used to illustrate the prevalence of long lines "in the early days." And instead of focusing on the family, Hine's new caption to the famous photograph of an Italian family who have lost their baggage focuses on the luggage in the background (figure 41).[85] "At the height of immigration," he wrote, "the entire first floor of the administration building was used to store baggage."[86]

Hine's photos from 1926, however, illustrate better immigration procedures and more respectable immigrants. His images from this period include a group portrait of "fairly prosperous" Germans dressed in "modern clothes" as well as photographs of immigrants being aided by social workers and gratefully consuming nutritious meals served to them by uniformed Ellis Island employees (figure 42).[87] "Notice the variety of foods on the table," Hine instructs the viewer in one caption. "This is a considerable improvement over earlier days. The room too is less crowded and more comfortable looking."[88] Hine's approach toward Ellis Island was shared by official visitors. The secretary of labor visited the immigration station shortly after the 1924 National Origins Act went into effect and "came away pleased and boasting that it looked like a 'deserted village.'"[89] The secretary explained that the island had been choked with

immigrants the previous year but that the new law had eased the congestion. Hine's later photographs continued many of the themes and formal patterns of his earlier images, but he also took more photos of large groups of immigrants interacting with Ellis Island employees. In these images, he seems to be representing the island as much as the immigrants.

In the absence of information about the motivations for Hine's later trip to Ellis Island, photographic historian Daile Kaplan has linked the two trips and suggest that they both reflect Hine's concerns about anti-immigrant attitudes and immigration restriction. She writes, for example, that Hine was initially concerned about "the public's aversion to the great influx of 'foreigners'" and notes that he returned to his work on Ellis Island in 1926 "when immigrant quotas were reinstituted."[90] Although she does not state so explicitly, Kaplan's formulation seems to suggest that Hine's later trip was motivated by the same concerns as his earlier visit. However, immigration quotas were first passed in 1921 and revised in 1924, two years before Hine's return visit. As restrictionists made clear, the 1924 National Origins Act was explicitly designed to limit the overall amount of immigration and to drastically reduce the amount of undesirable "new" eastern and southern European immigrants in favor of more racially desirable "old" immigration from northwestern Europe.[91]

In his portfolio for the Russell Sage Foundation, Hine repeatedly emphasizes the huge numbers of immigrants arriving in the period before the National Origins Act and the improvements at Ellis Island in the period since; however, not one of his captions mentions restriction or the implementation of quotas. As a result, it is difficult to suggest with any authority that he opposed quotas. In fact, his descriptions of the immigration station as quieter, more capacious, and more efficiently operated in 1926 serve to naturalize the implementation of racist immigration restrictions, making them seem benign or even beneficial to the immigrants still arriving. Although Hine never overtly referred to quotas, he was almost certainly aware of them, and a couple of his captions may be read as oblique references to the National Origins Act. In one photograph of a large German family being tagged for a railroad trip (figure 43), Hine wrote that "families of this size were responsible for keeping German immigration on the top of the list. From 1820 to 1938, 5,966,916 Germans came to America, the largest of all immigrant groups in the country."[92] The "list" is never specified, but it probably refers to the lists of immigration figures maintained by the Immigration Bureau. Hine's profiling of a large German family could be intended to dispel popular assumptions that only less desirable southern and eastern European im-

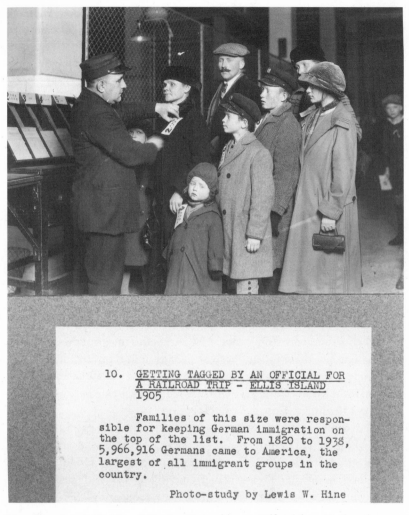

Figure 43. Lewis W. Hine, "Getting Tagged by an Official for a Railroad
Trip—Ellis Island, 1905," ca. 1905. Unit 1 (Immigrants), no. 10, Lewis W.
Hine Photograph Collection, Miriam and Ira D. Wallach Division of Art,
Prints and Photographs, New York Public Library, New York, N.Y.

migrants had large families. His detailed caption also reflected Hine's pro-
gressive concern with providing statistical information to support his pho-
tographs.[93] However, this caption suppresses the political history of the
ways in which Germans were aided by U.S. immigration laws, particu-
larly by quotas. Germans were always a significant source of U.S. im-
migration: between 1899 (when racial information was first recorded)

and the beginning of the First World War in 1914, only Jews, Italians, and Poles immigrated in larger numbers. However, after quotas were made more restrictive in 1924, Germans became the largest European immigrant group and remained the largest group in each year until 1930.[94] Hine's periodization, from 1820 to 1938 (the most recent figures available to him), ignores the various immigration restrictions implemented during this period. Instead, Hine suggests that Germans topped the immigration "list" for natural reasons, such as their ability to procreate and produce large families.

Hine's 1926 photo-studies emphasize more than the efficiency of the Immigration Bureau in processing immigrants. They also underscore the improvements in and even the virtues of detention. In three carefully posed images grouped together at the end of his Ellis Island portfolio, Hine shows immigrants engaged in various activities while they are detained. Although he does not mention the reasons for their detention, immigrants were typically detained while waiting to receive financial support, to meet delayed family members, or to recover from physical illnesses. The Immigration Bureau also detained immigrants whose cases were being investigated or who were going to be deported—for example, because they were stowaways. Like Sherman's image of the children's rooftop garden, these images present detention in a positive light, from the perspective of the immigration authorities rather than the immigrants themselves. However, unlike Sherman, Hine acknowledges in his captions that the immigrants were in detention.

The first photograph shows a member of the Daughters of the American Revolution (DAR) teaching immigrant women how to sew (figure 44). The second shows a group of immigrant children being pushed around a roundabout in the island's new playground (figure 45). And the last shows immigrants dancing to the musical accompaniment of the accordion (figure 46). The first two images date from 1926, and the third image, despite the mention of two different dates in the caption, is from 1905.[95]

Unlike Hine's 1905 images, which show only immigrants, the two 1926 photographs register the presence of social workers on the island. They form a group with the other later photographs, which show waiters, railroad workers, and social workers helping immigrants to negotiate their way in America (see, for example, figure 43). Not one of Hine's 1905 photographs shows anyone other than an immigrant, or apparent immigrant, on Ellis Island. All Hine's photographs that show immigrants interacting with Americans date from 1926. Hine specifically selected these group photographs for the portfolio: he also took, but decided not

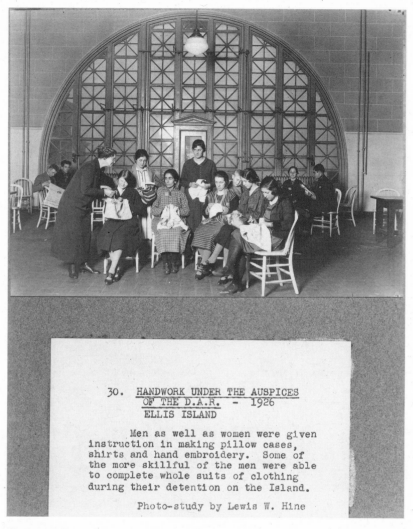

Figure 44. Lewis W. Hine, "Handwork under the Auspices of the D.A.R.—1926, Ellis Island," ca. 1926. Unit 1 (Immigrants), no. 30, Lewis W. Hine Photograph Collection, Miriam and Ira D. Wallach Division of Art, Prints and Photographs, New York Public Library, New York, N.Y.

to use, fine individual portraits of detainees learning needlework and relaxing in the playground (figures 47 and 48).[96] The individual portraits that Hine rejected have the hallmark of what is considered his familiar style: they focus on the individual subject in social context. However, the group portraits appear to have been selected to present a different image, as much about the institution of Ellis Island as the immigrants.

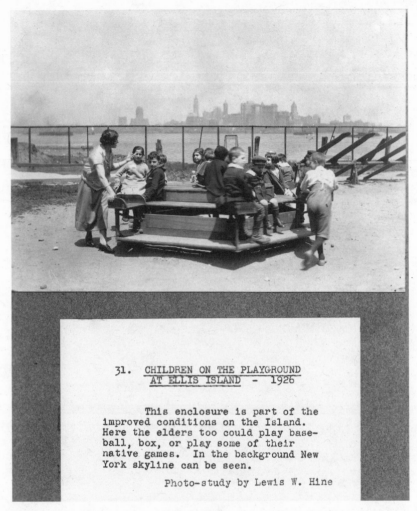

Figure 45. Lewis W. Hine, "Children on the Playground at Ellis Island—
1926," ca. 1926. Unit 1 (Immigrants), no. 31, Lewis W. Hine Photograph
Collection, Miriam and Ira D. Wallach Division of Art, Prints and Photo-
graphs, New York Public Library, New York, N.Y.

The 1926 detention photographs in the Russell Sage portfolio are
structured very similarly. The immigrants, whether women or children,
are grouped in the lower center of the photograph. Both groups of im-
migrants form a circle opened to the viewer in the front: the chairs of the
sewing circle have been placed in a group separate from the other ran-
domly positioned chairs in the background while the children are seated

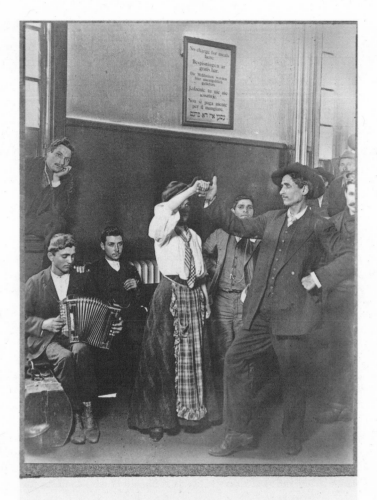

32. IMMIGRANTS DETAINED AT ELLIS
ISLAND TAKE TIME TO BE HAPPY
1926

In 1905 there was no organized
recreation, so the immigrants sup-
plied their own. The sign overhead
reads: "No charge for meals here".
It is written in six different
languages.
Photo-study by Lewis W. Hine

Figure 46. Lewis W. Hine, "Immigrants Detained at Ellis Island
Take Time to Be Happy," ca. 1905. Unit 1 (Immigrants), no. 32,
Lewis W. Hine Photograph Collection, Miriam and Ira D. Wallach
Division of Art, Prints and Photographs, New York Public Library,
New York, N.Y.

Figure 47. Lewis W. Hine, "Italian Child Detained at Ellis Island—1926—Hand Work Supplied and Directed by Trained Worker," ca. 1926. Photo no. 77:177:155, Photography Collection, George Eastman House, Rochester, N.Y.

on a roundabout. The American adult figure is positioned to the left of the photograph overlooking the immigrants. The two apparently American women in these photographs share very similar poses: their faces are both shown in profile looking toward their wards, with their bodies angled slightly forward and their feet placed slightly apart. Their backs curve toward and over the immigrants, suggesting both their concern and their control. The visual implication of the sewing instructor's control

Figure 48. Lewis W. Hine, "Ellis Island," ca. 1926. Photo no. 77:177:30,
Photography Collection, George Eastman House, Rochester, N.Y.

over the immigrants is reiterated in Hine's title: "Handwork under the
Auspices of the D.A.R.—1926, Ellis Island."

The formal structure of these images gives the impression of immi-
grants enclosed within Ellis Island. In figure 44, the strong semicircle of
the large arched window in the background reinforces this sense of en-
closure. It both echoes and contrasts with the curve of the DAR mem-
ber's back and the ragged half-circle of immigrant women. Instead of
providing a view, however, the window acts as a barrier between the im-
migrants and the outside world. It is divided by strong vertical columns
that suggest bars and reinforce the idea of Ellis Island as a detention cen-
ter. At the same time, the flat geometric patterns of the window muntins,
brick wall, and floor tiles associate the immigration station with unifor-
mity and regularity, in contrast to the random patterns formed by the
immigrant women and their clothes. This geometric regularity is em-
phasized by Hine's decision to position the window centrally.

In figure 45, the sense of enclosure is created by the literal enclosure
of the fence that forms a straight band of squares across the center of the
image. Here the fence is superimposed over the Hudson River between
Ellis and Manhattan islands, matching its artificial political barrier to the

natural dividing line of the river. Although, as Hine notes, the New York skyline can be seen in the background, the fence also acts as a formal division between the immigrant children on Ellis Island and the city. Almost none of the children appear to look outside the playground enclosure toward the city: their attention is directed either to the American teacher or to the photographer and subsequent viewer. None of the children even touch the city within the image: only the top of their teacher's head rises above the river to overlap with the edge of the skyline in the background. In both photographs, the space that surrounds the central group only reinforces their sense of isolation.

These images attempt to frame detention as the solicitous protection of immigrants rather than the protection of Americans from immigrants. They elide the harsh reality of imprisonment on the island as well as the fact that families were typically separated from one another and that individual family members were sometimes denied entry. In their content and captions, the photographs present detention as an opportunity for improvement rather than the curtailment of opportunity. In his caption to the needlework class shown in figure 44, Hine notes that "some of the more skillful of the men were able to complete whole suits of clothing during their detention on the Island." The length of their detention is measured in stitches: some people are not detained longer, Hine seems to be saying, they are just more productive.

Figure 46 is different from the previous two in both its content and its form. Like Hine's other photographs from 1905, this image shows no Americans, only immigrants. The central subject is a couple posing in a static moment from a folk dance. To the left, a seated man is playing the accordion, while the rest of the immigrants are gathered round. The observers, however, are more interested in watching the camera than the dance. "In 1905," as Hine writes, "there was no organized recreation, so the immigrants supplied their own." This image, unlike the others, suggests immigrant independence and self-reliance. The dancers display their own skills, rather than being instructed, and the observers appear to present themselves on their own terms. Hine's emphasis on self-reliance may also be related to the fact that this photograph presents mostly men, whereas his later photographs of detainees focus on women and children. Hine titles this photograph "Immigrants Detained at Ellis Island Take Time to Be Happy," but not one subject is smiling. The only trace of the island is a notice on the wall above the immigrants that notes in six languages that there is no charge for meals. However, this sign, like the lines of the wall and the windows, is askew. Hine's focus is on the immigrants

Figure 49. Virginia and Elba Farabegoli passport photograph, 1921. Photo no. 166/102, Elba F. Gurzau Manuscript and Photograph Collection (PG 166), Balch Institute for Ethnic Studies, Historical Society of Pennsylvania, Philadelphia.

rather than the immigration station, and he seems unconcerned with the uniformity that characterizes his 1926 images of the station.

It could be argued that Hine's proposal and portfolio are retrospective, that they reflect an older, more conservative attitude toward his earlier work on Ellis Island. According to this argument, the ambivalence of his 1930s captions for the Russell Sage Foundation and the heavy emphasis on racial types in his 1940 Guggenheim application reveal only that Hine had changed since he took his first photographs at Ellis Island. However, this response is unpersuasive. It does not address the fact that most of Hine's surviving comments about his work are retrospective or that his earlier photo-studies heavily represent racial types. Hine appears to have been, as Trachtenberg and other historians suggest, quite consistent in his political beliefs over the course of his life. However, in his attitudes toward immigrants he was consistently equivocal.

Figure 50. Virginia and Elba Farabegoli passport photograph, 1937. Photo
no. 166/118, Elba F. Gurzau Manuscript and Photograph Collection (PG
166), Balch Institute for Ethnic Studies, Historical Society of Pennsylvania,
Philadelphia.

Photographers working at Ellis Island were not the only photographers
who represented immigrants in potentially ambivalent ways or used the
honorific ethnographic mode. Images of ambivalence were common, and
the honorific ethnographic idiom was more widely used than has been
acknowledged.[97] As explored in the next chapter, when photographic
passports were required of all immigrants starting during the First World
War, European immigrants chose the ways in which they were represented
in these official images, just as the Chinese had done before them. By
1917, the conventions of passport photography were more clearly es-
tablished and more carefully enforced than they had been in the early
days of Chinese identity documentation: these portraits focused on the
head and shoulders of the subject and eliminated background details.
However, they were often printed with a soft oval framing the subject,

and when multiple family members were traveling on the same passport the photos included more than one individual. In these ways, early passport photographs retained some of the look of the studio portrait, even as they were used for new documentary purposes.

Virginia Farabegoli and her daughter Elba's passport portraits are illustrative. Dating from 1921 (figure 49) and 1937 (figure 50), these images show elements of both continuity and change. In both photographs, the women represent not only their identity but also their respectability and femininity. The image's gently faded edging and Elba's slightly tilted head evoke the studio portrait, while the women's carefully selected ornaments (Virginia chooses a necklace or earrings, Elba wears a bow in her hair or at her neck) suggest both resources and restraint. Although the second photograph is taken seventeen years after the first, each woman is posed in a similar position and has recognizably familiar features. At the same time, while these photographs served the same purpose, they look different. The earlier photograph has elements of disorder, particularly represented by the women's hair, that mirror some of the arrival photographs of immigrants and that were often associated with Italian immigrants. This disorder has been eliminated in the later photograph, controlled by the curling iron or careful braids. Although these changes may suggest Americanization, echoing the before-and-after photographs that were popular among social reformers, we should resist such an easy reading. The archival collections of which these photographs are a part show that Elba maintained a strong sense of her Italian identity, working both as a social worker and as a promoter of Italian folk dance throughout her life.[98] The Farabegolis not only maintained an ethnic Italian identity but retained their Italian citizenship. Both photographs were taken for the women's Italian passports, revealing that even though there was ample time for them to become American citizens the Farabegolis chose to remain Italian nationals. In fact, the earlier photograph is not an arrival image but a passport portrait taken to enable the women, who had already lived in the United States, to return to Italy for a visit.

The Imaginary Line

Passing and Passports on the Mexican-U.S. Border,
1906–17

The expenditure of vast energy and huge sums of money in
guarding the portals at Ellis Island against the entry of the
proscribed seems a vain and futile thing as long as the back-
yard gate swings loosely on its hinges.

Annual Report of the Commissioner General of Immigration, 1923

When Immigrant Inspector Marcus Braun looked out over the Mexican-
U.S. border in 1906, he saw "a broad expanse of land with an imagi-
nary line, all passable, all being used, all leading into the United States."[1]
However, Braun's viewing of the invisible international line was not sim-
ply an act of imagining. It was part of the Immigration Bureau's early
efforts to delineate the boundary between Mexico and the United States.
During the next two decades, as historians have shown, the border was
redefined from a passable, almost imaginary line to a place of increased
regulation and surveillance.[2] At the same time, long-standing practices
of border crossing were redefined, even made illegal. As George Sánchez
writes, ethnic Mexicans who had long resided in the region "were now
interlopers on familiar land, even as their labor became increasingly cru-
cial to its economic development and they had begun to settle their fam-
ilies in the United States."[3]

Between 1908, when the Immigration Bureau first recorded statistics
on Mexican immigration, and 1928, when identity cards were introduced
for all arriving immigrants, Mexicans entering the United States were in-
creasingly closely documented by the Immigration Bureau.[4] This was par-
ticularly apparent in El Paso, the Immigration Bureau's regional district
office, its busiest border station, and, in 1910, the U.S. city with the largest
Mexican American population.[5] In 1893, there was one immigration in-

spector stationed at El Paso for the entire Mexican-U.S. border; by 1905, the number had expanded to twenty-three officials, with four stationed at El Paso.[6] Although Ellis Island processed the largest number of immigrants, arrivals intending to become permanent residents in the United States, the El Paso immigration station handled substantially more entrants, including not only statistical immigrants but also nonstatistical border crossers, tourists, and other temporary visitors. By 1921, the total travelers crossing the bridge daily between Ciudad Juárez and El Paso numbered fifteen thousand.[7]

During the early twentieth century, new representational and regulatory practices on the border made Mexicans more visible to the Immigration Bureau and to Americans concerned about immigration. However, once they entered the United States, whether legally or illegally, the bureau showed little interest in investigating their immigration status or making their presence visible. As the inspector in charge in Douglas, Arizona, noted: "After their entry, these [illegal aliens] soon lose their identity."[8] Mexicans, like Chinese and European arrivals, were thought to blend in with the local population shortly after entering the United States. Whereas bureau officials argued that the recency of Chinese arrivals was difficult to determine because Chinese did not assimilate and therefore all Chinese looked similar to one another regardless of whether they were U.S. citizens or how long they had lived in the States, European immigrants were believed to assimilate quickly to dominant American norms of dress, becoming indistinguishable from the majority of Americans. In contrast, Mexican immigrants "lost their identity" not only because they integrated into the substantial Mexican communities in the U.S. Southwest but also because immigration officials had little interest in determining their legal status.

The dual policy of making Mexican immigrants visible at the border and allowing them to remain invisible within the United States was shaped by the conflicting pressures of restrictionists and employers. Restrictionists supported laws to limit and regulate the entry of Mexican laborers, whereas employers opposed both the passage and implementation of these laws in order to preserve their access to Mexican labor. Congressional representatives and immigration officials responded to these conflicting pressures by increasing regulation at the border but resisting a system of interior enforcement that would check the legal status of Mexican immigrants already in the United States.

Detailing the expansion of border regulation, historians have shown how immigration policies such as contract labor laws and visual med-

ical inspection were developed at Ellis Island, then implemented on the border with mixed results.[9] However, the development and implementation of new practices to regulate migration did not just circulate between Ellis Island and El Paso. They also moved along a different, less-explored circuit: from Angel Island to the Mexican-U.S. border, from Chinese exclusion to general immigration policies. Starting in 1917, the Immigration Bureau attempted to fortify the border using not only general immigration policies but also the photographic documentation policies first tested with the Chinese. In contrast to the processing of European immigrants at Ellis Island, which involved little use of photographic documentation, Chinese exclusion was an important reference point for immigration officials seeking to strengthen border enforcement through photographic identity documentation.

Such documentation underpinned the changing regulation of the border and gradually became the primary means through which Mexican border crossers were regulated. When photographic identification was introduced on the Mexican-U.S. border, it drew on practices already developed to implement Chinese exclusion. Unlike the Immigration Bureau's zealous visual regulation of Chinese immigrants, however, the photographic documentation of Mexicans was unevenly enforced. Even as medical inspection and general immigration rules were implemented with increasing efficiency on the border, photographic documentation continued to be used most extensively to regulate Chinese immigrants in the region.

After the passage of the 1875 Page Act, exclusion and immigration policies developed separately and served different purposes: exclusion laws focused on preventing the entry of Chinese unless they met narrow exemptions; immigration laws covered all immigrants, selectively restricting a limited number who didn't meet specific legal and medical requirements. From the beginning of federal immigration controls, these policies were rarely implemented to restrict Mexican immigrants entering across the Mexican-U.S. land border. However, in the 1917 Immigration Act, Mexican immigration was more fully incorporated under general immigration policies, at the same time that Chinese exclusion was expanded to include almost all Asian groups.[10] The 1917 Immigration Act transformed both Mexican and Asian immigration.

The incorporation of Mexican immigrants under general immigration law in 1917 was preceded by three key developments: increasing concerns about unregulated Chinese and European immigration over the Mexican-U.S. border; the Mexican Revolution between 1910 and 1917,

with continuing unrest until 1921; and the First World War, which started in 1914 and into which the United States entered in 1917. Together, these events brought new concerns about security and, as a result, new scrutiny to the Mexican-U.S. border, transforming the imaginary line into a dividing line.

RACIAL PASSING: INVESTIGATING NON-MEXICAN MIGRATION IN THE SERAPHIC AND BRAUN REPORTS, 1906–7

In 1906, immigrant inspectors A. A. Seraphic and Marcus Braun were dispatched separately to Mexico and the Mexican border to investigate illegal immigration and conditions at the border-crossing stations. Their reports have formed the basis of many historical analyses of changing conditions at the border in the early twentieth century. However, these histories have rarely discussed the inspectors' uses of and recommendations regarding photography or the ways that the reports reveal immigration officials' concerns about visual legibility in the Mexican-U.S. border region.[11] Seraphic, an immigrant inspector of Greek descent, photographed himself in disguise as an immigrant and included a series of recommendations regarding the implementation of photographic regulation on the border. Braun appended to his report numerous photographs of Chinese and Syrian immigrants, whom he viewed with deep suspicion as illegal immigrants.[12] "There is," he claimed, "no such thing as a regular immigration of aliens—Europeans and Asiatics—by way of Mexico."[13]

As Erika Lee has shown in her exploration of illegal Chinese immigration across the Canadian and Mexican borders, Braun investigated allegations that many Chinese immigrants frequented the Daguerre photographic studio in Mexico City to obtain portraits for fraudulent U.S. immigration documents. He obtained twenty images from the studio and included them in his report alongside other photographs of Chinese in Mexico (figure 51). Although the portraits are indistinguishable from images taken by studio photographers in the United States and China, they took on a different valence in Mexico. Braun included these portraits not to aid in identifying specific individuals who might be evading the exclusion laws but as visual evidence "to show how in some cases it would be difficult to distinguish these Chinamen from Mexicans."[14] Braun's investigations apparently supported his claims about Chinese and Mexican somatic similarity. Braun determined that Chinese immigrants, rather than using these portraits to obtain fake U.S. documentation, used them

to apply for preliminary Mexican naturalization certificates, which were then used to enter the United States.[15] Given that all ethnic Chinese were excluded from the United States, regardless of their nationality, it appears that these certificates were used to represent their holders as either ethnic Mexican or other non-Chinese immigrants.

Braun's findings were part of a widespread concern within the Immigration Bureau about racial passing—in this context, the idea that non-Mexican immigrants, particularly Chinese immigrants, were disguising themselves as Mexicans to cross the border unexamined. Such concerns were visually based: racial passing disrupted the bureau's understanding that racial identity was visually legible. Like Seraphic and others, Braun reported that Chinese arrivals in Mexico learned to say a few words of Spanish, "cut off their pigtails and exchange[d] their blue-jeans and their felt slippers to the most picturesque Mexican dress" so that they could pass as Mexicans and enter the United States undetected.[16] A *Harper's Weekly* article included a carefully posed photograph that purported to show a "Coolie disguised as a Mexican Peon" dressed in traditional attire (figure 52).[17] As with the emphasis on picturesque dress in photographs of Europeans, these images were used to suggest the interdependence of the cultural and somatic aspects of race. In photographs of European immigrants, however, traditional folk clothing helped clarify the subject's racial identity. The photographs of Chinese posed as Mexicans suggested the opposite: that clothing could disrupt the representation of racial identity. Racial experts though they were, immigration officials accepted that they could not always distinguish between different European races; however, the idea that they could not differentiate between Asians, Mexicans, and Europeans caused them great concern.

According to Braun, the somatic distinctiveness of Chinese immigrants became blurred in the racially liminal Mexican-U.S. border region. In the enforcement of exclusion, it was the immediately visible racial identity of the Chinese that underpinned the effectiveness of Chinese photographic identity documentation. Congressional supporters of photographic regulation not only claimed that all Chinese looked alike but also assumed that all Chinese looked clearly different from non-Chinese immigrants. Even though they expressed concerns about the exchange and doctoring of documents, immigration officials accepted that they could easily identify who was Chinese and therefore was required to carry documentation. In the Mexican-U.S. borderlands, what concerned immigration officials was not so much the manipulation of photographic images and

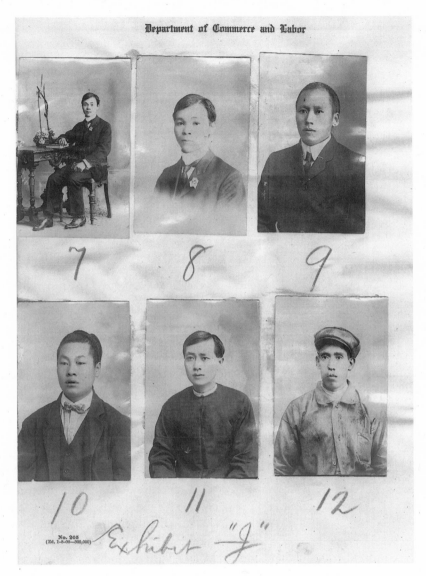

Figure 51. Daguerre Photo Studio, Mexico City, Mexico, "Exhibit J" (portraits of Chinese), ca. 1907. In Marcus Braun, "Report, First Detail to Mexico" (February 1907), File 52320/1, Records of the Immigration and Naturalization Service, (Record Group 85), National Archives and Records Administration, Washington, D.C.

Figure 52. Unknown photographer, "Coolie
Disguised as a Mexican Peon to Be Smuggled
into the United States," 1905. In Broughton
Brandenburg, "The Stranger within the
Gate, II," *Harper's Weekly*, August 5, 1905.

identity documents as the manipulation of racial identities. When Chinese, Syrian, or southern European immigrants could racially pass as Mexicans and freely cross the Mexican-U.S. border, the Chinese exclusion and general immigration laws became far more difficult to enforce.

The logic of racial instability was relational. Immigrants from outside western Europe were viewed by immigration officials as racially liminal. U.S. officials believed that Chinese, Middle Eastern, and southern European immigrants could pass as Mexicans because Mexicans were not clearly white. The unclear racial status of these liminal non-Mexican immigrants apparently offered them some latitude in negotiating the border by presenting themselves as Mexicans. However, ethnic Mexicans on both sides were increasingly constrained by immigration inspectors' uncertainty regarding their racial and national status. According to the Immigration Bureau, concerns about racial passing justified the increasing regulation of all border crossers. Mexicans could not be allowed to

pass freely, since they might not be Mexican. True racial identity could not be secured through a casual visual reading. More generally, concerns about racial passing helped to define Mexicans as aliens rather than Americans, as racial others who shared racial characteristics with Chinese, Middle Eastern, and suspect European immigrants rather than with Anglos.

Popular and official reports described the varied ways that racially liminal immigrants crossed the border as Mexicans. In some cases, as Braun described, Chinese immigrants used Mexican government documentation to pass under the eyes of immigrant inspectors. In others, Chinese arrivals assumed a Mexican identity in case they were discovered by an American citizen far from an official crossing point. Overall, Braun claimed a conservative estimate of fifteen thousand illegal European and Asian immigrants crossing into the United States from Mexico each year.[18] However, regardless of the ways in which they entered, these acts of racial passing made them largely invisible to the Immigration Bureau.[19]

In his report on border conditions, Inspector Seraphic recommended the photographing of debarred aliens—especially contract laborers and Orientals—at all border stations and the exchanging of these photographs among the stations to ensure that aliens excluded at one port did not gain entry at another. In addition, he suggested that "all Syrians and Greeks debarred at the said border be looked up at their intended destinations. The experienced officers, with good photographs of such aliens and their proper address, will have no trouble in locating them in the States and bringing about their deportation."[20] Although he did not reference Chinese exclusion, Seraphic was essentially recommending the implementation of border and interior enforcement practices, such as photographing immigrants upon entry or rejection, that were already in place to enforce Chinese exclusion.

However, despite the Immigration Bureau's apparent interest, this systematic use of photography was never implemented on the border. The bureau tested Seraphic's recommendations, unsuccessfully attempting to locate a Greek man debarred at the border. The bureau also solicited bids to provide photographic equipment at all border stations. Although the equipment costs were lower than expected and border officials were willing to adopt photographic enforcement measures, the bureau did not proceed with either of these plans.[21] Photographic equipment was not provided for every border port, but by 1907 the immigration stations at El Paso, Tucson, and San Diego were all equipped with photographic supplies to enable them to document debarred and excluded immigrants.[22] Smaller immigration stations, such as Dalhart, Texas, relied on local stu-

dio photographers to take identity portraits of detained Chinese immigrants.[23] At all of these stations, the only group to be systematically photographed was the Chinese.

San Francisco–based inspectors forwarded photographs to border officials when they suspected that rejected Chinese might attempt to reenter the United States via Mexico. And immigration officials circulated these photographs along the border.[24] The immigration authorities also suspected other groups, including Greeks and Syrians, of entering the United States illegally via Mexico. However, since these groups were not photographed at their initial ports of application, they were not subject to systematic photographic regulation on the border. In addition, unlike the Chinese, they were not photographed at the border even when they were rejected.[25]

Although El Paso was the largest border port, Tucson was the most active and efficient station in terms of photographic documentation, almost all of which was directed toward regulating the Chinese. The interest in photographic identification at the Tucson station might have been linked to the high numbers of Chinese in the Sonora-Arizona border region or to the presence of an immigration official with a particular interest in photographic regulation.[26] The Tucson office not only had their own equipment but also constructed a rotating photographic display that speeded up the process of inspectors comparing photographs of previously rejected Chinese applicants to the individuals applying at that port.[27] Although border officials frequently shared photographs, Tucson officials went further still. When they suspected Chinese living in Arizona of having entered illegally via Mexico, they armed an inspector with photographs and sent him to Sonora, Mexico, to locate witnesses.[28]

In contrast, there is very little evidence of any photographic activity at El Paso, possibly because the station was focused primarily on Mexican entrants. After 1917, as the station enforced new quarantines, medical inspections, and other restrictions with increasing consistency, it continued to adopt a somewhat lax attitude toward photographic identification. The El Paso station was supplied with photographic equipment by the Washington office but continued through the 1920s to rely on local photographers to make identity records of Chinese entering through or rejected at the port. On the border, as in the interior, photographic regulation had become almost exclusively associated with the Chinese. Chinese migrants not only were the first group in the United States subject to photographic identity documentation but also were among the first immigrants subject to such regulation on the Mexican-U.S. border.

THE "NATURAL HABITAT" OF THE BORDERLANDS, 1907–17

Prior to 1917, Mexican-U.S. border enforcement was primarily concerned with controlling non-Mexican migration. During this period, immigration officials monitored the border against immigrants who were specifically prohibited from entering the United States: Chinese subject to the exclusion laws as well as Europeans who had previously been rejected by public health and immigration officials at other immigration stations.[29] Mexican border crossers were largely unregulated.

An Immigration Bureau report described this situation in zoomorphic terms, evoking the image of Mexicans as animals roaming their land. "United States territory immediately adjacent to the boundary has been a natural habitat of the Mexicans from the beginning," the report described, "and residents of the borderland in Mexico, particularly of the laboring class, for a long time moved back and forth across the dividing line practically at will."[30] Although the bureau recognized the established experience of movement within the Mexican-U.S. borderlands, this phrasing also subtly suggested that border controls might be a civilizing influence on indiscriminate movement. Residents, however, remember the shift from relatively free to relatively restricted movement very differently.

Many local residents had roots in the region that dated back to, in the report's words, "the beginning," presumably the U.S. annexation of Mexico's northern territories in 1848. However, local practices of border crossing were not as natural as the description of a "natural habitat" seems to suggest. During the dictatorship of Porfirio Diaz between 1876 and 1910, Mexican land policies favored the development of large-scale agriculture, while efforts to modernize and industrialize the Mexican economy led to the development of a national railroad system using American capital. These policy developments displaced small landowners, increased the presence of American goods in Mexico, and created opportunities for Mexicans to migrate north. At the same time, increasing industrialization, mining, and large-scale agriculture in the U.S. Southwest offered new opportunities to Mexicans living through this dislocating social and economic change. As U.S. exclusion policies barred Chinese, Japanese, and then all Asian laborers, employers turned to Mexicans for flexible, low-wage labor. Mexican immigration to the United States increased during the early twentieth century not because Mexicans were naturally drawn to the United States but because of political and economic developments in both Mexico and the United States.[31]

When border residents described crossing the border prior to 1917, one of their key memories was the lack of documentation or "passports."[32] According to El Paso community leader Cleofas Calleros, "There were no restrictions as to crossing the bridge, no passports or anything like that. Everyone was happy, coming and going without any customs restrictions, any immigration restrictions, any health department restrictions."[33] In oral histories recorded by historians at the University of Texas, El Paso, other residents also nostalgically recalled the lack of passports, the freedom from investigation, and the minimal charges to cross the bridge. In some cases, such casual border enforcement meant that Mexicans had to make extra efforts to officially immigrate into the United States. Mauricio Cordero described how when he arrived with his mother at the Santa Fe Bridge between Ciudad Juárez and El Paso in 1907 "there were very few employees." Cordero located a fat man sitting in the basement, but when he told him that he wanted to immigrate the man replied, "You don't need to. You and your mother can go freely to El Paso." Only once Cordero insisted did the official register their names.[34] Margarita Jáquez de Alcalá identified 1917 as the year in which "the passports began. Before that one went and one came and nobody said anything. The relations got worse when the little restrictions began and they started to search people." "The Americans searched people a lot," de Alcalá remembered.[35]

MEXICAN REFUGEES AND THE "SPECTACLE OF DESPAIR," 1910–21

The first group of Mexican migrants to be closely observed and widely photographed were the masses of refugees displaced by the violence of Mexican Revolution. Between 1910 and 1920, approximately two hundred thousand Mexicans were recorded entering the United States, although not all were refugees.[36] The revolution itself, much of which took place in northern Mexico near the U.S. border, was viewed as a spectacle by many Texans. Residents of the El Paso–Juárez valley, including refugees, viewed the fighting from the banks of the Río Grande and the hilltops surrounding Juárez.[37] The *Brownsville Herald* reported that U.S. residents crossed the border "in droves, flocks, herds, crowds" to view the aftermath of battles at Matamoros, Mexico.[38] And as thousands of refugees traveled in the other direction across the border to the relative safety of the United States, the *El Paso Herald* described it as a "spectacle of despair."[39]

The revolution was seen as a spectacle by Americans not only because of its proximity to the United States but also because of the presence of large numbers of professional and amateur photographers. According to a reporter for the *New York Herald,* "The place was lousy with free lance photographers."[40] Some of these freelancers included local studio photographers such as Robert Runyon in Brownsville and Otis Aultman in El Paso. There were darkrooms on board the U.S. warships stationed at Vera Cruz and one in a refitted freight car used by a U.S. news photographer who traveled as part of revolutionary leader Francisco Villa's train convoy.[41]

By 1919, the Mexican government attempted to control the number of photographers, and possibly the content of their images, by issuing photography permits in border states such as Tamaulpais. In response to a complaint from Brownsville photographer Robert Runyon that American citizens were being prevented from photographing events in Mexico, Mexican authorities maintained that they issued permits to responsible parties with whom they were well acquainted and that frontier photography prohibitions were enforced not only against Americans but against all nonresidents of Mexico.[42] These photographs of the revolution and the refugees it displaced were reproduced in myriad formats: as picture postcards, in newspapers, in magazines, and by stock photo houses such as Underwood and Underwood.[43] The images recorded the revolution for a national U.S. newspaper audience as well as locals, tourists, and troops stationed along the border, who bought thousands of photographic postcards during the height of the postcard craze in the 1900s and 1910s.[44] In the process, they helped shape ideas about Mexican immigration to the United States.

The circulation of images, however, was not only within the United States. Nor did these images depict only Mexican refugees and revolutionaries. When Ernesto Galarza crossed the border into the United States, he recognized the U.S. military from pictures he had seen, suggesting that images of the border conflict may also have been popular in Mexico.[45]

As Frank Samponaro and Paul Vanderwood have shown in their detailed study of Robert Runyon, the demand for Runyon's postcards of the border conflict declined after 1916 as public attention focused on the European war and the National Guard troops stationed along the border were demobbed. In 1917, to make up the loss of income from declining postcard sales, Runyon opened a photographic studio specializing in portraiture. During the early 1920s studio photography was Runyon's most financially successful venture. Samponaro and Vander-

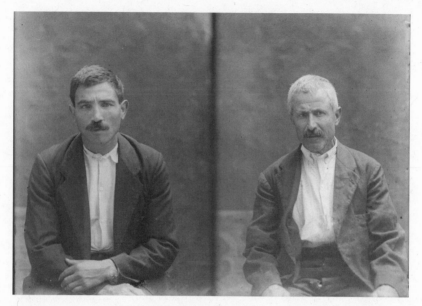

Figure 53. Robert Runyon, Untitled (male portraits, passport photos). Repro-
duction number 06083, Robert Runyon Photograph Collection, Center for
American History, University of Texas at Austin.

wood describe how Runyon's skill quickly established him as the pre-
eminent portraitist in Brownsville, photographing local soldiers, students,
and "thousands of local residents" for various events including "bap-
tisms, first communions, weddings, birthdays, anniversaries, promotions,
and retirements, but often simply because they wanted a professional pic-
ture of themselves and their families."[46]

The authors carefully delineate the timing of declining postcard sales
and the end of the American picture postcard craze. However, there may
be another reason why Runyon chose to open a portraiture studio in 1917
and why it was so successful. It was in this year that photographic por-
traits were first required for identification cards on the Mexican-U.S. bor-
der. Just as the introduction and enforcement of Chinese photographic
documentation resulted in a significant increase in business for San Fran-
cisco's studio photographers, it is likely that portrait studios gained new
business when photographic identity documents were first introduced on
the border.[47] In El Paso, for example, the number of professional pho-
tographers increased from twenty-one in 1917 to thirty-two in 1919: a
50 percent increase. Although it is impossible to determine exactly how
much of this increase might have been influenced by border crossers seek-

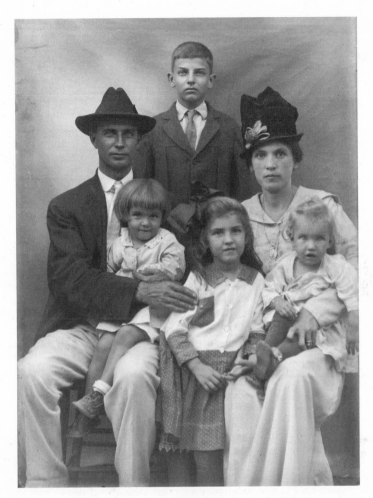

Figure 54. Robert Runyon, "Robert Runyon, Amelia Medrano Runyon, Lillian Runyon (Mahoney), Amali Runyon (Perkins), and William Thornton Runyon, made for a passport," ca. 1919. Reproduction no. 04790, Robert Runyon Photograph Collection, Center for American History, University of Texas at Austin.

ing photographs for their identity cards, the number of studios underwent a rapid expansion immediately after the photographic requirements were introduced and then remained steady during the 1920s.[48]

Like many other photographers on the Mexican and Canadian borders, Runyon worked on contract for the Immigration Bureau, providing portraits of "such Chinese or other aliens detained by the Immigration Service, as they might specify, to be used for identification purposes."[49]

However, the vast majority of his portraiture work focused on individuals who came to his studio to request images for their own use. Runyon's photographic archives are filled with images of men and women that were probably used for passport or other identity photographs. Although the notations in Runyon's records do not identify the purpose of most of these portraits, archivists have identified many as passport photos. In addition, they follow the conventions of portrait photographs on immigration documents recorded at the border.[50] These photographs were typically small individual portraits (figure 53), but they also occasionally represent a family as allowed by Immigration Bureau rules, such as the portrait that Runyon took of his own family for a passport (figure 54). Like the Chinese, cardholders did not always use traditional identity photographs but included studio photographs with oval and other decorative frames as well as family photographs identifying numerous people on one card. In addition to baptisms, weddings, and retirements, many local residents now obtained photographs to mark another—previously unmarked and unremarkable—event: crossing the border.

WARTIME MEASURES: THE INTRODUCTION OF PHOTOGRAPHIC PASSPORTS, 1914–19

The 1910s brought war to the Mexican-U.S. border, and war brought concerns about security, neutrality, labor, and immigration. From 1910 to 1917, these concerns were directed across the border at the Mexican revolutionary war. After 1914, and particularly after the United States' entry into European war in 1917, they were also directed across the Atlantic Ocean. The Mexican-U.S. border was considered a front in that war, and U.S. officials were concerned about the opportunities such a broad, unregulated border afforded enemy aliens to cross into the United States.

Concerns about border security were not limited to the United States. Across Europe and beyond, nations reversed a trend of increasing freedom of movement.[51] Britain, France, Germany, and Italy all introduced new restrictions on emigration and immigration. These measures required authorization to leave or enter the country, both to ensure that eligible citizens were not evading military service and to prevent potentially dangerous enemy aliens from entering the country.[52] The Mexican Carranza government also introduced passport requirements in 1915, primarily to control the entry of Mexicans opposed to their revolutionary government.[53] Later the same year, President Wilson issued an executive order

limiting the exit of U.S. citizens without passports.[54] Concerns about
Mexico's role in the European war were heightened by the publication
of the deciphered Zimmerman telegram in early 1917, when Americans
learned that German foreign secretary Alfred Zimmerman had proposed
a wartime alliance with Mexico against the United States.[55] In July 1917,
the secretary of state and secretary of labor issued a "joint order re-
quiring passports and certain information from aliens who desire to en-
ter the United States during the war."[56] In 1918, a new law reinforced
these provisions and a second executive order created a wartime depar-
ture passport-permit system.[57] This system required all U.S. residents—
citizens and aliens—to obtain a departure permit to ensure that they were
not planning to desert military service or carry secrets to the enemy. The
parallel passport-visé entry system required all aliens to obtain a pass-
port and have this document visaed, or approved, by the U.S. consulate
prior to entering the United States.[58] As the *El Paso Herald* reported, "The
object of the act and regulations is the institution of a more comprehensive
and at the same time more simple system."[59] Under these rules, the De-
partment of State centralized control over all travel documents, while Im-
migration Bureau employees undertook stronger implementation of
these controls.[60] Despite these extensive new passport requirements cov-
ering all international travel, the regulations allowed for border-cross-
ing cards to be used to travel within ten miles of the Mexican-U.S. bor-
der as well as to travel to America's insular possessions.[61]

As with other expansions of identity documentation, photographs
were a key component in the extension of passport regulations. In 1914,
a new requirement was introduced to ensure that passport applications
contained two photographs. In 1915, this number was increased to three
photographs, one of which was forwarded to the port of departure to
confirm the identity of the holder.[62] In 1918, the passport was defined
by executive order as "any document in the nature of a passport issued
by the United States or by a foreign government which shows the iden-
tity of the individual for whose use it was issued and bears his signed and
certified photograph."[63] Although early passports had not contained pho-
tographs, by 1918 the photograph was considered a necessary compo-
nent of the document designed not only to permit travel but also to cer-
tify identity.

Throughout the First World War, officials expressed concern about
the additional demands that new restrictions placed upon their time and
about the need for increased border patrols to protect the southern bor-
der of the United States. Meeting these additional demands was made

more difficult by the fact that many Immigration Bureau personnel were deployed in Europe. Nevertheless, by 1919, the commissioner general of immigration reported that increased patrols to enforce wartime regulations had led to higher numbers of legal entrants at points along the border, "whereas before that patrol was established many were able to cross the border at unguarded points without examination."[64]

One of the most significant shifts in immigration policy brought about by the passport-permit system was the implementation of what Aristide Zolberg has called a system of "remote control." Zolberg uses the term to describe the ways in which U.S. immigration officers screened potential immigrants in their ports of departure in the 1920s, issuing visas to those applicants who passed medical and legal inspections and who met the newly imposed quotas on national origins. John Torpey has noted, however, that this system originated in the practice of Chinese exclusion where U.S. diplomats visaed Chinese applicants' papers prior to their departure and that it was extended to Europeans and other immigrants in the passport-visé system.[65] U.S. immigration officials themselves made this connection, noting that the system offered a valuable "protection of the country against undesirable or undue immigration." "Observing this, and having in mind also the experience of the bureau in the enforcement of the Chinese-exclusion laws," the Immigration Bureau recommended permanent peacetime adoption of a similar system. Officials recognized that such a system must necessarily be different, since the administration of Chinese exclusion and that of general immigration were distinct and since, unlike the Chinese exclusion law, "the immigration law does not require that immigrants generally shall hold certificates of any kind."[66] However, they recognized the links between these two systems and emphasized the benefits of a "remote control system."

For most European governments, the establishment of passports was a permanent change: after the Armistice these governments continued to require passports for international travel.[67] The United States shared this trend, but with some key exceptions that highlighted the distinctions between coastal seaports and the Mexican-U.S. border. Following the conclusion of World War I, U.S. citizens did not need passports to enter or depart the United States, and aliens had to present passports only upon entry.[68] Although passports were required for U.S. citizens to enter many countries, they were not required again to leave the United States until 1941, during the Second World War.[69] In addition, even though there was a proliferation of different types of documents on the border after 1917, most of these remained optional documents. In fact, by 1922, the

wartime passport requirement was eliminated for travel within forty miles of the border.

U.S. officials were not primarily concerned about Mexican immigration when they issued reports concerning illegal Chinese and European immigration across the Mexican-U.S. border or developed the passport-permit system to regulate all border crossing during the First World War. However, although Immigration Bureau reports and wartime passport-permits did not focus on Mexican immigrants, they influenced the development of immigration policy on the border in ways that substantially affected Mexican migration. By introducing photographic identity documents on the border and raising concerns about security, racial liminality, and the nature of Mexican immigration, these events helped transform the "imaginary line" into a "dividing line" between the United States and Mexico.

The Dividing Line

Documentation on the Mexican-U.S. Border, 1917–34

The year 1917 marked a key moment in Mexican-U.S. border enforcement, particularly in terms of the proliferation of documentation. During this year, a range of different documents were introduced on the border: passports were required for entering aliens; compulsory identification cards were issued for agricultural laborers; weekly quarantine cards were provided to border crossers who underwent a newly instituted disinfection process; and border-crossing cards were introduced for habitual crossers on both sides of the border. At the same time, U.S. citizen identity cards were issued to border residents who made frequent trips to Mexico, and American tourist cards were created for short one-time stays in Mexico.[1]

The simultaneous implementation of passport controls and border identification was linked to concerns about both the European and Mexican wars, but it also reflected the fact that Mexican immigrants were becoming incorporated into the United States' racialized system of immigration restriction. In 1917, Mexican immigrants were made subject to the provisions of the new Immigration Act and were fully regulated for the first time under general immigration law. Although Mexican immigrants were not placed under quotas in the 1924 National Origins Act, as nonquota immigrants they were required to submit photographs to meet the new law's visa requirements. In addition, after 1928, Mexican immigrants were covered by a new rule requiring all immigrants to carry "immigrant identity cards." These documents were part of the increas-

ing regulation of the border, which attempted to control and even criminalize the casual crossings that had been part of local practices.[2]

Despite the rapid expansion of documentation on the border, local conditions—such as the strong demand for Mexican labor and longstanding practices of border crossing—contributed to an unevenness in the ways that different documents were introduced and used. Although the photographic identification of Mexicans drew on practices developed to regulate Chinese immigrants, local conditions allowed Mexicans more opportunities to negotiate the ways in which they were visually represented and regulated. However, during the course of the twentieth century photographic identity documentation became the first and most significant means through which border crossers were regulated. As more and more documentation requirements and restrictions were put in place on the border, lack of documentation became the principal reason for the rejection of most Mexican migrants.[3] Ultimately, the unevenness in the implementation of immigration documentation did not aid Mexican immigrants. By the 1930s, when their labor was not needed and their racial identities were viewed with increasing suspicion, lack of documentation was a key factor in the Immigration Bureau and other government agencies' ability to enforce Mexican repatriation.

THE 1917 IMMIGRATION ACT: RESTRICTING MEXICAN IMMIGRATION

The Immigration Act passed in February 1917 was a major development in immigration law: it not only fully incorporated Mexican immigrants under general immigration law for the first time but prevented almost all Asian immigration, banned the entry of illiterate immigrants, and instituted a substantial $8 head tax.[4] It also extended prohibitions on contract laborers and immigrants "liable to become a public charge," provisions that applied to all immigrants in the early twentieth century but had not been implemented on the border. Prior to 1917, Mexican border crossers had been examined for disease, the primary reason for their being denied entry. However, in early 1917, a typhus epidemic scare coincided with the passage of the new immigration act, leading to the implementation of an extended quarantine in El Paso as well as expanded medical inspections.[5] These new border restrictions have been explored in various histories. However, these histories have not considered the substantial role of photography or photographic documentation within the new border-crossing and immigration regulations.[6]

The immigration law and other restrictions implemented on the border in 1917 had two unintended, although not completely unexpected, effects. The restrictions increased illegal immigration and encouraged more illegal immigrants to become permanent residents in the United States. The Immigration Bureau recognized that illegal immigration increased in response to the new requirements, including the head tax, illiteracy provisions, "passport regulations and the expenses incident to securing passports, photographs, vises, etc."[7] "Aliens are advised," the chief inspector in San Antonio complained, "that it is a foolish procedure to apply legally for admission to the United States and submit themselves to the indignities of examination by the American officers, when they can go up the river 1 or 2 miles above or below Laredo and cross much cheaper."[8] George Sánchez has also shown how Mexican immigrants remained in the United States because they did not want to get caught traveling illegally back and forth across the border.[9] The commissioner general of immigration acknowledged that "it is difficult, if not impossible, to measure the illegal influx of Mexicans over the border, but everyone agrees that it is quite large."[10] In 1920, an immigration officer suggested that sixty thousand aliens had entered without inspection in the previous year just in the Laredo, Texas, region.[11] During the early twentieth century, an estimated 80 percent of all Mexican migrant workers entered the United States without documents.[12]

Although undocumented migration was the primary means of illegal immigration, border crossers did not evade these onerous new rules just by avoiding the immigration stations. Like the Chinese, some Mexicans also used the photographic identity cards issued on the border to negotiate their entry into the United States. Instead of bypassing inspection stations, these individuals would secure photographic documentation showing their right to entry, such as an agricultural laborer card or a border-crossing card, but then would choose not to work for the employer assigned on their laborer card or would choose to work even though their border permit prohibited employment. As Mae Ngai has suggested more generally, these immigrants fell outside the documented/undocumented binary sometimes used to describe illegal immigration; they were documented by the Immigration Bureau, but they rejected the legal restrictions of these documents. As a result, like Chinese immigrants who falsified their documentation, they were both documented and illegal.[13]

The bureau's primary response to widespread illegal immigration was to call for increased monitoring of the border. "There is no need of this office enlarging on the methods and manner of preventing the bringing

in of these persons from Mexico," the San Antonio chief inspector wrote to the commissioner general of immigration in Washington, D.C. "Your office is fully informed along these lines and knows that the remedy is sufficient help along the border to prevent smuggling."[14] In addition to new immigration restrictions, inspectors expressed concerns that new passport and permit controls were not being fully implemented because of insufficient funding and personnel. In its 1920 annual report, the Immigration Bureau frankly admitted that "many thousands of aliens have entered or departed" without being recorded because of such difficulties and that no permits were being issued at one border station, "owing to the inadequacy of the force, to even prepare and issue border permits of any character." This same year, border officials listed as their two enforcement priorities increasing the number of officers on the border and increasing the quality of officers.[15]

Despite the implementation of general immigration laws and photographic documentation on the border, strong countercurrents worked to preserve U.S. employer access to Mexican labor and local business access to Mexican consumers. In contrast to harsh Chinese exclusion regulations, immigration rules were specifically designed "for the entry and inspection of aliens from or through Canada and Mexico, so as not unnecessarily to delay, impede, or annoy persons in ordinary travel between the United States and said countries."[16] In addition, new requirements were not always enforced, and broad exemptions from the law were passed. The prohibition on contract labor, in particular, was openly violated.[17] After the 1917 Immigration Act implemented literacy tests and contract labor prohibitions for Mexican immigrants, these requirements were almost immediately waived for agricultural and some other laborers.

Many immigration histories have commented on the double bind of the contract labor and public charge provisions of immigration law. The contract labor clause prohibited immigrants from obtaining a labor contract prior to their arrival, but if they did not have sufficient means to support themselves until they obtained employment they could also be excluded as immigrants "liable to become a public charge."[18] Most Mexicans could have been excluded under either the contract labor or the public charge provisions. However, the fact that their labor was in demand meant that immigration officials generally overlooked these restrictions for Mexican workers. According to Inspector Braun, "The Mexicans can come and go. They know that upon crossing the border line they are received with open arms by [a labor] agent and work awaits them, work in abundance."[19] A member of the Border Patrol in Texas

also reported that during the cotton harvest they were regularly instructed by their supervisor to "shut our eyes to the most flagrant immigration violations."[20]

MEDICAL INSPECTION AND QUARANTINE ON THE BORDER

Medical inspections were increasingly strongly implemented on the border, especially after 1917. As early as 1907, the Immigration Bureau attempted to strengthen the medical inspection of immigrants at El Paso by transferring more experienced officers from Ellis Island.[21] Later, as border regulation became more focused on Mexican migration, medical procedures that had first been developed at Ellis Island were used to inspect and disinfect Mexican bodies.[22] After crossing the bridge into El Paso, aliens were checked for contagious disease and, if necessary, vaccinated.[23] According to the inspector in charge, "The majority of the second class arrivals are also bathed and deloused and their clothing and baggage fumigated by that Service."[24] Inspectors at the border adopted the categories of first- and second-class arrivals from the steamship classes used to differentiate among passengers arriving at coastal ports. As already outlined in the description of inspection procedures at Ellis Island, only "second-class" arrivals were directed through the immigration station and subject to detailed medical inspection. At the seaports, first-class ticket holders were inspected in their cabins on board ship and, if healthy, were released directly to shore. However, on the border, the distinction between these classes was based not on the tickets that they held but on the inspector's visual reading of the immigrant's appearance.[25] Race, class, and apparent health intersected in the inspector's decision to select second-class arrivals for disinfection. In 1917, for example, as the quarantine was being introduced, it was applied against "all persons of unclean appearance."[26]

Like the medical inspections at Ellis Island, the border inspection was a strongly visual expression of the inspector's power. However, although the medical inspection was modeled on Ellis Island practices, it was substantially different. During the "bathing" process at El Paso, men and women were separated by sex, completely undressed, and showered with a mixture of kerosene, soap, and water, while their clothes were chemically cleaned. Ellis Island immigrants were rarely made to undress, only if they had been individually selected for further examination. At El Paso, the bathing and vaccination process was not only a medical inspection but also a quarantine. In 1923, with the quarantine still in effect, 90 per-

cent of border crossers were defined as second class and directed through the kerosene baths.[27]

The baths and vaccinations were flash points for Mexican resistance, as immigrants and Mexican authorities protested the degrading new procedures. In January 1917, as the quarantine was being introduced, Mexican women who worked as domestics in El Paso led a demonstration against the new regulations. According to reports of the event, they were concerned not only about the safety of the baths but also about the visual exposure involved in the process. Gathering on the Mexican side of the bridge, they stopped traffic for several hours, shouting protests and sharing rumors that American soldiers photographed and distributed images of the naked, bathing women. "A moving picture man," possibly on the border to record revolutionary fighting, attempted to record the women's protest, but they evaded him, moving toward the edge of the bridge walls so that he could not get his footage.[28] Despite these protests, the quarantine was implemented in 1917. Historian Alexandra Stern describes how even though there were only five fatal cases of typhus in El Paso prior to the quarantine and three after it was implemented, the process was repeatedly extended until 1938.[29]

Both medical inspection and photographic documentation regulated the bodies of working-class ethnic Mexicans. Both were connected to the racialization of Mexican bodies on the border. However, medical inspection was a concentrated expression of power, defined by the time that immigrants were detained in the disinfection plant. In contrast, the early implementation of photographic documentation was diffuse and extended to all aspects of border crossing. Over time, it became the central means for enforcing immigration restrictions on the Mexican-U.S. border.

THE ADMISSION AND DOCUMENTATION OF AGRICULTURAL LABORERS, 1917–21

Although restrictionists had worked hard to ensure that Mexicans were included in the 1917 Immigration Act, agricultural growers strongly opposed this policy and quickly moved to ensure their continued access to Mexican labor. In May 1917, just three months after passage of the law, Secretary of Labor William Wilson waived literacy requirements, contract prohibitions, and head taxes for Mexican agricultural laborers.[30] Although less well known than the Bracero program that was instituted between 1942 and 1964, this agricultural admissions system was a model for the later labor importation program. Like the World War II Bracero

program, the admission of laborers was described as a temporary measure to meet the emergency needs of agricultural producers during a wartime labor shortage. However, this first Bracero program rapidly expanded after the Armistice and was repeatedly extended until 1921.[31] For a period during 1918 (recorded as part of fiscal year 1919 in table 2), the exemption program was expanded to include Canadian workers and additional industries. During four years, from May 1917 to March 1921, more than seventy thousand laborers were admitted to the United States under departmental exemptions.[32]

To ensure the laborers' adherence to the requirements of the exemption, Labor Secretary Wilson instituted a system of photographic identity cards to monitor their movement and employment. These cards—the first photographic identification issued to Mexicans on the border—were part of the Immigration Bureau's attempts to strengthen the border through controlling the movement of migrants. Like other aspects of this boundary delineation, the agricultural laborer identity cards focused on observing and regulating the migrant's body. However, the implementation of photographic documentation, unlike medical inspection and quarantine baths, appears to have been uneven, ineffective, and open to negotiation. Employers were primarily concerned with facilitating the entry of laborers into the United States, and they were prepared to accept documentary requirements as long as these documents expanded the labor pool and were not rigorously enforced.

At the national level, policy makers debated the agricultural exemptions to the 1917 Immigration Act in racial terms. The suspension of the law for Mexican laborers was lobbied for and supported by agricultural and industrial employers. At the same time, it was strongly opposed by nativists, restrictionists, and the American labor movement.[33] In response to congressional protests that key restrictions in the 1917 Immigration Act were being overturned by administrative order, Secretary Wilson offered a racial rationale for the necessity of this measure. He claimed that "the temporary admission to the United States of Mexicans and French-Canadians . . . is much preferable to the permanent establishment in any section of the country of large numbers of unskilled workers from the Philippines." Developing a comparison between racially liminal Mexicans and French Canadians, while reiterating the familiar opposition between temporary migrant labor and permanent Oriental colonies in the continental United States, the secretary continued that the Department of Labor was being inundated with calls for "common labor" from Asia, particularly China and the Philippines. He dismissed the possibility of

TABLE 2. MEXICAN LABORERS ADMISSIONS PROGRAM, 1917–21

Fiscal Year	Total Admitted	Presently Employed	Returned to Mexico	Residence Legalized	Died	Deserted (number)	Deserted (%)
1917	475	53	196	0	0	226	48%
1918	8,445	2,246	3,964	1	67	2,167	26%
1919	10,491	3,492	4,110	0	98	2,791	27%
1920	21,289	13,813	4,530	9	43	2,894	14%
1921	32,162	15,632	22,122	484	206	13,322	41%
Total	72,862	N/A	34,922	494	414	21,400	29%

SOURCE: *Annual Reports of the Commissioner General of Immigration for the Fiscal Years 1920–1921* (Washington, DC: Government Printing Office). The Immigration Bureau issued a ruling in 1920 allowing literate aliens admitted under the program to pay the head tax and have their status changed to legalized permanent residence. The number of "presently employed" laborers (1921) includes laborers from all years who "so far as can be ascertained" were "still in the employ of the original importers" in 1921. Other figures from 1921 were calculated from the Immigration Bureau's total figures (reported in 1921) and may not reflect the exact year during which, for example, laborers died or deserted.

importing Chinese labor (because of the exclusion acts) and continued that Mexican labor was preferable precisely because it could be "regulated and controlled to a very large degree."[34] Whereas Filipinos, as U.S. nationals, had rights of residence and therefore should be encouraged not to reside in the United States, Mexicans were legally foreign and could be controlled to ensure that they remained strictly temporary. "We have," Secretary Wilson wrote in rejecting calls for Asian labor, "all the race problems in the United States that it is advisable for us to undertake to deal with at the present time."[35] Nativists, however, disagreed with Wilson's perspective. They considered Mexicans cheap, unassimilable labor, a race problem similar to the problem of Asian immigrants.[36]

Such concerns about control and permanent settlement were not completely resolved against Asian labor. In 1918, the commissioner general of immigration reported favorably to Secretary Wilson on the importation of laborers from U.S. possessions, such as the Philippines, Puerto Rico, and the Virgin Islands, to meet emergency labor needs as part of the U.S. war effort. In an apparent reversal of his earlier expressed concerns, Wilson requested information from the War Department regarding the transportation of laborers from these colonial possessions. In this letter, he noted that "in addition to meeting the very urgent needs for common labor in connection with the conduct of the war, this plan might be made to produce very valuable incidental results in the way of benefitting the inhabitants of the insular possessions and binding them more closely to this country."[37]

Although Secretary Wilson drew a sharp division between Chinese and Mexican labor, the mechanism through which he planned to control Mexican labor migration was a process of registration and photographic identity documentation that drew on the Immigration Bureau's experience with regulating the presence of exempt Chinese in the United States. When photographic identification cards were introduced on the Mexican-U.S. border in 1917, there were far fewer debates about their acceptability than when they were first introduced for Chinese migrants in 1893. However, the limited discussion about border photographs referenced the implementation of Chinese exclusion. In a 1918 memo concerning the agricultural labor shortage in Texas, Arizona, and California, a Labor Department official questioned the necessity and legality of photographing Mexican laborers. "I do not see the necessity for photographing these aliens," J. B. Dunsmore wrote to another staff person in the department, "and call your attention to the fact that the Federal Courts have held it is unlawful to take such photographs, except in the case of Chinese, and

then only under the authority given in the Chinese Exclusion Act."[38] By 1918, twenty-five years after its statutory implementation under Chinese exclusion, photographic immigration documentation had become almost exclusively associated with the Chinese.

Whereas Chinese opposition to photographic documentation focused on personal and community concerns about being harassed and marked as criminals, concerns about Mexicans' photographic requirements were framed in terms of their availability as laborers. In language that was later repeated by immigration officials requesting waivers for photographs on border-crossing cards, Dunsmore added that "requiring photographs of Mexican aliens applying for admission creates an unnecessary expense which they are unable to bear, and places an insurmountable object in the way of securing such labor."[39] As the head of the U.S. Food Administration during the war, Herbert Hoover wrote to Assistant Labor Secretary Felix Frankfurter requesting that the department remove various restrictions on exempt agricultural laborers, including the requirement of photographic identification. "The Mexican has a primitive suspicion of the camera," Hoover wrote, "and besides has been given the idea that this proceeding is to net him into the Draft." Claiming that "this one feature" of the rules was a particular deterrent to immigration, Hoover mixed the racialized notion of Mexican primitivism with Mexican laborers' understandable concern about their exemption from the U.S. draft.[40] In fact, as foreign nationals, Mexican citizens were required to register with U.S. draft boards in order to show that they need not serve. However, this registration process itself caused concern.[41]

In addition to some government officials, El Paso's business community expressed concerns about the documentary requirements. When five hundred laborers arrived in Juárez in 1918, the El Paso Times reported that they had to wait for an extended period while U.S. officials completed their forms and took their photographs. The newspaper argued that the procedures were unnecessarily long and prevented employers from meeting their immediate needs for laborers.[42] These objections may suggest why photographic requirements were not initially extended on the border beyond the agricultural admissions program and the noncompulsory border-crossing cards, discussed later in this chapter: such requirements were opposed by politically powerful, large-scale agricultural employers and their supporters.

Despite such opposition, immigration officials strongly supported the necessity of photographs on identity documentation, especially for the imperative of ensuring wartime national security. When Representative

William McAdoo (NJ) questioned the use of photographs, Labor Secretary Wilson responded that they were "absolutely necessary in passport regulations to protect us from enemy intrigue."[43] Although their reliability had been unsettled by cases of illegal Chinese immigration, photographs remained the most acceptable and widespread means of linking an individual to documentation of his or her identity.

Agricultural laborer cards were issued for a period of six months and were similar to the other photographic identity documents issued on the border. In fact, the Immigration Bureau typically used optional border-crossing cards, described later, with "an appropriate notation thereon to show that the holder is temporarily admitted to the United States . . . to engage in agricultural labor."[44] The laborer's employer was required to provide "clear, untouched" photographs for the card "of sufficient size to render identification easy."[45] The bureau retained one copy of the card and returned the other to the employer for delivery to the admitted alien. Whether or not the card was actually given to the laborer, this arrangement reveals the ways that temporary admission was an agreement between the Immigration Bureau and the employer. The laborer himself was excluded from this agreement; his presence was not required. Instead, the laborer's body was represented by the photograph that recorded his identity for the Immigration Bureau and the documentation that permitted him to work for the agricultural employer.

Although the administration of the agricultural exemption program excluded the worker, Mexicans laboring under its auspices were able to exploit the differing goals of their employers and the Immigration Bureau in order to secure better work and wages for themselves. Mexican laborers who had entered the country legally could remain as documented, illegal immigrants because of lax enforcement of the program by the Immigration Bureau and inadequate reporting by employers. Relying on figures provided by agricultural employers, the Immigration Bureau reported that about one-quarter of the imported laborers deserted the program, typically leaving because they could earn better money and enjoy better housing with employers paying higher local wages. The Immigration Bureau did not fully trust these employer reports and suspected that the number of deserters was higher, since it was in the employers' interests to represent that the program was being effectively implemented.[46]

Although the Immigration Bureau required photographic clarity and legibility, there were no inspectors to review the cards or monitor the employers after the laborers were admitted. Once Mexican laborers entered the United States, they were largely unregulated and invisible. De-

spite the photographic identity and reporting requirements, the bureau acknowledged little success in controlling or even monitoring the movements of laborers. In his concluding report on the program, the commissioner general claimed that a "considerable percentage" of deserters probably returned to Mexico because of lower labor demand in the U.S. border states. However, he had no evidence to support this speculation. Ten years after Inspector Seraphic had called for interior enforcement in his report on border conditions, the Immigration Bureau continued to show little interest in monitoring Mexican documentation or controlling Mexican migrants once they had crossed the border.[47]

CONTROLLING THE ARMY OF THIRSTY TOURISTS, 1921–22

After the conclusion of both the Mexican revolutionary and European wars, El Paso business leaders expressed their concerns about passport regulations, including the border-crossing identity cards that were frequently referred to as passports, since the profitability of their businesses depended on free movement of consumers across the border. In 1921, the El Paso Chamber of Commerce urged that "every effort be made to eliminate passports" and passport fees for Mexicans entering the United States. With peace treaties signed in Paris and the tumult of the Mexican Revolution coming to an end, the chamber claimed that this was an opportune time to end documentary border controls.[48] The chamber's position was supported by Representative Claude Hudspeth (TX), who argued, according to the El Paso Herald, that the "irksome passport restrictions . . . are a hindrance to trade with Mexico and a source of annoyance to the people."[49]

In practice, the process through which wartime restrictions were removed on both sides of the border was complicated by concerns about parity and security. On July 13, 1921, President Harding issued an executive order lifting passport controls, effective once similar restrictions were removed by the Mexican government. If implemented, the order would end the use of border identity documents for U.S. and Mexican citizens who lived and traveled within forty miles on each side of the border. The new rules would also end the practice of requiring consular and immigration fees. The intent of the proclamation was to reestablish the passport-free zone that had existed in the border region prior to 1917.[50]

Initially, following a meeting of federal, city, and chamber of commerce officials from both sides of the border, Mexico reciprocated by removing its passport requirements. However, Mexican officials continued to

have reservations about the United States' wording and implementation of the agreement: according to Mexico, the U.S. restrictions had been lifted only for border crossers whose identities were already known to American immigration officials, and these officials demanded identification (not necessarily passports) to prove that other crossers were Mexican citizens who lived in the border region. In response, Mexican officials required passports from Americans, sometimes allowing them to pay their toll to cross the international bridge before informing them of the requirement. This tit-for-tat diplomacy was fostered by Mexican demands for equal treatment and a position of relative power within the dispute, given the fact that many U.S. citizens wished to travel to Mexico.[51] As the Immigration Bureau noted after the passage of Prohibition in 1920, an army of thirsty tourists "laid siege to the border, an army of approximately some 400,000 strong."[52]

The Mexican response may have been partly informed by its interest in passport fees from Americans who crossed the border to drink legally, as was reported in U.S. newspapers. However, the Mexican consul also noted significant concerns about the equal treatment of its citizens traveling to the United States. In early 1921 prior to the lifting of restrictions, Mexican tourists were charged $18 in U.S. consular and immigration fees, whereas American tourists were charged only modest Mexican consular fees. "The Mexican government does not believe removal of border restrictions involves merely dollars and cents," Consul Luis Montes de Oca wrote in the *El Paso Herald,* "but a principle."[53]

However important the principle, the complex responses of the U.S. and Mexican authorities were also the result of the difficulties of identification and documentation. Only local residents were covered by the passport-free zone; American tourists were still required to obtain visaed permits from Mexican government, and Mexican residents had to prove to U.S. authorities that they lived within forty miles of the border. However, without official documentation or personal familiarity, it was impossible to tell a tourist from a local resident. In fact, on the border, as throughout much of the U.S. Southwest, it was impossible to tell who was a U.S. citizen and who was a Mexican national: extended families lived on both sides of the line, and racial assumptions about citizenship, though broadly held, were often deceptive.

Although the passport dispute lasted almost seven months, from July 1921 until February 1922, it was finally resolved by the broad removal of restrictions on travel in the region. As the experience of regulating the Chinese had proven, as long as some groups of Chinese were not required

to carry documentation, all Chinese might be able to evade documentary requirements. With Chinese exclusion, all U.S. residents of Chinese descent—including U.S. citizens—were required to carry photographic documentation. On the border, policies moved in a different direction: in 1922, federal authorities determined that no border crossers would be required to provide documentary evidence of their identity.[54] These policies remained in place until 1926, when the Mexican government instituted new policies that required U.S. border crossers to use their passports or obtain Mexican-government border-crossing cards.[55]

BORDER PERMITS AND U.S. CITIZEN IDENTITY CARDS, 1917–28

Like public health and immigration restrictions, and part of them, migration documentation was centrally associated with the new restrictions on the border. The changing requirements for photographic identity documentation marked the changing administration of the border. Despite the shifting documentary requirements on the border, applicants to enter the United States were still investigated to ensure that they met the requirements of immigration law. As a result, there was still demand for the optional documents certifying that the holders had met these requirements and enabling them to bypass repeated investigations.

Border permits were the primary form of documentation issued to local Mexican users (figure 55).[56] Also known as border-crossing cards, alien identification cards, local passports, or just passports, these permits were issued to Mexicans who resided in the communities on both sides of the Mexican-U.S. border and who frequently crossed the international boundary. Border permits were introduced in 1917 and had to be renewed annually. The cards were issued after an initial Immigration Bureau investigation to determine eligibility and contained a photograph to identify their holders. They allowed local residents to avoid repeated immigration investigations each time they crossed the border to shop, visit friends and family, or conduct other business. The Immigration Bureau described the border permit procedure as follows:

> An officer on duty quickly glances at a crossing card when presented, compares the photograph and description with the alien, and if it appears to be in the hands of the right person and there is no evidence of substitution or alteration, the alien is permitted to proceed; aliens not holding such cards and who are not personally known to the officers to be entitled to enter the United States are sent into the immigration office for further

inspection; and thus it is possible for a few officers to handle a line of 15,000 or 20,000 persons daily without serious congestion.[57]

In essence, border permits allowed crossers to continue some of the typical crossing practices prior to the implementation of the 1917 Immigration Act on the Mexican-U.S. border. However, permit holders were still subject to medical inspection, disinfection baths, and delousing in order to obtain their weekly quarantine cards and were required to show their quarantine cards each time they crossed into the United States.

Border cards did not permit their holders to work in the United States. Until the 1920s, however, there was little regulation of border crossers, and it appears that many Mexicans did use their border-crossing privileges to work in the United States. Before the introduction of border permits, one immigration inspector estimated that between five hundred and six hundred Juárez residents worked in El Paso in addition to other Mexican residents working in other communities along the border.[58] In an interview with anthropologist Manuel Gamio in the 1920s, Pedro Villamil described how his family lived in Juárez but worked in El Paso for six months: he and his brother commuted to the El Paso foundry, while Villamil's aunt worked as a maid in a hotel.[59]

The border permits were officially issued to "aliens" resident in Mexico and the United States. However, on the Mexican-U.S. border, these aliens were almost exclusively Mexicans. When Chinese immigrants applied for crossing cards, the bureau was initially loath to provide them on the grounds that it could facilitate easier movement for Chinese and thus increase the possibility of smuggling and other illegal activities. However, in 1922, as border permits became more widely used, their privileges were also extended to a few Chinese merchants who lived in Mexico and who were known to immigration officers, either personally or "by sight."[60]

While border permits were issued only to aliens, U.S. citizens who lived in the border region and had legitimate business in Mexico were issued citizen identity cards that allowed them to travel within the Mexican border region (figure 56). These citizen identity cards were first issued in 1918 at the same time as wartime passport-permit restrictions, but they continued to be issued after the war's conclusion.[61] U.S. citizens were allowed to use such identity cards in place of passports for travel within ten miles of the international boundary. During strict wartime controls, passports or citizen identity cards were required of all citizens crossing the border. However, in the postwar period, the identity cards, like Mexican border permits, were optional.

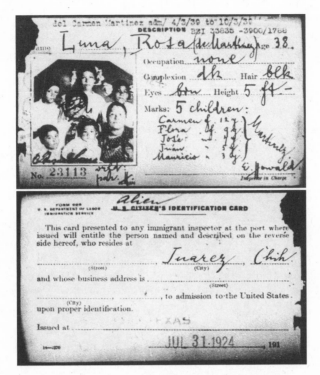

Figure 55. Rosa (de Martinez) Luna, Alien Identifica-
tion Card (border permit), National Archives Microfilm
Publication A3406, Nonstatistical Manifests and Statisti-
cal Index Cards of Aliens Arriving at El Paso, Texas,
1905–1927, Roll 68, July 31, 1924. Records of the U.S.
Immigration and Naturalization Service (Record Group
85), National Archives and Records Administration,
Washington, D.C.

Official figures do not specify the race of U.S. citizens who obtained
identity cards after the war. U.S. citizens of Chinese descent were issued
the cards, which, at least in policy, allowed them "to cross and recross
the boundary . . . practically at will and without molestation."[62] How-
ever, it seems likely that the majority of cards were issued to U.S. citi-
zens of Mexican descent. Mexican Americans obtained U.S. citizen bor-
der permits because their appearance coded them as Mexicans rather than
Americans. In the Immigration Bureau's exclusionary logic of identity,
one could not look both Mexican and American. In a lecture about bor-
der procedures, an immigration official noted that thousands of Mexi-
can American citizens were "glad to avail themselves of this privilege, so

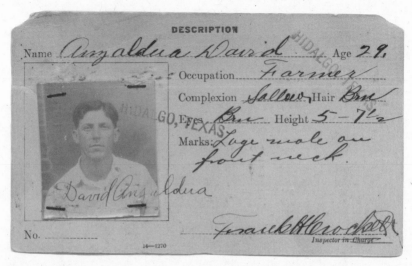

Figure 56. David Anzaldua, U.S. Citizen's Identification Card, November 8, 1924, Hidalgo, Texas, U.S. Citizenship and Immigration Services History Office and Library, Washington, D.C.

that their alien appearance may not subject them to delay when entering the United States."[63] By delaying Mexican Americans crossing the border and describing their appearance as alien, the bureau both accepted and enforced the equation of U.S. citizenship with whiteness.[64]

In the racial and class hierarchies of the borderlands, ethnic Mexicans, particularly those who were coded as working class or indigenous, faced questions about their U.S. citizenship, while U.S. citizens of western European descent expected to cross the border without harassment. In one case in 1925, Charles Geck, a naturalized U.S. citizen of French descent who lived in Sonora, Mexico, complained bitterly about being questioned regarding his citizenship. Asked whether he had a passport, Geck told the inspector: "I did not, I told him that I had a passport when we were at war, when everyone was required to carry a passport, but that I did not know that an American citizen was required to carry a passport now in order to cross back and forth between Mexico and the United States, that I had been crossing the international line now for about the last 18 years, and at almost every port along the line and that he was the first man to doubt my veracity as to my citizenship." Geck continued that the inspector "then asked me what my occupation was, what I did for a livelihood, and a lot of other foolish and irrelevant questions and finally after considerable hesitation he let me pass."

Geck's complaint was directed generally at the stringent administration of immigration law under a new chief inspector in Naco, Arizona; however, his anger in this particular situation also seems to have been aroused by the fact that his questioner was "an Americanized Mexican," the only person who remains unnamed, marked only by his race, in his complaint.[65] As a white American and longtime resident of the region, Geck was adamant about both his right to cross the border without documentation and the visual certainty of his citizenship, which he assumed could be read without recourse to documentation. In contrast, he viewed the immigration inspector, despite his role as a representative of the U.S. government, through his racial rather than national identity: a Mexican who was Americanized rather than an American of Mexican descent.

Not only white Americans but also elite Mexicans complained about being subject to new immigration restrictions and documentation requirements. Mexican diplomats, like their counterparts in the Chinese consulate, objected to suggestions that they obtain identification cards. Invoking a respectable class position and official status, the Mexican consul suggested that requests for identification were "considered impolite."[66]

Despite their efforts to regulate habitual border crossing, Immigration Bureau officials acknowledged that initially "we had a hard time persuading the local crossers to get the cards."[67] In 1919, the agency issued approximately thirty-five thousand crossing cards for limited travel on both sides of the boundary line, including almost thirteen thousand cards for Mexicans resident in the United States and more than twenty-two thousand cards for Mexicans resident in Mexico. In the same year, more than fifteen thousand American citizens who lived in the United States and 362 who lived in Mexico obtained citizen's identity cards for border travel. However, almost forty-eight thousand "aliens without border permits" were examined under passport regulations.[68] Many local residents who did not obtain crossing cards avoided the hardship of repeated immigration investigations either by avoiding the immigration stations and entering illegally, as the Immigration Bureau believed, or by making less frequent shopping trips to the United States, as American border businesses and chambers of commerce maintained.[69]

Unlike medical inspections for Mexican border crossers and identity documents for Chinese entrants, photographic border-crossing cards were never compulsory during peacetime. Border officials recognized that "while theoretically these cards are for the convenience of the aliens, we perhaps derive more benefit from them that they do."[70] From the introduction of the cards through at least the 1930s, there were simply too

few immigrant inspectors to thoroughly inspect every local crosser if none of them chose to use border permits. Therefore, Mexican residents had some limited opportunities to negotiate the ways in which their border permits were used.

Officials at smaller stations along the border wrote to larger district offices requesting exemptions from the rules to facilitate border crossing, and district offices wrote to the national office requesting the same. The El Paso and Galveston district directors, for example, aligned with local residents to oppose the central bureau's suggestion that they charge fees to issue the cards. "One of the objections in the past has been the cost of photographs," the Galveston director wrote, "and to charge a fee in addition would result in many more refusing to take out the cards."[71] At other times, cardholders did not use the required photographs at all. Border officials in rural locations wrote to the district office in El Paso requesting exemptions from the photographic requirements. Explaining the lack of local photographers, the expense of obtaining photographs, and the financial hardship of area residents, these officials suggested issuing cards with fingerprints or without any biometric identification. Harold Brown, the immigration inspector in Columbus, New Mexico, emphasized that his port had issued few cards because the residents of Palomas, Chihuahua, "are very poor and really cannot pay the price demanded for passport photos such as are required for non-resident identification cards." As an alternative, he requested that the right thumb print be used in the space provided for the photograph on the identification card.[72] As late as 1937, the lone immigration officer in Sasabe, Arizona, implicitly acknowledged his informal attitude toward frequent border crossers, commenting that "at the present time, the U.S. Immigration office is situated where the aliens need not pass it . . . but the new inspection station is located within 60 feet of the line."[73] Since he would now be required to inspect frequent crossers, he requested that they be issued temporary crossing cards without photographs. His request was approved.

THE VISA ACT AND THE BORDER PATROL, 1924–30

Throughout the 1920s, there continued to be a split in the Immigration Bureau's regulation of Mexican and non-Mexican migration on the border. After the passage of racialized immigration quotas in 1921 and 1924, the border became a key site for the illegal immigration of European immigrants excluded by the strict new racial quota system.[74] The Border

Patrol was established in 1924 not only to prevent the entry of illegal Chinese immigrants, Mexican immigrants, and bootlegged liquor but also to control this new source of illegal European immigration. One immigration official described the patrol as the "first line of defense against the army of aliens who, unable to obtain admission to the country by legal means, attempt to enter illegally."[75] Another patrolman remembered that "the thing that established the Border Patrol was the influx of European aliens."[76] At the end of its first year, the Border Patrol had 450 employees, a number that almost doubled to 805 by 1930.[77]

Europeans who were not able to enter under the strict new quota limits resorted to various tactics to enter the United States illegally. Many of these tactics, as well as some of the smuggling networks that helped them to cross the border, had been previously used by Chinese immigrants.[78] As Libby Garland explores in her study of illegal Jewish immigration, Jews who were unable to secure permission to leave from governmental authorities in Russia and Poland during the early twentieth century sometimes resorted to fake documentation. A young Polish immigrant, for example, had his photograph placed on another person's passport in Berlin. He was detected attempting to cross the border at El Paso when U.S. immigration officials became suspicious of his travel documentation.[79] The quota laws included an exemption for children under eighteen similar to the exemption for Chinese children of merchants and native-born U.S. citizens. As a result, some immigrants used fake birth certificates to falsify the birth years of their children. Although less elaborate than the Chinese paper son system, these evasions operated on a similar principle.[80] In still other cases, European immigrants arrested for being illegally in the United States claimed to be legal immigrants. To support this claim, an immigrant might present the passport of a legal immigrant in which the identity photograph had either been altered or replaced by a photograph of the illegal immigrant. As with the Chinese, the Immigration Bureau maintained that "the alien under arrest had been carefully coached, so that his apparent knowledge of the person he was impersonating, of his family and business connections . . . was almost convincing." As in their investigations of Chinese arrivals, immigration officials searched the legal immigrant's "accustomed haunts," hoping to compare this individual with the passport photograph. However, according to immigration officials, the immigrant would deliberately hide from them so that "only the most searching inquiry established the deception and attempted fraud."[81]

Although the 1924 law is now commonly known as the National Ori-

gins Act, in the 1920s it was also described as "the Visa Act." Unlike to-
day's visas, typically a stamp in a passport, early visas were often pack-
ets, including the Foreign Service form, a photograph, and vital docu-
ments (figure 57).[82] For the first time in general immigration law, the act
implemented substantial documentary requirements for all immigrants.
In addition to providing detailed personal information, the law required
that each immigrant provide a valid passport, a certificate of medical ex-
amination, two unmounted passport photographs, "two copies of his
'dossier' and prison and military record, two certified copies of his birth
certificate, and two copies of all other available public records concern-
ing him kept by the Government to whom he owes allegiance."[83] These
requirements were based on and similar to the extensive documentary
requirements under Chinese exclusion. As with the Chinese exclusion
laws, a permit to reenter was provided for departing immigrants: immi-
grants could apply for a visa abroad if they had not obtained a reentry
permit prior to their departure, but this process was more difficult and
expensive.[84]

Western hemispheric immigration was not included under the quota
allotments, but the law changed the regulation of Mexican immigration
just as earlier expansions of immigration law had done.[85] As one border
patrolman acknowledged, the Visa Act "kinda put another obstacle for
them," since immigrants now had to pay $10 for an immigrant visa from
the American consul in addition to the $8 head tax that had been intro-
duced in 1917.[86] In its annual report, the Immigration Bureau officially
recognized that the stringency of new passport regulations and immi-
gration laws increased illegal immigration across U.S. land borders. The
1921 law, the bureau report noted, proved a "prolific promoter of smug-
gling and border running in general."[87]

Between 1917 and the implementation of visa requirements for Mex-
icans, the primary reasons for Mexican rejection at the border were that
immigrants were "liable to become a public charge," had medical dis-
barments, or were illiterate. However, after the 1924 introduction of visas
for Mexicans, the numbers of debarred Mexicans increased dramatically,
with lack of immigration visas constituting the reason for almost the en-
tire increase. In 1926, almost twice as many Mexicans were debarred,
not allowed to enter the United States, for lack of visas (726) as for lack
of the means to support themselves (395). The following year, lack of
visa documentation became an even more significant reason for rejec-
tion, with 1,356 Mexicans rejected for visa reasons and only 206 con-
sidered liable to become a public charge.[88]

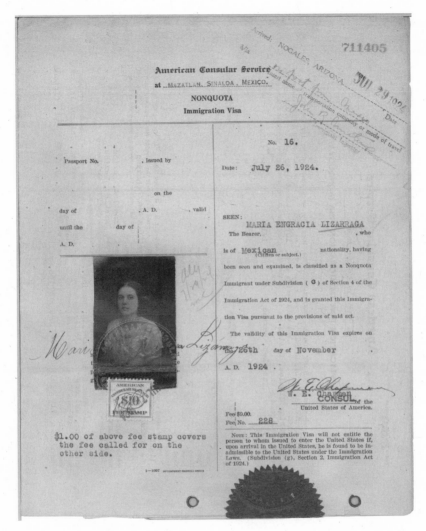

Figure 57. Maria Engracia Lizarraga, Visa 711405, July 26, 1924, Arizona. 85–52A172. Records of the U.S. Immigration and Naturalization Service (Record Group 85), National Archives and Records Administration, Washington, D.C.

Despite these changes, the Immigration Bureau continued to regulate Mexican migration somewhat loosely. In 1924, José Rayle was issued a nonquota immigration visa by the American vice consul in Mexicali, Mexico. Rayle did not have a passport or any other documentation. However, in the space on the form provided for a list of "documents required by the Immigration Act of 1924," the vice consul wrote that Rayle was

"well-known both sides of line."[89] Many other immigrants received visas without providing documents to the U.S. authorities, some with no explanation and others with affidavits that explained why they could not provide documentation.[90]

After 1924, there was a hardening of attitudes toward all forms of organized illegal immigration across border, including Mexican migration. In the 1910s, when the Mexican-U.S. border was first becoming more clearly defined, the Immigration Bureau suggested that many illegal migrants probably did not need to enter illegally but were duped by smugglers. In 1923, El Paso officials expressed concern that at peak seasons the slow pace of inspection meant that "hundreds, even thousands" of laborers were forced to wait weeks for legal entry. "In the meantime," the officials noted, "their slender resources become exhausted, and, though willing to stand inspection and pay head tax, they are forced to resort to illegal entry to avoid starvation."[91] By the late 1920s, however, the bureau stressed that bootlegged immigrants were of the worst class because they a priori had no respect for American law.[92]

Although U.S. authorities initiated and continually pushed for increased regulation of the border, the inspection process was not entirely one-sided. Mexican migration officers were also posted at the border to regulate traffic into and out of Mexico. Like U.S. officials, they checked passports and questioned border crossers. In 1926, the Mexican government introduced an immigration law that required departing Mexicans to complete a detailed form and supply three photographs to the Migration Office. To avoid the problem that earlier U.S. laws had created with Mexicans stranded on the border, the Mexican Migration Service also required emigrants to pass a physical exam and have sufficient travel funds.[93]

Changing American attitudes toward Mexican migration during the 1920s were accompanied by changes in U.S. law and large increases in apprehensions and deportations of undocumented Mexicans. In late 1928 and early 1929, new laws on immigration violations required that "any person who had been previously deported from the United States could not thereafter reenter the United States."[94] As the Border Patrol increasingly focused on illegal Mexican migration, the numbers of apprehended aliens increased from over ten thousand in 1927 to almost thirty thousand in 1929. Between 1925 and 1931, the number of formally deported Mexicans increased from 1,751 to 8,335. Almost half were deported for entering without inspection or valid documentation.[95] One Border Patrol officer described the pressure for apprehensions but expressed his prefer-

ence for preventing Mexicans from entering the United States rather than deporting them. "On paper, it doesn't look as good, because you're not making the number of apprehensions," he explained, but "it's better for them and better for us if they don't come here in the first place."[96]

In 1927, the Immigration Service issued General Order Number 86, which reclassified as immigrants those local crossers who worked in the United States while living in Mexico or Canada.[97] The order created a more clear distinction between immigrants and nonimmigrants on the border, a distinction that was represented in the creation of immigrant and nonimmigrant identification cards. However, the implementation of these rules was sometimes erratic. Mexican border crossers who weren't sure whether they wanted to immigrate permanently or just cross temporarily for work were sometimes told to enter without completing immigration papers and to legalize their status as immigrants if they decided to remain.[98]

As immigrants faced increasing pressures from new rules and as they resided longer in the United States, some decided to legalize their status. For these immigrants, legal status was equated with documentation. Eutimia Mercado had lived in El Paso for nine years before she decided in 1923, "I had to emigrate and ... I had to carry a passport."[99] Jesús Pérez entered illegally in 1923, but "in 1928 when immigration became very tough," he spoke to his wife about legalizing his status. "Listen," he told her, "I am going to risk it, to see if I can arrange my passport." He returned to Mexico and "arrived at immigration from the other side." After "seven long days" his passport was approved and he became a legal resident.[100] The prevalence of undocumented Mexican immigration is highlighted by the case of Maria Zamora de Garcia, who immigrated to the United States in 1918 without registering or paying the requisite head tax. In 1924, settled and married with three children, she decided to legalize her immigration status and the status of her Mexican-born child by traveling to Nogales, Arizona, stepping over the border into Mexico, and returning to resume her residence in the United States. She was accompanied by her husband and brought with her an affidavit from his employer attesting to his character and requesting assistance from the Immigration Bureau. His employer was the U.S. Consular Service.[101] In 1929, as part of a voluntary registration act, undocumented immigrants of good moral character who had immigrated prior to June 1921 were authorized to legalize their status. However, although Mexican immigrants were eligible for such legalization, it appears that many were unaware of the law or unable to fulfill the requirements, which included

documenting their residence, providing two witnesses, paying a $20 fee, and submitting ten passport-size photographs.[102]

The expansion of identity documents on the border brought some of the same problems that inspectors saw with Chinese identification under exclusion and with European documents under the 1924 Visa Act. The *El Paso Herald* reported that passports were investigated for a range of reasons: "The majority of them are out of date, some of them are faked and others simply altered to fit the occasion."[103] In addition, the national office of the Immigration Bureau was concerned about "numerous frauds committed on the border by aliens who substitute photographs and forge signatures and alter entries" on their border permits.[104] The El Paso district director questioned whether individuals frequently used border-crossing cards to enter the United States as immigrants, since it marked them and placed their names on record with the Immigration Bureau.[105] However, he distinguished between law-abiding individuals and smugglers who made "considerable use of nonimmigrant crossing cards . . . for the purpose of getting immigrant aliens across the International Line."[106] Border inspectors were also familiar with the problems that Pacific Coast inspectors experienced with the Chinese, citing these experiences in response to a conference about improving the security of border-crossing cards.[107]

With the establishment of the Border Patrol and the increasing documentation of both immigrant and non-immigrant Mexicans, local residents were increasingly pressured to obtain border permits. By 1929, border permits had become far more widely used and better accepted, both because other forms of documentation had become the norm on the border and because border crossers had fewer options of entering the country without being documented. In this year, the Immigration Bureau issued almost 222,000 alien identification or border-crossing cards, with about one-quarter issued to Mexicans in the United States (65,000) and three-quarters to Mexicans living in Mexico (157,000).[108]

Starting in 1928, and closely related to the increase in illegal Mexican migration, the U.S. government implemented a policy of limiting Mexican immigrants by controlling the visas given through U.S. consular offices.[109] The policy was expanded to include Canadians and other immigrants in 1930. Under this administrative action, consular officials closely scrutinized quota and nonquota applicants to ensure that none of the immigrants were "liable to become a public charge." Given rising unemployment during the Great Depression, this long-standing law created a high standard for immigrants. Although the law itself had not changed, the "work in abundance" that Inspector Marcus Braun had de-

scribed waiting for Mexican laborers as soon as they crossed the border in the early 1900s no longer existed. However, the strict implementation also led to legitimate applicants' being rejected. In January 1932, U.S. officials in Mexico issued 96 percent fewer visas than in January 1928, the last month before the new policy was introduced.[110]

The introduction of identity cards for all new immigrants in 1928 was also accompanied by expanded documentation for immigrants on the border. Mexican immigrants newly had to provide U.S. immigration officials with their birth and marriage certificates, as well as papers signed by their hometown mayor or certificates from Mexican police authorities stating that they did not have a criminal record. The Mexican consul in El Paso expressed his concern about these new documentary requirements and the hardships they could create for immigrants, who had to wait up to two weeks to obtain the documents and cross the border.[111] According to sociologist Paul Taylor, who studied Mexican agricultural laborers at the time, immigration officials deliberately "built up the problems of providing documentation." Rather than making statutory changes, this administrative policy "gave the restrictionists what they wanted [and] . . . saved face with the Mexicans and Latin Americans who didn't want their restriction written on the statute books."[112]

THE ROLE OF DOCUMENTATION IN REPATRIATION, 1931–34

Mexicans and Mexican Americans alike experienced the increased atmosphere of hostility during the Depression. In 1931, Cleofas Calleros, the Mexican border representative of the National Catholic Welfare Conference who described the openness of border crossing prior to 1917, was stopped and interrogated in El Paso. Later that day he delivered a short letter to the Border Patrol expressing his deep resentment of his treatment, "the questions propounded at me and the insinuations of a uniformed Border Patrol Inspector," stating that the inspector owed him an apology.[113] Less elite Mexicans faced even greater difficulties. Blamed for the Depression by federal officials and facing increasingly hostile popular opinion, ethnic Mexicans were often the first to lose their jobs regardless of whether they were U.S. citizens or immigrants.[114]

In response to widespread anti-Mexican attitudes, a number of state and local governments implemented Mexican repatriation programs. Drawing little distinction between legal immigrants, illegal immigrants, and citizens of Mexican descent, these programs typically threatened to

remove Mexicans from relief rolls and then offered them free transportation to the border. The Mexican government coordinated with some local governments and made offers of support to its returning citizens. Spurred by the lack of opportunities in the United States and the hope of assistance in Mexico, many immigrants and their families, as many as 60 percent of whom were children or U.S. citizens, opted to return.[115] As it was for new arrivals in the 1920s, El Paso was a major crossing point for repatriated Mexicans in the early 1930s.[116] However, any initial enthusiasm subsided as the first wave of returnees contacted their compatriots who told them that conditions were no better in Mexico, the Mexican government was not meeting its promises of assistance, and the journey itself was not entirely voluntary. "I don't know how they could believe it would be easier to live in Mexico than here," José Cruz Burciaga commented, in an oral history, about his relatives who had repatriated.[117] As Mexicans became less interested in returning and the Mexican consuls withdrew their support for repatriation programs, local authorities applied more pressure and more coercive techniques to force them to leave. In total, an estimated four hundred thousand Mexicans were repatriated.[118]

Mexicans with no immigration documentation or without the appropriate documentation were most vulnerable to repatriation pressures. According to Patrick Ettinger's research on repatriation in Gary, Indiana, "Several informants remembered that authorities at times had exploited a Mexican individual or family's uncertain immigration status to exert pressure on them to leave the community."[119] In oral history interviews, El Paso residents shared the same understanding that repatriation had often been connected to a lack of official papers.[120]

In addition to the voluntary repatriation programs initiated by local governments, the Immigration Bureau increased and expanded its enforcement of immigration regulations. Throughout the country, the bureau engaged in a series of raids to identify and deport undocumented Mexicans. However, as Francisco Balderrama and Raymond Rodríguez argue, "All Mexicans, whether legal or illegal, looked alike to immigration officials." In 1931, bureau officials conducted a highly publicized raid of the Plaza in Los Angeles, a popular gathering place at the heart of the Mexican community. Officials rounded up about four hundred people, demanded documentary proof of their legal status, and held approximately thirty Mexicans as well as five Chinese suspects.[121] In other cases, as in the bureau's Chinatown raids and "censuses," immigration officials traveled to heavily Mexican communities and knocked on every

door demanding documentation. If the residents could not prove their legal immigration status, they were arrested and jailed.[122] In 1934, the bureau also began a campaign to detain Juárez residents who used border-crossing cards to work in El Paso in violation of regulations.[123] These federal government efforts were distinct from locally initiated repatriation programs because they deported immigrants in violation of immigration law rather than pushing them to return as part of a voluntary repatriation campaign. However, both repatriation and deportation contributed to the increasingly hostile environment for all ethnic Mexicans during the Great Depression. José Cruz Burciaga captures the mixture of coercion and volition, the forced choices, involved in repatriation when he notes that his family members were "deported voluntarily."[124]

As Camille Guerin-Gonzales has shown, "Repatriation exposed the racial limitations of the American Dream for Mexican-Americans."[125] Although U.S. authorities had assured voluntary emigrants that they would be allowed to return, their passports were stamped with the charities that paid their fares, and some were refused reentry on the grounds that they were "liable to become a public charge." In other cases, legal U.S. residents who had not been repatriated but had crossed the border for their own purposes were refused return entry to the United States on the same grounds.[126] Burciaga describes how different family members returned to El Paso after the Depression ended but struggled without legal rights of residence. They stayed in the United States "as long as they weren't caught—six months, a year, two years." Once the fathers were detected, they moved back to Juárez, while their children remained in school in El Paso.[127] During the Depression, immigration documents became a double bind for Mexicans: without documentation, they were vulnerable to repatriation and deportation; with it, their documents could mark them as excludable and prevent them from being able to return to the United States.

※ ※ ※

Although the Immigration Bureau's earliest attempts to regulate the border through photography focused largely on non-Mexican migrants, these practices foreshadowed the regulation of Mexicans in the region. Initially, the bureau extended its visual regulation of the excluded Chinese from Angel Island to border immigration stations. However, photographic documentation was eventually extended to other immigrant groups, including Mexicans. At the same time, Mexican immigrants resisted the implementation of these new restrictions both by evading the gaze of the

immigration inspectors and by using photographic documentation to enter and remain in the United States illegally.

Unlike the Chinese, Mexican immigrants were facilitated in their efforts by the Immigration Bureau's lack of enforcement controls for photographic documentation. As long as their labor was in demand, Mexicans were able to exploit this situation to their advantage. As Oscar Martínez has argued, U.S. authorities should recognize their own role in facilitating legal *and* illegal immigration: "Repeatedly U.S. immigration laws have been conveniently bent or completely overlooked by American authorities, allowing both legal immigrants and undocumented workers to cross the Rio Grande with minimum restrictions during times of critical labor shortages. Such practices have contributed greatly to the institutionalization of a long-standing pattern of migration to the border."[128]

However, during periods when their labor was rejected, the unevenness of Mexican documentation worked against those who had been able to evade the Immigration Bureau's regulation. As restrictions on immigration increased throughout the 1910s and 1920s, some Mexican U.S. residents who had entered without documentation returned to the border to legalize and document their status. But throughout the extended economic crisis of the 1930s these opportunities were curtailed. During the Great Depression, Mexicans faced pressure from the increasingly strict regulation of documentation and from repatriation campaigns.

By the 1930s, fifty years after they were first introduced for Chinese migrants, immigration identity documents had become central to control of Mexican immigration. As racial immigration quotas and photographic documentation were introduced for European immigrants, the Immigration Bureau recognized that the enforcement of immigration restrictions had shifted from Ellis Island to El Paso. "A great change has been taking place along our borders," the commissioner general of immigration wrote in 1928: the borders had displaced Ellis Island and were "approaching a place of first importance in the scheme of things."[129] This scheme of things included the photographic regulation of immigrants through identity documentation.

Conclusion

> Every citizen is a potential immigration inspector.
>
> I. F. Wixon, *Immigration Border Patrol* (1934)

One Saturday evening in February 1931, thirty immigration officials and "Alien Bureau" policemen converged on the Finnish Workers' Educational Association building in New York City. As the band played for about one thousand people gathered at a dance, the police entered the building and blocked the doors to prevent anyone from leaving. They then ordered the musicians to stop and required every person "to show credentials or offer other evidence that they were in this country legally." As the *New York Times* reported, "In an atmosphere of hysteria tinged with indignation, the dancers came forward singly and offered their proof."[1] During the raid's mass document inspection, only eighteen people were unable to offer proof of their citizenship or legal residence. These sixteen men and two women were detained and ordered deported, taken first to the police station and then to Ellis Island.

Although the raid on the Finnish Hall netted only a few undocumented aliens, immigration officials suggested that this raid was just the beginning of a larger roundup. Ellis Island was reportedly crowded with deportees from raids at missions, lodging houses, and other immigrant gathering places throughout New York. Echoing language that it had used thirty years earlier to describe the masses of arriving immigrants, the *Times* claimed that "Ellis Island's detention pens are being taxed to capacity by aliens seized by the police and federal authorities for being in this country illegally." In the first few weeks of 1931, more than five hundred undocumented immigrants were detained at the island awaiting deportation.

As national origins restrictions, overseas inspections, and new documentation provisions were implemented and expanded in the late 1920s, Ellis Island's role in immigration control shifted from inspection to deportation, from a port of entry to a place of departure. This shift was both a reversal from its earlier role in processing entrants and consistent with the station's ongoing enforcement of immigration restrictions.[2]

According to the *Times*, Secretary of Labor William Doak estimated that there were more than four hundred thousand illegal immigrants in the United States in 1931, "many of them criminals, others unemployed and still more who are employed but depriving American citizens and other aliens of the jobs which rightfully are theirs." Concerned about the scarcity of jobs for legal residents and citizens during the Great Depression, Doak vowed to round up illegal immigrants through a series of nationwide raids. As outlined in the previous chapter, Mexicans formed the largest number of immigrants targeted for repatriation and removed under such campaigns during the Great Depression. During the early 1930s, however, New York City joined Chinatowns and Mexican neighborhoods throughout the country as "an uncertain residence for illegal entrants."[3] As raids on Chinese and Mexican communities had shown, these were an intentionally spectacular form of immigration enforcement always accompanied by a demand for documentation. The expansion of raids to European immigrant communities in New York City and beyond reflects the fact that, by the late 1920s, the regime of photographic identity documentation that had underpinned the interior enforcement of Chinese exclusion had been expanded to cover all immigrants, as well as naturalized citizens. Perhaps the most surprising aspect of the Finnish Dance raid is that almost every one of the thousand detainees was able to prove his or her immigration or citizenship status to the satisfaction of the authorities.

The expansion of immigrant identification was the logical response to the implementation of racial quotas in 1921 and 1924, which, like restrictions on Chinese and Mexican immigrants previously, spurred an increase in illegal immigration. After the passage of racial quotas, officials worked on enforcement of the law through three connected areas: immigration documentation, immigration registration, and naturalization documentation. As immigration officials had learned in their efforts to enforce Chinese exclusion, interior immigration enforcement depended upon a comprehensive system of photographic identity documentation. Documents were required to link immigrants to their records of arrival or registration, and photographs were required to link immigrants to their

documents. Without widespread use of immigration documents, illegal immigrants could claim to be legal. Without compulsory naturalization documents, undocumented individuals who appeared to be immigrants—through their physical appearance, their accented speech, or their association with other immigrants—might claim to be citizens. Without documentation there was no convenient way to distinguish between legal and illegal residents within the United States or to enforce the restrictive quota laws beyond the border. At the same time, authorities recognized that documentation—even photographic documentation—was vulnerable to fraud. Therefore, some proponents argued that the federal government, in addition to recording immigrants upon their arrival, should keep a registry of all immigrants in the United States. The expansion of documentation and registration was closely linked to the expansion of deportation during the 1920s. Increasingly, documents became viewed not primarily as a means to facilitate entry but as a means to support interior enforcement and its logical corollary for unauthorized individuals: deportation.[4]

IMMIGRATION DOCUMENTATION

On July 1, 1928, the Immigration Bureau implemented a new policy of issuing photographic identity cards to all arriving immigrants. The policy, an administrative rather than a statutory change, had originally been designed to include all immigrants in the United States, but in the face of opposition it was limited to new arrivals only. As the policy was introduced, Acting Commissioner of Immigration George Harris made clear that it was based on the precedent of Chinese identity documents and Mexican border-crossing cards. "About fifteen years ago the immigration service adopted an engraved certificate for the use of the Chinese admitted," Harris noted, claiming that "the system proved a thorough success." "Later on," he continued, "immigration identification cards were adopted for the use of aliens residing in cities and towns on either side of our international borders." This plan, according to Harris, was similarly successful. Leaving aside immigration officials' perpetual concerns about Chinese document fraud and the patchwork implementation of border documentation, Harris argued that an immigrant identification card encompassing all arrivals was the logical extension of these earlier programs and that it fulfilled a long-standing need in immigration regulation.[5]

Like Chinese registration and Mexican border-crossing cards, such

proposals were presented as a protection for the legal entrant, which "will
save aliens lawfully in the United States time and trouble in establishing
their identifying bona fides." But social activist Bruno Lasker challenged
this claim: "From what danger, exactly, is the immigrant to be protected
by means of the identification card?" Only from the danger of the law
itself, he argued. In language almost identical to that of the opponents
who had argued that the Geary Act's system of documentation subjected
every Chinese person in America to suspicion, Lasker claimed that
"every man who wears a beard and reads a foreign-language newspaper
is to be suspected unless he can produce either an identification paper or
a naturalization paper."[6] More recently, in the 1980s, a coalition opposed
to the Rodino bill creating sanctions for employers who hired illegal im-
migrants echoed the earlier concerns of Chinese and European immigrants,
arguing that "all Latinos, Chicanos, Mejicanos will be obligated to pro-
duce identity papers, and many applicants for jobs will be denied a chance
for employment based solely on the fact that we may 'appear' alien."[7]

The 1928 implementation of photographic identity cards for arriving
immigrants represented a substantial expansion of the number and types
of immigrants who were subject to official photographic representation
and regulation by the Immigration Bureau. Most notably, European im-
migrants—who had been previously been only partly incorporated into
a regime of visual immigration regulation—were now required to have
photographic immigrant identity cards. However, according to restric-
tionists who continued to express concern about immigration, these doc-
umentation measures were not enough.

IMMIGRATION REGISTRATION

Throughout the 1920s, as immigration officials introduced more com-
prehensive immigration identity documentation, congressional repre-
sentatives and immigration officials also pursued immigration registra-
tion. Although voluntary registration was passed in 1929, mandatory
registration was not implemented until World War Two. In addition to
recording immigrants upon their arrival, various proposals mandated the
federal government to keep a registry of all immigrants in the United
States. Legislative historian Edward Hutchison has noted that such bills
had long been introduced during periods of concern about alien subver-
sion, and immigration scholar Libby Garland has shown how they were
part of the hardening divide between aliens and Americans during the
1920s.[8] However, registration proposals were also the logical culmina-

tion of expanded immigration restriction and documentary regulation, and they were recognized as such by their critics at the time.

When general systems of immigration registration were recommended during the 1920s, both the proposals and the protests intentionally echoed the debates about Chinese registration thirty years earlier. Like Acting Commissioner of Immigration George Harris, Secretary of Labor Davis frankly invoked the Chinese exclusion laws as a precedent for general immigrant registration.[9] Max Kohler, a lawyer who represented both early Chinese and later Jewish opposition to registration systems, drew the clearest and most sustained comparisons of such policies. "However unintended," he wrote in testimony submitted to the House Immigration Committee regarding a 1923 bill, "you are proposing a registration of aliens machinery on the pattern of our Chinese exclusion laws, which will challenge the rights of millions of inoffensive alien residents, cause them to be viewed with suspicion, dislike, and hatred, and in fact, do them no good, but only harm."[10] Echoing language used to critique the Geary Act's registration requirements, he compared immigrant registration to a ticket-of-leave system and claimed that it was unnecessary, undemocratic, and unenforceable.[11]

In their eagerness to expand interior enforcement, immigration officials set aside their previous concerns. As Libby Garland has observed, "Even as alien registration proposals insisted on the power of data to regulate national borders, they also called this power into question."[12] Alien registration was intended to distinguish between legal and illegal immigrants, but the proposals modeled on Chinese exclusion overlooked the ways that registration had been unsuccessful in preventing the illegal immigration of excluded Chinese. This failure resulted not only from the vulnerability of documentation, according to opponents of registration, but also from the instability of identity. Immigrant supporters such as Max Kohler expressed their concerns about documentation: inadvertent mistakes were frequently made in existing immigration records, certificates might get lost, and Chinese registration had led to widespread corruption among inspectors. Kohler also emphasized the instability of identity, noting that "changes in appearance may take place" and "that it is practically impossible to distinguish aliens from American citizens and aliens who have previously come to this country."[13] Deliberately overlooking the fact that some immigrants intentionally fabricated identities, exchanged documents, and bribed immigration officials, Kohler was employed by immigrant advocacy groups to suggest that immigrants had little agency in the immigration process.

Like Bruno Lasker and others, Max Kohler viewed registration as "an opening wedge" for the surveillance not only of all immigrants but also of every naturalized and native-born citizen. Progressive Republican senators Robert LaFollette (WI) and George Norris (NE) described compulsory registration as "a spy system," while Democratic Senator Robert Wagner (NY) expressed his opposition to "legislation which sets the immigrant apart to be specially registered, identified, numbered and watched."[14] As immigration officials had conceded when they introduced certificates of identity for all Chinese residents in the United States twenty years earlier, Lasker determined that "nothing short of a system of registration for the whole population will be really effective."[15]

NATURALIZATION DOCUMENTATION

Once photographic identity documentation was expanded beyond all Chinese and various Mexican entrants to cover all arriving immigrants in 1928, U.S. officials turned their attention to a new area of regulation: citizenship documents. Immigration officials had long expressed concerns about fraudulent naturalization practices, but with their success in establishing a comprehensive system of *immigration* documentation, the federal control of *citizenship* documentation was within their sights.[16] Such concerns were not directed toward Asian immigrants because, under the terms of the 1917 Immigration Act, Asians were "aliens ineligible for citizenship."[17] However, European and Mexican immigrants obtained certificates both when they declared their intent to naturalize and if they naturalized.[18] Although most immigrants were not required to obtain documentation prior to 1928, they often used their declaration of intent certificates for purposes of identification.

Spurred by newspaper reports as well as their experiences with fraud, local and federal officials expressed concerns about the unreliability of both sets of citizenship papers. In 1919, an official at the American Consulate in Seoul claimed that hundreds of citizens were naturalized "under names not legally their own." He recommended that each immigrant present a valid photographic passport when declaring his or her intent or applying to become a citizen. This would ensure, he argued, "that courts admitting aliens to citizenship may be satisfied that the applicant for naturalization is the person he presents himself to be, and that the name he gives is one he is legally entitled to bear."[19] Of course, the requirement to present a photographic passport could be made only in 1919, after the United States defined passports as travel documents containing photo-

graphs.[20] In 1923, an immigration examiner in San Antonio, Texas, noted that naturalization certificates were vulnerable to fraud because they contained only general descriptions of their holders. Echoing earlier arguments about Chinese identity documents, he suggested that "photographs (similar to the ones used in connection with passport applications) be attached to such declarations and petitions in such manner that substitutions may be impracticable."[21] In the same year, the same suggestion was made by the naturalization clerk in Syracuse, New York. He noticed that since employers had begun requiring citizenship documentation the Clerk's Office had experienced a spike in the number of applicants claiming they had lost their certificates. Although he acknowledged that he had no concrete evidence, the clerk suggested that "there is a very great probability that certain declarants are loaning their papers to friends who are seeking positions but have no citizenship status of their own."[22]

As a result of such concerns, in 1924 U.S. officials moved forward with regulations requiring photographic identification on citizenship certificates. However, despite restrictionist sentiment that led to passage of the Visa Act in the same year and in contrast to the practices of officials who routinely went beyond statutory requirements to enforce Chinese exclusion, the commissioner of naturalization halted implementation of these regulations because of the bureau's lack of authority in this area.[23] Even though Europeans were increasingly subject to restriction and documentation, they retained some privileges that removed them from the surveillance of immigration officials.

Five years later in 1929, Congress passed a law requiring photographs on both declarations of intent and certificates of citizenship, as well as expanded inspection for replacement certificates.[24] With this law, the Immigration Bureau's documentary controls were expanded to include not only immigrants but also naturalized citizens. The same law also saw the enactment of voluntary immigrant registration.[25] Although broader registration requirements were not passed in 1929, mandatory alien registration covering all immigrants was introduced eleven years later during World War II, echoing the expansion of mandatory photographic documentation during the First World War. The Alien Registration Act enacted in 1940 required all aliens fourteen years and older to register their address and submit their fingerprints to the immigration authorities. Two years later, enemy aliens were required to reregister, obtain new photographic identity cards, and carry these cards with them at all times.[26]

❦ ❦ ❦

In Sight of America focuses on the period during which federal immigra-
tion policies were introduced, between 1875 and 1930. Although these
years have been frequently studied, when they are viewed through the
prism of visual culture, new histories come into focus. This study argues
that photography shaped the development of U.S. immigration policy in
significant ways. On one level, visual medical inspection and photographic
documentation were used to implement racialized immigration restric-
tions, to ensure that arriving immigrants were lawfully entitled to enter
the United States. As each immigrant group was restricted, it was incor-
porated into the system of visual regulation that underpinned these con-
trols. At the same time, visual systems of observation and documenta-
tion not only regulated but also shaped understandings of who could
become an American. As a central mechanism of immigration policy, vi-
sually based regulation was part of the process through which immigra-
tion policy created and reinforced racial hierarchies. Some groups, such
as the Chinese, were extensively photographed and documented, denied
the privilege of evading immigration officials' surveillance. Other groups,
such as European immigrants, were viewed relatively briefly upon their
arrival and, until they were incorporated into racialized immigration re-
strictions in the 1920s, were largely unmonitored once they entered the
United States. The history of immigration documentation shows how im-
migration policy was part of state-based practices of racial formation and
how Chinese exclusion was central to the development of U.S. immi-
gration policy.

As this study argues, the United States has pursued different immi-
gration policies regarding different racial groups. These varied policies
have extended to the ways in which immigrants were observed, inspected,
and documented by the Immigration Bureau. Chinese immigrants were
the first to be subject to new techniques of documentation and obser-
vation, and they remained more closely documented and more severely
restricted than any other group throughout the exclusion period. When
Ellis Island was constructed in 1892 to regulate largely European immi-
gration, it was built as an observation station to allow both tourists and
immigration inspectors to view the arriving immigrants. Although Eu-
ropean arrivals were not marked by official photographic practices until
the implementation of quotas and visas in the National Origins Act of
1924, they were both viewed as an Old World spectacle and subjected
to inspection. During the same period, as the Mexican-U.S. border was
becoming increasingly clearly defined, Mexican migration was regulated

through both medical inspection procedures developed at Ellis Island and photographic documentation practices first tested with Chinese immigrants.

Immigrants resisted the implementation of visual immigration policies in varied ways. Their resistance not only shaped the implementation of immigration policy but also challenged the authority of photography. Since photographic documentation was central to the administration of exclusion, Chinese migrants had strong incentives to shape their representation of themselves before the Immigration Bureau and to subvert the visual regimes underpinning exclusion laws. In contrast, European immigrants had very little at stake in the ways they were photographed at Ellis Island. They were generally represented in an honorific ethnographic style that simultaneously emphasized their racial otherness upon arrival and their potential to become Americans. Although these images were used to shape popular conceptions about European immigration and to argue for new restrictions, they were not used to determine individual immigrants' fates during the medical inspection process. Europeans engaged in limited tactics to evade visual medical inspection, but their efforts were limited in part because the vast majority of European immigrants successfully entered the United States under the system of visual medical inspection. Once they were restricted by racial quotas in the 1920s, however, some Europeans adopted the same tactics and even the same smuggling networks that Chinese immigrants had used before them.

Throughout the early twentieth century, the U.S. government worked to change the Mexican-U.S. border from an "imaginary" to a "dividing line." Photographic identity documents, which were introduced extensively in 1917, played a central role in implementing these changes. Although Mexican border crossers were subject to documentation practices that drew on the Immigration Bureau's experience with Chinese identity documentation, these requirements were unevenly enforced on the border and allowed Mexicans more opportunities to negotiate their visual representation and regulation. However, this limited border enforcement worked against Mexican immigrants during the Great Depression, as local governments used lack of documentation as part of their campaigns to repatriate Mexicans and Mexican Americans.

Since the first federal immigration law in 1875, immigration policy has always been in part about making immigrants visible. Immigration identity documentation has been the point at which the representation and regulation of immigrants have converged. Concerns about national

security and American identity have similarly centered on questions of document security. However, immigrants themselves questioned the implementation of identity documentation, shaped the ways in which they were represented, and challenged the authority of the photographic evidence. In the process, not only were they placed in sight of America, but they placed America within their sights.

Notes

The following are abbreviations used in the notes:

ARCGI	*Annual Report of the Commissioner General of Immigration*
ASPC	Augustus Sherman Photograph Collection, Statue of Liberty National Monument, U.S. National Park Service, New York, NY
BL	Bancroft Library, University of California, Berkeley
CFIFI	Entry 232, Case Files of Immigration Fraud Investigations (12016), 1914–24, Records of the Immigration and Naturalization Service (Record Group 85), National Archives and Records Administration, Pacific Region (San Francisco)
CHS	California Historical Society
CLSSC	C. L. Sonnichsen Special Collections Department, University Library, University of Texas at El Paso
EIOHP	Ellis Island Oral History Project, Statue of Liberty National Monument, U.S. National Park Service, New York, NY
GPO	Government Printing Office
HHNP	Hart Hyatt North Papers, Bancroft Library, University of California, Berkeley
IACF	Immigration Arrival Case Files, 1884–1944, Records of the Immigration and Naturalization Service (Record Group 85), National Archives and Records Administration, Pacific Region (San Francisco)
INS	U.S. Immigration and Naturalization Service

IOH	Institute of Oral History, C. L. Sonnichsen Special Collections Department, University Library, University of Texas at El Paso
JYC	Judy Yung Collection, Asian American Studies Collection, Ethnic Studies Library, University of California, Berkeley
LCPPD	Library of Congress, Washington, DC, Prints and Photographs Division
LHPC	Lewis Hine Photograph Collection, Miriam and Ira D. Wallach Division of Art, Prints and Photographs, New York Public Library, New York, NY
NARA-DC	National Archives and Records Administration, Washington, DC
NARA-MD	National Archives and Records Administration, College Park, MD
NARA-SF	National Archives and Records Administration, Pacific Region (San Francisco)
NCWC	National Catholic Welfare Conference
NPCC	Ng Poon Chew Collection, Asian American Studies Collection, Ethnic Studies Library, University of California, Berkeley
NYPL	New York Public Library
PHS	U.S. Public Health Service
PHHNP	Photographs from the Hart Hyatt North Papers, Bancroft Library, University of California, Berkeley
RG	Record Group
R-INS	Records of the U.S. Immigration and Naturalization Service (Record Group 85)
R-INS-A-1	U.S. Immigration and Naturalization Service, *Records of the U.S. Immigration and Naturalization Service, Series A, Subject Correspondence Files. Part 1: Asian Immigration and Exclusion, 1906–1913.* Microfilm. Bethesda, MD: University Publications of America, 1994.
R-INS-A-2	U.S. Immigration and Naturalization Service, *Records of the U.S. Immigration and Naturalization Service, Series A, Subject Correspondence Files. Part 2: Mexican Immigration, 1906–1930.* Microfilm. Bethesda, MD: University Publications of America, 1994.
R-PHS	Records of the U.S. Public Health Service (Record Group 90)
WWP	William Williams Papers, Rare Books and Manuscript Division, New York Public Library, New York, NY
WWPC	William Williams Photograph Collection, Local History and Genealogy Division, New York Public Library, New York, NY

INTRODUCTION

1. Harry E. Hull, Commissioner-General, Bureau of Immigration, Washington, to the Secretary of Labor, memo, August 28, 1930, File 55728–357, Entry 9, R-INS, NARA-DC.

2. Quoted in Connie Young Yu, "Rediscovered Voices: Chinese Immigrants and Angel Island," *Amerasia Journal* 4, no. 2 (1977): 123.

3. *ARCGI* (1931), 216–17; Roger Daniels, *Guarding the Golden Door: American Immigration Policy and Immigrants since 1882* (New York: Hill and Wang, 2004), 59–60.

4. On racial differentiation within immigration policy, see Bill Ong Hing, *Making and Remaking Asian America through Immigration Policy, 1850–1990* (Stanford: Stanford University Press, 1993); Howard Markel and Alexandra Minna Stern, "Which Face? Whose Nation? Immigration, Public Health, and the Construction of Disease at America's Ports and Borders, 1891–1928," *American Behavioral Scientist* 42 (June–July 1999): 1313–30. On disability within immigration policy, see Douglas C. Baynton, "Disability and the Justification of Inequality in American History," in *The New Disability History*, ed. Paul Longmore and Lauri Umanski (New York: New York University Press, 2001), 33–57.

5. Immigration Act of March 3, 1875 (19 Stat. 477); George Anthony Peffer, *If They Don't Bring Their Women Here: Chinese Female Immigration before Exclusion* (Urbana: University of Illinois Press, 1999); Eithne Luibhéid, *Entry Denied: Controlling Sexuality at the Border* (Minneapolis: University of Minnesota Press, 2002); and Leti Volpp, "Divesting Citizenship: On Asian American History and the Loss of Citizenship through Marriage," *UCLA Law Review* 53, no. 2 (2005): 409, 465–68. Despite new attention to the Page Act, most histories continue to identify Chinese exclusion as beginning in 1882. While noting Peffer's research, renowned historian Roger Daniels opens his recent history of immigration policy in 1882, arguing that "in the beginning Congress created the Chinese Exclusion Act." Daniels, *Guarding the Golden Door*, 3.

6. Lawrence Glickman, "Inventing the 'American Standard of Living': Gender, Race and Working-Class Identity, 1880–1925," *Labor History* 34 (Spring–Summer 1993): 221–35; Alexander Saxton, *The Indispensable Enemy: Labor and the Anti-Chinese Movement in California* (Berkeley: University of California Press, 1971).

7. An Act to Execute Certain Treaty Stipulations Relating to Chinese (Chinese Exclusion Act) of May 6, 1882 (22 Stat. 58); Immigration Act of August 3, 1882 (23 Stat. 214). On the neglect of Chinese exclusion and its centrality to immigration history, see Roger Daniels, "No Lamps Were Lit for Them: Angel Island and the Historiography of Asian American Immigration," *Journal of American Ethnic History* 17 (Fall 1997): 2–18. For an example of the twin tracks thesis, see John Bodnar, *The Transplanted: A History of Immigrants in Urban America* (Bloomington: Indiana University Press, 1985). On the centrality of Chinese exclusion, see Charles McClain, *In Search of Equality: The Chinese Struggle against Discrimination in Nineteenth-Century America* (Berkeley: University of California Press, 1994); Lucy Salyer, *Laws Harsh as Tigers: Chinese Immigrants and the Shaping of Modern Immigration Law* (Chapel Hill: University of North Carolina

Press, 1995); Erika Lee, *At America's Gates: Chinese Immigration during the Exclusion Era, 1882–1943* (Chapel Hill: University of North Carolina Press, 2003).

8. Immigration Act of March 3, 1891 (26 Stat. 1084); Act of May 5, 1892 (27 Stat. 25). Chinese exclusion laws were enforced by federal customs collectors while general immigration laws were administered by state officials. In 1894, the Immigration Bureau was made responsible for exclusion as well as immigration laws. McClain, *In Search of Equality,* 215.

9. Immigration Act of February 5, 1917 (39 Stat. 874); Daniels, *Guarding the Golden Door,* 46–47.

10. *ARCGI* (1930), 1, 198–201.

11. Immigration Act of 1924 (43 Stat. 153); John Higham, *Strangers in the Land: Patterns of American Nativism, 1860–1925* (New York: Atheneum, 1963), 300; E. Lee, *At America's Gates,* 11; Daniels, *Guarding the Golden Door,* 48–55. See also Mae Ngai, "The Architecture of Race in American Immigration Law: A Reexamination of the Immigration Act of 1924," *Journal of American History* 87 (June 1999): 67–92; Amy L. Fairchild, *Science at the Borders: Immigrant Medical Inspection and the Shaping of the Modern Industrial Labor Force* (Baltimore: Johns Hopkins University Press, 2003), 215–16.

12. George J. Sánchez, "Race, Nation and Culture in Recent Immigration Studies," *Journal of American Ethnic History* 18 (Summer 1999): 66–84, and "Race and Immigration History," *American Behavioral Scientist* 42 (June–July 1999): 1271–75; Erika Lee, "Immigrants and Immigration Law: A State of the Field Assessment," *Journal of American Ethnic History* 18 (Summer 1999): 85–114; Luibhéid, *Entry Denied;* Fairchild, *Science at the Borders.*

13. On the medical inspection of immigrants at Ellis Island, see Harlan D. Unrau, *Historic Resource Study (Historical Component), Ellis Island, Statue of Liberty National Monument* (Washington, DC: National Park Service, 1984); Alan Kraut, *Silent Travelers: Germs, Genes and the "Immigrant Menace"* (New York: HarperCollins, 1994), 54–73; Elizabeth Yew, "Medical Inspection of Immigrants at Ellis Island, 1891–1924," *Bulletin of the New York Academy of Medicine* 56, no. 5 (1980): 488–510. Some of the works that consider the visual aspects of medical inspection are Anne-Emanuelle Birn, "Six Seconds per Eyelid: The Medical Inspection of Immigrants at Ellis Island, 1892–1914," *Dynamis* 17 (1997): 292, 301; Nayan Shah, *Contagious Divides: Epidemics and Race in San Francisco's Chinatown* (Berkeley: University of California Press, 2001), 180–81; Fairchild, *Science at the Borders,* 53–115.

14. Peter Quartermaine, "Johannes Lindt: Photographer of Australia and New Guinea," in *Representing Others: White Views of Indigenous Peoples,* ed. Mick Gidley (Exeter: University of Exeter Press, 1992), 85.

15. Although this study focuses on the documentation and representation of immigrants, these practices were also extended to other racialized groups in the United States. As Libby Garland and others have noted, the movement of slaves and free blacks was extensively regulated throughout the period prior to Emancipation. Although not typically visually based, the earliest American controls over movement were "passes" given by masters to their slaves to show that the slaves had permission to travel unaccompanied. According to Eric Foner, these passes were "among the most resented of slavery's restrictions." The opposite

of passes, advertisements attempting to locate runaway slaves, relied on detailed written descriptions and usually included only a schematic illustration of a running slave rather than a likeness of the individual. Migration control was not limited to slaves. During this time, numerous northern and western states prohibited the immigration of blacks across state lines without certification of their freedom. After the Civil War, some northern states continued to restrict black immigration, and many southern Jim Crow states passed vagrancy laws, designed to force black workers into labor contracts. As with Chinese exclusion, these laws relied on the racial appearance of the subject and documentation (of freedom or a labor contract) for their enforcement. In addition, the federal government played an extensive role in controlling Native American migrations through forced marches and the establishment of reservations. Though Native Americans were extensively photographed, I have not located any records that show they were issued photographic identity documents. In fact, even today, American Indian cards do not contain photographs. Other peoples, particularly residents of Cuba, Puerto Rico, and the Philippines colonized by the United States in 1898, were photographed for U.S. census reports that represented their supposedly halting progress toward civilization. However, these reports paralleled the Immigration Bureau reports rather than immigrant identity documents. Libby Garland, "Through Closed Gates: Jews and Illegal Immigration to the United States, 1921–1933" (PhD diss., University of Michigan, 2004), 28; Eric Foner, *A Short History of Reconstruction* (New York: Harper and Row, 1988), 37; James R. Grossman, *Land of Hope: Chicago, Black Southerners and the Great Migration* (Chicago: University of Chicago Press, 1989), 20–23; Leon Litwack, *North of Slavery: The Negro in the Free States, 1790–1860* (Chicago: University of Chicago Press, 1961), 66–74; Laura Wexler, *Tender Violence: Domestic Visions in an Age of U.S. Imperialism* (Chapel Hill: University of North Carolina Press, 2000); Ardis Cameron, ed., *Looking for America: The Visual Production of Nation and People* (Malden, MA: Blackwell, 2005); Vicente Rafael, *White Love and Other Events in Filipino History* (Durham: Duke University Press, 2000).

16. John Torpey, *The Invention of the Passport: Surveillance, Citizenship and the State* (Cambridge: Cambridge University Press, 2000), 107–17; Jane Caplan and John Torpey, eds., *Documenting Individual Identity: The Development of State Practices in the Modern World* (Princeton: Princeton University Press, 2001); Garland, "Through Closed Gates," 135, 197–201.

17. Sucheng Chan, "European and Asian Immigration into the United States in Comparative Perspective, 1820s to 1920s," in *Immigration Reconsidered: History, Sociology, and Politics,* ed. Virginia Yans-McLaughlin (Oxford: Oxford University Press, 1990), 37; E. Lee, "Immigrants and Immigration Law." For cross-cultural comparative work, see Grace Peña Delgado, "In the Age of Exclusion: Race, Region and Chinese Identity in the Making of the Arizona-Sonora Borderlands, 1863–1943" (PhD diss., University of California, Los Angeles, 2000).

18. Coco Fusco, "Racial Time, Racial Marks, Racial Metaphors," in *Only Skin Deep: Changing Visions of the American Self,* ed. Coco Fusco and Brian Wallis (New York: International Center of Photography with Harry N. Abrams, 2003), 16. On race and representation, see also Michael D. Harris, *Colored Pic-*

tures: Race and Visual Representation (Chapel Hill: University of North Carolina Press, 2003).

19. On state-based racial formation in immigration policy, see Kitty Calavita, *Inside the State: The Bracero Program, Immigration, and the I.N.S.* (New York: Routledge, 1992); Hing, *Making and Remaking Asian America;* Ian Haney López, *White by Law: The Legal Construction of Race* (New York: New York University Press, 1996); E. Lee, "Immigrants and Immigration Law."

20. On publication, see Frank Luther Mott, *History of American Magazines, 1885–1905,* vol. 4 (Cambridge, MA: Harvard University Press, 1957), 153–54; Neil Harris, "Iconography and Intellectual History: The Halftone Effect," in *Cultural Excursions: Marketing Appetites and Cultural Tastes in Modern America* (Chicago: University of Chicago Press, 1990), 304–17. For examples of major texts that pay limited attention to immigrants, see Robert Taft, *Photography and the American Scene: A Social History, 1839–1889* (New York: Dover Publications, 1964); Peter Bacon Hales, *Silver Cities: The Photography of American Urbanization, 1839–1915* (Philadelphia: Temple University Press, 1984); Maren Stange, *Symbols of Ideal Life: Social Documentary Photography in America, 1850–1950* (Cambridge: Cambridge University Press, 1989); Alan Trachtenberg, *Reading American Photographs: Images as History—Matthew Brady to Walker Evans* (New York: Hill and Wang, 1989). The few critical studies of immigration photography include Rob Kroes, "Migrating Images: The Role of Photography in Immigrant Writing," in *American Photographs in Europe,* ed. David Nye and Mick Gidley (Amsterdam: VU Press, 1994), 189–204; Vicki Goldberg, "The Camera and the Immigrant," in *Points of Entry: A Nation of Strangers,* ed. Museum of Photographic Arts, San Diego (Albuquerque: University of New Mexico Press, 1995); Monique Berlier, "Picturing Ourselves: Photographs of Belgian Americans in Northeastern Wisconsin, 1888–1950" (PhD diss., University of Iowa, 1999); Carrie Tirado Bramen, "The Urban Picturesque and the Spectacle of Americanization," *American Quarterly* 52 (September 2000): 444–77; Anthony W. Lee, *Picturing Chinatown: Art and Orientalism in San Francisco* (Berkeley: University of California Press, 2001). Most studies consider immigrant photography through the lens of a few photographers. See, for example, Alexander Alland, *Jacob A. Riis: Photographer and Citizen* (Millerton, NY: Aperture, 1974); Sally Stein, "Making Connections with the Camera: Photography and Social Mobility in the Career of Jacob Riis," *Afterimage* 10 (May 1983): 9–16; Judith Mara Gutman, *Lewis W. Hine and the American Social Conscience* (New York: Walker, 1967); Walter Rosenblum and Naomi Rosenblum, *America and Lewis Hine* (Millerton, NY: Aperture, 1977); Alan Trachtenberg, "Camera Work/Social Work," in *Reading American Photographs;* John Kuo Wei Tchen, *Genthe's Photographs of San Francisco's Old Chinatown* (New York: Dover Publications, 1984). Reference to photographic identity documentation can be found in McClain, *In Search of Equality,* 203; Luibhéid, *Entry Denied,* 42–48, 50–53; E. Lee, *At America's Gates,* 42, 84–85.

21. John Tagg, *The Burden of Representation: Essays on Photographies and Histories* (Minneapolis: University of Minnesota Press, 1988), 36; David Green, "Veins of Resemblance: Photography and Eugenics," *Oxford Art Journal* 7, no. 2 (1984): 8; Allan Sekula, "The Body and the Archive," in *The Contest of Mean-*

ing: Critical Histories of Photography, ed. Richard Bolton (Cambridge, MA: MIT Press, 1989), 343–89.

22. On the breadth and complexity of nineteenth-century racial imagery, see Fusco, "Racial Time," especially 20–21, and M. Harris, *Colored Pictures*, 38–82.

23. Laura Wexler, "Techniques of the Imaginary Nation: Engendering Family Photography," in *Race and the Production of Modern American Nationalism*, ed. Reynolds Scott-Childress (New York: Garland, 1999): 379. See also Fusco and Wallis, *Only Skin Deep*; Cameron, *Looking for America*; Blake Stimson, *The Pivot of the World: Photography and Its Nation* (Cambridge, MA: MIT Press, 2006).

24. On immigration policy as a dialectical process, see Salyer, *Laws Harsh as Tigers*; E. Lee, *At America's Gates*, 76; Jennifer Gee, "Sifting the Arrivals: Asian Immigrants and the Angel Island Immigration Station, San Francisco, 1910–1940" (PhD diss., Stanford University, 1999), 42–43; Estelle Lau, *Paper Families: Identity, Immigration Administration and Chinese Exclusion* (Durham: Duke University Press, 2006), 115. On photography as a practice, see Marita Sturken and Lisa Cartwright, *Practices of Looking: An Introduction to Visual Culture* (Oxford: Oxford University Press, 2001).

25. On attitudes toward Chinese immigrants prior to exclusion, see John Kuo Wei Tchen, *New York before Chinatown: Orientalism and the Shaping of American Culture, 1776–1882* (Baltimore: Johns Hopkins University Press, 1999).

26. Recent analyses of Chinese political action can be found in McClain, *In Search of Equality*; Salyer, *Laws Harsh as Tigers*; E. Lee, *At America's Gates*; K. Scott Wong and Sucheng Chan, eds., *Claiming America: Constructing Chinese American Identities during the Exclusion Era* (Philadelphia: Temple University Press, 1998).

27. On paper sons, see Him Mark Lai, Genny Lim, and Judy Yung, *Island: Poetry and History of Chinese Immigrants on Angel Island, 1910–1940* (San Francisco: Chinese Culture Foundation and HOC DOI, 1980), 20–22; Salyer, *Laws Harsh as Tigers*, 58–62; E. Lee, *At America's Gates*, 200–207.

28. Martin Jay, "Scopic Regimes of Modernity," in *Vision and Visuality*, ed. Hal Foster (New York: New Press, 1988), 2–27.

29. See, for example, Louise Eberle, "Where Medical Inspection Fails," *Colliers*, February 8, 1913, 27.

30. Vicki Goldberg makes a similar point in her essay "The Camera and the Immigrant" but does not address Chinese photographs until the relatively late opening of Angel Island in 1910 (23).

31. This occurred in a project dating roughly between 1906 and 1909, then started again consistently in 1917. Conversation with Marian Smith, historian, INS, February 26, 2002.

32. George J. Sánchez, *Becoming Mexican American: Culture and Identity in Chicano Los Angeles* (New York: Oxford University Press, 1993), 55–56.

33. Ibid., 50–51; E. Lee, *At America's Gates*, 157–65.

34. *ARCGI* (1918), 321.

35. Executive Order No. 2932 of August 8, 1918, sec. 5, in U.S. Department of Justice, *Laws Applicable to Immigration and Nationality* (Washington, DC: GPO, 1953), 1051.

36. J. B. Dunsmore to [Louis] Post, memo, June 4, 1918, File 54261–202, Entry 9, R-INS, NARA-DC.

37. Francisco E. Balderrama and Raymond Rodríguez, *Decade of Betrayal: Mexican Repatriation in the 1930s* (Albuquerque: University of New Mexico Press, 1995); Abraham Hoffman, *Unwanted Mexican Americans in the Great Depression: Repatriation Pressures, 1929–1939* (Tucson: University of Arizona Press, 1974).

38. Wesley E. Stiles, interview by Wesley C. Shaw, January 1986, pp. 4–5, IOH.

39. Executive Order No. 2932 of August 8, 1918, title 1, sec. 5; Immigration Act of 1924 (43 Stat. 153), sec. 2b.

40. Order No. 106, July 1, 1928, Department of Labor; "Immigration Cards to Identify Aliens," *New York Times*, June 16, 1928, 18; Act of March 2, 1929 (45 Stat. 1516).

41. Mae Ngai, *Impossible Subjects: Illegal Aliens and the Making of Modern America* (Princeton: Princeton University Press, 2004), 204, 218–24; E. Lee, *At America's Gates*, 191, 240–42.

42. Kelly Lytle Hernández, "The Crimes and Consequences of Illegal Immigration: A Cross-Border Examination of Operation Wetback, 1943–1954," *Western Historical Quarterly* 37 (Winter 2006): 423–24.

1. FIRST IMPRESSIONS

1. Maxine Hong Kingston, *China Men* (New York: Vintage International, 1989), 145.

2. Ronald Takaki, *Strangers from a Different Shore: A History of Asian Americans* (New York: Penguin Books, 1989), 85; Sucheng Chan, *Asian Americans: An Interpretive History* (Boston: Twayne, 1991), 30.

3. Daniels, "No Lamps Were Lit," 4.

4. Salyer, *Laws Harsh as Tigers*; E. Lee, *At America's Gates*, 19.

5. Act of March 3, 1875 (18 Stat. 477).

6. Act of May 6, 1882 (22 Stat. 58).

7. Sucheng Chan, "The Exclusion of Chinese Women," in *Entry Denied: Exclusion and the Chinese Community in America, 1882–1943*, ed. Sucheng Chan (Philadelphia: Temple University Press, 1991), 109–23.

8. Act of May 5, 1892 (27 Stat. 25).

9. Act of November 3, 1893 (28 Stat. 7).

10. U.S. Bureau of Immigration, *Treaty, Laws and Regulations Governing the Admission of Chinese* (Washington, DC: GPO, 1910).

11. Act of December 17, 1943 (57 Stat. 600–601); Hing, *Making and Remaking Asian America*, 36–38.

12. These practices are considered most fully in Shah, *Contagious Divides*, 179–203. See also Fairchild, *Science at the Borders*, 132–39.

13. Shah, *Contagious Divides*, 180–81. Some European immigrants were also required to disrobe, but only if they were detained for further examination. Kraut, *Silent Travelers*, 55–56.

14. Fairchild, *Science at the Borders*, 180.

15. See, for example, Saxton, *Indispensable Enemy;* Andrew Gyory, *Closing the Gate: Race, Politics, and the Chinese Exclusion Act* (Chapel Hill: University of North Carolina Press, 1998).

16. Gunther Barth, *Bitter Strength: A History of the Chinese in the United States, 1850–1870* (Cambridge, MA: Harvard University Press, 1964); Saul Jacobs and Saul Landau, *Colonials and Sojourners* (New York: Random House, 1971), 107. Some very early histories do address Chinese political action. In 1898, in an article steeped in anti-Chinese stereotypes, Charles Holder argued that the Chinese were "astute politicians," comparing Chinese community organizations to a political machine and its leaders to political bosses. In her favorable 1909 history of the Chinese in America, in contrast, Mary Coolidge addressed elite "Chinese agitation" but argued that claims of evasion and fraud were exaggerated. Charles Frederick Holder, "The Chinaman in American Politics," *North American*, February 1898, 226–27; Mary Roberts Coolidge, *Chinese Immigration* (New York: Henry Holt, 1909), 278–301.

17. S. Chan, *Entry Denied;* McClain, *In Search of Equality;* Salyer, *Laws Harsh as Tigers;* E. Lee, *At America's Gates.*

18. Kim Man Chan, "Mandarins in America: The Early Chinese Ministers to the United States, 1878–1907" (PhD diss., University of Hawaii, 1981). The original protests can be found in Notes from the Chinese Legation in the United States to the Department of State, 1868–1906, RG 59, Microfilm M98, NARA-MD.

19. McClain, *In Search of Equality,* 3.

20. Salyer, *Laws Harsh as Tigers,* xiii.

21. *United States v. Wong Kim Ark,* 169 U.S. 649 (1898). Chinese litigants also won court cases ruling that exclusion laws could not be applied retroactively, that Chinese merchants living in the United States did not have to get certificates from China before leaving that country, and that the section of the Geary Act that provided for punitive hard labor without a jury trial was unconstitutional. McClain, *In Search of Equality,* 171, 219.

22. (Wong) Bing Foon to Wong Som Gar, January 24, 1916, translated by Interpreter H. K. Tang, no file number, "San Francisco District INS, Coaching Papers," CFIFI.

23. My reading of this type of resistance is informed by James Scott's *Domination and the Arts of Resistance.* Scott identifies two types of resistance: the public form of politics (evident in petitions, demonstrations, and strikes) and the hidden form of "infrapolitics." Infrapolitics, according to Scott, is manifested in a wide range of everyday forms of resistance, from deliberately shabby work to "hidden transcripts" within slave, serf, and working-class cultures that secretly criticize those with power. Politics is recorded in the dominant record, but infrapolitics is more elusive, as it is shared only within a limited community and known only through the hidden transcript. Using Scott, I see Chinese protests, boycotts, and legal challenges as public politics and the evasion of exclusion as infrapolitical resistance. James Scott, *Domination and the Arts of Resistance: Hidden Transcripts* (New Haven: Yale University Press, 1990).

24. For a range of estimates, see E. Lee, *At America's Gates,* 190–91; Ngai, *Impossible Subjects,* 204; Daniels, *Guarding the Golden Door,* 24–25. For government estimates, see U.S. Congress, House, Committee on Immigration and

Naturalization, *Chinese Immigration,* 52nd Cong., 1st sess., 1892, H. Rept. 255, Serial 3042, 1.

25. Holder, "Chinaman in American Politics," 230. Chinese supporters argued that the numbers of fraudulent entries were far less than contemporary reports suggested. Coolidge, *Chinese Immigration,* 189–90.

26. "The Life Story of a Chinaman," in Hamilton Holt, ed., *The Life Stories of Undistinguished Americans as Told by Themselves* (1906; repr., New York: Routledge, 2000), 174, 178.

27. Immigration Act of March 3, 1875 (19 Stat. 477); George Anthony Peffer, "Forbidden Families: Emigration Experiences of Chinese Women under the Page Law, 1875–1882," *Journal of American Ethnic History* 6 (Fall 1986): 28–46, and *If They Don't Bring Their Women Here;* Luibhéid, *Entry Denied;* Volpp, "Divesting Citizenship." Despite recent recognition of the importance of the Page Act, some historians, such as Estelle Lau, continue to overlook the law. Lau, *Paper Families,* 4, 14.

28. Peffer, *If They Don't Bring Their Women Here,* 43–49, 60–61; Luibhéid, *Entry Denied,* 41–3.

29. Volpp, "Divesting Citizenship," 405–84.

30. Notice of F. P. Sargent, Commissioner-General of Immigration to Commissioners of Immigration and Immigrant Inspectors in Charge, June 8, 1907, and Inspector in Charge, Honolulu, Hawaii, to Commissioner-General of Immigration, August 17, 1909, both in File 51520/21, in *R-INS-A-1.* Regarding Japanese picture brides, see also Kei Tanaka, "Japanese Picture Marriage in 1900–1924 California: Construction of Japanese Race and Gender" (PhD diss., Rutgers University, 2002).

31. Luibhéid, *Entry Denied,* 31.

32. Act of May 6, 1882 (22 Stat. 58), sec. 4.

33. Act of March 4, 1884 (23 Stat. 115); In re Ah Lung. See McClain, *In Search of Equality,* 155–56 and 159–60; Salyer, *Laws Harsh as Tigers,* 19–20; K. Chan, "Mandarins in America," 187. The 1884 amendment also refined the definition of a merchant, required additional information from laborers, and established the practice of deportation for Chinese determined to be unlawfully in the United States. Like all other Chinese exclusion laws, this revision explicitly exempted Chinese diplomats.

34. Representative Blair, *Congressional Record,* 53rd Cong., 1st sess., vol. 25, pt. 2 (1893): 2552.

35. William Sears, Collector of Customs, to Daniel Manning, Secretary of the Treasury, July 23, 1885, Records of the U.S. Customs Service (Port of San Francisco), Copies of Letters Sent to the Secretary of the Treasury, 1869–1912, RG 36, NARA-SF.

36. Act of October 1, 1888 (25 Stat. 504).

37. Erika Lee writes that twenty thousand laborer certificates were nullified by the act; Charles McClain offers a contemporary estimate of thirty thousand. E. Lee, *At America's Gates,* 45; McClain, *In Search of Equality,* 194.

38. McClain, *In Search of Equality,* 194–97. In his history of criminal identification, Simon Cole makes the important point that Chinese identification triggered U.S. interest in fingerprinting. However, he overlooks the much more wide-

spread use of photography on Chinese certificates and suggests that the issue of identification "became moot" when the 1888 Scott Act ended the return certificate system. In fact, as explored here, the use of Chinese identity certificates did not end in 1888 and was expanded and standardized in the following years. Simon Cole, *Suspect Identities: A History of Fingerprinting and Criminal Identification* (Cambridge, MA: Harvard University Press, 2001), 163–64.

39. McClain, *In Search of Equality,* 198–201.

40. S. J. Ruddell, Customs Inspector in Charge, Chinese Bureau, testimony, in U.S. Congress, House, Committee on Immigration and Naturalization, *Chinese Immigration,* 51st Cong., 2nd sess., 1891, H. Rept. 4048, Serial 2890, 280–81. Despite this assertion, only a very few case files contained photographs at this time. In a sample of seventy-five files from 1888, for example, only two contained photographs. IACF.

41. Act of May 5, 1892 (27 Stat. 25).

42. McClain, *In Search of Equality,* 203.

43. Coolidge, *Chinese Immigration,* 324.

44. McClain, *In Search of Equality,* 207.

45. Salyer, *Laws Harsh as Tigers,* 47.

46. The secretary of the treasury reported that nationwide only 13,242 out of 106,687 Chinese had registered. Calculating that about 10 percent of Chinese were probably nonlaborers exempt from the law, Representative McCreary argued that about eighty-five thousand Chinese were eligible for deportation. *Congressional Record,* 53rd Cong., 1st sess., vol. 25, pt. 2 (1893): 2421.

47. Salyer, *Laws Harsh as Tigers,* 47.

48. *Fong Yue Ting v. United States,* 149 U.S. 698 (1893).

49. Act of November 3, 1893 (28 Stat. 7).

50. *Congressional Record,* 53rd Cong., 1st sess., vol. 25, pt. 3, appendix (1893): 231. See also "Now the Chinese Must Go," *San Francisco Call,* May 16, 1893.

51. *Congressional Record,* 53rd Cong., 1st sess., vol. 25, pt. 3, appendix (1893): 230.

52. Ibid., 231.

53. Ibid., 230.

54. *Congressional Record,* 53rd Cong., 1st sess., vol. 25, pt. 2 (1893): 2440–41.

55. Ibid., 2554.

56. See, for example, Jesse B. Cook, "San Francisco's Old Chinatown," *San Francisco Police and Peace Officers' Journal,* June 1931, www.sfmuseum.org/hist9/cook.html; Ivan Light, "From Vice District to Tourist Attraction: The Moral Career of American Chinatowns, 1880–1940," *Pacific Historical Review* 43 (1974): 367–94; Shah, *Contagious Divides.*

57. E. Lee, *At America's Gates,* 147; Ngai, *Impossible Subjects,* 202.

58. Tchen, *New York before Chinatown.*

59. Paul Frenzeny, "Chinese Immigrants at the San Francisco Custom-House" (illustration) and "Chinamen at the Custom-House, San Francisco" (text), *Harper's Weekly,* February 3, 1877, 81, 91.

60. Inspector in Charge, Honolulu, Hawaii, to Commissioner-General of Immigration, August 17, 1909, File 51520/21, in *R-INS-A-1.*

61. *Congressional Record,* 53rd Cong., 1st sess., vol. 25, pt. 2 (1893): 2423.
62. McClain, *In Search of Equality,* 203.
63. "The New and Monstrous Anti-Chinese Bill. 'The Geary Registration Act.' Formation of the Chinese Equal Rights League and Its Mass Meeting at Cooper Institute, New York, on September 22, 1892," Scrapbook 4 (Chinese Exclusion Clippings), NPCC. On the Geary Act's implementation of an unfair ticket-of-leave system, see also Charles H. Shinn, "The Geary Act in California," *Nation,* May 18, 1893, 373–74; E. L. Godkin, "The Decision on the Geary Act," *Nation,* May 18, 1893, 358.
64. *Congressional Record,* 53rd Cong., 1st sess., vol. 25, pt. 2 (1893): 2450.
65. Sekula, "Body and the Archive," 344. As John Tagg notes, some police departments in Britain started employed commercial photographers to take daguerreotypes of prisoners as early as the 1840s. However, police photography did not become fully established until the 1900s. In Britain, the Alien Order Act of 1920 (Act 17, Section 3) empowered police officers to photograph aliens. Tagg, *Burden of Representation,* 74.
66. Donald Dilworth, *Identification Wanted: Development of the American Criminal Identification System, 1893–1943* (Gaithersburg, MD: International Association of Chiefs of Police, 1977), 1.
67. Jesse Brown Cook Scrapbooks Documenting San Francisco History and Law Enforcement, ca. 1895–1936, vol. 30, p. 6, BL.
68. Mug books featuring exclusively Chinese subjects were also maintained by other authorities, including James McGregor, the sheriff and tax collector of Sierra County, Downieville, California, and Delos Woodruff, an officer with the Chinatown Division of the San Francisco Police Department until 1874, who wrote "Judge Woodruff" in his album of Chinese prisoners. Ledger book listing Chinese photographed with photographs and descriptions, Vault 184, CHS; Delos Woodruff's Album of Chinese Prisoners, some taken as early as 1872, Vault 185, CHS.
69. Mug Book Collection, San Francisco Police Department, San Francisco History Center, San Francisco Public Library. Simon Cole notes that the New York Police Department introduced a "yellow" file of fingerprints in 1922 to augment its "black" and "white" files. As in San Francisco, the separation of Chinese criminal identity photographs both assumed and reinforced the distinct racial identity of the Chinese population in America, even though fingerprints do not register racial identity. Cole, *Suspect Identities,* 121–27.
70. E. Lee, *At America's Gates,* 126–31.
71. Delber McKee, "The Chinese Boycott of 1905–1906 Reconsidered: The Role of Chinese Americans," *Pacific Historical Review* 55 (March 1986): 165–91; E. Lee, *At America's Gates,* 126.
72. "Wu Ting Fang on Exclusion," *Salt Lake City News,* April 4, 1902.
73. Ng Poon Chew, "The Treatment of the Exempt Classes of Chinese in the United States" (San Francisco, January 1908), p. 14, Box 3, Folder 15, NPCC.
74. *Congressional Record,* 53rd Cong., 1st sess., vol. 25, pt. 2 (1893): 2435.
75. Ibid., 2443.
76. Quoted in E. Lee, *At America's Gates,* 226.
77. Photographic requirements varied for different groups over time. In De-

cember 1900, Commissioner General Powderly introduced rules requiring Chinese in transit to provide four photographs and a bond of at least $500 to the customs collector at the port of arrival. Two photographs were retained by this collector, the third was attached to the transit certificate, and the fourth was forwarded to the collector at the proposed point of departure. Once the Chinese traveler's identity and departure were confirmed, the bond would be released. However, the commissioner general remained concerned that Chinese immigrants used the transit exemption to gain entry to and establish residence in the United States. Regulations promulgated in 1903 required photographs on both transit and return certificates, and photographs appear on these certificates, but some memos note that exempt classes were not required to have their photographs taken. *ARCGI* (1901), 50–51.

78. William Sears, Collector of Customs, to Daniel Manning, Secretary of the Treasury, July 23, 1885, Records of the U.S. Customs Service (Port of San Francisco), Copies of Letters Sent to the Secretary of the Treasury, 1869–1912, USCS, RG 36, NARA-SF.

79. James G. McCurdy, "Use of Photographs as Evidence," *Scientific American,* November 15, 1902, 328.

80. Green, "Veins of Resemblance," 8.

81. Tagg, *Burden of Representation,* 36.

82. Fong Get Photo Studio, San Francisco, "Hsu Ping chon," n.d., 1980.098: 71—PIC, PHHNP; Shew's Pioneer Gallery, Untitled ("Merchant in Fancy Dress, Seated"), FN-13245, CHS; Shew's Pioneer Gallery, Untitled ("Young Woman with Fan, Seated"), FN-32027, CHS; File 9564/10 and File 9560/49, IACF; File 12017/31836, Return Certificate Application Case Files of Chinese Departing (12017), 1912–44; File 12016/1076, CFIFI.

83. Peter Palmquist, "Asian Photographers in San Francisco, 1850–1930," *Argonaut: Journal of the San Francisco Historical Society* 9 (Fall 1998): 88.

84. Ibid., 92–95; W. F. Song, 800 Washington Street, San Francisco, FN-19253, CHS; Kai Suck Photographic Gallery, 929 Dupont Street, San Francisco, FN-32025, CHS; Lai Yong, Portrait Painter and Photograph Gallery, 743 Washington Street, San Francisco, FN-32026, CHS; Ho Can Photo Studio, Photo of Ah Sing, Chinese Peddler, 1888, Chinese Women of America Collection, AASC; Wai Cheu Hin, photographer, BANC PIC 1975.019—POR, BL.

85. Palmquist, "Asian Photographers," 88.

86. See, for example, Files 10055/117 and 10395/36, IACF.

87. Shew's Pioneer Gallery also offered the choice of a European garden setting, visible in an 1883 photograph of a Chinese woman. However, it is not clear from the photographic record whether this was supplemented or replaced by the Chinese garden backdrop. Shew's Pioneer Gallery, Untitled photograph ("Woman with Flowers, Standing"), FN-32023, CHS.

88. Jan Stuart and Evelyn Rawski, *Worshiping the Ancestors: Chinese Commemorative Portraits* (Stanford, CA: Freer Gallery of Art and Arthur M. Sackler Gallery, Smithsonian Institution, 2001), 166–67.

89. Application form for certificate issued under the Chinese Registration (Geary) Act of 1892, Scrapbook 4 (Chinese Exclusion), n.p., Box 6, NPCC. The application form also specified that "no tintype or other metal pictures will be

received" because in tintypes—like the earlier and more expensive daguerreo-types—the image was projected directly onto a metal plate rather than a nega-tive. Each tintype was a unique image, whereas each negative could produce mul-tiple identical copies of the same image.

90. Section 6 certificates for members of exempt classes specified a photo-graph location sometime between 1903 and 1905. Transit certificates had iden-tified a photograph location by 1906.

91. Richard Vinograd, *Boundaries of the Self: Chinese Portraits, 1600–1900* (Cambridge: Cambridge University Press, 1992), 2.

92. Ibid., 144; Stuart and Rawski, *Worshiping the Ancestors,* 165–74.

93. Stuart and Rawski, *Worshiping the Ancestors,* 165, 168–69.

94. Vinograd, *Boundaries of the Self,* 85.

95. Stuart and Rawski, *Worshiping the Ancestors,* 168. Similarly, as Stuart and Rawski note, the face of Father Ruifeng in his 1890 memorial portrait shows the influence of photography on memorial portraiture.

96. Ibid., 166–67.

97. See, for example, photographs sent by Consul General Hsu Ping Chen to San Francisco Immigration Commissioner Hart Hyatt North (1980.098:71—PIC, 1980.098:72—PIC, 1980.098:73—PIC, and 1980.098:74—PIC), all in PHHNP.

98. H. C. Kennah, Chinese Inspector, to Chinese Inspector in Charge, June 22, 1905, File 10061/28, IACF.

99. Claudia Brush Kidwell, foreword to *Dressed for the Photographer: Or-dinary Americans and Fashion, 1840–1900,* by Joan L. Severa (Kent: Kent State University Press, 1995), xiii.

100. John Dunn, Chinese Inspector, to Chinese Inspector in Charge, ca. June–July 1905, File 10059/6390, IACF.

101. Affidavit of Low Shee in support of merchant's son, Young Fui (also spelled Young Fou), June 19, 1905, File 10059/52, IACF.

102. Helen Ong Chang, interview by Nellie Wong Balch, December 10, 1976, p. 166, Asian American Oral History Composite, 1976–77, BANC MSS 78/123 c, BL.

103. Stuart and Rawski, *Worshiping the Ancestors,* 172.

104. Coaching paper, no date, translated by Interpreter H. K. Tang, Decem-ber 3, 1924, no file number (Folder 6, Box 1), CFIFI. See also coaching paper addressed to Yip Ngaw, February, 15, 1910, translated by Interpreter H. K. Tang, December 2, 1924, no file number (Folder 6, Box 1), CFIFI.

105. W. Silas Sheetz, the Camera Shop, to Commissioner-General, Bureau of Immigration and Naturalization, February 7, 1907, and F. P. Sargent, Commis-sioner-General, to George W. Webb, Inspector in Charge, Tucson, Ariz., Febru-ary 11, 1907, both in A. A. Seraphic, "Report re: Conditions on the Mexican Bor-der, 1906–1907," January 1908, File 51423/1, Reel 1, in *R-INS-A-2.* See also Immigration Inspectors 1 and 2, Box 1, Folders 47 and 48, JYC.

106. Erika Lee has identified similar photographs taken as part of the de-portation process in *At America's Gates,* 229.

107. Duplicate Certificates of Identity, 1908–1943, R-INS, NARA-SF. Al-though certificates of identity were issued in 1909, the San Bruno National Archives does not have any files dating from before 1914.

2. PHOTOGRAPHIC PAPER SONS

1. Hart Hyatt North to Frank Sargent, April 23, 1906, HHNP.

2. Roger Daniels, *Asian America: Chinese and Japanese in the United States since 1850* (Seattle: University of Washington Press, 1988), 94–96.

3. Although it was not legal to loan certificates, *United States v. Wong Ock Hong* ruled that it was not cause for deportation. *United States v. Wong Ock Hong,* 179 F. 1004 (D. Ore. 1910).

4. See, for example, H[arold] Edsell, Chinese Inspector in Charge, to Commissioner-General of Immigration, February 1, 1907, p. 4, File 14610/183, Entry 132, R-INS, NARA-DC.

5. Daniels, "No Lamps Were Lit."

6. See, for example, Mr. Chan, Box 1, Folder 23, and Mr. Chew, Box 1, Folder 24, both in JYC. Some, but not all, of the names used by Judy Yung in this collection of oral histories are pseudonyms. See also Judy Yung, *Unbound Voices: A Documentary History of Chinese Women in San Francisco* (Berkeley: University of California Press, 1999), 33.

7. Immigration Inspector 3, Box 1, Folder 49, JYC.

8. Lai, Lim, and Yung, *Island;* S. Chan, *Entry Denied;* Salyer, *Laws Harsh as Tigers,* 58–62; E. Lee, *At America's Gates.*

9. *United States v. Ah Sou,* 132 F. 878 (No. Dak. D.C. 1904).

10. In *United States v. Ah Won,* the judge ruled that forged blank copies of residence certificates discovered by immigration officials did not violate any law, as they had not yet been completed with the intent to defraud government officials. *United States v. Ah Won,* 97 F. 494 (D. Ore. 1899).

11. E. Lee, *At America's Gates,* 151–87.

12. After 1909, even U.S. citizens of Chinese descent were required to carry certificates of identity. However, prior to this time many illegal immigrants were apparently able to get recognized as native-born citizens by the courts.

13. Salyer, *Laws Harsh as Tigers,* 61, 150.

14. *ARCGI* (1901), 46–47.

15. Ngai, *Impossible Subjects,* 205.

16. Representative Loud (CA), *Congressional Record,* 53rd Cong., 1st sess., vol. 25, pt. 2 (1893): 2441.

17. Acting Inspector in Charge, New York, N.Y., to Commissioner-General of Immigration, Washington, D.C., December 14, 1917, File 54735-99, Entry 9, R-INS, NARA-DC.

18. Immigrant Inspector, Buffalo, N.Y., to Commissioner-General of Immigration, Washington, D.C., May 24, 1914, File 54735-99, Entry 9, R-INS,NARA-DC; Chinese Inspector in Charge, New York, N.Y., to Inspector Richard Taylor, Washington, D.C., April 26, 1915, File 54735-99, Entry 9, R-INS, NARA-DC; Assistant Commissioner-General to All Commissioners of Immigration and Inspectors in Charge of Districts, memo, June 26, 1915, File 54735-99, Entry 9, R-INS, NARA-DC.

19. Fong Get Photo Studio, San Francisco, "Hsu Ping chon," n.d., 1980.098: 71—PIC, PHHNP.

20. Fong Get's testimony appears in the following files: File 9564/10 and File

9560/49, IACF; File 12017/31836, Return Certificate Application Case Files of Chinese Departing (12017), 1912–44; and File 12016/1076, CFIFI. Unfortunately, although the fraud is described in detail, the photographs are not on file.

21. *ARCGI* (1917), xxxi; E. Lee, *At America's Gates*, 200.

22. Roland Barthes, *Camera Lucida: Reflections on Photography*, trans. Richard Howard (New York: Hill and Wang, 1981), 76.

23. Case of Wee Shue Ning, 1937, File 55953–219, Accession 58A734, R-INS, NARA-DC.

24. See, for example, H[arold] Edsell, Chinese Inspector in Charge, to Commissioner-General of Immigration, February 1, 1907, pp. 1–3, File 14610/183, Entry 132, R-INS, NARA-DC; H[arold] Edsell, Chinese Inspector in Charge, to Commissioner-General of Immigration, February 2, 1907, pp. 1–2, File 14610/184, Entry 132, R-INS, NARA-DC.

25. Two certificates of identity issued to Chin Tom, 1922, In re: Chin Tom, File 55027, Duplicate Certificates of Identity, 1908–1943, R-INS, NARA-SF. My thanks to independent researcher Vincent Chin for sharing these images with me.

26. Application form for certificate issued under the Chinese Registration (Geary) Act of 1892, Scrapbook 4 (Chinese Exclusion), n.p., Box 6, NPCC. The application form also specified that "no tintype or other metal pictures will be received" because in tintypes—like the earlier and more expensive daguerreotypes—the image was projected directly onto a metal plate rather than a negative. Each tintype was a unique image, whereas each negative could produce multiple identical copies of the same image.

27. Mr. Lai, interview, Box 1, Folder 28, JYC. See also John Dunn, Chinese Inspector, to Chinese Inspector in Charge, June 13, 1905, p. 1, File 10055/117, IACF; Inspector in Charge, Ketchikan, Alaska, to Commissioner-General of Immigration, Washington, D.C., December 17, 1903, File 11099, Entry 9, R-INS, NARA-DC.

28. *ARCGI* (1901), 47–48.

29. Charles R. Shepherd, *The Ways of Ah Sin* (New York: Fleming H. Revell, 1923).

30. *Reisterer v. Lee Sum*, 94 F. 343 (2nd Cir. 1899). See also Thomas Thurston's hypertext article about the legal reception of photographic evidence, "Hearsay of the Sun: Photography, Identity, and the Law of Evidence in 19th-Century American Courts," *American Quarterly Hypertext Scholarship in American Studies*, 1999, http://chnm.gmu.edu/aq/photos.

31. See, for example, Inspector in Charge, Ketchikan, Alaska, to Commissioner-General of Immigration, Washington, D.C., December 17, 1903, File 11099, Entry 9, R-INS, NARA-DC.

32. See, for example, Case of Looe Yooe (landed July 27, 1905), File 10055/117, IACF.

33. Samuel Backus, Commissioner, Angel Island Station, Finding and Decree, In the Matter of Wong Quon Young, File 10739/10862, IACF.

34. Samuel Backus, Commissioner, Angel Island Station, Finding and Decree, In the Matter of Wo Bing, March 27, 1912, File 10739/10860, IACF. Other cases of discrepant photographs in this file series include Files 10739/10861 and 10740/3.

35. Joseph Scully, Immigrant Inspector, Angel Island Station, to Chinese Inspector in Charge, March 26, 1912, p. 1, File 10739/10860, IACF. See also Case of Wong Sear Oun, File 10395/26 (1910), IACF.

36. Allan Sekula also notes the problems with "constructing an overly monolithic or unitary model of nineteenth-century realist discourse" (351) in "Body and the Archive." He points to conflicts within the field of criminal photography between those who had faith in the powers of photography and those who had "a crisis of faith in optical empiricism" (351), such as Alphonse Bertillon. Sekula, "Body and the Archive," 343–89.

37. U.S. Congress, House, Committee on Immigration and Naturalization, *Chinese Immigration* (1892).

38. Immigration Inspector 2, Box 1, Folder 48, JYC.

39. Derrick Price, "Surveyors and Surveyed," in *Photography: A Critical Introduction*, ed. Liz Wells (London: Routledge, 1997), 66.

40. Hart Hyatt North to Honorable George Hatton, December 27, 1907, HHNP.

41. See, for example, File 10739/10860, IACF.

42. Mr. Tsang, Box 1, Folder 30, JYC.

43. Case of Ah Jew Mooey, File 23586/5-2 (1924), IACF.

44. Inspector Albert Long to Inspector in Charge, Chinese Division, Angel Island, July 31, 1911, pp. 3–4, File 53329–111, Accession 60A600, R-INS, NARA-DC.

45. "Rules for the Government of United States Immigrant Inspectors and Boards of Special Inquiry," January 20, 1903, File 5738 (1905–06), Entry 10, Central Files, 1897–1923, R-PHS, NARA-MD.

46. Mr. Lai, Box 1, Folder 28, JYC.

47. Mr. Chan, Box 1, Folder 23, JYC. See also Mr Yuen, Angel Island tour, March 1975, pp. 13, 24, Combined Asian American Resources Oral History Project, San Francisco, Regional Oral History Office, BL.

48. Young Fou, File 10059/52, IACF.

49. *In re: Tang Tun et ux.*, 168 F. 488 Circuit Court of Appeals (9th Cir. 1909).

50. Act of March 3, 1903 (32 Stat. 1213); "Chinese Exclusion," *Outlook*, April 23, 1904, 964.

51. Sekula, "Body and the Archive," 357, 360, 363.

52. Bids for photographing Chinese subjects from F. A. Kirk and Frank Spencer to Chinese Inspector in Charge, Malone, N.Y., July 10, 1905, File 14178, Entry 132, R-INS, NARA-DC.

53. File 10055/117, IACF.

54. E. Lee, *At America's Gates*, 85.

55. Ng Poon Chew, *The Treatment of the Exempt Classes of Chinese in the United States* (San Francisco, 1908), p. 10, Box 3, Folder 15, NPCC.

56. "U.S. Announces Change in Photo Standard to Take Effect August 2nd, 2004," press release, August 2, 2004, www.uscis.gov/files/pressrelease/04_08_02photo_release.pdf. In his study of criminal photographic identification, Allan Sekula argued that the decline of the signaletic system was caused by the rise of fingerprinting to identify criminals, "although hybrid systems operated for some years." Sekula was apparently unaware that the BCIS used a hybrid

system until 2004, requiring both a fingerprint *and* one ear to be fully visible to aid identification of resident aliens on green cards. Allan Sekula, "Body and the Archive," 362.

57. Thurston, "Hearsay of the Sun." See also *Reisterer v. Lee Sum,* 94 F. 343 (2nd Cir. 1899), and File 10055/117, IACF.

58. Ansel H. Paine, Chinese Inspector in Charge, Portal, N.D., to Secretary of Commerce and Labor, January 31, 1907, File 14610–172, Entry 132, R-INS, NARA-DC. On Japanese picture brides, see Kei Tanaka, "Japanese Picture Marriage in 1900–1924 California: Construction of Japanese Race and Gender" (PhD diss, Rutgers University, 2002).

59. Wexler, "Techniques of the Imaginary Nation," 374.

60. Commissioner-General of Immigration, to Richard Halsey, Inspector in Charge, Immigration Service, Honolulu, December 3, 1912, File 53492–169, Accession 60A600, R-INS, NARA-DC.

61. Lauritz Lorenzen, Chinese Inspector, to Inspector in Charge, Chinese Division, April 9, 1910, p. 4, File 10395/36, IACF.

62. File 55598–130 (1926), IACF.

63. See Immigration Inspectors 1 and 2, Box 1, Folders 47 and 48, JYC.

64. For an example of a case involving the use of passport photographs, see Chinese Inspector to Chinese Inspector in Charge, Angel Island Station, April 3, 1912, p. 3, File 10739/10862, IACF. On the use of photographs from court cases, see Case of Wong Sear Oun, 1910, File·10395/26, IACF. See also Joseph Scully, Immigrant Inspector, to Inspector in Charge, Chinese Division, Angel Island, April 3, 1912, File 10740/3, IACF.

65. The coaching materials unearthed as part of the Densmore investigation into official corruption, for example, contain numerous photographs. CFIFI.

66. Coaching paper from Yook to Chang Sam, translated by Chinese Inspector and Interpreter John Endicott Gardner, September 1, 1913, File 12907/5-1, IACF; Coaching paper from Dong Hung to Dong Loon, mailed April 18, 1925, translated by Interpreter H. K. Tang, May 1, 1925, File 23847/5-7, pp. 49–50, IACF.

67. Mr. Dea, Box 1, Folder 13, JYC.

68. Translation of coaching letter from Bing Ying to Shew Non, 1907, File 14610/179, Entry 132, R-INS, NARA-DC.

69. Coaching paper from Dong Hung to Dong Loon, mailed April 18, 1925, translated by Interpreter H. K. Tang, May 1, 1925, File 23847/5-7, pp. 49–50, IACF. See also Lauritz Lorenzen, Chinese Inspector, to Inspector in Charge, Chinese Division, April 9, 1910, p. 3, File 10395/36, IACF.

70. Case of Lee Choy, 1910, File 10395/36, IACF; Case of Yee Kim Sue, 1911, File 53329–111, Accession 60A600, R-INS, NARA-DC; Case of Wong Tai Luck, 1912, File 53492–169, Accession 60A600, R-INS, NARA-DC; Case of Jew Lan Wah, 1924–25, File 23847/5–14, IACF; Testimony of Quong Sam Fat, January 12, 1925, pp. 3–5, File 23847/5-3, IACF; Ju Yick Mee to "Officials of the Immigration Service," April 14, 1941, File 40766/11–15, IACF. Witnesses for the applicant were also asked these questions. See, for example, Testimony of Louie Ak, July 7, 1905, pp. 1–2, File 10055/117, IACF.

71. Case of Wong Quon Young, 1912, File C-393, Chinese Immigration Case Files, 1903–15, R-INS, NARA-SF.

72. Case of Wong Quon Young, 10739/10862, IACF.

73. In the matter of (Lum) Tai Sing, 1912, File 10739/10861, IACF.

74. Lauritz Lorenzen, Chinese Inspector, to Inspector in Charge, Chinese Division, April 9, 1910, p. 4, File 10395/36, IACF.

75. Testimony of Quong Sam Fat, January 12, 1925, pp. 3–5, File 23847/5–3, IACF.

76. Testimony of Lee Youn, February 13, 1925, p. 5, File 23847/5–8, IACF. Other reasons for Lee Youn's denial included his changing testimony, his demeanor in answering questions, and the fact that his alleged father and uncles had no daughters, only sons.

77. Immigration Interpreter 2, Box 1, Folder 50, JYC. See also Mr. Chow, Angel Island tour, March 1975, p. 3, Combined Asian American Resources Oral History Project, San Francisco, California, Regional Oral History Office, BL.

78. E. Lee, At America's Gates, 351–52.

79. Conclusion of R. F. Davis, Chairman, Board of Special Inquiry, in the matter of Jew Lan Wah and Jew Lan Foo, January 8, 1925, p. 23, Files 23847/5–14 and 23847/5–15, IACF. For more information on European racial typing, see chapters 3 and 4 on Ellis Island." On the differences between Bertillon and Galton's methods, see Sekula, "Body and the Archive," 353–76.

80. File 18431/5–2, IACF.

81. File 23852/2–15, IACF.

82. After locating this photograph in NARA-SF, I learned the complex history behind this image from Lisa See's family history, On Gold Mountain: The One-Hundred-Year Odyssey of My Chinese-American Family (New York: Vintage Books, 1995).

83. Robert F. Lym, Chinese Interpreter, Angel Island, to Commissioner of Immigration, September 4, 1914, File 12017/5542, Return Certificate Case Files, 1912–44, R-INS, NARA-SF.

84. Jessie Gee Fou (possibly You) inscribed his name on the reverse of his portrait, and Hart Hyatt North identified Lori Sing in his handwriting. Photograph of Jessie Gee Fou, BANC PIC 1979.032—AX, PHHNP; photograph of Lori Sing and his sons, BANC PIC 1980.098:78, PHHNP.

85. Lauritz Lorenzen, Chinese Inspector, to Inspector in Charge, Angel Island, Calif., May 20, 1910, pp. 1–2, File 10395/30, IACF.

86. Charles Franklin, Immigrant Inspector, to Commissioner of Immigration, San Francisco, Calif., May 4, 1925, File 23847/5–7, IACF.

87. John A. Robinson Photographs and John A. Robinson Papers pertaining to the U.S. Immigration Service, San Francisco, 1906–1936, MSP 1816, CHS.

88. Memorandum from Assistant Commissioner-General to Commissioner-General of Immigration, October 27, 1913, p. 1, File 52516–10, Entry 9, R-INS, NARA-DC.

89. Minister Wu Ting Fang, Chinese Legation, to John Sherman, Secretary of State, November 10, 1897, p. 2, Notes from the Chinese Legation in the United States to the Department of State, 1868–1906, RG 59, Microfilm M98, roll 3, NARA-MD.

90. On the Portland raids, see Minister Wu Ting Fang to John Hay, Secretary of State (with enclosures), January 23, 1899. On New York and Boston in

1902, see Minister Wu Ting Fang to Alvey Adee, Acting Secretary of State (with enclosures), August 30, 1902. On Boston in 1903, see Minister Wu Ting Fang to John Hay, Secretary of State (with enclosures), November 10, 1903. All three are in Notes from the Chinese Legation in the United States to the Department of State, 1868–1906, RG 59, Microfilm M98, NARA-MD. On U.S.-Mexican border towns, see T. F. Schmucker, Chinese Inspector in Charge, District of Texas, to the Commissioner-General of Immigration, June 30, 1905, cited in *ARCGI* (1905), 96.

91. *Ex parte Chin Hen Lock*, 174 F. 282 (D. Vt. 1909).

92. W. E. Howard, Immigrant Inspector in Charge, New Orleans to Commissioner-General of Immigration, March 27, 1903, File 6891, Chinese General Correspondence, 1893–1908, Entry 132, R-INS, NARA-DC, quoted in Lee, *At America's Gates*, 230.

93. "Reported cases" refers to cases reported by the Chinese Legation and in major newspapers. Minister Wu Ting Fang to Alvey Adee, Acting Secretary of State, August 30, 1902, p. 2, Notes from the Chinese Legation in the United States to the Department of State, 1868–1906, RG 59, Microfilm M98, roll 5, NARA-MD.

94. See, for example, *Boston Post*, October 13, 1903, and *Boston Herald*, October 15, 1903; Coolidge, *Chinese Immigration*, 177.

95. Rule 47, U.S. Bureau of Immigration, *Treaties, Laws and Regulations* (1907), 52–53.

96. William Tomkins, Immigrant Inspector, to Commissioner of Immigration, memo, July 24, 1925, File 15843/3–14, IACF.

97. Maxine Hong Kingston, "San Francisco's Chinatown," *American Heritage* 30 (December 1978): 37–47.

98. According to Lai, Lim, and Yung, *Island* (12), U.S. immigration officials "frequently swept through Chinese establishments, ensnaring alleged illegal immigrants."

99. Mr. Tom, Box 1, Folder 23, JYC.

100. Immigration Inspector 3, Box 1, Folder 49, JYC.

101. T. F. Schmucker, Chinese Inspector in Charge, District of Texas, to the Commissioner-General of Immigration, June 30, 1905, in *ARCGI* (1905), 96.

102. Chentung Liang Cheng, Chinese Legation, to John Hay, Secretary of State, December 15, 1903, p. 2, Notes from the Chinese Legation in the United States to the Department of State, 1868–1906, RG 59, Microfilm M98, NARA-MD.

103. Wu Ting Fang, Chinese Legation, to John Sherman, Secretary of State, November 10, 1897, p. 2, Notes from the Chinese Legation in the United States to the Department of State, 1868–1906, RG 59, Microfilm M98, NARA-MD; John W. Foster, "The Chinese Boycott," *Atlantic Monthly*, January 1906, 122.

104. "What the Chinese Think about the Chinese Exclusion Act: Wong Kai Kah, Former Minister to England Points Out Some Objections to the Way It Is Enforced," *Spokane Press*, May 23, 1905.

105. Commissioner-General of Immigration, File 10605-C, Entry 132, R-INS, NARA-DC.

106. Daniel Keefe, Commissioner-General of Immigration, to Assistant Secretary of Commerce and Labor, memo, January 16, 1909, File 52516–10, Entry 9, R-INS, NARA-DC. Historians have disagreed about the effectiveness of

the Chinese boycott. As Delber McKee notes in an essay that offers a useful historiography of the event, the boycott has traditionally been seen as a failure. However, recent reinterpretations by historians such as McKee and Erika Lee have offered a more positive view of the boycott. Although it failed to achieve its purpose of ending exclusion, they view the boycott as effectively curtailing the harsh enforcement of the law and galvanizing the transnational Chinese community in America and abroad. McKee, "Chinese Boycott"; E. Lee, *At America's Gates,* 125–26.

107. Department Circular No. 81, File 52516–10, Entry 9, R-INS, NARA-DC.

108. Daniel Keefe, Commissioner-General of Immigration, to Assistant Secretary of Commerce and Labor, memo, January 16, 1909, File 52516–10, Entry 9, R-INS, NARA-DC.

109. Daniel Keefe, Commissioner-General of Immigration, to Acting Secretary of Commerce and Labor, memo, June 8, 1909, File 52516–10, Entry 9, R-INS, NARA-DC.

110. See also F. H. Larned, Acting Commissioner-General of Immigration, to Daniel Keefe, Commissioner-General of Immigration, memo, June 12, 1909, p. 2, File 52516–10, Entry 9, R-INS, NARA-DC.

111. On the extensive use of and trade in false birth certificates, see letter from I. F. Nixon [no addressee given], File 1300–67656, R-INS, NARA-SF, cited in Lau, *Paper Families,* 35–36. See also two court cases involving individuals accused of holding discharge certificates that did not belong to them: *Ah Tai v. United States,* 135 F. 513 (1st Cir. 1905), and *Ex parte Chin Hen Lock,* 174 F. 282 (D. Vt. 1909).

112. F. H. Larned, Acting Commissioner-General, to Commissioner of Immigration, San Francisco, January 22, 1912, p. 2, File 52516/10, Entry 9, R-INS, NARA-DC. See also Samuel Backus, Commissioner of Immigration, San Francisco, to Commissioner-General of Immigration, January 12, 1912, p. 2, File 52516/10, Entry 9, R-INS, NARA-DC.

113. For conflicts between the courts and the Immigration Bureau, see Salyer, *Laws Harsh as Tigers,* 81–85, 93, 100–102, 114–15.

114. Quong Yuen Shing & Co. to Commissioner-General of Immigration, August 24, 1905, File 10605-C, Entry 132, R-INS, NARA-DC.

115. Testimony of Woo Dung, September 2, 1921, File 23852/2–11, R-INS, NARA-DC.

116. Green and Bennett, Attorneys at Law, to Collector of Internal Revenue, December 22, 1903, File 10860-C, Entry 132, R-INS, NARA-DC.

117. McClain, *In Search of Equality,* 147–72, 191–219; Salyer, *Laws Harsh as Tigers.*

118. *Reisterer v. Lee Sum,* 94 F. 343 (2nd Cir. 1899).

119. *United States v. Wong Ock Hong,* 179 F. 1004 (D. Ore. 1910). On the issue of a different person apparently possessing the same certificate, the judge ruled that although Wong may have loaned his certificate to someone else, this was not a deportable offense.

120. Charles W. Seaman, Inspector in Charge, Minneapolis, to Commissioner-General of Immigration, February 15, 1912, File 53416–39, located with File 53329–111, Accession 60A600, R-INS, NARA-DC.

121. George Billings, Commissioner, Chinese Division, Boston, to Daniel J. Keefe, Commissioner-General of Immigration, November 7, 1911, File 53329–111, Accession 60A600, R-INS, NARA-DC.

3. ELLIS ISLAND AS AN OBSERVATION STATION

1. Markel and Stern, "Which Face? Whose Nation?" 1318.
2. Yew, "Medical Inspection of Immigrants," 492. For another overlapping analysis of the numbers of debarred immigrants, see Kraut, *Silent Travelers*, 66–67.
3. Daniels, *Guarding the Golden Door*, 46–47.
4. Marian L. Smith, "Immigration and Naturalization Service," in *A Historical Guide to the U.S. Government*, ed. George T. Kurian (New York: Oxford University Press, 1998), 305.
5. Fairchild, *Science at the Borders*, 86.
6. In Broughton Brandenburg, "The Stranger within the Gate, II," *Harper's Weekly*, August 5, 1905, 1116.
7. [New York] *World*, July 1912, in Scrapbook 2, WWP. See also "The Inflowing Tide," in Howard B. Grose, *Aliens or Americans?* (New York: Young People's Missionary Movement, 1906), opp. 18. Similar photographs were also taken of Asian immigrants arriving at Angel Island. See, for example, "Officers of the USPHS Making Quarantine Inspection of Passengers on a Trans-Pacific Liner from the Orient," February 1924, Photograph 90-G-519, R-PHS, NARA-MD.
8. *ARCGI* (1896).
9. *ARCGI* (1901), 40; *ARCGI* (1902), 52. The 1900 immigration station and later hospital buildings are the same ones that now stand on Ellis Island, with the immigration station housing the Ellis Island Immigration Museum.
10. Frederic J. Haskin, *The Immigrant: An Asset and a Liability* (New York, 1913), 75–81, cited in Unrau, *Historic Resource Study*, 551.
11. On the description of Angel Island as the Ellis Island of the West, see, for example, Mary Bamford, *Angel Island: The Ellis Island of the West* (Chicago: Woman's American Baptist Home Mission Society, 1917). More recent histories, such as Kraut's *Silent Travelers*, also draw comparisons between Ellis and Angel Islands (56). On the differences between Angel Island and Ellis Island, see Daniels, "No Lamps Were Lit," and Markel and Stern, "Which Face? Whose Nation?" 1313–30.
12. Lai, Lim, and Yung, *Island*, 20.
13. Birn, "Six Seconds per Eyelid," 290.
14. "An Enormous Building," *New York Times*, July 28, 1891, 8.
15. Victor Safford, *Immigration Problems: Personal Experiences of an Official* (New York: Dodd, Mead, 1925), 98–99.
16. Ibid., 100.
17. "Visitors' Guide to Ellis Island" (December 1913), in *Historic Resource Study (Historical Component), Ellis Island, Statue of Liberty National Monument*, by Harlan D. Unrau (Washington, DC: National Park Service, 1984), 545.
18. "The Spectator," *Outlook*, March 25, 1905, 730.

19. Julian Dimock, "Ellis Island As Seen by the Camera-Man," *World To-Day*, April 1908, 396; Moses King, *King's Handbook of New York City* (Boston: Moses King, 1893), 71. Even before the immigration station opened, *Harper's Weekly* described the new building as one of the city's sights. Julian Ralph, "Landing the Immigrant," *Harper's Weekly*, October 24, 1891, 821.

20. "Visitors' Guide," 545.

21. George William Carter, General Secretary, New York Bible Society, to William Williams, Commissioner, Ellis Island, June 13, 1910, and June 17, 1912, Box 2, WWP.

22. Robert Watchorn, "The Gateway of the Nation, Illustrated with Studies of Immigrant Types by Julian A. Dimock and Underwood & Underwood," *Outlook*, December 28, 1907, 897.

23. W. G. McAdoo, Secretary of the Treasury, to Homer Folks, Secretary, State Charities Aid Association, December 16, 1913, Box 37, File 219, Entry 10, R-PHS, NARA-MD.

24. "Visitors' Guide," 545.

25. Ibid.

26. "The General Committee of Immigrant Aid at Ellis Island, New York Harbor," n.d., pp. 8–9, NCWC Papers, CLSSC. See also Henry Hall's article contrasting the "heart-rending scenes" of deportation with the joyous "scenes one may witness when the immigrants are admitted." Henry N. Hall, "The Great American Hold-Up at Ellis Island," *World*, November 13, 1913, in File 219, Entry 10, R-PHS, NARA-MD.

27. "Visitors' Guide," 546.

28. Bamford, *Angel Island*, 11.

29. Philip Cowen, *Memories of an American Jew* (1932; repr., New York: Arno Press, 1975), 144–45. Cowen described his experiences as an inspector on the island in 1907.

30. Safford, *Immigration Problems*, 34.

31. Robert Rydell, *All The World's a Fair: Visions of Empire at the American International Expositions, 1876–1916* (Chicago: University of Chicago Press, 1984); Julie Brown, *Contesting Images: Photography and the World's Columbian Exposition* (Tucson: University of Arizona Press, 1994).

32. Jacob Riis, *How the Other Half Lives: Studies among the Tenements of New York* (New York: Scribner's and Sons, 1890); Kevin Mumford, "Slumming," in *Interzones: Black/White Sex Districts in the Early Twentieth Century* (New York: Columbia University Press, 1993).

33. William Williams, Commissioner of Ellis Island, to Commissioner-General of Immigration, July 10, 1903, File 39516, Entry 7, R-INS, NARA-DC.

34. H. G. Wells, *The Future in America* (1906), quoted in Susan Jonas, ed., *Ellis Island: Echoes from a Nation's Past* (New York: Aperture, 1989), 10–11.

35. *ARCGI* (1893), 13. See also Haskin, *Immigrant*, 75–81; Commissioner of Immigration, Ellis Island, to Commissioner-General of Immigration, March 31, 1913, p. 3, Box 37, File 219, Entry 10, R-PHS, NARA-MD.

36. Fairchild, *Science at the Borders*, 65, 74.

37. Anne-Emmanuelle Birn and Amy Fairchild are exceptions. Birn's research addresses some of the visual aspects of medical inspection at Ellis Island, and

Amy Fairchild explores the concept of "the medical gaze." Birn, "Six Seconds per Eyelid," 292, 301; Fairchild, *Science at the Borders*, 83–115.

38. The process of medical inspection has been well documented in the following histories: Unrau, *Historic Resource Study;* Yew, "Medical Inspection of Immigrants"; Kraut, *Silent Travelers;* Birn, "Six Seconds per Eyelid"; Fairchild, *Science at the Borders*.

39. Unrau, *Historic Resource Study*, 9.

40. Kraut, *Silent Travelers*, 60.

41. *ARCGI* (1900), 4.

42. *ARCGI* (1901), 13. See also Allan McLaughlin, "How Immigrants Are Inspected," *Popular Science Monthly*, February 1905, 358.

43. Manny Steen, interview by Paul Sigrist, March 22, 1991, EIOHP, cited in Fairchild, *Science at the Borders*, 69.

44. In 1910, Immigration Restriction League founder Robert DeCourcey Ward wrote to Ellis Island Commissioner William Williams praising his work and explaining how the league got the idea for restricting immigrants with poor physiques "from one of your reports, and we incorporated it into our bill, which was introduced into Congress." Ward continued that "the poor physique clause in the present Immigration Act is almost word for word what we had in our bill." Robert DeCourcey Ward to William Williams, March 19, 1910, Box 2, WWP.

45. Unrau, *Historic Resource Study*, 585, 616.

46. Markel and Stern, "Which Face? Whose Nation?" 1316.

47. "Memorandum Report Relative to Increased Facilities for the Medical Examination of Aliens at Ellis Island," n.d., File 0950, Box 163, Entry 10, General Subject File 1924–1935 Domestic Stations: N.Y., Ellis Island, R-PHS, NARA-MD.

48. Alfred C. Reed, "The Medical Side of Immigration," *Popular Science Monthly*, April 1912, 386.

49. Ibid.

50. "Book of Instruction for the Medical Inspection of Immigrants," n.p, n.d, in Unrau, *Historic Resource Study*, 653.

51. Ibid.

52. McLaughlin, "How Immigrants Are Inspected," 359. On the rise of the numbers of immigrants rejected as "liable to become a public charge," see Birn, "Six Seconds per Eyelid," 300; Yew, "Medical Inspection of Immigrants."

53. Birn, "Six Seconds per Eyelid," 292.

54. Henry Arthur, "Among the Immigrants," *Scribner's Magazine*, March 1901, 301–11, cited in Birn, "Six Seconds per Eyelid," 293.

55. Dora Rich, interview, transcript, pp. 2–3, and Elda Willits, interview EI-62, transcript, p. 35, both in EIOHP.

56. F. W. van Loon to Surgeon General, PHS, July 21, 1913, Box 37, File 219, Entry 10, R-PHS, NARA-MD.

57. Markel and Stern, "Which Face? Whose Nation?" 1317.

58. Fairchild, *Science at the Borders*, 69–71.

59. "The Life Story of a Hungarian Peon," in Holt, *Life Stories*, 201.

60. McLaughlin, "How Immigrants Are Inspected," 359.

61. Samuel B. Grubbs, *By the Order of the Surgeon General* (Greenfield, IN:

William Mitchell, 1943), cited in Birn, "Six Seconds per Eyelid," 296. See also Eberle, "Where Medical Inspection Fails," 27.

62. Cited in Yew, "Medical Inspection of Immigrants," 504.

63. Birn, "Six Seconds per Eyelid," 290. In addition to those who were marked by inspectors, some immigrants were also removed from the line to be photographed or to be measured for research on immigrant types. During the early 1900s, Smithsonian curator Ales Hrdlicka conducted anthropological measurements of immigrants at Ellis Island. Obtained with the assistance of PHS staff, these measurements were exhibited at the eugenic International Congress on Hygiene and Demography in Washington, D.C., in 1912. E. K. Sprague, Chief Medical Officer, to Surgeon General, PHS, March 8, 1926, S. B. Grubbs, Acting Surgeon General, PHS, to Dr. A. Hrdlicka, May 4, 1926, Dr. A. Rathburn, Acting Secretary, Smithsonian Institution, to Dr. A. Hrdlicka, September 11, 1915, and Rupert Blue, Surgeon-General, PHS, to Chief Medical Officer, PHS, Ellis Island, February 23, 1912, all in File 0950, Box 163, Entry 10, General Subject File 1924–1935, Domestic Stations: N.Y., Ellis Island, R-PHS, NARA-MD.

64. Birn, "Six Seconds per Eyelid," 301.

65. L. L. Williams, "The Medical Examination of Aliens, Routine Inspection versus Careful Physical Examination," n.d., File 219, Box 39, Entry 10, R-PHS, NARA-MD; "Memorandum Report Relative to Increased Facilities for the Medical Examination of Aliens at Ellis Island," n.d., File 0950, Box 163, Entry 10, R-PHS, NARA-MD.

66. Markel and Stern, "Which Face? Whose Nation?" 1318.

67. McLaughlin, "How Immigrants Are Inspected," 359.

68. Elda Willits, interview EI-62, transcript, p. 35, EIOHP.

69. See, for example, Detroit Publishing Company, "Immigrants at Ellis Island, New York," postcard, PC NEW YC-Ell, Mid-Manhattan Library Picture Collection, NYPL.

70. Bertha M. Boody, *A Psychological Study of Immigrant Children at Ellis Island, 1922–1923* [1926], in Unrau, *Historic Resource Study,* 717.

71. Ibid.

72. Alfred C. Reed, "Going through Ellis Island," *Popular Science Monthly,* January 1913, 5–6.

73. For outside criticism regarding the inadequacy of the line inspection, see Markel and Stern, "Which Face? Whose Nation?" 1316.

74. Yew, "Medical Inspection of Immigrants," 504.

75. "Report on an Investigation of Conditions at Ellis Island," *Modern Health Advocate,* January 1921, 11; William Slavens McNutt, "We and the Immigrant Foot the Bill," *American Legion Weekly,* September 9, 1921, 5–6, 20–21, in Box 38, File 219, Entry 10, R-PHS, NARA-MD.

76. Grubbs, *By the Order of the Surgeon General,* quoted in Birn, "Six Seconds per Eyelid," 296.

77. Quoted in Yew, "Medical Inspection of Immigrants," 504.

78. "Says the Foreigner Is Not Appreciated," *Brooklyn Standard Union,* March 23, 1921, Box 38, File 219, Entry 10, R-PHS, NARA-MD; W. C. Billings, Draft Report, n.d., Box 163, File 0950, Entry 10, R-PHS, NARA-MD; "Methods of Medical Examination of Arriving Aliens," January 19, 1921, Box 38, File

219, Entry 10, R-PHS, NARA-MD; L. L. Williams, "The Medical Examination of Aliens, Routine Inspection versus Careful Physical Examination," n.d., Box 39, File 219, Entry 10, R-PHS, NARA-MD.

79. E. H. Mullan, "Mental Examination of Immigrants: Administration and Line Inspection at Ellis Island," *Public Health Reports* 32 (May 18, 1917): 733–46, in Unrau, *Historic Resource Study,* 857.

80. Cited in Boody, *Psychological Study,* 717.

81. *Annual Report of the Surgeon General of the Public Health and Marine Hospital Service* (Washington, DC: GPO, 1905), in Unrau, *Historic Resource Study,* 596.

82. Letter relative to the preparation of a manual for the mental examination of immigrants, December 6, 1913, Box 37, File 219, Entry 10, R-PHS, NARA-MD.

83. Fairchild, *Science at the Borders,* 166–67, 205.

84. George W. Stocking Jr., "The Turn-of-the-Century Concept of Race," *Modernism/Modernity* 1 (1994): 4–16.

85. Even though most histories identify overseas examinations as occurring after the passage of immigration quotas in the 1920s, Amy Fairchild notes that many immigrants were excluded during medical inspections conducted abroad during the 1890s and 1900s. Fairchild, *Science at the Borders,* 58–63.

4. ELLIS ISLAND AS A PHOTO STUDIO

1. Anne Haverick Cross, interview EI-357, transcript, p. 21, EIOHP.

2. Halftone technology used a chemical process to transfer photographs to the page as a matrix of dots, increasing both the speed and accuracy with which photographs could be reproduced in newspapers, magazines, and books. By 1893, roughly one-third of the images in *Century,* half the images in *Harper's* Magazine, and almost all the images in *Cosmopolitan* used the new technology. In addition to these general-interest periodicals, illustrated articles about immigrants were prominently featured in ethnographic magazines such as *National Geographic* and social work publications such as *Charities and the Commons* (later renamed the *Survey*). Newspapers and weekly publications continued to use engravings, offering picturesque street scenes of urban immigrant enclaves. However, these illustrations were often described as drawn from photographs. Mott, *History of American Magazines,* 153–54; Harris, "Iconography and Intellectual History."

3. Maltine Company, *Quarantine Sketches,* 1903, Lot 4837, LCPPD. For snapshot photographs, see "Guests at Ellis Island, 1909–1913 (Partial List)," Box 7, WWP. Charles Holmes, a guest hosted by Williams at Ellis Island, commented in his letter of thanks that "the pictures are giving Mrs. Holmes no end of pleasure"; Charles Holmes to William Williams, March 7, 1912, Box 2, WWP. For stereographic images of immigrants, see Keystone View Company Collection, Lot 11021, LCPPD. For images used in publications, see Photography Collection, NYPL; Bain News Service Collection, Lot 7172, LCPPD; Howard Knox, Assistant Surgeon, to Surgeon General, PHS, July 25, 1915, Box 37, File 219, Entry 10, R-PHS, NARA-MD; E. H. Mullan, PHS, to

Surgeon General, PHS, March 21, 1917, Box 37, File 219, Entry 10, R-PHS, NARA-MD; R. S. Williams to Mr. Creel, September 23, 1921, Box 38, File 219, Entry 10, R-PHS, NARA-MD. For collections of photographs taken by immigration officials, see Colonel Weber Photograph Collection and ASPC, both at the Statue of Liberty National Monument, National Park Service, New York, NY.

4. Goldberg, "Camera and the Immigrant," 23–24.

5. Frank Hankins, "Birth Control and the Racial Future," *People*, April 1931, 11–15; "Four Years of Progress at Ellis Island," *New York Times*, February 12, 1905; Edward Marshall, "Commissioner Williams Analyzes Immigration Evils," *New York Times*, January 15, 1911; "Proposal to Furnish Supplies or Services Other Than Personal for the Public Health Service," 1921, Box 38, File 219, Entry 10, R-PHS, NARA-MD.

6. Julian Dimock, "Ellis Island as Seen by the Camera-Man," *World To-Day*, April 1908, 395.

7. On cartoons, see Joshua Brown, "Reconstructing Representation: Social Types, Readers, and the Pictorial Press, 1865–1877," *Radical History Review* 66 (1996): 5–38; Chloe Burke, "Germs, Genes, and Dissent: Representing Radicalism as Disease in American Political Cartooning, 1877–1919" (PhD diss., University of Michigan, 2004).

8. Matthew Frye Jacobson, *Whiteness of a Different Color: European Immigrants and the Alchemy of Race* (Cambridge, MA: Harvard University Press, 1998); Thomas Guglielmo, *White on Arrival: Italians, Race, Color, and Power in Chicago, 1890–1945* (New York: Oxford University Press, 2003).

9. Although biographical information about Sherman is limited, some details are given in Andrea Temple and June Tyler, *Ellis Island and the Augustus Sherman Collection* (Wethersfield, CT: First Experience, 1986), and Peter Mesenhöller, *Augustus F. Sherman: Ellis Island Portraits, 1905–1920* (New York: Aperture, 2005), 7.

10. In addition to the approximately 150 Augustus Sherman photographs in the Ellis Island library, there are apparently about fifty further images in the curatorial collections. However, access to these glass plate negatives is restricted because of their fragile condition. Ellis Island curator of collections Geraldine Santoro, e-mail, January 4, 2006; Ellis Island librarian Barry Moreno, telephone conversation, October 22, 2008.

11. See WWP.

12. Conversation with Rosemary Milward, Robert Watchorn Papers, Watchorn Memorial Methodist Church, Alfreton, Derbyshire, England, December, 18, 1998.

13. Temple and Tyler, *Ellis Island;* Mesenhöller, *Augustus F. Sherman*.

14. On Sherman's portraits of muscled men and "freaks," see Erica Rand, *The Ellis Island Snow Globe* (Durham: Duke University Press, 2005), 67–106.

15. Data calculated from charts in *ARCGI* (1925), 226. Although Sherman worked at Ellis Island between 1892 and February 1925, these percentages are calculated from July 1, 1898 (when the Immigration Bureau started recording immigration by race) to June 30, 1924 (prior to Sherman's death).

16. Augustus Sherman, "Return This Group of Wallachians," photo no. 2A-11, ASPC.

17. Sherman's photographs were used to illustrate the following publications during his tenure at Ellis Island: *ARCGI* (1904), opp. 99; "Four Years of Progress at Ellis Island," *New York Times,* February 12, 1905; "Our Immigration during 1904," *National Geographic,* January 1905, 22; Grose, "Aliens or Americans?"; Gilbert H. Grosvenor, "Some of Our Immigrants," *National Geographic,* May 1907, 317–34; *ARCGI* (1907); Edward Marshall, "Commissioner Williams Analyzes Immigration Evils," *New York Times,* January 15, 1911; Alfred Rossiter, "The Truth about Ellis Island," *City Life and Municipal Facts,* June 8, 1911; Peter Roberts, *The New Immigration: A Study of the Industrial and Social Life of Southeastern Europeans in America* (New York: Macmillan, 1912); Gilbert H. Grosvenor, "Our Foreign-Born Citizens," *National Geographic,* February 1917, 95–130. See also Collection Guide, WWPC.

18. Roberts, *New Immigration.*

19. This failure of publications to credit Sherman for photographs of his that they reproduce has continued beyond the period in which these articles were published. Sherman's photographs appear in many books and almost every illustrated history about Ellis Island, but unlike Riis's or Hine's they are rarely attributed to him. See, for example, Wilton Tifft and Thomas Dunne, *Ellis Island* (New York: W. W. Norton, 1971); David M. Brownstone, Irene Franck, and Douglass Brownstone, *Island of Hope, Island of Tears* (New York: Rawson Wade, 1979). Sherman has received increasing recognition and attribution, however, with the publication of the Museum of Photographic Arts, San Diego, *Points of Entry,* and Mesenhöller, *Augustus F. Sherman.*

20. Augustus Sherman's obituary, *New York Times,* February 21, 1925, 11, col. 5.

21. Fairchild, *Science at the Borders.*

22. Augustus Sherman, Untitled (Rumanian Woman), photo no. 1A-14, ASPC. The titles in parentheses are racial designations provided by the National Park Service in their materials on the Augustus Sherman collection.

23. On the tensions between the picturesque and the ethnographic, see Bramen, "Urban Picturesque."

24. Julian Dimock, "A Roumanian from Bukharest," ca. 1908, in *World To-Day,* April 1908, 339.

25. Dimock, "Ellis Island," 395.

26. Ibid. Although Dimock resisted the ethnographic approach in his images of immigrants, he took photographs of Native Americans and African Americans that presented strongly ethnographic racial types. Julian Dimock Collection, American Museum of Natural History, New York.

27. "Four Years of Progress at Ellis Island," *New York Times,* February 12, 1905; Edward Marshall, "Commissioner Williams Analyzes Immigration Evils," *New York Times,* January 15, 1911.

28. Augustus Sherman, Untitled (Chinese Woman), photo no. 1A-47, ASPC.

29. Of course, this effect also relies partly on the fact that the building's architecture includes apparently "Oriental" details as part of its decoration. On the architecture of Ellis Island, see Robert Twombly, "Ellis Island: An Architectural History," in Jonas, *Ellis Island,* 122–37.

30. Augustus Sherman, Untitled (Commissioner Robert Watchorn), ASPC.

31. Augustus Sherman, Untitled (Algerian Man), photo no. 4A-8, ASPC.

32. Rydell, *All The World's a Fair*, 154–83.

33. *ARCGI* (1903), opp. 82; "Our Immigration during 1904," 25. My thanks to both Dalia Habib and Michael Schecter for drawing my attention to the Social Museum Collection of the Harvard University Library, available online, which includes various Ellis Island photographs by J. H. Adams.

34. *ARCGI* (1903), opp. 66; "Our Immigration during 1904," 24. The frontal image also appears in William Williams's scrapbook, WWP.

35. Augustus Sherman, "Magyar" and "Dutch Women," in *ARCGI* (1907).

36. Augustus Sherman, Untitled (Two Dutch Women with Child), photo no. 1B-7, ASPC.

37. Frank Spencer, "Some Notes on the Attempt to Apply Photography to Anthropometry during the Second Half of the Nineteenth Century," in *Anthropology and Photography*, ed. Elizabeth Edwards (New Haven: Yale University Press, 1992), 99–107.

38. Augustus Sherman, "Slovak," photo no. 5-8, ASPC.

39. Sekula, "Body and the Archive," 365–73.

40. Augustus Sherman, Untitled (Gypsy Family), photo nos. 2A-10 and 2A-2, ASPC.

41. U.S. Immigration Commission (1907–10), *Abstracts of Reports of the Immigration Commission, with Conclusions and Recommendations and Views of the Minority* (41 vols.), 61st Cong., 3rd sess., 1911, S. Doc. 747, 1:245.

42. Phillipps Ward, "Old World Types That Arrive in the New World," Scrapbook 2, WWP; and the articles "Gypsies Can't Come Here," *Sun*, July 21, 1909, "Gypsies Fight to Resist Deportation," *Mail*, July 22, 1909, "Wield Babies as War Clubs," *Globe*, July 22, 1909, and "Some Undesirable Citizens," *Tribune*, July 25, 1909, all in Scrapbook 2, WWP.

43. Augustus Sherman, "Jakob Mithelstadt and Family," photo no. 2B-7, ASPC.

44. Augustus Sherman, Untitled (Children's Playground), photo no. 5-7, ASPC. A version of this image also appears in *ARCGI* (1904), opp. 99, and Scrapbook 1, WWP.

45. Commissioner Howe to Secretary of Labor Davis, October 5, 1921, Chief Clerk's File, 2/174B, Records of the Department of Labor (RG 174), NARA-DC, cited in Unrau, *Historic Resource Study*, 557.

46. Robert F. Zeidel, *Immigrants, Progressives, and Exclusion Politics: The Dillingham Commission, 1900–1927* (DeKalb: Northern Illinois University Press, 2004); Michael LeMay, *From Open Door to Dutch Door: An Analysis of U.S. Immigration Policy since 1820* (New York: Praeger, 1987), 11–12, 69; U.S. Immigration Commission (1907–10), *Abstracts of Reports of the Immigration Commission, with Conclusions and Recommendations and Views of the Minority* (41 vols.), 61st Cong., 3rd sess., 1911.

47. U.S. Immigration Commission (1907–10), *Abstracts of Reports*, 1:13–14; *ARCGI* (1906), 62.

48. See, for example, William Z. Ripley, "The Racial Geography of Europe," *Popular Science Monthly*, March 1897, 17–34.

49. "The Spectator," *Outlook*, January 13, 1912, 96.

50. Safford, *Immigration Problems*, 6.

51. Renato Rosaldo, "Imperialist Nostalgia," *Representations* 26 (Spring 1989): 107–8. Sherman's ethnographic photographs of European folk worked in a similar way to photographs of "disappearing" native Americans taken by Edward Sheriff Curtis and others at this time.

52. Paul Kellogg, "The Pittsburgh Survey," *Charities and the Commons*, January 2, 1909, 517.

53. Lewis Wickes Hine, "Social Photography," paper presented at the National Conference of Charities and Corrections, June 1909, in *Classic Essays on Photography*, ed. Alan Trachtenberg (New Haven, CT: Leete's Island Books, 1980), 111.

54. Alan Trachtenberg, "Ever—the Human Document," in *America and Lewis Hine: Photographs, 1904–1940*, ed. Walter Rosenblum and Naomi Rosenblum (Millerton, NY: Aperture, 1977), 123.

55. Walter and Naomi Rosenblum note that Hine's first Ellis Island photographs are dated through 1909. Hine himself dates some photographs from 1908, 1912, and 1934, but his dating is known to be somewhat unreliable. Rosenblum and Rosenblum, *America and Lewis Hine*, 17. On Hine's unreliable dating, see Jonathan L. Doherty, comp., *Lewis Wickes Hine's Interpretive Photography: The Six Early Projects* (Chicago: University of Chicago Press, 1978), 2–3.

56. Hankins, "Birth Control," 11.

57. Lewis Hine to Elizabeth McCausland, October 23, 1938, in Daile Kaplan, *Photo Story: Selected Letters and Photographs of Lewis W. Hine* (Washington, DC: Smithsonian Institution, 1992), 126–27. The abbreviations and errors are in the original.

58. Peter Seixas and Sara Blair are the exceptions. Seixas claims that Hine's photography, with its emphasis on the dignity of the worker, was harnessed to serve the purposes of corporate capitalism in the period after the First World War. Blair argues that Hine's ideal of visual purity was disrupted by the indeterminacy of race. Peter Seixas, "Lewis Hine: From 'Social' to 'Interpretive' Photographer," *American Quarterly* 39 (Fall 1987): 381–409; Sara Blair, "Documenting the Alien: Racial Theater in *The American Scene*," in *Henry James and the Writing of Race and Nation* (Cambridge: Cambridge University Press, 1996), 158–210.

59. Gutman, *Lewis W. Hine and the American Social Conscience*, 33; Trachtenberg, "Ever—the Human Document," 118.

60. On the differences between Hine and the Photo-Secessionists, differences that Hine himself articulated, see Gutman, *Lewis W. Hine and the American Social Conscience*, 27–28; Trachtenberg, "Ever—the Human Document," 119–20; Daile Kaplan, *Lewis Hine in Europe: The "Lost" Photographs* (New York: Abbeville Press, 1988), 27–29; Trachtenberg, "Camera Work/Social Work," in his *Reading American Photographs*. On differences between Hine and Riis, see Trachtenberg, "Ever—the Human Document," 120, 128; Kaplan, *Lewis Hine in Europe*, 21–22; Stange, *Symbols of Ideal Life*. Although we have no records of Hine's attitude toward Riis, he was probably aware of Riis's work, since Riis wrote for *Charities and the Commons* at the same time that Hine produced photographs for them.

61. Gutman, *Lewis W. Hine and the American Social Conscience*, 21.

62. Trachtenberg, "Ever—the Human Document," 119, 124.

63. Kaplan, *Lewis Hine in Europe*, 9. Other critics who emphasize Hine's compassionate vision of dignified individuals include Beaumont Newhall, *The History of Photography from 1839 to the Present*, rev. ed. (Boston: Little, Brown, 1982), 235; and Karl Steinorth, ed., *Lewis Hine: Passionate Journey, Photographs 1905–1937* (Zurich: Edition Stemmle, 1996), 18.

64. Alan Trachtenberg is the exception here. Although he views Hine as a sympathetic and compassionate photographer, Trachtenberg develops this argument by focusing on Hine's respectful representation of working people and their labor. Trachtenberg mentions Hine's Ellis Island photographs but does not focus on them in detail.

65. Lewis Hine, "Notes on Early Influence," in Kaplan, *Photo Story*, 123. This quote is attributed to Hine as well as Manny in Kaplan, *Photo Story*, xxv. See also Steinorth, *Lewis Hine*, 18.

66. Trachtenberg, "Ever—the Human Document," 122–23; Gutman, *Lewis W. Hine and the American Social Conscience*, 20.

67. Trachtenberg, "Ever—the Human Document," 118.

68. Quoted in Gutman, *Lewis W. Hine and the American Social Conscience*, 12.

69. These views reflected the persistence of earlier white working-class concerns that free blacks would undercut white labor. See, for example, David Roediger, *The Wages of Whiteness: Race and the Making of the American Working Class* (London: Verso, 1991). Lawrence Glickman considers how the idea of an American standard of living was invented during this period as part of organized labor's white male ideology, including its opposition to immigration. Glickman, "Inventing the 'American Standard of Living.'"

70. Stocking, "Turn-of-the-Century Concept"; Jacobson, *Whiteness of a Different Color*.

71. Sánchez, *Becoming Mexican American*.

72. Daniel Rodgers, "In Search of Progressivism," *Reviews in American History* 10 (December 1982): 113–32.

73. Jane Addams to Joseph Cannon, June 11, 1906, *Congressional Record*, 59th Cong., 1st sess., vol. 40 (1906): n.p., in Birn, "Six Seconds per Eyelid," 314.

74. Curran, *From Pillar to Post*, 300, 296, 305. See also Ngai, *Impossible Subjects*.

75. Lewis Wickes Hine, "Plans for Work," Guggenheim application, October 1940, in Kaplan, *Photo Story*, 175.

76. The wording is Alan Trachtenberg's in "Ever—the Human Document," 126.

77. This is particularly clear in Alan Trachtenberg's essay "Ever—the Human Document," which avoids any mention of race and carefully selects other terms used by Hine in his Guggenheim Fellowship application (118); Blair, "Documenting the Alien."

78. Hine, "Plans for Work," 175.

79. Trachtenberg, *Reading American Photographs*, 310 n. 67.

80. Hine cites the racial identity of his subjects in all but five out of thirty-two images of immigrants at Ellis Island. In the cases where the subjects' race is

not identified, there is typically a large number of immigrants, who may be from different racial backgrounds, rather than an individual or family. Lewis W. Hine, "A Slovak Immigrant—Ellis Island, 1905," Unit 1 (Immigrants), no. 14, LHPC. For examples of other captions containing historical information related to the immigrant's race, see "Italian Grandmother at Ellis Island—1905," Unit 1 (Immigrants), no. 15, "Armenian Jew—Ellis Island, 1905," Unit 1 (Immigrants), no. 20, and "Jew from Russia at Ellis Island, 1905," Unit 1 (Immigrants), no. 23, all in LHPC.

81. Lewis W. Hine, "Slavic Mother and Child at Ellis Island—1905," Unit 1 (Immigrants), no. 11, LHPC.

82. Doherty, *Lewis Wickes Hine's Interpretive Photography,* 4.

83. H. Parker Willis, "The Findings of the Immigration Commission," *Survey,* January 7, 1911, 569–70.

84. Lewis W. Hine, "Italian Family en Route to Ellis Island," Unit 1 (Immigrants), no. 2, LHPC.

85. Lewis W. Hine, "Climbing into America—Ellis Island—1905," Unit 1 (Immigrants), no. 3, LHPC.

86. Lewis W. Hine, "Italian Immigrants at Ellis Island—1905," Unit 1 (Immigrants), no. 4, LHPC.

87. These photographs are "A Group of German Immigrants at Ellis Island—1926," Unit 1 (Immigrants), no. 8; "Mid-morning Lunch at Ellis Island—1926," Unit 1 (Immigrants), no. 5; "A Group of Germans Having Lunch at Ellis Island—1926," Unit 1 (Immigrants), no. 6; and "A Social Worker at Ellis Island—1926," Unit 1 (Immigrants), no. 29. All the photographs appear to be of the same group of Germans, and all are in the LHPC.

88. Lewis W. Hine, "A Group of Germans Having Lunch at Ellis Island—1926," Unit 1 (Immigrants), no. 6, LHPC.

89. "Finds Ellis Island 'Deserted Village,'" *New York Times,* July 20, 1924, 5.

90. Kaplan, *Photo Story,* xxv. Kaplan also makes the same point in *Lewis Hine in Europe,* 23.

91. Ngai, "Architecture of Race."

92. Lewis W. Hine, "Getting Tagged by an Official for a Railroad Trip—Ellis Island 1905," Unit 1 (Immigrants), no. 10, LHPC. Although Hine gives the date 1905, some of the people in this image also appear in other images from 1926, suggesting that the date is a mistake and should read 1926. (This is also noted in a comment on the reverse of the copy print in the New York Public Library.) Although the mistake is probably accidental, the idea that large German families were immigrating to the United States before the implementation of quotas would have supported Hine's argument in this caption.

93. For example, Hine notes elsewhere that there are about two million Slavs and two million Russian Jews in the United States. Lewis W. Hine, "Slavic Mother—Ellis Island," Unit 1 (Immigrants), no. 21, and "Jew from Russia at Ellis Island—1905," Unit 1 (Immigrants), no. 23, both in LHPC.

94. Data calculated from charts in *ARCGI* (1925), 226, and *ARCGI* (1931), 126–27.

95. Lewis W. Hine, "Handwork under the Auspices of the D.A.R.—1926, Ellis Island," Unit 1 (Immigrants), no. 30, "Children on the Playground at Ellis

Island—1926," Unit 1 (Immigrants), no. 31, and "Immigrants Detained at Ellis Island Take Time to Be Happy." Unit 1 (Immigrants), no. 32, all in LHPC.

96. Lewis W. Hine, "Italian Child Detained at Ellis Island—1926—Hand Work Supplied and Directed by Trained Worker," photo no. 77:177:155, and "Ellis Island," photo no. 77:177:30, both in Photography Collection, George Eastman House, Rochester, NY.

97. Goldberg, "Camera and the Immigrant," 24.

98. Wexler, *Tender Violence*; Virginia and Elba Farabegoli passport photographs, 1921 and 1937, photo nos. 166/102 and 166/118, Elba F. Gurzau Manuscript and Photograph Collection (PG 166), Balch Institute for Ethnic Studies, Historical Society of Pennsylvania, Philadelphia.

5. THE IMAGINARY LINE

1. The "imaginary line" was a common conception of the border among immigration inspectors and other officials, a conception that persisted even as their regulation of the border increased. Marcus Braun, Immigrant Inspector, "Report, First Detail to Mexico" (February 1907), p. 32, File 52320/1, Reel 2, in *R-INS-A-2*. See also F. R. Stone, "Report to Supervising Inspector F. W. Berkshire, Immigration Service, El Paso, Texas," June 30, 1910, p. 4, File 52546/31-C, Reel 2, in *R-INS-A-2*; Inspector in Charge, Douglas, Ariz., in *ARCGI* (1920), 441; J. W. Tappan, "Protective Health Measures on United States-Mexico Border," *Journal of the American Medical Association* 87, no. 13 (1926): 1022.

2. Patricia Nelson Limerick, *The Legacy of Conquest: The Unbroken Past of the American West* (New York: Norton, 1987), ch. 7; Sánchez, *Becoming Mexican American*, 38–83.

3. Sánchez, *Becoming Mexican American*, 62.

4. The Immigration Bureau first recorded Mexican immigrants in 1908 and Mexican nonimmigrants, the majority of border crossers, in 1911. *ARCGI* (1911), 314.

5. Responding to the changing laws and practices of migration during this period, the Immigration Bureau changed its administration of the Mexico-U.S. border region. In 1918, El Paso's administrative reach included border ports in Texas, Arizona, New Mexico, and Southern California. Only the area surrounding Galveston, Texas, was not included under El Paso's supervision. However, by 1924 there were three Mexican border districts with headquarters at El Paso, San Antonio, and Los Angeles. See *ARCGI* (1918), 316; *ARCGI* (1924), 17; Oscar J. Martínez, *Border Boom Town: Ciudad Juárez since 1848* (Austin: University of Texas Press, 1978), 34.

6. INS, "Early Immigrant Inspection along the US/Mexican Border," 2003, www.minorityjobs.net/article.php?id=218; Sharon Masanz, "The History of the Immigration and Naturalization Service," report prepared for the Select Commission on Immigration and Refugee Policy, 96th Cong., 2nd sess., 1980, 14.

7. "Young and Old Beg to Enter U.S.; Men at Bridge Know Lots of Secrets about El Pasoans," *El Paso Herald*, March 10, 1921, 11.

8. *ARCGI* (1920), 441.

9. Sánchez, *Becoming Mexican American*, 55–56; Markel and Stern, "Which

Face? Whose Nation?" 1313–30; George Stoner, Chief Medical Officer, Ellis Island, Report on Immigrant Stations in Texas, the Pacific Coast and the Canadian Border, November 9, 1907, File 5738 (1907), Central Files, 1897–1923, Entry 10, R-PHS, NARA-MD.

10. Immigration Act of February 5, 1917 (39 Stat. 874); *ARCGI* (1924), 13; Bill Ong Hing, *Defining America through Immigration Policy* (Philadelphia: Temple University Press, 2004), 121.

11. Erika Lee is an exception, attending to the photographic records in these reports; however, her work uses these images to explore the expansion of immigration policy on the Mexican and Canadian borders rather than focusing on photography and photographic documentation. E. Lee, *At America's Gates*, 161–63.

12. Braun's report contained thirty-three photographs. However, Braun noted that "numerous other pictures which I took with my camera while traveling through Mexico and observing groups of Chinese, Japanese and other foreigners traveling on foot to the United States, were unfortunately destroyed by the climactic conditions." Braun, "Report, First Detail," 34.

13. Ibid., 12.

14. Ibid., 33.

15. Although Braun emphasized throughout his report Mexico's lack of and need for "modern immigration laws" in line with U.S. immigration restrictions, it is interesting to note that Mexico used photographs in its naturalization application process as early as 1906, whereas photographs were not included on U.S. naturalization documentation until 1924. Ibid., 4. During his second Mexican investigation, Braun also reported that "the Mexican government has the most complete system of supervising prostitutes. Each one of them must have a little booklet with her photograph, and I found that it would be no difficulty to obtain duplicates of these photographs for eventual identification if the case should so require it." Braun proposed that these photographs might be used to identify "immoral women" who entered from Mexico to work in cities on the American side of the border. Marcus Braun, "Report, Second Detail to Mexico" (June 1907), p. 15, File 52320/1A, Reel 2, in *R-INS-A-2*.

16. Braun, "Report, First Detail," 10, 29–30, 33.

17. Brandenburg, "Stranger within the Gate, II," 1114.

18. Braun, "Report, First Detail," 34.

19. Braun was concerned not only about the apparent invisibility of thousands of illegal immigrants crossing the border to the United States each year but also, in his second report, about the visibility of the immigration inspectors. In his conclusion, Braun recommended that the officers on the Mexican border line should be permitted to wear khaki instead of navy uniforms. Not only would this hide the "immense quantity of alkaline dust prevailing at the border," but it would also assist "those mounted men who are out scouting and looking for aliens who endeavor to cross the border line surreptitiously." Immigration officials, he noted, "are visible miles and miles off in their blue uniforms, while in a woolen khaki uniform, they cannot be seen except at very close range." Although many histories point to the increasingly visible presence of officials on the border in the first decades of the twentieth century, their ability to enforce increasingly strict immigration restrictions and police the U.S. boundary also depended

on their invisibility. Braun, "Report, Second Detail," 17–18. When Border Patrol uniforms were distributed in 1925, they were khaki as Braun had recommended. Wesley E. Stiles, interview by Wesley C. Shaw, January 1986, p. 8, IOH.

20. Seraphic, "Report," 23, 25.

21. Commissioner-General to various camera shops, soliciting bids, 1907, Luther Steward, Inspector in Charge, San Antonio, to Commissioner-General of Immigration, February 16, 1907, and F. P. Sargent, Commissioner-General, to George W. Webb, Inspector in Charge, Tucson, Ariz., May 15, 1907, all in Seraphic, "Report."

22. W. Silas Sheetz, the Camera Shop, to Commissioner-General, Bureau of Immigration and Naturalization, February 7, 1907, and F. P. Sargent, Commissioner-General, to George W. Webb, Inspector in Charge, Tucson, Ariz., February 11, 1907, both in Seraphic, "Report."

23. File 14714–3, Entry 132, R-INS, NARA-DC.

24. See, for example, F. W. Berkshire, Chinese Inspector in Charge, Malone, N.Y., to F. P. Sargent, Commissioner-General of Immigration, February 16, 1907, File 14610–181, Entry 132, R-INS, NARA-DC; Charles V. Mallet, Chinese Inspector, to Commissioner of Immigration, Philadelphia, February 21, 1914, File 53636–46, Accession 60A600, R-INS, NARA-DC.

25. Not one examination transcript included in Seraphic's "Report" contains a record of a non-Chinese detainee being photographed or being required to review photographs, unlike the transcripts of Chinese examinations. See "Additional Examination of Farris Masser," August 27, 1906, in Seraphic, "Report."

26. Delgado, "In the Age of Exclusion."

27. George W. Webb, Inspector in Charge, Tucson, to F. P. Sargent, Commissioner-General of Immigration, February 16, 1907, in Seraphic, "Report."

28. F. W. Berkshire, Supervising Inspector, to Commissioner-General of Immigration, November 2, 1907, File 15093/18, Entry 132, R-INS, NARA-DC.

29. Sánchez, Becoming Mexican American, 50–51; Neil Foley, The White Scourge: Mexicans, Blacks, and Poor Whites in Texas Cotton Culture (Berkeley: University of California Press, 1997), 47; Seraphic, "Report"; Braun, "Report, First Detail."

30. ARCGI (1923), 16. See also Mario García, Desert Immigrants: The Mexicans of El Paso, 1880–1920 (New Haven: Yale University Press, 1981), 195.

31. Sánchez, Becoming Mexican American, 19–25; Hing, Defining America, 120–22.

32. Enrique Acevedo, interview by Robert H. Novak (in Spanish), May 17, 1974, transcription of Tape 130, pp. 14–15; Felix López Urdiales, interview by Oscar J. Martínez (in Spanish), February 22, 1974, transcription of Tape 144c, p. 5; Felipe Rodríguez, interview by José Gutiérrez (in Spanish), December 11, 1976, transcription of Tape 278, p. 4; Conrado Mendoza, interview by Mike Acosta (in Spanish), December 8 and 9, 1976, transcription of Tape 252, pp. 3–4; Genaro Hernández, interview by Virgilio H. Sánchez (in Spanish), April 19, 1978, transcription of Tape 553, p. 6; Miguel Ordóñez, interview by Virgilio H. Sánchez Saucedo (in Spanish), July 9, 1979, transcription of Tape 618, p. 2; Zaré Gonzalez, interview by Sarah E. John (in Spanish), November 3, 1977, transcription of Tape 708, pp. 4–5, all in IOH. All translated by Tom Nehil.

33. Cleofas Calleros, interview by Oscar Martínez, September 14, 1972, transcription of Tape 157, p. 9, IOH.

34. Mauricio Cordero, interview by Oscar J. Martínez (in Spanish), February 15, 1974, transcription of Tape 142, IOH. Translated by Tom Nehil.

35. Margarita Jáquez de Alcalá, interview by Oscar J. Martínez (in Spanish), February 16, 1974, transcription of Tape 232, p. 32, IOH. Translated by Tom Nehil. The nonuse of passports was particular to the Mexican-U.S. border at this time; by 1903, Immigration Bureau rules required that "the absence of passports as to incoming aliens is to be regarded with suspicion," especially since deported immigrants had this noted on their travel documents. Frank Sargent, "Rules of the Government of U.S. Immigrant Inspectors and Boards of Special Inquiry," January 20, 1903, File 5738, Entry 10, R-PHS, NARA-MD.

36. Hing, *Defining America*, 121. The Immigration Bureau did not keep separate records on refugees until they were recognized as a distinct category within immigration law in the 1950s.

37. Martínez, *Border Boom Town*, 39; García, *Desert Immigrants*, 178, 181–82. See also Linda Hall and Don Coerver, *Revolution on the Border: The United States and Mexico, 1910–1920* (Albuquerque: New Mexico University Press, 1988), 20; Paul Vanderwood and Frank N. Samponaro, *Border Fury: A Picture Postcard Record of Mexico's Revolution and U.S. War Preparedness, 1910–1917* (Albuquerque: University of New Mexico Press, 1988), 18.

38. *Brownsville Herald,* June 4, 1913, quoted in Frank Samponaro and Paul Vanderwood, *War Scare on the Rio Grande: Robert Runyon's Photographs of the Border Conflict, 1913–1916,* Barker Texas History Center Series 1 (Austin: Texas State Historical Association, 1992), 6.

39. *El Paso Herald,* December 9, 1913, 2, quoted in Martínez, *Border Boom Town,* 42.

40. W. A. Willis, quoted in George R. Leighton, "Afterword: The Photographic History of the Mexican Revolution," in *The Wind That Swept Mexico: The History of the Mexican Revolution, 1910–1942,* by Anita Brenner (1943; repr., Austin: University of Texas Press, 1971), 295.

41. Vanderwood and Samponaro, *Border Fury,* 25; Leighton, "Afterword," 297; William C. Stewart, "Mexican Revolution of 1911: Story Uncovers First Girl War Photographer," *Los Angeles Times,* March 10, 1968.

42. James Havens, Eastman Kodak Company, to Robert Runyon, September 26, 1919, including copy of letter from Alvey Alvoe, Department of State, to Eastman Kodak Company, September 18, 1919, Robert Runyon Papers, Center for American History, University of Texas at Austin.

43. Samponaro and Vanderwood, *War Scare,* 7–8.

44. Vanderwood and Samponaro, *Border Fury,* 1–14, 17.

45. Ernesto Galarza, *Barrio Boy* (Notre Dame: University of Notre Dame Press, 1971), 181–82.

46. Samponaro and Vanderwood, *War Scare,* 9–10; University of Texas at Austin, General Libraries, "Robert Runyon: Border Photographer," n.d., Robert Runyon Photograph Collection, http://runyon.lib.utexas.edu/bio.html. Claire Fox offers an intriguing reading of portrayals of the Mexican Revolution in photographs, postcards, and developing film technologies in ch. 3 of *The Fence and*

the River: Culture and Politics at the U.S-Mexico Border (Minneapolis: University of Minnesota Press, 1999).

47. McCurdy, "Use of Photographs," 328.

48. *El Paso City Directory,* 1917–25 (El Paso: R. L. Polk); "Photographers in El Paso, 1886–1925," El Paso Vertical File—Photographers and Photography, 1886–1925, El Paso Public Library.

· 49. Robert Runyon to Inspector in Charge, Immigration Service, Brownsville, Texas, May 1923, Robert Runyon Papers, Center for American History, University of Texas at Austin; Expenditures to Robert Runyon for photos of aliens at Brownsville, February 23, 1923 and June 15, 1923, in R-INS, Subject Index to Correspondence and Case Files of the INS, 1903–1952, Microfilm T-458. Perhaps one of the few photographers who did not take identity photographs for the Immigration Bureau or for immigration documents was Otis Aultman of El Paso. Although he worked as a commercial photographer, he refused to take formal portraits. Mary Sarber, *Photographs from the Border: The Otis A. Aultman Collection* (El Paso: El Paso Public Library Association, 1977), xii.

50. It is possible to reproduce only a limited range of these documents in this study because the original documents of Mexicans who entered the United States at various border stations have been microfilmed and destroyed, leaving only poor-quality images. See, for example, Nonstatistical Manifests and Statistical Index Cards of Aliens Arriving at Eagle Pass, Texas, June 1905–November 1929, Microfilm M1754; Nonstatistical Manifests and Statistical Index Cards of Aliens Arriving at El Paso, Texas, 1905–1927, Microfilm A3406; Nonstatistical Manifests and Statistical Index Cards of Aliens Arriving at Laredo, Texas, May 1903–November 1929, Microfilm A3379; all in R-INS, NARA-DC.

51. Torpey, *Invention of the Passport,* 111–12.

52. Ibid., 112–16.

53. "Rebel Immigration Office Moves into New Quarters," *El Paso Herald,* April 17, 1914, 12; "All Entering Mexico Must Have Carranza Passports," *El Paso Herald,* November 18, 1915, 2; "In Old El Paso: Twenty-five Years Ago," *El Paso Herald,* February 23, 1942, 4.

54. Executive Order No. 2285 of December 15, 1915.

55. Friedrich Katz, *The Secret War in Mexico: Europe, the United States, and the Mexican Revolution* (Chicago: University of Chicago Press, 1981), 350–67.

56. Order of July 26, 1917; *ARCGI* (1918), 11.

57. Act of May 22, 1918 (40 Stat. 559); Executive Order No. 2932 of August 8, 1918.

58. Masanz, "History," 24–25.

59. *El Paso Herald,* August 9, 1918.

60. *ARCGI* (1918), 11.

61. *El Paso Herald,* August 9, 1918.

62. "Can't Leave Here without Passport," *New York Times,* December 16, 1915, 7; National Archives, "Passport Applications," November 2005, www.archives.gov/genealogy/passport/.

63. Executive Order No. 2932 of August 8, 1918, sec. 5.

64. *ARCGI* (1919), 24.

65. Aristide Zolberg, *A Nation by Design: Immigration Policy in the Fash-*

ioning of America (Cambridge, MA: Harvard University Press, 2006), 264; Torpey, *Invention of the Passport,* 99, 120.

66. *ARCGI* (1919), 66–67.

67. Torpey, *Invention of the Passport,* 116–17.

68. Act of November 10, 1919 (41 Stat. 353); "U.S. Consul Advised," *El Paso Herald,* April 16, 1921, 2.

69. National Archives, "Passport Applications"; Act of June 21, 1941 (55 Stat. 252).

6. THE DIVIDING LINE

1. *ARCGI* (1918), 321.

2. Immigration Act of February 7, 1917 (39 Stat. 874); Act of May 26, 1924 (43 Stat. 153); Order No. 106, July 1, 1928, Department of Labor.

3. *ARCGI* (1926), 10; *ARCGI* (1927), 7.

4. Immigration Act of February 5, 1917 (39 Stat. 874).

5. Alexandra Stern, *Eugenic Nation: Faults and Frontiers of Better Breeding in Modern America* (Berkeley: University of California Press, 2005), 62–67.

6. Mark Reisler, *By the Sweat of Their Brow: Mexican Immigrant Labor in the United States, 1900–1940* (Westport, CT: Greenwood Press, 1976); Sánchez, *Becoming Mexican American,* 59–60.

7. Inspector in Charge, Brownsville, Texas, in *ARCGI* (1920), 440. See also *ARCGI* (1921), 13–14; *ARCGI* (1924), 13, 16, 17.

8. *ARCGI* (1920), 442.

9. Sánchez, *Becoming Mexican American,* 58–59.

10. *ARCGI* (1923), 16.

11. *ARCGI* (1920), 442. This estimate does not identify how many of the aliens were assumed to be Mexican nationals.

12. Devra Weber, *Dark Sweat, White Gold: California Farm Workers, Cotton and the New Deal* (Berkeley: University of California Press, 1994), 48.

13. Ngai, *Impossible Subjects,* xvi.

14. *ARCGI* (1920), 442.

15. *ARCGI* (1920), 445, 451, 453–54.

16. Immigration Act of February 5, 1917, sec. 23 (39 Stat. 892).

17. Reisler, *By the Sweat of Their Brow.* See also Stone, "Report," 4.

18. Brandenburg, "Stranger within the Gate, II." Kelly Lytle Hernández has also explained how, given the 1917 Mexican Constitution's requirement that emigrants have labor contracts and the U.S. law that prohibited contract laborers, "legal labor migration of Mexican workers to the United States [was] virtually impossible." "Crimes and Consequences," 423–24.

19. Braun, "Report, First Detail," 29.

20. Quoted in Foley, *White Scourge,* 47. See also Sánchez, *Becoming Mexican American,* 60–61; Patrick Ettinger, "Imaginary Lines: Border Enforcement and the Origins of Undocumented Immigration, 1882–1930" (PhD diss., Indiana University, 2000), 195–260.

21. Seraphic, "Report," 24; INS, Memorandum: In Regards to Inspector Seraphic as to Mexican Border, February 2, 1907, p. 4, File 51423/1, Reel 1, in

R-INS-A-2. The PHS also sent Ellis Island's chief medical officer to inspect the medical inspections conducted at these border stations. George Stoner, Chief Medical Officer, Ellis Island, Report on Immigrant Stations in Texas, the Pacific Coast and the Canadian Border, November 9, 1907, File 5738 (1907), Central Files, 1897–1923, Entry 10, R-PHS, NARA-MD.

22. Sánchez, *Becoming Mexican American*, 55–57. See also Fairchild, *Science at the Borders*, 150–59.

23. On vaccination, see John McKiernan, "Fevered Measures: Race, Communicable Disease and Community Formation on the Texas-Mexican Border, 1880–1923" (PhD diss., University of Michigan, 2002).

24. Inspector in Charge Will E. Soult to Supervisor, December 13, 1923, File 52903/29, p. 1, R-INS, NARA-DC, quoted in Sánchez, *Becoming Mexican American*, 55.

25. Sánchez, *Becoming Mexican American*, 56.

26. "Quarantine Riot in Juarez," *New York Times*, January 29, 1917, 4.

27. Irving McNeil to J. W. Tappan, December 22, 1923, File 52903, in *R-INS-A-2*, cited in Stern, *Eugenic Nation*, 65. For frequent crossers, the baths were a weekly process. After each disinfection, they would be issued quarantine certificates, without photographs, that were valid for one week. Although European immigrants were generally required to undress only from the waist up if they were detained for secondary medical inspection, they also remembered this experience as deeply embarrassing. Kraut, *Silent Travelers*, 55–56.

28. Stern, *Eugenic Nation*, 60–62; "Quarantine Riot in Juarez," *New York Times*, January 29, 1917, 4.

29. Disinfection baths were ended at El Paso in 1938 and at other border immigration stations in the early 1940s. Stern, *Eugenic Nation*, 61–62, 65–66.

30. May 23, 1917, Circular, File 54261–202, Entry 9, R-INS, NARA-DC; "Waives the Labor Law," *New York Times*, May 24, 1917, 11.

31. *ARCGI* (1920), 429; "Period for Importing Mexican Labor Extended," *El Paso Herald*, June 9, 1919, 9; "Texans Wish to Extend Order Admitting Labor from Mexico to States," *El Paso Herald*, November 26, 1919, 4; "Order Admits Mexican Labor," *El Paso Herald*, February 17, 1920, 5; "Farmers Must Return Laborers to Border," *El Paso Herald*, March 15, 1921, 10. See also Reisler, *By the Sweat of Their Brow*, 24–48; George Kiser and Martha Woody Kiser, introduction to Section I, "The World War Era," in *Mexican Workers in the United States: Historical and Political Perspectives*, ed. George Kiser and Martha Woody Kiser (Albuquerque: University of New Mexico Press, 1979), 4, 9–12; Hing, *Defining America*, 122, 126–31.

32. *ARCGI* (1921), 7.

33. Foley, *White Scourge*, 45–46, 51–52; Reisler, *By the Sweat of Their Brow*, 28–29.

34. William Wilson to John Burnett, Chairman, House Committee on Immigration and Naturalization, May 31, 1917, File 54261–202, Entry 9, R-INS, NARA-DC.

35. William Wilson, Secretary of Labor, to John Burnett, Chairman, House Committee on Immigration and Naturalization, June 8, 1917, File 54261–202, Entry 9, R-INS, NARA-DC.

36. Some nativists who expressed concern about the permanent settlement of Mexicans in the United States also drew a contrast with Chinese and other Asian immigrants, although in their view the Chinese were more favorable acquisitions than Mexican immigrants. Chester Rowell later wrote about the Chinese worker: "He will turn less food into more work, with less trouble, than any other domestic animal. He does not even plague us with his progeny. His wife and children are in China, and he returns there himself when we no longer need him." Chester Rowell, "Why Make America an Exception?" *Survey,* May 1, 1931, quoted in Foley, *White Scourge,* 53. See also Foley, *White Scourge,* 55.

37. *ARCGI* (1918); Secretary of Labor to Secretary of War, July 23, 1918, File 54261–202, Entry 9, R-INS, NARA-DC.

38. J. B. Dunsmore to [Louis] Post, memo, June 4, 1918, File 54261–202, Entry 9, R-INS, NARA-DC.

39. Ibid.

40. Herbert Hoover, Food Administrator, to Felix Frankfurter, Assistant to the Secretary of Labor, June 4, 1918, File 54261–202, Entry 9, R-INS, NARA-DC.

41. Lawrence Cardoso, "Labor Emigration to the Southwest, 1916 to 1920: Mexican Attitudes and Policy," in Kiser and Kiser, *Mexican Workers,* 27; Anastacio Torres in Manuel Gamio, *The Life Story of the Mexican Immigrant: Autobiographic Documents* (1931; repr., New York: Dover, 1971), 56.

42. *El Paso Times,* July 6, 1918, 3, cited in García, *Desert Immigrants,* 49.

43. William Wilson, Secretary of Labor, to Hon. William G. McAdoo, San Francisco, telegram, July 22, 1918, File 54261–202, Entry 9, R-INS, NARA-DC.

44. May 23, 1917, Circular, File 54261–202, Entry 9, R-INS, NARA-DC.

45. June 15, 1917, Circular, File 54261–202, Entry 9, R-INS, NARA-DC.

46. The problem of desertion, however, was not new to the war or the agricultural admissions program. The *Daily Free Lance* newspaper in El Centro, California, reported in 1910 that "the Southern Pacific [Railroad] has a permanent order at El Paso for about fifty Mexicans per week, as that is the number which experience has shown to be deserting in that time." Nevertheless, the Immigration Bureau's efforts to control workers and limit desertions using photographic identification in the agricultural admissions program was a new development, which proved unsuccessful and somewhat embarrassing. *ARCGI* (1920), 427–29; *ARCGI* (1923), 28; "Farmers Must Return Laborers to the Border," *El Paso Herald,* March 15, 1921, 6; *Daily Free Lance,* March 1, 1910, File 52546/31, Reel 2, in *R-INS-A-2.*

47. On the lack of inspectors, see *ARCGI* (1920), 428. On the summary concluding report on the Agricultural Admissions Program, see *ARCGI* (1921), 7.

48. "C. of C. Wants Passport Law to Be Revoked," *El Paso Herald,* April 26, 1921, 8.

49. "Hudspeth Asks Removal of El Paso Passport Rules," *El Paso Herald,* October 20, 1921, 2.

50. "40-Mile Border No-Passport Zone Approved by President," *El Paso Herald,* July 14, 1921, 1.

51. "Mexico Abolishes the Border Passport," *El Paso Herald,* August 3, 1921, 1; "U.S. Lets People Cross, but Mexico Dissatisfied with Wording of Decree," *El Paso Herald,* August 6, 1921, 2; "Passport Restrictions in Douglas Are

Lifted," *El Paso Herald,* August 8, 1921, 2; "Border Residents May Cross Line without Passports but Tourists Must Have Permits," *El Paso Herald,* August 10, 1921, 1; "Mexico Misinterprets Order from U.S.; Passports Are Again Demanded at Bridge," *El Paso Herald,* August 13 and 14, 1921, 1; "Border Cards Again Issued at City Hall," *El Paso Herald,* August 16, 1921, 10.

52. *ARCGI* (1920), 454.

53. Luis Montes de Oca, "Mexican Consul Gives Mexico's Stand on Passport Question," *El Paso Herald,* May 6, 1921; "Mexican Passport Receipts $115,405 during 1921," *El Paso Herald,* January 11, 1922, 7; *ARCGI* (1920), 445.

54. "President Obregon Removes Passports for Americans Entering the Interior Consulate Informed," *El Paso Herald,* January 19, 1922, 1; "U.S. Lifts Ban on Passports from Mexico," *El Paso Herald,* January 25, 1922, 1; "U.S. Citizens and Mexicans Need No Passes," *El Paso Herald,* January 26, 1922, 12.

55. Memo to Bruce Mohler, Director, Bureau of Immigration, NCWC, "Mexican Border Office," July 3, 1926, Cleofas Calleros Papers, CLSSC; Cleofas Calleros to Bruce Mohler, Director, Bureau of Immigration, NCWC, memo, "New Mexican Immigration Law," November 3, 1926, Cleofas Calleros Papers, CLSSC.

56. Act of February 5, 1917; U.S. Immigration Bureau, *Immigration Laws: Rules of May 1, 1917,* 7th ed. (Washington, DC: GPO, 1922), rule 12, subd. 9, and rule 13, subd. 3. See also Act of May 22, 1918; Executive Order No. 2932 of August 8, 1918.

57. G. C. Wilmoth, *Mexican Border Procedure,* INS, Lecture No. 23 (Washington, DC: GPO, 1934), 6.

58. Stone, "Report," 7.

59. Pedro Villamil in Gamio, *Life Story,* 70.

60. Memo for Robe Carl White, Second Assistant Secretary, Department of Labor, In re: The Mexican Border Crossing Privilege of Chinese Merchants Domiciled in Mexico, April 3, 1924, File 51941/10-B, Entry 9, R-INS, NARA-DC. See also Files 51941/10-A and 51941/10-C, Entry 9, R-INS, NARA-DC.

61. *ARCGI* (1918), 321; William Phillips, Acting Secretary of State, "Notice to Americans Going into Mexico," Washington, September 24, 1919, Robert Runyon Papers, Center for American History, University of Texas at Austin. Confusingly, the Immigration Bureau itself sometimes refers to citizen cards as border permits.

62. F. W. Berkshire, Supervising Inspector, Mexican Border District, El Paso, Texas, to Commissioner-General of Immigration, Washington, D.C., December 21, 1921, File 51941/10-A, Entry 9, INS, NARA-DC.

63. Wilmoth, *Mexican Border Procedure,* 7.

64. More recently, Mexican American historian George Sánchez has spoken about his own citizen identification card, which his mother obtained for him as a child in 1963. The card, as Sánchez says, "speaks volumes about the fear that Mexican immigrant families had of their children being taken away from them and deported." George Sánchez, "Working at the Crossroads: American Studies for the 21st Century: Presidential Address to the American Studies Association, November 9, 2001," *American Quarterly* 54 (March 2002): 9.

65. Deposition of Charles Geck, July 17, 1925, File 55301/217-A, Reel 16, in *R-INS-A-2.*

66. Mexican consul quoted in G. C. Wilmoth, District Director, El Paso, to Commissioner-General of Immigration, October 29, 1928, File 55638/251, Reel 17, in *R-INS-A-2*.

67. G. C. Wilmoth, District Director, El Paso District, to Commissioner, INS, February 18, 1934, p. 2, File 55854–758, Accession 58A734, R-INS, NARA-DC; William A. Whalen, District Director, Galveston District, to Commissioner, INS, February 16, 1934, p. 2, File 55854–758, Accession 58A734, R-INS, NARA-DC.

68. *ARCGI* (1919), 412. The 1919 numbers are the earliest Immigration Bureau figures for border permits.

69. See, for example, the efforts of the Nogales, Arizona, Chamber of Commerce to have the immigration station removed from the international line to the northern edge of town to facilitate border crossing. File 55637/640-A, Reel 17, in *R-INS-A-2*.

70. G. C. Wilmoth, District Director, El Paso District, to Commissioner, INS, February 18, 1934, p. 2, File 55854–758, Accession 58A734, R-INS, NARA-DC.

71. William A. Whalen, District Director, Galveston District, to Commissioner, INS, February 16, 1934, p. 2, File 55854–758, Accession 58A734, R-INS, NARA-DC, p. 2.

72. Harold Brown, Immigrant Inspector, Columbus, N.M., to District Director, El Paso, Texas, October 18, 1937, File 55854–758, Accession 58A734, R-INS, NARA-DC.

73. Edmund Fisher, Immigrant Inspector, Sasabe, Ariz., to District Director, El Paso, Texas, February 11, 1937, File 55854/758, Accession 58A734, R-INS, NARA-DC.

74. *ARCGI* (1924), 19; Garland, "Through Closed Gates."

75. I. F. Wixon, *Immigration Border Patrol*, INS, Lecture No. 7 (Washington, DC: GPO, 1934), 2.

76. 43 Stat. 240; Wesley E. Stiles, interview by Wesley C. Shaw, January 1986, p. 3, IOH. See also Alejandro Portes, "From South of the Border: Hispanic Minorities in the United States," in Yans-McLaughlin, *Immigration Reconsidered*, 162.

77. Masanz, "History," 36–37. Until 1943, however, most of these employees were not stationed on the Mexican-U.S. border. Hernández, "Crimes and Consequences," 427.

78. *ARCGI* (1924), 19–20; Garland, "Through Closed Gates," 154–156. As Garland details, however, Jewish immigrants also used many strategies based on the particularities of the quota laws that had not been previously used by the Chinese. Garland, "Through Closed Gates," 214–19.

79. "Information on Jewish Immigrants to Juarez and Vera Cruz, Mexico," Small Collections, American Jewish Archives, quoted in Garland, "Through Closed Gates," 88–90. See also Garland, "Through Closed Gates," 131–74; EIOHP; "Life Story of a Lithuanian," in Holt, *Life Stories*, 12–13.

80. Garland, "Through Closed Gates," 172–73.

81. *ARCGI* (1924), 19; see also Garland, "Through Closed Gates," 222.

82. Marian Smith, "Visa Files, July 1, 1924–March 31, 1944," www.uscis.gov/

portal/site/uscis/menuitem.5af9bb95919f35e66f614176543f6d1a/?vgnextoid=
8d6bfd262fa4b110VgnVCM1000004718190aRCRD&vgnextchannel=d21f37
11ca5ca110VgnVCM1000004718190aRCRD (accessed July 28, 2005).

83. Act of May 26, 1924 (43 Stat. 153); "Immigration," p. 573, NCWC Bureau of Immigration (1928), NCWC Papers, CLSSC.

84. "Immigration," p. 576, NCWC Papers, CLSSC.

85. Wilmoth, *Mexican Border Procedure*, 7.

86. Wesley E. Stiles, interview by Wesley C. Shaw, January 1986, p. 5, IOH.

87. *ARCGI* (1922), 13; *ARCGI* (1924), 13.

88. *ARCGI* (1926), 10; *ARCGI* (1927), 7.

89. Visa 711561, July 24, 1924, California, Box 1965, Accession 85–52A172, R-INS, NARA-DC.

90. See, for example, Visa 711524, July 19, 1924; Visa 711515, July 28, 1924, California, Accession 85–52A172, R-INS, NARA-DC.

91. *ARCGI* (1923), 18.

92. *ARCGI* (1927), 16.

93. In terms of immigration into Mexico, the 1926 law discontinued local passports for Americans entering Mexico, requiring them have a passport or documentary proof that they were tourists. Local residents, both U.S. and Mexican citizens, could obtain a Mexican border permit by proving their local residence and paying a small fifty-five-centavo fee. Cleofas Calleros to Bruce Mohler, Director, Bureau of Immigration, NCWC; "Mexican Border Office," memo, July 3, 1926, Cleofas Calleros Papers, CLSSC; Cleofas Calleros to Bruce Mohler, Director, Bureau of Immigration, NCWC; "New Mexican Immigration Law," memo, November 3, 1926, Cleofas Calleros Papers, CLSSC.

94. Violation Acts, section 2 and 1a; Wesley E. Stiles, interview by Wesley C. Shaw, January 1986, pp. 7, 8–9, IOH.

95. Ettinger, "Imaginary Lines," 258; Mae Ngai, "Illegal Aliens and Alien Citizens: United States Immigration Policy and Racial Formation, 1924–1945" (PhD diss., Columbia University, 1998), 171.

96. Harold D. Frakes, interview by Oscar J. Martínez, October 11, 1978, transcript, p. 22, IOH.

97. U.S. Bureau of Immigration, "Land Border Crossing Procedure," General Order No. 86, April 1, 1927 (in NCWC Papers, CLSSC); District Director, El Paso, Texas, to Inspector in Charge, Nogales, Arizona, October 27, 1927, File 55301/217-A, Reel 16, in *R-INS-A-2*. On migrants working with local passports, see also Sánchez, *Becoming Mexican American*, 61.

98. Wesley E. Stiles, interview by Wesley C. Shaw, January 1986, p. 6, IOH.

99. Eutimia B. Mercado, interview by Mary E. Ortega (in Spanish), November 30 1977, transcription of Tape 640, IOH. Translated by Tom Nehil.

100. Jesús Pérez, interview by Magdaleno Cisneros (in Spanish), May 1976, transcription of Tape 249, IOH. Translated by Tom Nehil.

101. Visa 711375, July 21, 1924, Nogales, Arizona, Acc. 52A172, R-INS, NARA-DC.

102. Registry Act of 1929 (45. Stat. 1512); NCWC Adjustment of Status application forms (in Spanish), NCWC Papers, CLSSC; Ngai, *Impossible Subjects*, 82.

103. "Young and Old Beg to Enter U.S.; Men at Bridge Know Lots of Secrets about El Pasoans," *El Paso Herald,* March 10, 1921, 11.

104. Memo to Mr. Light, February 27, 1934, File 55854/758, Accession 58A734, R-INS, NARA-DC.

105. G. C. Wilmoth, District Director, El Paso District, to Commissioner of Immigration and Naturalization, February 18, 1934, p. 2, File 55854/758, Accession 58A734, R-INS, NARA-DC.

106. G. C. Wilmoth, District Director, El Paso District, to Commissioner of Immigration and Naturalization, memo, February 19, 1934, File 55854/758, Accession 58A734, R-INS, NARA-DC. Frauds were reported on both the southern and northern U.S. borders, although immigration officers on the northern borders tended to emphasize the numbers as "negligible." John L. Zurbick, District Director, Detroit District, to Commissioner of Immigration and Naturalization, January 24, 1934, p. 1, File 55854/758, Accession 58A734, R-INS, NARA-DC.

107. John L. Zurbick, District Director, Detroit District, to Commissioner of Immigration and Naturalization, January 24, 1934, p. 2, File 55854/758, Accession 58A734, R-INS,NARA-DC.

108. The numbers did not increase so substantially for U.S. citizens. They were issued about 40,500 border-crossing cards in 1929: 39,000 to U.S. citizens in the United States and 1,500 to U.S. citizens in Mexico. *ARCGI* (1929), 15.

109. Ettinger, "Imaginary Lines," 257; Martínez, *Border Boom Town,* 82.

110. Chamber of Commerce of the United States, Immigration Committee, *Emergency Restriction of Immigration,* pamphlet (Washington, DC: Chamber of Commerce of the United States, March 1932), in Pamphlet Boxes of Materials on Mexicans in California, BL; Martínez, *Border Boom Town,* 82.

111. Consul General Enrique Leikens to Mexican Ambassador in Washington, D.C., December 6, 1928, Archivo Historico de la Secretaria de Relaciones Exteriores, Mexico City, IV-89-3, cited in Martínez, *Border Boom Town,* 75; Paul Shuster Taylor, interview by Suzanne B. Riess, 1970, pp. 201–2, Regional Oral History Office, BL, available through Online Archive of California, www .oac.cdlib.org/.

112. Paul Shuster Taylor, interview by Suzanne B. Riess, 1970, p. 202, Regional Oral History Office, BL.

113. Cleofas Calleros to Mr. Horsley, memo, September 15, 1931, Cleofas Calleros Papers, CLSSC.

114. Neil Betten and Raymond A. Mohl, "From Discrimination to Repatriation: Mexican Life in Gary, Indiana, during the Great Depression," *Pacific Historical Review* 42 (August 1973): 377; Sánchez, *Becoming Mexican American,* 213; Ngai, *Impossible Subjects,* 71–74.

115. Ngai, *Impossible Subjects,* 72; Sánchez, *Becoming Mexican American,* 209–26.

116. Armando B. Chavez M., interview by Oscar J. Martínez (in Spanish), December 10, 1973, transcription of Tape 146, IOH. Translated by Tom Nehil.

117. José Cruz Burciaga, interview by Oscar J. Martínez (in Spanish), February 16, 1974, transcription of Tape 143, p. 40, IOH.

118. Balderrama and Rodríguez, *Decade of Betrayal,* 121; Hoffman, *Unwanted Mexican Americans,* ix.

119. Ettinger, "Imaginary Lines," 2–3.

120. See, for example, Margarita Jáquez de Alcalá, interview by Oscar J. Martínez (in Spanish), February 16, 1974, transcription of tape, p. 32, IOH. Translated by Tom Nehil.

121. Ngai, *Impossible Subjects*, 73.

122. Balderrama and Rodríguez, *Decade of Betrayal*, 55–56.

123. Martínez, *Border Boom Town*.

124. José Cruz Burciaga, interview by Oscar J. Martínez (in Spanish), February 16, 1974, transcription of Tape 143, p. 40, IOH, and Miguel Ordóñez, interview by Virgilio H. Sánchez Saucedo (in Spanish), July 9, 1979, transcription of Tape 618, p. 3, IOH, both translated by Tom Nehil.

125. Camille Guerin-Gonzales, *Mexican Workers and American Dreams: Immigration, Repatriation, and California Farm Labor, 1900–1939* (New Brunswick: Rutgers University Press, 1994), 97.

126. Martínez, *Border Boom Town*, 82.

127. José Cruz Burciaga, interview by Oscar J. Martínez (in Spanish), February 16, 1974, transcription of Tape 143, p. 40, IOH.

128. Martínez, *Border Boom Town*, 155.

129. *ARCGI* (1928), 2.

CONCLUSION

1. "Eighteen Aliens Seized at Finnish Dance," *New York Times*, February 16, 1931, 17.

2. Ibid.

3. Ibid. Not only immigrants but also Filipino nationals were affected by policies of repatriation and deportation: during the 1930s, unemployed Filipinos were similarly repatriated to the Philippines.

4. Ngai, *Impossible Subjects*, 56–90.

5. Order No. 106, July 1, 1928, Department of Labor; Max Kohler, *Immigration and Aliens in the United States* (New York: Bloch, 1936), 365; "Immigration Cards to Identify Aliens," *New York Times*, June 16, 1928, 18.

6. Acting Commissioner George Harris, quoted in Kohler, *Immigration and Aliens*, 363; Bruno Lasker, *Congressional Record*, 70th Cong., 2nd sess., vol. 70, pt. 1 (December 6, 1928): 150–52. On the rhetorics promoting and opposing Chinese documentation and registration, see chapter 1.

7. David Gutiérrez, *Walls and Mirrors: Mexican Americans, Mexican Immigrants, and the Politics of Ethnicity* (Berkeley: University of California Press, 1995), 193.

8. Edward P. Hutchinson, *Legislative History of American Immigration Policy, 1798–1965* (Philadelphia: University of Pennsylvania Press, 1981), 540–42; Garland, "Through Closed Gates," 229. Also marking the hardening of this divide, 1928 was the first national election in which no alien in any state could vote. Milton Konvitz, *The Alien and Asiatic in American Law* (Ithaca: Cornell University Press, 1946), 1.

9. The Secretary of Labor's "report," 110–11, invokes the precedent of Fong You Ting. Cited in Kohler, *Immigration and Aliens*, 341.

10. Kohler, *Immigration and Aliens,* 361.

11. Ibid., 348–50. For additional comparisons with Chinese registration systems, see ibid., 369.

12. Garland, "Through Closed Gates," 238.

13. Kohler, *Immigration and Aliens,* 348–50.

14. Ibid., 360, 367, 369–71.

15. Bruno Lasker, editor of *Inquiry,* quoted in Kohler, *Immigration and Aliens,* 364. In relation to Chinese registration, see Garland, "Through Closed Gates," 255. During the 1970s, President Jimmy Carter unsuccessfully attempted to develop a national identification plan to address illegal immigration, acknowledging that regulation of illegal immigration requires regulation of all Americans. Gutiérrez, *Walls and Mirrors,* 201.

16. Masanz, "History," 13, 38.

17. As noted earlier, native-born Chinese citizens had also already been subject to photographic documentation almost twenty years earlier in 1909, when all Chinese residents in the United States were required to use a uniform identity certificate.

18. C. R. Riddiough, *Documentary Evidence of Citizenship Status,* INS, Lecture No. 25 (Washington, DC: GPO, 1934), 3–4.

19. Leo Burgholz to Secretary of State, June 13, 1919, File 509503–22, Entry 26, R-INS, NARA-DC.

20. Executive Order No. 2932 of August 8, 1918, sec. 5.

21. M. H. Anthoni, Office of the Examiner, San Antonio, Texas, to Chief Examiner, Washington, D.C., January 19, 1923, File 509503–22, Entry 26, R-INS, NARA-DC.

22. John Miller, County Clerk's Office, Onondaga County, New York, to Raymond Crist, Commissioner of Naturalization, March 12, 1923, File 509503–22, Entry 26, R-INS, NARA-DC.

23. Raymond Crist, Commissioner of Naturalization, to Second Assistant Secretary, September 24, 1924, File 509503–22, Entry 26, R-INS, NARA-DC. Although the administration of naturalization was centralized within the newly renamed Bureau of Immigration and Naturalization in 1906, decisions on naturalization remained the responsibility of state courts. In 1913, immigration and naturalization were split into two separate bureaus. Masanz, "History," 14–15. 19.

24. Act of March 2, 1929 (45 Stat. 1516); Riddiough, *Documentary Evidence,* 3–6.

25. The same year also saw the enactment of the Registry Act, which allowed for the regularization of Mexican immigrants. See Ngai, *Impossible Subjects,* 82; Masanz, "History," 39.

26. 1940 Alien Registration Act (54 Stat. 670); Presidential Proclamation 2527, January 14, 1942. Although various sections of the 1940 Alien Registration Act have not been enforced since the war, historian Roger Daniels has noted how these provisions have been used "in the aftermath of 9/11 as a means of deporting large numbers of otherwise law-abiding residents of Middle Eastern and South Asian origin." The compulsory registration of young immigrant men from nations with Muslim majorities after the terrorist attacks on the United States in

September 2001 also has an established precedent in racialized registration policies. During the Iran hostage crisis of 1979 and 1980, when scores of U.S. Embassy workers were kept hostage by Iranian militants, President Jimmy Carter required Iranian nationals in the United States to submit to photographing and fingerprinting. Roger Daniels, "Immigration Policy in a Time of War: The United States, 1939–1945," *Journal of American Ethnic History* 25 (Winter–Spring 2006): 108; Joane Nagel, "Constructing Ethnicity: Creating and Recreating Ethnic Identity and Culture," *Social Problems* 41 (February 1994): 158.

Bibliography

ARCHIVES

American Museum of Natural History, New York, NY

Julian Dimock Collection

Asian American Studies Collection, Ethnic Studies Library, University of California, Berkeley

Angel Island Oral History Project, Judy Yung Collection
Chinese Women of America Photograph Collection
Ng Poon Chew Collection
Pon Family, Affidavits to Establish Nativity and Identity, AAS ARC 2000/31

Balch Institute for Ethnic Studies, Historical Society of Pennsylvania, Philadelphia

Raymond J. Bodziak Photograph Collection, PG 30
Albert Guris Family Photograph Collection, PG 265
Elba F. Gurzau Photograph Collection, PG 166
Elba F. Gurzau Manuscript Collection, MSS 48
Jung Family Photograph Collection, PG 84
Justave Family Photograph Collection, PG 222
Pucetas Family Photograph Collection, PG 55
Bernard and Jennie Rachman Photograph Collection, PG 38
Rosner Family Photograph Collection, PG 78
Tuomi Family Photograph Collection, PG 76

Bancroft Library, University of California, Berkeley

Angel Island Immigration Station Collection, BANC MSS 78/122 C
Asian American Oral History Composite, BANC MSS 78/123
Combined Asian American Resources Oral History Project Interviews, 1974–76, BANC MSS 80/31 C
Jesse Brown Cook Scrapbooks Documenting San Francisco History and Law Enforcement, ca. 1895–1936, BANC PIC 1996.003—fALB
Hart Hyatt North Papers, BANC MSS 79/60c
Hart Hyatt North Papers, Photographs from the Hart Hyatt North Papers, 1980.098—PIC
Pamphlet Boxes of Materials on Mexicans in California, BANC F870.M5 P16
Photo album of Harry Q.H. and Moey Lock Lee, BANC PIC 1994.003—fALB
Photographs relating to Manuel Gamio's research on Mexican immigration to the United States, BANC PIC 1937.003–.005—PIC
Pictorial Collections—Portraits, BANC PIC 1975.019—POR
Miscellaneous Papers Relating to the Chinese in California, 1894–1926, BANC MSS C-R 153
Regional Oral History Office Collection
Scrapbooks on Chinese Immigration, 1877–1893, Horace David Collection, BANC MSS 89/151 c

Bentley Historical Library, University of Michigan, Ann Arbor, Michigan

Samuel B. Grubbs Pamphlet Collection
Theodore Wesley Koch Collection

California Historical Society, San Francisco

John A. Robinson Papers pertaining to the U.S. Immigration Service, San Francisco, 1906–1936, and Photographs, MSP 1816
Photography Collection

Center for American History, University of Texas at Austin

Robert Runyon Papers
Robert Runyon Photograph Collection

El Paso Public Library, El Paso, Texas

George Eastman House, Rochester, New York
Photography Collection

Hoover Institution on War, Revolution, and Peace, Stanford University, California

Survey of Race Relations: A Canadian-American Study of the Oriental on the Pacific Coast

Library of Congress, Washington, DC

Prints and Photographs Division

Michigan State University Museum, East Lansing, Michigan

John and Selma Appel Collection of Ethnic Caricature

National Archives and Records Administration, Washington, DC

Records of the U.S. Immigration and Naturalization Service. Record Group 85
Records of the U.S. Immigration and Naturalization Service, Subject Index to Correspondence and Case Files of the Immigration and Naturalization Service, 1903–1952. Microfilm T-458.

National Archives and Records Administration, College Park, MD

Notes from the Chinese Legation in the United States to the Department of State, 1868–1906, Record Group 59, Microfilm M98
Photographs of the U.S. Public Health Service, Record Group 90
Records of the U.S. Public Health Service, Record Group 90

National Archives and Records Administration, Pacific Region, San Francisco

Records of the U.S. Bureau of Customs, Record Group 36, Port of San Francisco, Copies of Letters Sent to the Secretary of the Treasury
Records of the U.S. Immigration and Naturalization Service, Record Group 85

Nettie Lee Benson Latin American Collection, University of Texas at Austin

Hernando Garcia Collection
José de la Luz Sáenz Papers
Records of the League of United Latin American Citizens
Records of the Order Sons of America (Council 5)
Rómulo Munguía Collection

New York Public Library, New York, NY

Lewis Hine Photograph Collection, Miriam and Ira D. Wallach Division of Art, Prints and Photographs
Mid-Manhattan Library Picture Collection
Photography Collection, Miriam and Ira D. Wallach Division of Arts, Prints and Photographs
William Williams Papers, Rare Books and Manuscript Division
William Williams Photograph Collection, Miriam and Ira D. Wallach Division of Art, Prints and Photographs

San Francisco History Center, San Francisco Public Library

Mug Book Collection, San Francisco Police Department
San Francisco History Photograph Collection

C. L. Sonnichsen Special Collections Department, University Library, University of Texas at El Paso

Casasola Photography Studio Photograph Collection
Cleofás Calleros Papers, 1860–1977, MS 231
Institute of Oral History
National Catholic Welfare Conference Papers, MS 173

Statue of Liberty National Monument, National Park Service, New York, NY

Ellis Island Oral History Project
Augustus Sherman Photograph Collection
Colonel Weber Photograph Collection

ELECTRONIC COLLECTIONS
American Memory Collection, Library of Congress

Robert Runyon Photograph Collection

Online Archive of California

Chinese in California Collection

NEWSPAPERS

El Paso Herald
El Paso Times
New York Times

PRIMARY SOURCES

Aldrich, Thomas Bailey. "Unguarded Gates." *Atlantic Monthly,* July 1892, 57.
American Federation of Labor. *Some Reasons for Exclusion, Meat vs. Rice, American Manhood against Asiatic Coolieism, Which Shall Survive?* 57th Cong., 1st sess., 1902, S. Doc. 137.
Annual Report of the Surgeon-General of the Public Health and Marine Hospital Service (Washington, DC: Government Printing Office, 1905). In *Historic Resource Study (Historical Component), Ellis Island, Statue of Liberty National Monument,* by Harlan D. Unrau. Washington, DC: National Park Service, 1984.
Archibald, A. R. *Enforcement of Immigration Laws in Relation to Insular Possessions and Territories.* U.S. Immigration and Naturalization Service, Lecture No. 31. Washington, DC: Government Printing Office, 1935.
"Architectural Appreciations—No. 3. The New York Immigrant Station." *Architectural Record* 12 (December 1902): 726–33.
Arthur, Henry. "Among the Immigrants." *Scribner's Magazine,* March 1901, 301–11.
Bamford, Mary. *Angel Island: The Ellis Island of the West.* Chicago: Woman's American Baptist Home Mission Society, 1917.
Batchelder, Roger. *Watching and Waiting on the Border.* Boston, 1917.
Bertillon, Alphonse. "The Bertillon System of Identification." *New York Forum* 11 (May 1891): 331–40.
———. *Signaletic Instructions Including the Theory and Practice of Anthropometric Identification.* Translated by R. W. McLaughry. Chicago: Werner, 1896.
Boas, Franz. *Changes in Bodily Form of Descendants of Immigrants.* U.S. Immigration Commission Reports, vol. 38. 61st Cong., 3rd sess., 1911, S. Doc. 208.

Boody, Bertha M. *A Psychological Study of Immigrant Children at Ellis Island, 1922–1923* [1926]. In *Historic Resource Study, (Historical Component), Ellis Island, Statue of Liberty National Monument,* by Harlan D. Unrau. Washington, DC: National Park Service, 1984.

"Book of Instruction for the Medical Inspection of Immigrants." N.p, n.d. In *Historic Resource Study (Historical Component), Ellis Island, Statue of Liberty National Monument,* by Harlan D. Unrau, 652–60. Washington, DC: National Park Service, 1984.

Brandenburg, Broughton. "The Stranger within the Gates." *Harper's Weekly,* June 17, 1905, 868–70.

———. "The Stranger within the Gate, II." *Harper's Weekly,* August 5, 1905, 1114–16, 1133.

Braun, Marcus. "Report, First Detail to Mexico." February 1907. File 52320/1, Reel 2, in U.S. Immigration and Naturalization Service, *Records of the U.S. Immigration and Naturalization Service, Series A, Subject Correspondence Files. Part 2: Mexican Immigration, 1906–1930,* microfilm. Bethesda, MD: University Publications of America, 1994.

———. "Report, Second Detail to Mexico." June 1907. File 52320/1A, Reel 2, in U.S. Immigration and Naturalization Service, *Records of the U.S. Immigration and Naturalization Service, Series A, Subject Correspondence Files. Part 2: Mexican Immigration, 1906–1930,* microfilm. Bethesda, MD: University Publications of America, 1994.

Byrnes, Thomas. "Why Thieves Are Photographed." In *Professional Criminals of America.* New York: Cassell, 1886.

California. Mexican Fact-Finding Committee. *Mexicans in California: Report of Governor C. C. Young's Mexican Fact-Finding Committee.* San Francisco, 1930.

California. Special Committee on Chinese Immigration. *Chinese Immigration: Its Social, Moral, and Political Effect. Report to the California State Senate of Its Special Committee on Chinese Immigration.* Sacramento: State Printing Office, 1878.

California. State Board of Control. *California and the Oriental: Japanese, Chinese and Hindus.* Sacramento: State Printing Office, 1920.

Chamber of Commerce of the United States. Immigration Committee. *Emergency Restriction of Immigration.* Pamphlet. Washington, DC: Chamber of Commerce of the United States, March 1932.

Chentung Liang Cheng. "Commercial Relations between United States and China." *Harper's Weekly,* December 23, 1905, 1860–70.

"Chinamen at the Custom-House, San Francisco." *Harper's Weekly,* February 3, 1877, 1, 91.

"Chinese Exclusion." *Outlook,* April 23, 1904, 963–65.

Clark, Jane Perry. *Deportation of Aliens from the United States to Europe.* 1931. Reprint, New York: Arno Press, 1969.

Condit, Ira M. *The Chinaman as We See Him.* Chicago: F. H. Revell, 1900.

Cook, Jesse B. "San Francisco's Old Chinatown," *San Francisco Police and Peace Officers' Journal,* June 1931, www.sfmuseum.org/hist9/cook.html.

Coolidge, Mary Roberts. *Chinese Immigration.* New York: Henry Holt, 1909.

Corsi, Edward. *In the Shadow of Liberty.* 1935. Reprint, New York: Arno Press, 1969.

Cowen, Philip. *Memories of an American Jew.* 1932. Reprint, New York: Arno Press, 1975.

Curran, Henry H. *From Pillar to Post.* New York: Charles Scribner's Sons, 1941.

Dimock, Julian. "Ellis Island as Seen by the Camera-Man." *World To-Day,* April 1908, 394–96.

————. "New Americans: Photographs." *World To-Day,* April 1908, 337–42.

Eberle, Louise. "Where Medical Inspection Fails." *Colliers,* February 8, 1913, 27.

Ebey, Howard D. *Chinese Exclusion Laws and Immigration Laws as Applied to Chinese.* U.S. Immigration and Naturalization Service, Lecture No. 32. Washington, DC: Government Printing Office, 1935.

Folkmar, Daniel. *Dictionary of Races or Peoples.* U.S. Immigration Commission Reports, vol. 5. 61st Cong., 3rd sess., 1911, S. Doc. 662.

"For a Better Ellis Island." *Outlook,* October 21, 1914, 402–3.

Foster, John W. "The Chinese Boycott." *Atlantic Monthly,* January 1906, 118–27.

Gamio, Manuel. *The Life Story of the Mexican Immigrant: Autobiographic Documents.* Introduction by Paul S. Taylor. 1931. Reprint, New York: Dover, 1971.

Gates, Solon. "Photographing Character." *World To-Day,* July 1905, 709–12.

Godkin, E. L. "Decision on the Geary Act." *Nation,* May 1894, 358.

Grose, Howard B. *Aliens or Americans?* New York: Young People's Missionary Movement, 1906.

Grosvenor, Gilbert H. "Our Foreign-Born Citizens." *National Geographic,* February 1917, 95–130.

————. "Some of Our Immigrants." *National Geographic,* May 1907, 317–34.

Hankins, Frank. "Birth Control and the Racial Future." *People,* April 1931, 11–15.

Hendrick, Burton J. "The Skulls of Our Immigrants." *McClure,* May 1910, 36–50.

Hine, Lewis Wickes. *Men at Work: Photographic Studies of Modern Men and Machines.* New York: Macmillan, 1939.

————. "Notes on Early Influence." In *Photo Story: Selected Letters and Photographs of Lewis W. Hine,* edited by Daile Kaplan. Washington, DC: Smithsonian Institution, 1992.

————. "Plans for Work." Guggenheim application, October 1940. In *Photo Story: Selected Letters and Photographs of Lewis W. Hine,* edited by Daile Kaplan. Washington, DC: Smithsonian Institution, 1992.

————. "Social Photography." Paper presented at the National Conference of Charities and Corrections, June 1909. Reprinted in *Classic Essays on Photography,* edited by Alan Trachtenberg. New Haven, CT: Leete's Island Books, 1980.

Ho Yow. "The Chinese Question." *Overland Monthly,* October 1901, 249–57.

Holder, Charles Frederick. "The Chinaman in American Politics." *North American,* February 1898, 226–33.

Holt, Hamilton, ed. *The Life Stories of Undistinguished Americans as Told by Themselves.* 1906. Reprint, New York: Routledge, 2000.

Howe, Frederic C. *Confessions of a Reformer.* New York: Charles Scribner's Sons, 1925.

Kellogg, Paul. "The Pittsburgh Survey." *Charities and the Commons,* January 2, 1909, 517–26.

King, Moses. *King's Handbook of New York City.* Boston: Moses King, 1893.

Kohler, Max. "The Administration of Our Chinese Immigration Laws." *Journal of the American Asiatic Association* 5 (July 1905): 176–79.

———. *Immigration and Aliens in the United States.* New York: Bloch, 1936.

La Guardia, Fiorello H. *The Making of an Insurgent: An Autobiography, 1882–1919.* Philadelphia: J. B. Lippincott, 1948.

MacCormack, D. W., and H. L. Volker. *Naturalization Requirements Concerning Race, Education, Residence, Good Moral Character, and Attachment to the Constitution.* U.S. Immigration and Naturalization Service, Lecture No. 8. Washington, DC: Government Printing Office, 1934.

McCurdy, James G. "Use of Photographs as Evidence." *Scientific American,* November 15, 1902, 328.

McLaughlin, Allan. "How Immigrants Are Inspected." *Popular Science Monthly,* February 1905, 357–59.

Michaud, Gustave. "What Shall We Be? The Coming Race in America." *Century,* March 1903, 683–92.

Morgan, Patricia. *Shame of a Nation: Documented Story of Police State Terror against Mexican-Americans.* Los Angeles: Los Angeles Committee for the Protection of the Foreign Born, 1954.

Mullan, E. H. "Mental Examination of Immigrants: Administration and Line Inspection at Ellis Island." *Public Health Reports* 32 (May 18, 1917), 733–46. In *Historic Resource Study, (Historical Component), Ellis Island, Statue of Liberty National Monument,* by Harlan D. Unrau. Washington, DC: National Park Service, 1984.

Murphy, Thomas J. *American Consular Procedure and Technical Advisers in Immigration Work.* U.S. Immigration and Naturalization Service, Lecture No. 9. Washington, DC: Government Printing Office, 1934.

Ng, Poon Chew. *The Treatment of the Exempt Classes of Chinese in the United States.* San Francisco: Chung Sai Yat Po, 1908.

North, Hart Hyatt. "Chinese and Japanese Immigration to the Pacific Coast." *California Historical Quarterly* 28 (1949): 343–50.

North American Civic League for Immigrants. *Annual Reports, 1908–1909 to 1918–1919.* Boston: North American Civic League for Immigrants, 1910–20.

"Our Immigration during 1904." *National Geographic,* January 1905.

"Photographing Savages." *Popular Science Monthly,* August 1893, 570.

Ralph, Julian. "The Chinese Leak." *Harper's New Monthly Magazine,* March 1891, 515–25.

———. "Landing the Immigrant." *Harper's Weekly,* October 24, 1891, 821–24.

Reed, Alfred C. "Going through Ellis Island." *Popular Science Monthly,* January 1913, 5–18.

———. "The Medical Side of Immigration." *Popular Science Monthly,* April 1912, 383–92.

————. "The Relation of Ellis Island to the Public Health." *New York Medical Journal* 98 (1913): 172–75.

————. "Scientific Medical Inspection at Ellis Island." *Medical Review of Reviews* 18 (1912): 541–44.

Riddiough, C. R. *Documentary Evidence of Citizenship Status.* U.S. Immigration and Naturalization Service, Lecture No. 25. Washington, DC: Government Printing Office, 1934.

Riis, Jacob. *How the Other Half Lives: Studies among the Tenements of New York.* New York: Scribner's and Sons, 1890.

Ripley, William Z. "The Racial Geography of Europe." *Popular Science Monthly,* March 1897, 17–34.

Roberts, Peter. *The New Immigration: A Study of the Industrial and Social Life of Southeastern Europeans in America.* New York: Macmillan, 1912.

Rossiter, Alfred. "The Truth about Ellis Island." *City Life and Municipal Facts,* June 8, 1911, n.p.

Safford, Victor. *Immigration Problems: Personal Experiences of an Official.* New York: Dodd, Mead, 1925.

Sargent, Frank. "The Need for Closer Inspection and Greater Restriction of Immigrants." *Century,* January 1904, 470–73.

Sayles, Mary B. "The Keepers of the Gate. Illustrated with Photographs by Arthur Hewitt." *Outlook,* December 28, 1907, 913–23.

Seraphic, A. A. "Report re: Conditions on the Mexican Border, 1906–1907." January 1908. File 51423/1, Reel 1, in U.S. Immigration and Naturalization Service, *Records of the U.S. Immigration and Naturalization Service, Series A, Subject Correspondence Files. Part 2: Mexican Immigration, 1906–1930,* microfilm. Bethesda, MD: University Publications of America, 1994.

Seward, George F. *Chinese Immigration: Its Social and Economic Aspects.* 1881. Reprint, New York: Arno Press, 1970.

Shepherd, Charles R. *The Ways of Ah Sin.* New York: Fleming H. Revell, 1923.

Shinn, Charles H. "The Geary Act in California." *Nation,* May 18, 1893, 365.

"The Spectator." *Outlook,* March 25, 1905, 730–32.

"The Spectator." *Outlook,* January 13, 1912, 96.

Stone, F. R. "Report to Supervising Inspector F. W. Berkshire, Immigration Service, El Paso, Texas." June 30, 1910. File 52546/31-C, Reel 2, in U.S. Immigration and Naturalization Service, *Records of the U.S. Immigration and Naturalization Service, Series A, Subject Correspondence Files. Part 2: Mexican Immigration, 1906–1930,* microfilm. Bethesda, MD: University Publications of America, 1994.

Straus, Oscar. "The Spirit and Letter of Exclusion." *North American Review* 187 (April 1908): 481–85.

Tappan, J. W. "Protective Health Measures on United States-Mexico Border." *Journal of the American Medical Association* 87, no. 13 (1926): 1022–26.

Uhl, Byron H. *Immigration Procedure at Seaports.* U.S. Immigration and Naturalization Service, Lecture No. 28. Washington, DC: Government Printing Office, 1934.

U.S. Bureau of Immigration. *Annual Reports of the Commissioner General of*

Immigration for the Fiscal Years 1897–1932. Washington, DC: Government Printing Office.

————. *Treaties, Laws and Regulations Governing the Admission of Chinese.* Washington, DC: Government Printing Office, 1903–17.

U.S. Congress. House. Committee on Immigration and Naturalization. *Chinese Immigration.* 52nd Cong., 1st sess., 1892, H. Rept. 255, Serial 3042.

U.S. Congress. House. Select Committee on Immigration and Naturalization. *Chinese Immigration.* 51st Cong., 2nd sess., 1891, H. Rept. 4048.

U.S. Department of Justice. *Immigration and Nationality Laws and Regulations.* Washington, DC: Government Printing Office, 1944.

————. *Immigration Manual: For Confidential and Exclusive Use of Officers and Employees of the Immigration and Naturalization Service.* Washington, DC, 1943.

————. *Laws Applicable to Immigration and Nationality.* Washington, DC: Government Printing Office, 1953.

U.S. Department of State. *The American Passport: Its History.* Washington, DC: Government Printing Office, 1899.

U.S. Immigration and Naturalization Service. *General Information Concerning United States Immigration Laws.* Washington, DC: Government Printing Office, 1934, 1938.

————. *Immigration Laws: Immigration Rules and Regulations of January 1, 1930, as Amended up to and including December 31, 1936.* Washington, DC: U.S. Department of Labor.

————. *Immigration Laws: Rules of May 1, 1917.* 7th ed. Washington, DC: Government Printing Office, 1922.

————. *Information Concerning Origin, Activities, Accomplishments, Organization and Personnel of the Immigration Border Patrol.* Washington, DC: Government Printing Office, 1938.

————. *Records of the U.S. Immigration and Naturalization Service, Series A, Subject Correspondence Files. Part 1: Asian Immigration and Exclusion, 1906–1913.* Microfilm. Bethesda, MD: University Publications of America, 1994.

————. *Records of the U.S. Immigration and Naturalization Service, Series A, Subject Correspondence Files. Part 2: Mexican Immigration, 1906–1930.* Microfilm. Bethesda, MD: University Publications of America, 1994.

————. *Treaties, Laws and Regulations Governing the Admission of Chinese.* Washington, DC: Government Printing Office, 1920, 1926.

U.S. Immigration Commission (1907–10). *Abstracts of Reports of the Immigration Commission, with Conclusions and Recommendations and Views of the Minority.* 41 vols. 61st Cong., 3rd sess., 1911, S. Doc. 747.

U.S. Public Health Service. *Manual of the Mental Examination of Aliens.* Miscellaneous Publication No. 18. Washington, DC: Government Printing Office, 1918.

Unrau, Harlan D. *Historic Resource Study (Historical Component), Ellis Island, Statue of Liberty National Monument.* Vols. 1–3. Washington, DC: National Park Service, 1984.

"Visitors' Guide to Ellis Island" (December 1913). In *Historic Resource Study (Historical Component), Ellis Island, Statue of Liberty National Mon-*

ument, by Harlan D. Unrau, 545–46. Washington, DC: National Park Service, 1984.

Wagner, J. Henry. *Reentry Permits.* U.S. Immigration and Naturalization Service, Lecture No. 10. Washington, DC: Government Printing Office, 1934.

Watchorn, Robert. *Autobiography.* Edited by Herbert F. West. Oklahoma City: Robert Watchorn Charities, 1958.

———. "The Gateway of the Nation, Illustrated with Studies of Immigrant Types by Julian A. Dimock and Underwood & Underwood." *Outlook,* December 28, 1907, 897–911.

Weiss, Feri Felix. *The Sieve—or Revelations of the Man Mill, Being the Truth about American Immigration.* Boston: Page, 1911.

"What the Chinese Think about the Chinese Exclusion Act. Wong Kai Kah, Former Minister to England Points Out Some Objections to the Way It Is Enforced." *Spokane Press,* May 23, 1905.

Wiggin, M. P. "How the Chinese Took It." *Harper's Weekly,* June 3, 1893, 526.

Willis, H. Parker. "The Findings of the Immigration Commission." *Survey,* January 7, 1911, 569–70.

Wilmoth, G. C. *Mexican Border Procedure.* U.S. Immigration and Naturalization Service, Lecture No. 23. Washington, DC: Government Printing Office, 1934.

Wixon, I. F. *Immigration Border Patrol.* U.S. Immigration and Naturalization Service, Lecture No. 7. Washington, DC: Government Printing Office, 1934.

Wu Ting-fang. *America through the Spectacles of an Oriental Diplomat.* New York: Frederick A. Stokes, 1914.

Yawman and Erbe Mfg. Co. *Criminal Identification by "Y and E": Bertillon and Finger Print Systems.* Rochester, NY, 1913.

SECONDARY SOURCES

Alinder, Jasmine. "Out of Site: Photographic Representations of Japanese American Internment." PhD diss., University of Michigan, 1999.

Alland, Alexander. *Jacob A. Riis: Photographer and Citizen.* Millerton, NY: Aperture, 1974.

Alloula, Malek. *Colonial Harem.* Translated by Myrna Godzich. Minneapolis: University of Minnesota Press, 1986.

Almaguer, Tomás. *Racial Faultlines: The Historical Origins of White Supremacy in California.* Berkeley: University of California Press, 1994.

Anzaldúa, Gloria. *Borderlands/La Frontera: The New Mestiza.* San Francisco: Spinsters/aunt lute, 1987.

Bach, Robert. "Mexican Immigration and the American State." *International Migration Review* 12, no. 4 (1978): 536–57.

Balderrama, Francisco E., and Raymond Rodriguez. *Decade of Betrayal: Mexican Repatriation in the 1930s.* Albuquerque: University of New Mexico Press, 1995.

Banta, Melissa, and Susan Taylor, eds. *A Timely Encounter: Nineteenth-Century Photographs of Japan.* Cambridge, MA: Peabody Museum Press, 1988.

Barkan, Elazar. *The Retreat of Scientific Racism: Changing Concepts of Race in*

Britain and the United States between the World Wars. Cambridge: Cambridge University Press, 1992.

Barrett, James R., and David Roediger. "In-Between Peoples: Race, Nationality and the 'New Immigrant' Working Class." *Journal of American Ethnic History* 16 (Spring 1997): 3–44.

Barth, Gunther. *Bitter Strength: A History of the Chinese in the United States, 1850–1870.* Cambridge, MA: Harvard University Press, 1964.

Barthes, Roland. *Camera Lucida: Reflections on Photography.* Translated by Richard Howard. New York: Hill and Wang, 1981.

Baynton, Douglas C. "Disability and the Justification of Inequality in American History." In *The New Disability History,* edited by Paul Longmore and Lauri Umanski, 33–57. New York: New York University Press, 2001.

Benjamin, Walter. "A Small History of Photography." In *One Way Street and Other Writings,* translated by Edmund Jephcott and Kingsley Shorter, 240–57. London: Verso, 1985.

————. "The Work of Art in the Age of Mechanical Reproduction." In *Illuminations: Essays and Reflections,* edited by Hannah Arendt, translated by Harry Zohn, 217–51. New York: Schocken Books, 1969.

Berlant, Lauren. *The Queen of America Goes to Washington City.* Durham: Duke University Press, 1997.

Berlier, Monique. "Picturing Ourselves: Photographs of Belgian Americans in Northeastern Wisconsin, 1888–1950." PhD diss., University of Iowa, 1999.

Betten, Neil, and Raymond A. Mohl. "From Discrimination to Repatriation: Mexican Life in Gary, Indiana, during the Great Depression." *Pacific Historical Review* 42 (August 1973): 370–88.

Bhabha, Homi. "Of Mimicry and Man: The Ambivalence of the Colonial Discourse." In *The Location of Culture,* 121–31. London: Routledge, 1994.

————. "The Other Question: The Stereotype and Colonial Discourse." In *The Location of Culture,* 94–120. London: Routledge, 1994.

Birn, Anne-Emanuelle. "Six Seconds per Eyelid: The Medical Inspection of Immigrants at Ellis Island, 1892–1914." *Dynamis* 17 (1997): 281–316.

Blair, Sara. "Documenting the Alien: Racial Theater in *The American Scene.*" In *Henry James and the Writing of Race and Nation,* 158–210. Cambridge: Cambridge University Press, 1996.

Bloom, Lisa, ed. *With Other Eyes: Looking at Race and Gender in Visual Culture.* Minneapolis: University of Minnesota Press, 1999.

Bodnar, John. *The Transplanted: A History of Immigrants in Urban America.* Bloomington, Indiana University Press, 1985.

Bolton, Richard, ed. *The Contest of Meaning: Critical Histories of Photography.* Cambridge, MA: MIT Press, 1993.

Bramen, Carrie Tirado. "The Urban Picturesque and the Spectacle of Americanization." *American Quarterly* 52 (September 2000): 444–77.

Brown, Joshua. *Beyond the Lines: Pictorial Reporting, Everyday Life, and the Crisis of Gilded Age America.* Berkeley: University of California Press, 2002.

————. "Reconstructing Representation: Social Types, Readers, and the Pictorial Press, 1865–1877." *Radical History Review* 66 (1996): 5–38.

Brown, Julie. *Contesting Images: Photography and the World's Columbian Exposition*. Tucson: University of Arizona Press, 1994.

Brownstone, David, Irene Franck, and Douglass Brownstone. *Island of Hope, Island of Tears*. New York: Rawson Wade, 1979.

Buck-Morss, Susan. "Passports." *Documents* (New York) 1 (Summer 1993): 66–77.

Burke, Chloe. "Germs, Genes, and Dissent: Representing Radicalism as Disease in American Political Cartooning, 1877–1919." PhD diss., University of Michigan, 2004.

Calavita, Kitty. *Inside the State: The Bracero Program, Immigration, and the I.N.S.* New York: Routledge, 1992.

Cameron, Ardis, ed. *Looking for America: The Visual Production of Nation and People*. Malden, MA: Blackwell, 2005.

Campomanes, Oscar. "The New Empire's Forgetful and Forgotten Citizens: Unrepresentability and Unassimilabilty in Filipino-American Postcolonialities." *Critical Mass* 2 (Spring 1995): 145–200.

Caplan, Jane, and John Torpey, eds. *Documenting Individual Identity: The Development of State Practices in the Modern World*. Princeton: Princeton University Press, 2001.

Cardoso, Lawrence. "Labor Emigration to the Southwest, 1916 to 1920: Mexican Attitudes and Policy." In *Mexican Workers in the United States: Historical and Political Perspectives*, edited by George Kiser and Martha Woody Kiser, 16–32. Albuquerque: University of New Mexico Press, 1979.

Carpenter, Sue Ann. "Gold Mountain, Texas: From China to El Paso in 1915." *Paso del Norte* (November 1983): 50–53.

Carter, John E. *Solomon Butcher: Photographing the American Dream*. Lincoln: University of Nebraska Press, 1985.

———. "The Trained Eye: Photographs and Historical Context." *Public Historian* 15 (Winter 1993): 55–66.

Cartwright, Lisa. *Screening the Body: Tracing Medicine's Visual Culture*. Minneapolis: University of Minnesota Press, 1995.

Center for Creative Photography, Tucson. *Points of Entry: Reframing America*. Essays by Andrei Codrescu and Terence Pitts. Albuquerque: University of New Mexico Press, 1995.

Certeau, Michel de. *The Practice of Everyday Life*. Translated by Stephen Rendall. Berkeley: University of California Press, 1984.

Chalfen, Richard. *Turning Leaves: The Photograph Collections of Two Japanese American Families*. Albuquerque: University of New Mexico Press, 1991.

Chan, Kim Man. "Mandarins in America: The Early Chinese Ministers to the United States, 1878–1907." PhD diss., University of Hawaii, 1981.

Chan, Sucheng. *Asian Americans: An Interpretive History*. Boston: Twayne, 1991.

———, ed. *Entry Denied: Exclusion and the Chinese Community in America, 1882–1943*. Philadelphia: Temple University Press, 1991.

———. "European and Asian Immigration into the United States in Comparative Perspective, 1820s to 1920s." In *Immigration Reconsidered: History, Sociology, and Politics*, edited by Virginia Yans-McLaughlin, 37–79. Oxford: Oxford University Press, 1990.

———. "The Exclusion of Chinese Women." In *Entry Denied: Exclusion and the Chinese Community in America, 1882–1943*, edited by Sucheng Chan, 94–146. Philadelphia: Temple University Press, 1991.

Chang, Robert S. *Disoriented: Asian Americans, Law and the Nation-State.* New York: New York University Press, 1999.

Chavez, Leo. *Shadowed Lives: Undocumented Immigrants in American Society.* Fort Worth, TX: Harcourt Brace College Publishers, 1992.

Chen, Wen-Hsien. "Chinese under Both Exclusion and Immigration Laws." PhD diss., University of Chicago, 1940.

Choy, Philip, Lorraine Dong, and Marlon Hom, eds. *The Coming Man: Nineteenth Century American Perceptions of the Chinese.* Seattle: University of Washington, 1994.

Cizmic, Ivan. "The Experiences of South Slav Immigrants on Ellis Island and the Establishment of the Slavonic Immigrant Society in New York." In *In the Shadow of the Statue of Liberty: Immigrants, Workers, and Citizens in the American Republic,* edited by Marianne Debouzy, 67–82. Urbana: University of Illinois Press, 1992.

Cole, Simon. *Suspect Identities: A History of Fingerprinting and Criminal Identification.* Cambridge, MA: Harvard University Press, 2001.

Conzen, Kathleen Neils, David A. Gerber, Ewa Morawska, George E. Pozzetta, and Rudolph J. Vecoli. "The Invention of Ethnicity: A Perspective from the U.S.A." *Journal of American Ethnic History* 12 (Fall 1992): 3–63.

Crary, Jonathan. *Techniques of the Observer: On Vision and Modernity in the Nineteenth Century.* Cambridge, MA: MIT Press, 1990.

Daniels, Roger. *Asian America: Chinese and Japanese in the United States since 1850.* Seattle: University of Washington Press, 1988.

———. *Guarding the Golden Door: American Immigration Policy and Immigrants since 1882.* New York: Hill and Wang, 2004.

———. "Immigration Policy in a Time of War: The United States, 1939–1945." *Journal of American Ethnic History* 25 (Winter–Spring 2006): 107–16.

———. "No Lamps Were Lit for Them: Angel Island and the Historiography of Asian American Immigration." *Journal of American Ethnic History* 17 (Fall 1997): 2–18.

Daston, Lorraine, and Peter Galiston. "The Image of Objectivity." *Representations* 40 (Fall 1992): 81–128.

De la Cruz, Enrique B., and Pearlie Rose S. Baluyut, eds. *Confrontations, Crossings and Convergence: Photographs of the Philippines and the United States, 1898–1998.* Los Angeles: UCLA Asian American Studies Center and UCLA Southeast Asian Program, 1998.

Delano, Pablo. *Faces of America: Photographs.* Washington, DC: Smithsonian Institution Press, 1992.

Delgado, Grace Peña. "In the Age of Exclusion: Race, Region and Chinese Identity in the Making of the Arizona-Sonora Borderlands, 1863–1943." PhD diss., University of California, Los Angeles, 2000.

Deutsch, Sarah. *No Separate Refuge: Culture, Class, and Gender on an Anglo-Hispanic Frontier in the American Southwest, 1880–1940.* Oxford: Oxford University Press, 1987.

Dicker, Laverne Mau. *Chinese in San Francisco: A Pictorial History*. New York: Dover, 1979.

Dilworth, Donald. *Identification Wanted: Development of the American Criminal Identification System, 1893–1943*. Gaithersburg, MD: International Association of Chiefs of Police, 1977.

Diner, Hasia. *Erin's Daughters in America: Irish Immigrant Women in the Nineteenth Century*. Baltimore: Johns Hopkins University Press, 1983.

Dobrosky, Nanette. *Voices from Ellis Island: An Oral History of American Immigration*. Microfilm. Frederick, MD: University Publications of America, 1988.

Doherty, Jonathan L., comp. *Lewis Wickes Hine's Interpretive Photography: The Six Early Projects*. Chicago: University of Chicago Press, 1978.

Edwards, Elizabeth, ed. *Anthropology and Photography, 1860–1920*. New Haven: Yale University Press, 1992.

———. "Ordering Others: Photography, Anthropology and Taxonomies." In *In Visible Light: Photography and Classification in Art, Science and the Everyday*, edited by Chrissie Iels and Russell Roberts, 54–68. New York: Museum of Modern Art, 1997.

———. "The Photographic Type." *Visual Anthropology* 111 (1990).

Egan, Ronald. "Calligraphy and Painting." In *Word, Image and Deed in the Life of Su Shi*, 261–99. Cambridge: Cambridge University Press, 1994.

Ellis Island Oral History Project. *Voices from Ellis Island: Interviews from the Ellis Island Oral History Project*. New York: AKRF, 1985.

Eng, David L. "I've Been (Re)Working on the Railroad: Photography and National History in *China Men* and *Donald Duk*." In *Racial Castration: Managing Masculinity in Asian America*, 35–103. Durham: Duke University Press, 2001.

Eskind, Andrew, and Greg Blake. *Index to American Photographic Collections*. Boston: G. K. Hall, 1990.

Ettinger, Patrick. "Imaginary Lines: Border Enforcement and the Origins of Undocumented Immigration, 1882–1930." PhD diss., Indiana University, 2000.

Evans, Peter, Dietrich Rueschmeyer, and Theda Skocpol, eds. *Bringing the State Back In*. Cambridge: Cambridge University Press, 1985.

Fairchild, Amy L. *Science at the Borders: Immigrant Medical Inspection and the Shaping of the Modern Industrial Labor Force*. Baltimore: Johns Hopkins University Press, 2003.

Farkas, Lani Ah Tye. *Bury My Bones in America: The Saga of a Chinese Family in California. 1852–1996. From San Francisco to the Sierra Gold Mines*. Nevada City, CA: Carl Mautz, 1998.

Farrar, Nancy. *The Chinese in El Paso*. Southwestern Studies 33. El Paso: Texas Western Press, 1972.

Fischer, Michael. "Ethnicity and the Post-Modern Arts of Memory." In *Writing Culture: The Poetics and Politics of Ethnography*, edited by James Clifford and George E. Marcus, 194–233. Berkeley: University of California Press, 1986.

Flores, William V., and Rina Benmayor. *Latino Cultural Citizenship: Claiming Identity, Space, and Rights*. Boston: Beacon Press, 1997.

Foley, Neil. *The White Scourge: Mexicans, Blacks, and Poor Whites in Texas Cotton Culture*. Berkeley: University of California Press, 1997.

Foner, Eric. *A Short History of Reconstruction*. New York: Harper and Row, 1988.

Foster, Hal, ed. *Vision and Visuality*. New York: New Press, 1988.

Foucault, Michel. *Discipline and Punish: The Birth of the Prison*. Translated by Alan Sheridan. New York: Pantheon, 1979.

———. "The Eye of Power." In *Power/Knowledge: Selected Interviews and Other Writings by Michel Foucault*, edited by Colin Gordon, 146–65. New York: Pantheon Books, 1980.

Fox, Claire F. *The Fence and the River: Culture and Politics at the U.S-Mexico Border*. Minneapolis: University of Minnesota Press, 1999.

Freund, Giselle. *Photography and Society*. Boston: David R. Godine, 1980.

Friends of Photography, San Francisco. *Points of Entry: Tracing Cultures*. Introduction by Andy Grunberg. Essays by Rebecca Solnit and Ronald Takaki. Albuquerque: University of New Mexico Press, 1995.

Fusco, Coco. "Racial Time, Racial Marks, Racial Metaphors." In *Only Skin Deep: Changing Visions of the American Self*, edited by Coco Fusco and Brian Wallis, 13–50. New York: International Center of Photography with Harry N. Abrams, 2003.

Fusco, Coco, and Brian Wallis, eds. *Only Skin Deep: Changing Visions of the American Self*. New York: International Center of Photography with Harry N. Abrams, 2003.

Galarza, Ernesto. *Barrio Boy*. Notre Dame: University of Notre Dame Press, 1971.

———. *Merchants of Labor: The Mexican Bracero Story*. Santa Barbara, CA: McNally, 1964.

García, Mario. *Desert Immigrants: The Mexicans of El Paso, 1880–1920*. New Haven: Yale University Press, 1981.

Gardner, John. "The Image of the Chinese in the United States, 1885–1915." PhD diss., University of Pennsylvania, 1961.

Garland, Libby. "Through Closed Gates: Jews and Illegal Immigration to the United States, 1921–1933." PhD diss., University of Michigan, 2004.

Gee, Jennifer. "Sifting the Arrivals: Asian Immigrants and the Angel Island Immigration Station, San Francisco, 1910–1940." PhD diss., Stanford University, 1999.

Gibson, Pamela Church, and Roma Gibson, eds. *Dirty Looks: Women, Pornography and Power*. London: British Film Institute, 1993.

Ginzburg, Carlo. "Morelli, Freud, and Sherlock Holmes: Clues and Scientific Method." In *The Sign of Three: Dupin, Holmes, and Peirce*, edited by Thomas Sebeok, 81–119. Bloomington: University of Indiana Press, 1983.

Glickman, Lawrence. "Inventing the 'American Standard of Living': Gender, Race and Working-Class Identity, 1880–1925." *Labor History* 34 (Spring–Summer 1993): 221–35.

Goldberg, Vicki. "The Camera and the Immigrant." In *Points of Entry: A Nation of Strangers*, edited by Museum of Photographic Arts, San Diego, 21–27. Albuquerque: University of New Mexico Press, 1995.

Gómez-Peña, Guillermo. "Documented/Undocumented." In *Graywolf Annual*

Five: Multi-Cultural Literacy, edited by Rick Simonson and Scott Walker, 127–
 34. Saint Paul, MN: Graywolf, 1988.
Gould, Stephen Jay. *The Mismeasure of Man.* New York: W. W. Norton, 1981.
Green, David. "Veins of Resemblance: Photography and Eugenics." *Oxford Art
 Journal* 7, no. 2 (1984): 3–16.
Greene, Victor. "Old Ethnic Stereotypes and the New Ethnic Studies." *Ethnic-
 ity* 5 (September 1978): 328–50.
Grossman, James R. *Land of Hope: Chicago, Black Southerners and the Great
 Migration.* Chicago: University of Chicago Press, 1989.
Guérin-Gonzales, Camille. *Mexican Workers and American Dreams: Immigra-
 tion, Repatriation, and California Farm Labor, 1900–1939.* New Brunswick:
 Rutgers University Press, 1994.
Guglielmo, Thomas. *White on Arrival: Italians, Race, Color, and Power in
 Chicago, 1890–1945.* New York: Oxford University Press, 2003.
Gunning, Tom. "Tracing the Individual Body *aka* Photography, Detectives, Early
 Cinema and the Body of Modernity." Paper presented at the Society for Cin-
 ema Studies Conference, New Orleans, 1993.
Gutiérrez, David. *Walls and Mirrors: Mexican Americans, Mexican Immigrants,
 and the Politics of Ethnicity.* Berkeley: University of California Press, 1995.
Gutman, Judith Mara. *Lewis W. Hine and the American Social Conscience.* New
 York: Walker, 1967.
———. *Lewis W. Hine, 1874–1940: Two Perspectives.* New York: Grossman,
 1974.
Gyory, Andrew. *Closing the Gate: Race, Politics, and the Chinese Exclusion Act.*
 Chapel Hill: University of North Carolina Press, 1998.
Hales, Peter Bacon. *Silver Cities: The Photography of American Urbanization,
 1839–1915.* Philadelphia: Temple University Press, 1984.
Hall, Dawn, ed. *Drawing the Borderline: Artist-Explorers of the U.S.-Mexico
 Boundary Survey.* Albuquerque: Albuquerque Museum, 1996.
Hall, Linda, and Don Coerver. *Revolution on the Border: The United States and
 Mexico, 1910–1920.* Albuquerque: New Mexico University Press, 1988.
Hall, Stuart. "Encoding/Decoding." In *The Cultural Studies Reader,* edited by
 S. Durring, 90–103. 1980. Reprint, London: Routledge, 1993.
Handlin, Oscar. *Race and Nationality in American Life.* Boston: Little, Brown,
 1957.
———. *The Uprooted: The Epic Story of the Great Migrations That Made the
 American People.* Boston: Little, Brown, 1951.
Harding, Sandra, ed. *The "Racial" Economy of Science: Toward a Democratic
 Future.* Bloomington: Indiana University Press, 1993.
Harris, Michael D. *Colored Pictures: Race and Visual Representation.* Chapel
 Hill: University of North Carolina Press, 2003.
Harris, Neil. "Iconography and Intellectual History: The Halftone Effect." In
 *Cultural Excursions: Marketing Appetites and Cultural Tastes in Modern
 America,* 304–17. Chicago: University of Chicago Press, 1990.
Haynes, David. *Catching Shadows: A Directory of Nineteenth-Century Texas
 Photographers.* Austin: Texas State Historical Association, 1993.
Heinze, Andrew. *Adapting to Abundance: Jewish Immigrants, Mass Consump-*

tion, and the Search for American Identity. New York: Columbia University Press, 1990.

Hernández, Kathleen Anne Lytle. "Entangling Bodies and Borders: Racial Profiling and the U.S. Border Patrol, 1924–1955." PhD diss., University of California, Los Angeles, 2002.

Hernández, Kelly Lytle. "The Crimes and Consequences of Illegal Immigration: A Cross-Border Examination of Operation Wetback, 1943–1954." *Western Historical Quarterly* 37 (Winter 2006): 421–44.

Higham, John. *Send These to Me: Immigrants in Urban America.* Rev. ed. Baltimore: Johns Hopkins University Press, 1984.

———. *Strangers in the Land: Patterns of American Nativism, 1860–1925.* New York: Atheneum, 1963.

Hing, Bill Ong. *Defining American through Immigration Policy.* Philadelphia: Temple University Press, 2004.

———. *Making and Remaking Asian America through Immigration Policy, 1850–1990.* Stanford: Stanford University Press, 1993.

Hobsbawm, Eric, and Terence Ranger. *The Invention of Tradition.* Cambridge: Cambridge University Press, 1983.

Hoffman, Abraham. *Unwanted Mexican Americans in the Great Depression: Repatriation Pressures, 1929–1939.* Tucson: University of Arizona Press, 1974.

Hondagneu-Sotelo, Pierrette. *Gendered Transitions: Mexican Experiences in Immigration.* Berkeley: University of California Press, 1994.

Horsman, Reginald. *Race and Manifest Destiny: The Origins of American Racial Anglo-Saxonism.* Cambridge, MA: Harvard University Press, 1981.

Hoy, William. *The Chinese Six Companies.* San Francisco: Chinese Consolidated Benevolent Association, 1942.

Hsu, Madeline Yuan-yin. *Dreaming of Gold, Dreaming of Home: Transnationalism and Migration between the United States and South China, 1882–1943.* Stanford: Stanford University Press, 2000.

Huber, Judith Claire. "Assimilation or Exclusion: The Image of the Irish and the Chinese in American Popular Prints, 1850–1882." PhD diss., University of Virginia, 1996.

Hutchinson, Edward P. *Legislative History of American Immigration Policy, 1798–1965.* Philadelphia: University of Pennsylvania Press, 1981.

Jacobs, Paul, and Saul Landau. *Colonials and Sojourners.* Vol. 2 of *To Serve the Devil.* New York: Random House, 1971.

Jacobson, Matthew Frye. *Special Sorrows: The Diasporic Imagination of Irish, Polish, and Jewish Immigrants in the United States.* Cambridge, MA: Harvard University Press, 1995.

———. *Whiteness of a Different Color: European Immigrants and the Alchemy of Race.* Cambridge, MA: Harvard University Press, 1998.

Jay, Martin. *Downcast Eyes: The Denigration of Vision in Twentieth-Century French Thought.* Berkeley: University of California Press, 1993.

———. "In the Empire of the Gaze." In *Foucault: A Critical Reader,* edited by David Couzens Hoy, 175–204. Oxford: Basil Blackwell, 1986.

———. "Scopic Regimes of Modernity." In *Vision and Visuality,* edited by Hal Foster, 2–27. New York: New Press, 1988.

Jenks, Chris, ed. *Visual Culture*. London: Routledge, 1995.

Jonas, Susan, ed. *Ellis Island: Echoes from a Nation's Past*. New York: Aperture, 1989.

Jones, Maldwyn Allen. *American Immigration*. Chicago: University of Chicago Press, 1960.

Jussim, Estelle. "Icons or Ideology: Stieglitz and Hine." *Massachusetts Review* 19 (Winter 1978): 680–92.

Kaplan, Daile. *Lewis Hine in Europe: The "Lost" Photographs*. New York: Abbeville Press, 1988.

———. *Photo Story: Selected Letters and Photographs of Lewis W. Hine*. Washington, DC: Smithsonian Institution, 1992.

Katz, Friedrich. *The Secret War in Mexico: Europe, the United States, and the Mexican Revolution*. Chicago: University of Chicago Press, 1981.

Kazal, Russell. "Revisiting Assimilation: The Rise, Fall, and Reappraisal of a Concept in American Ethnic History." *American Historical Review* 100 (April 1995): 437–71.

Kelley, Robin. *Race Rebels: Culture, Politics, and the Black Working Class*. New York: Free Press, 1994.

Kevles, Daniel. *In the Name of Eugenics: Genetics and the Uses of Human Heredity*. 1985. Reprint, Cambridge, MA: Harvard University Press, 1995.

King, Peter. *Making Americans: Immigration, Race, and the Origins of the Diverse Democracy*. Cambridge, MA: Harvard University Press, 2000.

Kingston, Maxine Hong. *China Men*. New York: Vintage International, 1989.

———. "San Francisco's Chinatown." *American Heritage* 30 (December 1978): 37–47.

Kiser, George, and Martha Woody Kiser, eds. *Mexican Workers in the United States: Historical and Political Perspectives*. Albuquerque: University of New Mexico Press, 1979.

Konvitz, Milton. *The Alien and Asiatic in American Law*. Ithaca: Cornell University Press, 1946.

Kraut, Alan M. *Silent Travelers: Germs, Genes and the "Immigrant Menace."* New York: HarperCollins, 1994.

Kroes, Rob. "Migrating Images: The Role of Photography in Immigrant Writing." In *American Photographs in Europe*, edited by David Nye and Mick Gidley, 189–204. Amsterdam: VU Press, 1994.

Kumar, Amitava. *Passport Photos*. Berkeley: University of California Press, 2000.

Kung, Shien-woo. *Chinese in American Life, Some Aspects of Their History, Status, Problems, and Contribution*. Seattle: University of Washington Press, 1962.

Lai, Him Mark, Genny Lim, and Judy Yung. *Island: Poetry and History of Chinese Immigrants on Angel Island, 1910–1940*. San Francisco: Chinese Culture Foundation and HOC DOI (History of Chinese Detained on Island), 1980.

Lau, Estelle. *Paper Families: Identity, Immigration Administration, and Chinese Exclusion*. Durham: Duke University Press, 2006.

Lee, Anthony W. *Picturing Chinatown: Art and Orientalism in San Francisco*. Berkeley: University of California Press, 2001.

Lee, Erika. *At America's Gates: Chinese Immigration during the Exclusion Era, 1882–1943*. Chapel Hill: University of North Carolina Press, 2003.

———. "The Chinese Exclusion Example: Race, Immigration and American Gatekeeping, 1882–1924." *Journal of American Ethnic History* 21, no. 3 (2002): 36–62.

———. "Enforcing the Borders: Chinese Exclusion along the U.S. Borders with Canada and Mexico, 1882–1924." *Journal of American History* 89 (June 2002): 54–86.

———. "Immigrants and Immigration Law: A State of the Field Assessment." *Journal of American Ethnic History* 18 (Summer 1999): 85–114.

Lee, Robert G. *Orientals: Asian Americans and Popular Culture*. Philadelphia: Temple University Press, 1999.

Leighton, George R. "Afterword: The Photographic History of the Mexican Revolution." In *The Wind That Swept Mexico: The History of the Mexican Revolution, 1910–1942*, by Anita Brenner, 293–99. 1943. Reprint, Austin: University of Texas Press, 1971.

LeMay, Michael. *From Open Door to Dutch Door: An Analysis of U.S. Immigration Policy since 1820*. New York: Praeger, 1987.

Leung, Peter. "When a Haircut Was a Luxury: A Chinese Farm Laborer in the Sacramento Delta." *California History* 64 (1985): 211–17.

Levine, Robert M. *Images of History: Nineteenth and Early Twentieth Century Latin American Photographs as Documents*. Durham: Duke University Press, 1989.

Light, Ivan. "From Vice District to Tourist Attraction: The Moral Career of American Chinatowns, 1880–1940." *Pacific Historical Review* 43 (1974): 367–94.

Limerick, Patricia Nelson. *The Legacy of Conquest: The Unbroken Past of the American West*. New York: W. W. Norton, 1987.

Lipsitz, George. *The Possessive Investment in Whiteness: How White People Profit from Identity Politics*. Philadelphia: Temple University Press, 1998.

Litwack, Leon. *North of Slavery: The Negro in the Free States, 1790–1860*. Chicago: University of Chicago Press, 1961.

Liu, Eric. *The Accidental Asian: Notes of a Native Speaker*. New York: Vintage Books, 1998.

López, Ian Haney. *White by Law: The Legal Construction of Race*. New York: New York University Press, 1996.

Lowe, Lisa. *Immigrant Acts: On Asian American Cultural Politics*. Chapel Hill: Duke University Press, 1997.

Luibhéid, Eithne. *Entry Denied: Controlling Sexuality at the Border*. Minneapolis: University of Minnesota Press, 2002.

Lutz, Catherine A., and Jane L. Collins. *Reading National Geographic*. Chicago: University of Chicago Press, 1993.

Markel, Howard, and Alexandra Minna Stern. "Which Face? Whose Nation? Immigration, Public Health, and the Construction of Disease at America's Ports and Borders, 1891–1928." *American Behavioral Scientist* 42 (June–July 1999): 1313–30.

Martínez, Oscar J. *Border Boom Town: Ciudad Juárez since 1848*. Austin: University of Texas Press, 1978.

Masanz, Sharon. "The History of the Immigration and Naturalization Service." Select Commission on Immigration and Refugee Policy, 96th Cong., 2nd sess., 1980.

McClain, Charles. *In Search of Equality: The Chinese Struggle against Discrimination in Nineteenth-Century America*. Berkeley: University of California Press, 1994.

McCunn, Ruthanne Lum. *Chinese American Portraits, Personal Histories, 1828–1988*. San Francisco: Chronicle Books, 1988.

McKee, Delber. "The Chinese Boycott of 1905–1906 Reconsidered: The Role of Chinese Americans." *Pacific Historical Review* 55 (March 1986): 165–91.

McKeown, Adam. "Transnational Chinese Families and Chinese Exclusion, 1875–1943." *Journal of American Ethnic History* 18 (Winter 1999): 73–110.

McKiernan, John. "Fevered Measures: Race, Communicable Disease and Community Formation on the Texas-Mexican Border, 1880–1923." PhD diss., University of Michigan, 2002.

McWilliams, Carey. *Factories in the Field: The Story of Migratory Farm Labor in California*. Boston: Little, Brown, 1939.

———. *Ill Fares the Land*. Boston: Little, Brown, 1942.

———. *North from Mexico: the Spanish-Speaking People of the United States*. 1948. Reprint, New York: Greenwood Press, 1968.

Mears, Eliot G. *Resident Orientals on the American Pacific Coast: Their Legal and Economic Status*. New York: American Group, Institute of Pacific Relations, 1927.

Mercer, Kobena. "Skin Head Sex Thing: Racial Difference and the Homoerotic Imaginary." *New Formations*, no. 16 (Spring 1992): 1–23.

Mesenhöller, Peter. *Augustus F. Sherman: Ellis Island Portraits, 1905–1920*. New York: Aperture, 2005.

Miller, Stuart C. *The Unwelcome Immigrant*. Berkeley: University of California Press, 1969.

Mink, Gwendolyn. *Old Labor and New Immigrants in American Political Development: Union, Party, and State, 1875–1920*. Ithaca: Cornell University Press, 1986.

Molina, Natalia. *Fit to Be Citizens? Public Health and Race in Los Angeles, 1879–1939*. Berkeley: University of California Press, 2006.

———. "Medicalizing the Mexican: Immigration, Race, and Disability in the Early Twentieth Century United States." *Radical History Review* 94 (Winter 2006): 22–37.

Montejano, David. *Anglos and Mexicans in the Making of Texas, 1836–1986*. Austin: University of Texas Press, 1987.

Moreno, Barry. *Encyclopedia of Ellis Island*. Westport, CT: Greenwood Press, 2004.

Mott, Frank Luther. *History of American Magazines, 1885–1905*. Vol. 4. Cambridge, MA: Harvard University Press, 1957.

Moy, James. *Marginal Sights: Staging the Chinese in America*. Iowa City: University of Iowa Press, 1993.

Mumford, Kevin. *Interzones: Black/White Sex Districts in the Early Twentieth Century*. New York: Columbia University Press, 1993.

Museum of Photographic Arts, San Diego. *Points of Entry: A Nation of Strangers*.

Essays by Vicki Goldberg and Arthur Ollman. Albuquerque: University of New Mexico Press, 1995.

Nagel, Joane. "Constructing Ethnicity: Creating and Recreating Ethnic Identity and Culture." *Social Problems* 41 (February 1994): 152–76.

National Archives. "Passport Applications." 2005. www.archives.gov/genealogy/passport/.

Nee, Victor G., and Brett de Bary Nee. *Longtime Californ': A Documentary Study of an American Chinatown.* New York: Pantheon Books, 1972.

Neuman, Gerald. "The Lost Century of Immigration Law, 1776–1875." *Columbia Law Review* 93 (December 1993): 1833–1901.

Newhall, Beaumont. *The History of Photography from 1839 to the Present.* Rev. ed. Boston: Little, Brown, 1982.

Ng, Franklin. "The Sojourner, Return Migration, and Immigration History." *Chinese America: History and Perspectives* 1 (1987): 53–72.

Ngai, Mae. "The Architecture of Race in American Immigration Law: A Reexamination of the Immigration Act of 1924." *Journal of American History* 87 (June 1999): 67–92.

———. "Illegal Aliens and Alien Citizens: United States Immigration Policy and Racial Formation, 1924–1945." PhD diss., Columbia University, 1998.

———. *Impossible Subjects: Illegal Aliens and the Making of Modern America.* Princeton: Princeton University Press, 2004.

Novotny, Ann. *Alice's World: The Life and Photography of an American Original, Alice Austen, 1866–1952.* Old Greenwich, CT: Chatham Press, 1976.

———. *Strangers at the Door: Ellis Island, Castle Garden and the Great Migration to America.* Riverside, CT: Chatham Press, 1971.

Oboler, Suzanne. *Ethnic Labels, Latino Lives: Identity and the Politics of Representation in the United States.* Minneapolis: University of Minnesota Press, 1995.

Okihiro, Gary. *Margins and Mainstreams: Asians in American History and Culture.* Seattle: University of Washington Press, 1994.

Oles, James. *South of the Border: Mexico in the American Imagination, 1914–1917.* Washington, DC: Smithsonian Institution Press, 1993.

Olin, Spencer. "European Immigrant and Oriental Alien: Acceptance and Rejection by the California Legislature of 1913." *Pacific Historical Review* 35 (August 1966): 303–15.

Omi, Michael, and Howard Winant. *Racial Formation in the United States from the 1960s to the 1990s.* 2nd ed. New York: Routledge, 1994.

Orsi, Robert Anthony. "Religious Boundaries of an Inbetween People." *American Quarterly* 44 (September 1992): 313–47.

Orton, Fred, and Griselda Pollock. "Les données bretonnantes: Le prairie de répresentation." *Art History* 3 (September 1980): 314–44.

Palmquist, Peter. "Asian American Photographers on the Pacific Frontier, 1850–1930." In *With New Eyes: Toward an Asian American Art History in the West,* edited by Irene Poon Andersen et al. San Francisco: College of Creative Arts, Art Department Gallery, 1995.

———. "Asian Photographers in San Francisco, 1850–1930." *Argonaut: Journal of the San Francisco Historical Society* 9 (Fall 1998): 86–107.

Panzer, Mary. *Lewis Hine*. London: Phaidon, 2002.

Park, Robert E. *Race and Culture*. Glencoe, IL: Free Press, 1950.

Pedraza, Silvia, and Ruben Rumbaut, eds. *Origins and Destinies*. Belmont, CA: Wadsworth, 1996.

Peffer, George Anthony. "Forbidden Families: Emigration Experiences of Chinese Women under the Page Law, 1875–1882." *Journal of American Ethnic History* 6 (Fall 1986): 28–46.

———. *If They Don't Bring Their Women Here: Chinese Female Immigration before Exclusion*. Urbana: University of Illinois Press, 1999.

Pegler-Gordon, Anna. "Chinese Exclusion, Photography, and the Development of U.S. Immigration Policy." *American Quarterly* 58 (March 2006): 51–77.

Peterson, Larry. "Producing Visual Traditions among Workers: The Uses of Photography at Pullman." *International Labor and Working Class History* 42 (Fall 1992): 40–69.

Pitkin, Thomas M. *Keepers of the Gate: A History of Ellis Island*. New York: New York University Press, 1975.

Portes, Alejandro. "From South of the Border: Hispanic Minorities in the United States." In *Immigration Reconsidered: History, Sociology, and Politics*, edited by Virginia Yans-McLaughlin, 160–86. Oxford: Oxford University Press, 1990.

Pratt, Mary-Louise. *Imperial Eyes: Travel Writing and Transculturation*. London: Routledge, 1992.

Price, Derrick. "Surveyors and Surveyed." In *Photography: A Critical Introduction*, edited by Liz Wells, 65–68. London: Routledge, 1997.

Price, Sally. *Primitive Art in Civilized Places*. Chicago: University of Chicago Press, 1989.

Quartermaine, Peter. "Johannes Lindt: Photographer of Australia and New Guinea." In *Representing Others: White Views of Indigenous Peoples*, edited by Mick Gidley, 103–19. Exeter: University of Exeter Press, 1992.

Quitsland, Toby Gersten. "Arnold Genthe: A Pictorial Photographer in San Francisco, 1895–1911." PhD diss., George Washington University, 1988.

Rafael, Vicente. *White Love and Other Events in Filipino History*. Durham: Duke University Press, 2000.

———. "White Love: Surveillance and Nationalist Resistance in the U.S. Colonization of the Philippines." In *Cultures of U.S. Imperialism*, edited by Amy Kaplan and Donald Pease, 185–218. Durham: Duke University Press, 1993.

Rajchman, John. "Foucault's Art of Seeing." *October* 44 (Spring 1988): 89–117.

Rand, Erica. *The Ellis Island Snow Globe*. Durham: Duke University Press, 2005.

Reisler, Mark. *By the Sweat of Their Brow: Mexican Immigrant Labor in the United States, 1900–1940*. Westport, CT: Greenwood Press, 1976.

Rhodes, Henry. *Alphonse Bertillon: Father of Scientific Detection*. New York: Abelard-Schuman, 1956.

Ribb, Richard. "Lynching the Dead: The Texas Rangers' Use of Photography in a Strategy of Terror." Paper presented at the annual meeting of the American Historical Association, 2002.

Rodgers, Daniel. "In Search of Progressivism." *Reviews in American History* 10 (December 1982): 113–32.

Roediger, David R. *The Wages of Whiteness: Race and the Making of the American Working Class*. London: Verso, 1991.

Rosaldo, Renato. "Imperialist Nostalgia." *Representations* 26 (Spring 1989), 107–22. Reprinted in *Culture and Truth: The Remaking of Social Analysis*, 68–90. Boston: Beacon Press, 1989.

Rosenblum, Naomi. *A World History of Photography*, rev. ed. New York: Abbeville Press, 1989.

Rosenblum, Walter, and Naomi Rosenblum. *America and Lewis Hine*. Millerton, NY: Aperture, 1977.

Rouse, Roger. "Mexican Migration in the Social Space of Postmodernism." *Diaspora* 1 (Spring 1991): 8–23.

Ruiz, Vicki. *Cannery Women, Cannery Lives: Mexican Women, Unionization, and the California Food Industry, 1930–1950*. Albuquerque: University of New Mexico Press, 1987.

Rydell, Robert. *All The World's a Fair: Visions of Empire at the American International Expositions, 1876–1916*. Chicago: University of Chicago Press, 1984.

Said, Edward. *Orientalism*. New York: Vintage Books, 1979.

Salyer, Lucy. *Laws Harsh as Tigers: Chinese Immigrants and the Shaping of Modern Immigration Law*. Chapel Hill: University of North Carolina Press, 1995.

Samponaro, Frank, and Paul Vanderwood. *War Scare on the Rio Grande: Robert Runyon's Photographs of the Border Conflict, 1913–1916*. Barker Texas History Center Series 1. Austin: Texas State Historical Association, 1992.

Sánchez, George J. *Becoming Mexican American: Ethnicity, Culture and Identity in Chicano Los Angeles, 1900–1945*. New York: Oxford University Press, 1993.

———. "Race and Immigration History." *American Behavioral Scientist* 42 (June/July 1999): 1271–75.

———. "Race, Nation and Culture in Recent Immigration Studies." *Journal of American Ethnic History* 18 (Summer 1999): 66–84.

———. "Working at the Crossroads: American Studies for the 21st Century: Presidential Address to the American Studies Association, November 9, 2001." *American Quarterly* 54 (March 2002): 1–23.

Sarber, Mary. *Photographs from the Border: The Otis A. Aultman Collection*. El Paso, TX: El Paso Public Library Association, 1977.

Saxton, Alexander. *The Indispensable Enemy: Labor and the Anti-Chinese Movement in California*. Berkeley: University of California Press, 1971.

Schivelbusch, Wolfgang. *The Railway Journey: The Industrialization of Time and Space in the 19th Century*. Berkeley: University of California Press, 1986.

Schreier, Barbara. *Becoming American Women: Clothing and the Jewish Immigrant Experience*. Chicago: Chicago Historical Society, 1994.

Scott, James. *Domination and the Arts of Resistance: Hidden Transcripts*. New Haven: Yale University Press, 1990.

———. *Seeing Like a State: How Certain Schemes to Improve the Human Condition Have Failed*. New Haven: Yale University Press, 1998.

Scruggs, Otey M. *Braceros, "Wetbacks," and the Farm Labor Problem: Mexican Agricultural Labor in the United States, 1942–1954*. Reprint. New York: Garland, 1988.

See, Lisa. *On Gold Mountain: The One-Hundred-Year Odyssey of My Chinese-American Family.* New York: Vintage Books, 1995.

Seixas, Peter. "Lewis Hine: From 'Social' to 'Interpretive' Photographer." *American Quarterly* 39 (Fall 1987): 381–409.

Sekula, Allan. "The Body and the Archive." In *The Contest of Meaning: Critical Histories of Photography,* edited by Richard Bolton, 343–89. Cambridge, MA: MIT Press, 1989.

Severa, Joan L. *Dressed for the Photographer: Ordinary Americans and Fashion, 1840–1900.* Kent: Kent State University Press, 1995.

Shah, Nayan. *Contagious Divides: Epidemics and Race in San Francisco's Chinatown.* Berkeley: University of California Press, 2001.

Sisneros, Samuel. "The Casasola Legacy in El Paso." *Password* (El Paso County Historical Society) 47 (Spring 2002): 23–28.

Siu, Paul. "The Chinese Laundryman: A Study of Social Isolation." PhD diss., University of Chicago, 1953.

Skowronek, Stephen. *Building a New American State: The Expansion of National Administrative Capacities, 1877–1920.* Cambridge: Cambridge University Press, 1982.

Smith, Marian L. "Immigration and Naturalization Service." In *A Historical Guide to the U.S. Government,* edited by George T. Kurian, 305–8. New York: Oxford University Press, 1998.

Smith, Shawn Michelle. *American Archives: Gender, Race, and Class in Visual Culture.* Princeton: Princeton University Press, 1999.

———. *Photography on the Color Line: W. E. B. DuBois, Race, and Visual Culture.* Durham: Duke University Press, 2004.

Solomon, Barbara Miller. *Ancestors and Immigrants.* Cambridge, MA: Harvard University Press, 1956.

Solomon-Godeau, Abigail. *Photography at the Dock: Essays on Photographic History, Institutions and Practices.* Minneapolis: University of Minnesota Press, 1991.

Sontag, Susan. *On Photography.* 1973. Reprint, New York: Anchor Books/Doubleday, 1990.

Spencer, Frank. "Some Notes on the Attempt to Apply Photography to Anthropometry during the Second Half of the Nineteenth Century." In *Anthropology and Photography,* edited by Elizabeth Edwards, 99–107. New Haven: Yale University Press, 1992.

Spencer, Stephanie. "O. G. Rejlander's Photographs of Street Urchins." *Oxford Art Journal* 7, no. 2 (1984): 17–24.

Squiers, Carol, ed. *The Critical Image: Essays on Contemporary Photography.* Seattle, WA: Bay Press, 1990.

Stange, Maren. *Symbols of Ideal Life: Social Documentary Photography in America, 1890–1950.* Cambridge: Cambridge University Press, 1989.

Stein, Sally. "Making Connections with the Camera: Photography and Social Mobility in the Career of Jacob Riis." *Afterimage* 10 (May 1983): 9–16.

Steinorth, Karl, ed. *Lewis Hine: Passionate Journey, Photographs, 1905–1937.* Zurich: Edition Stemmle, 1996.

Stern, Alexandra Minna. "Buildings, Boundaries, and Blood: Medicalization and Nation-Building on the US-Mexico Border, 1910–1930." *Hispanic American Historical Review* 79, no. 1 (1999): 41–82.

———. *Eugenic Nation: Faults and Frontiers of Better Breeding in Modern America.* Berkeley: University of California Press, 2005.

———. "Eugenics beyond Borders: Science and Medicalization in Mexico and the U.S. West, 1900–1950." PhD diss., University of Chicago, 1999.

Stern, Alexandra Minna, and Howard Markel. "All Quiet on the Third Coast: Medical Inspections of Immigrants in Michigan." *Public Health Reports* 114, no. 2 (1999): 178–82.

Stimson, Blake. *The Pivot of the World: Photography and Its Nation.* Cambridge, MA: MIT Press, 2006.

Stocking, George W., Jr. *Race, Culture and Evolution: Essays in the History of Anthropology.* 1968. Reprint, Chicago: University of Chicago Press, 1982.

———. "The Turn-of-the-Century Concept of Race." *Modernism/Modernity* 1 (1994): 4–16.

Stoler, Ann Laura. *Race and the Education of Desire: Foucault's "History of Sexuality" and the Colonial Order of Things.* Durham: Duke University Press, 1995.

Stott, William. *Documentary Expression and Thirties America.* New York: Oxford University Press, 1973.

Street, Brian. "British Popular Anthropology: Exhibiting and Photographing the Other." In *Anthropology and Photography, 1860–1920,* edited by Elizabeth Edwards, 122–31. New Haven: Yale University Press, 1992.

Stuart, Jan, and Evelyn Rawski. *Worshiping the Ancestors: Chinese Commemorative Portraits.* Stanford, CA: Freer Gallery of Art and Arthur M. Sackler Gallery, Smithsonian Institution, 2001.

Sturken, Marita, and Lisa Cartwright. *Practices of Looking: An Introduction to Visual Culture.* Oxford: Oxford University Press, 2001.

Sun, Shirley. *Three Generations of Chinese—East and West.* Oakland, CA: Oakland Museum, 1973.

Sun, Yumei. "From Isolation to Participation: *Chung Sai Yat Po* [China West Daily] and San Francisco's Chinatown." PhD diss., University of Maryland, College Park, 1999.

Taft, Robert. *Photography and the American Scene: A Social History, 1839–1889.* New York: Dover Publications, 1964.

Tagg, John. *The Burden of Representation: Essays on Photographies and Histories.* Minneapolis: University of Minnesota Press, 1988.

Takaki, Ronald. *Iron Cages: Race and Culture in 19th Century America.* Seattle: University of Washington Press, 1979.

———. *Strangers from a Different Shore: A History of Asian Americans.* New York: Penguin Books, 1989.

Tam, Shirley Sui Ling. "Images of the Unwelcome Immigrant: Chinese Americans in American Periodicals, 1900–1924." PhD diss., Case Western University, 1999.

Tanaka, Kei. "Japanese Picture Marriage in 1900–1924 California: Construction of Japanese Race and Gender." PhD diss., Rutgers University, 2002.

Tchen, John Kuo Wei. *Genthe's Photographs of San Francisco's Old Chinatown.* New York: Dover Publications, 1984.

———. *New York before Chinatown: Orientalism and the Shaping of American Culture, 1776–1882.* Baltimore: Johns Hopkins University Press, 1999.

Temple, Andrea, and June Tyler. *Ellis Island and the Augustus Sherman Collection.* Wethersfield, CT: First Experience, 1986.

Teng, Ssu-yu. "China's Examination System and the West." In *China,* edited by Harley Farnsworth McNair. Berkeley: University of California Press, 1951.

Thurston, Thomas. "Hearsay of the Sun: Photography, Identity, and the Law of Evidence in 19th-Century American Courts." *American Quarterly Hypertext Scholarship in American Studies,* 1999, http://chnm.gmu.edu/aq/photos.

Tifft, Wilton, and Thomas Dunne. *Ellis Island.* New York: W. W. Norton, 1971.

Timmons, W. H. *El Paso: A Borderlands History.* El Paso: Texas Western Press, 1990.

Tolentino, Roland. "Bodies, Letters, and Catalogues: Filipinas in Transnational Space." *Social Text* 48 (1996): 49–76.

Torpey, John. *The Invention of the Passport: Surveillance, Citizenship and the State.* Cambridge: Cambridge University Press, 2000.

Trachtenberg, Alan. "Ever—the Human Document." In *America and Lewis Hine: Photographs, 1904–1940,* edited by Walter Rosenblum and Naomi Rosenblum, 118–37. Millerton, NY: Aperture, 1977.

———. *Reading American Photographs: Images as History—Matthew Brady to Walker Evans.* New York: Hill and Wang, 1989.

Tsai, Shih-Shan Henry. "Reaction to Exclusion: The Boycott of 1905 and Chinese National Awakening." *Historian* 39 (1976): 95–110.

Twombly, Robert. "Ellis Island: An Architectural History." In *Ellis Island: Echoes from a Nation's Past,* edited by Susan Jonas, 122–37. New York: Aperture, 1989.

Urry, John. *The Tourist Gaze: Leisure and Travel in Contemporary Societies.* Thousand Oaks, CA: Sage Publications, 1990.

U.S. Immigration and Naturalization Service. "Early Immigrant Inspection along the US/Mexican Border." 2003. www.minorityjobs.net/article.php ?id=218.

University of Texas at Austin. General Libraries. "Robert Runyon: Border Photographer." n.d. Robert Runyon Photograph Collection. http://runyon.lib.utexas .edu/bio.html.

Vanderwood, Paul, and Frank N. Samponaro. *Border Fury: A Picture Postcard Record of Mexico's Revolution and U.S. War Preparedness, 1910–1917.* Albuquerque: University of New Mexico Press, 1988.

Vinograd, Richard. *Boundaries of the Self: Chinese Portraits, 1600–1900.* Cambridge: Cambridge University Press, 1992.

Volpp, Leti. "Divesting Citizenship: On Asian American History and the Loss of Citizenship through Marriage." *UCLA Law Review* 53, no. 2 (2005): 405–84.

Walker, John A., and Sarah Chaplin. *Visual Culture: An Introduction.* Manchester: Manchester University Press, 1997.

Weber, Devra. *Dark Sweat, White Gold: California Farm Workers, Cotton and the New Deal.* Berkeley: University of California Press, 1994.

Weber, Max. "Ethnic Groups." In *Economy and Society,* 1:385–98. 1956. Reprint, New York: Bedminster Press, 1968.

Wells, Liz, ed. *Photography: A Critical Introduction.* London: Routledge, 1997.

Wexler, Laura. "Techniques of the Imaginary Nation: Engendering Family Photography." In *Race and the Production of Modern American Nationalism,* edited by Reynolds J. Scott-Childress, 359–82. New York: Garland, 1999.

———. *Tender Violence: Domestic Visions in an Age of U.S. Imperialism.* Chapel Hill: University of North Carolina Press, 2000.

Willis, Deborah, ed. *Picturing Us: African American Identity in Photography.* New York: New Press, 1994.

Wischnitzer, Mark. *Visas to Freedom: The History of the HIAS.* Cleveland, OH: World Publishing, 1956.

Wong, K. Scott, and Sucheng Chan, eds. *Claiming America: Constructing Chinese American Identities during the Exclusion Era.* Philadelphia: Temple University Press, 1998.

Worswick, Clark. "Photography in Nineteenth-Century Japan." In *Japan: Photographs, 1854–1905,* edited by Clark Worswick, 129–39. New York: Pennwick, 1979.

Worswick, Clark, and Jonathan Spence. *Imperial China: Photographs, 1850–1912.* New York: Pennwick, 1978.

Yans-McLaughlin, Virginia, ed. *Immigration Reconsidered: History, Sociology, and Politics.* Oxford: Oxford University Press, 1990.

Yew, Elizabeth. "Medical Inspection of Immigrants at Ellis Island, 1891–1924." *Bulletin of the New York Academy of Medicine* 56, no. 5 (1980): 488–510.

Yu, Connie Young. "The Chinese in American Courts." *Bulletin of Concerned Asian Scholars* 4 (1972): 22–30.

———. "Rediscovered Voices: Chinese Immigrants and Angel Island." *Amerasia Journal* 4, no. 2 (1977): 123–39.

Yung, Judy. *Unbound Feet: A Social History of Chinese Women in San Francisco.* Berkeley: University of California Press, 1995.

———. *Unbound Voices: A Documentary History of Chinese Women in San Francisco.* Berkeley: University of California Press, 1999.

Zeidel, Robert F. *Immigrants, Progressives, and Exclusion Politics: The Dillingham Commission, 1900–1927.* DeKalb: Northern Illinois University Press, 2004.

Zo, Kil Young. *Chinese Emigration into the United States, 1850–1880.* New York: Arno Press, 1978.

Zolberg, Aristide. "The Great Wall against China: Reponses to the First Immigration Crisis, 1885–1925." In *Migration, Migration History, History: Old Paradigms and New Perspectives,* edited by Jan Lucassen and Leo Lucassen, 291–315. New York: Peter Lang, 1997.

———. "Matters of State: Theorizing Immigration Policy." In *Handbook of International Migration,* edited by Charles Hischman et al., 71–93. New York: Russell Sage Foundation, 1999.

————. *A Nation by Design: Immigration Policy in the Fashioning of America.* Cambridge, MA: Harvard University Press, 2006.

Zurier, Rebecca, et al. *Metropolitan Lives: The Ashcan Artists and Their New York.* Washington, DC: National Museum of American Art, 1996.

————. *Picturing the City: Urban Vision and the Ashcan School.* Berkeley: University of California Press, 2006.

Index

Text:	10/13 Sabon
Display:	Sabon
Compositor:	Integrated Composition Systems, Inc.
Indexer:	Sharon Sweeney
Printer and binder:	Thomson-Shore, Inc.